SANDRA NUNNERLEY

INTERIORS

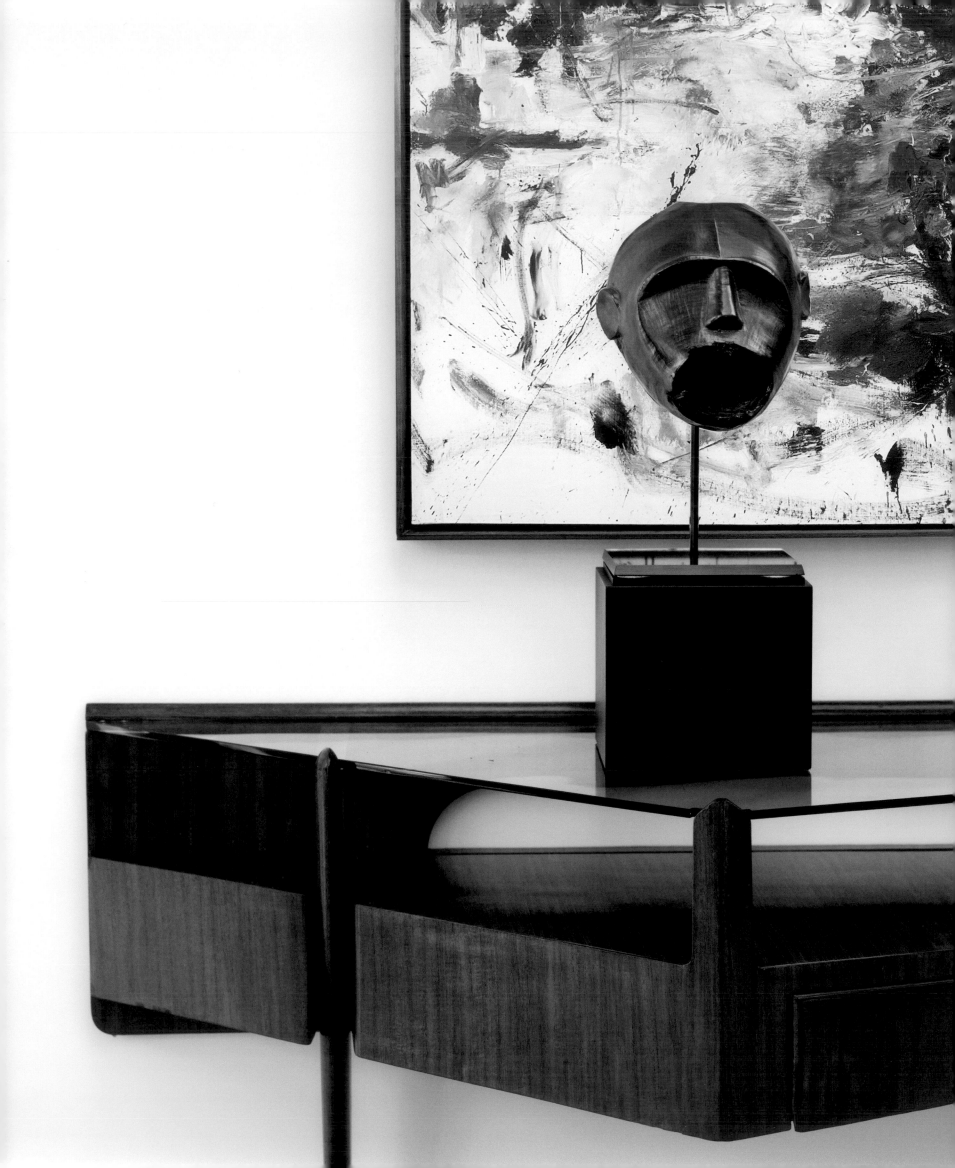

SANDRA NUNNERLEY

INTERIORS

WRITTEN WITH CHRISTINE PITTEL

pH powerHouse Books
BROOKLYN, NY

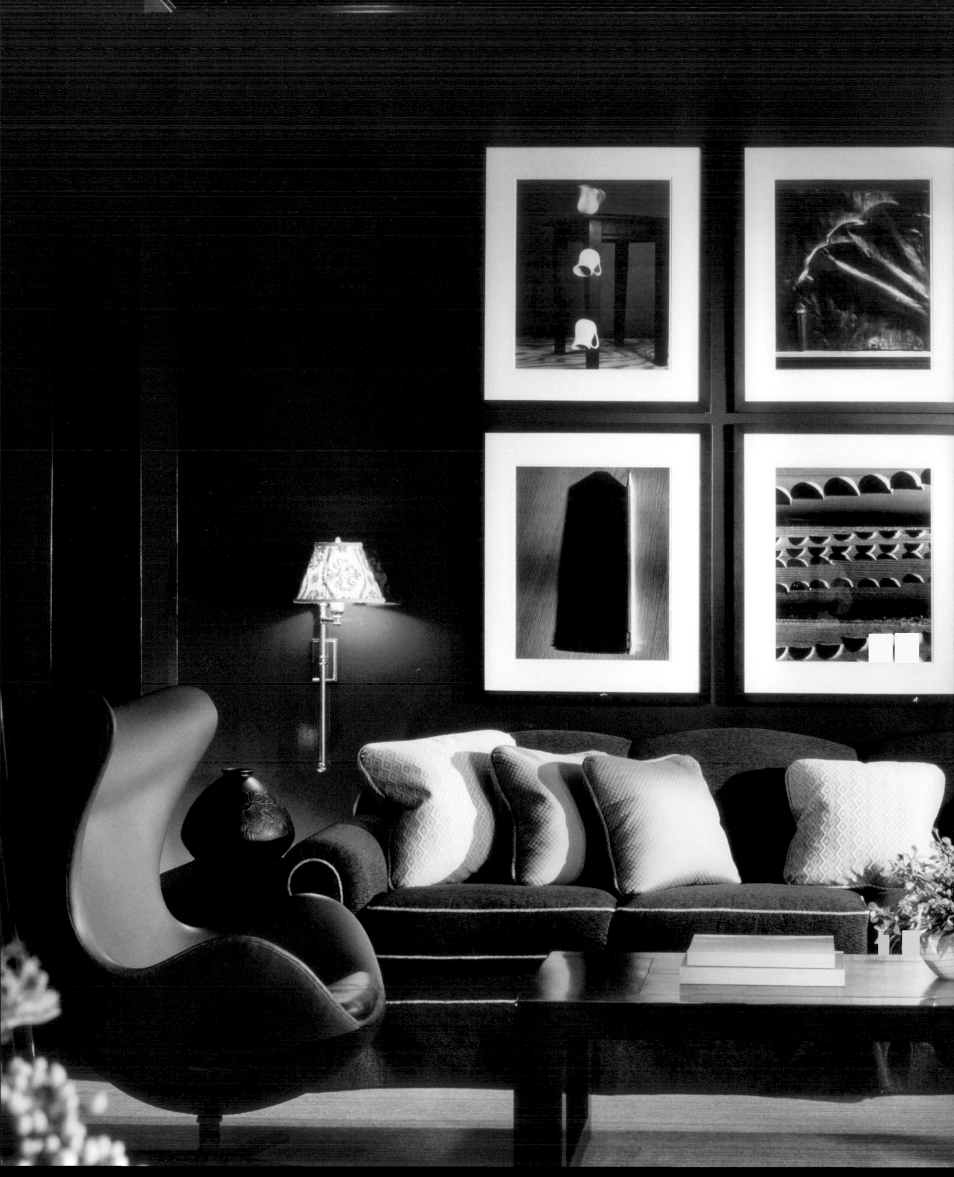

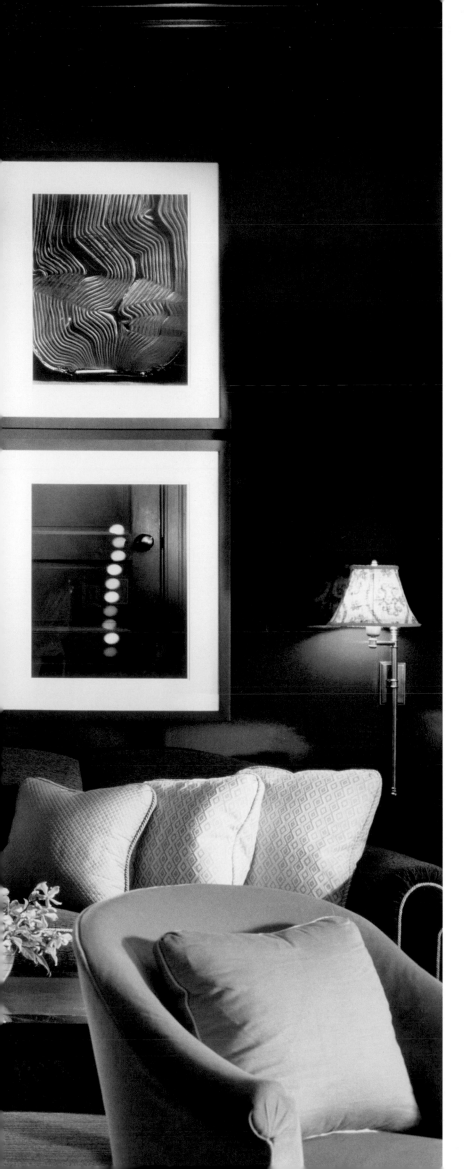

To . . .

My mother, for letting me paint the living room red

My grandmother, for teaching me how to make afternoon tea

My mentors, for showing me the way

My clients, for sharing my vision

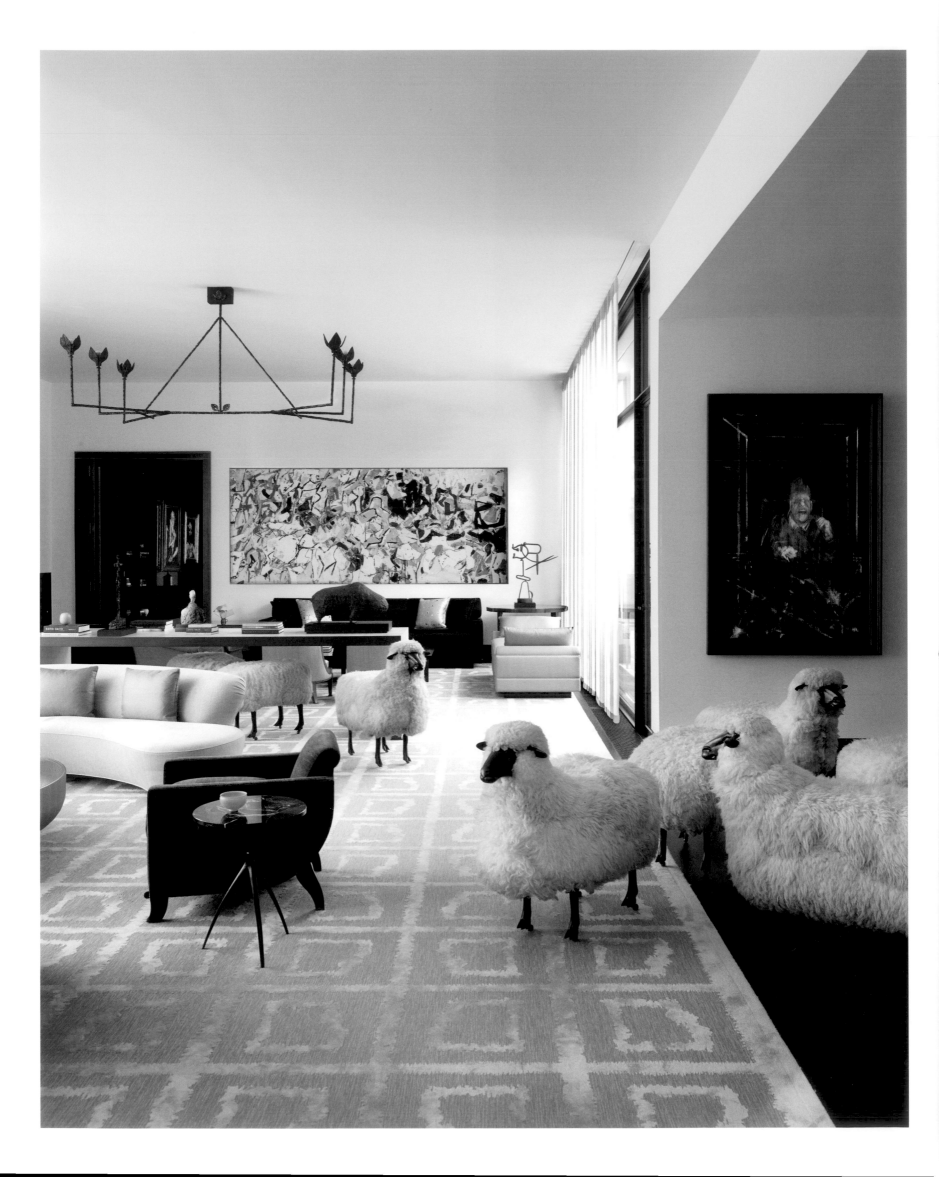

Portrait of Sandra Nunnerley by Richard Corman.

FOREWORD

I met Sandra Nunnerley at the annual Decorator Show House presented by the New York Kips Bay Boys & Girls Club, in which top designers each make over a room in their own style. It was her first time showing there and my first visit to the event. While we were exchanging greetings, my eyes traveled toward her "room." It was distinctively different from the others I had seen climbing up the white banister staircase to the top of the house where the "young" interior designers had been given spaces. There was a timeless elegance about Nunnerley's boudoir-living room. It was classic with a twist; soft, but not overly feminine; with an interesting mix of antique pieces, contemporary furniture, and art. You could feel it had been carefully curated. My sonar could detect a very educated, sensitive, and personal approach to design.

After I became editor-in-chief of French *Architectural Digest*, I continued to follow the impressive steps of Nunnerley's career. Over the years, her sense of "art de vivre" grew into a style where the traditional meets the contemporary with an easy grace. Her background in architecture and fine arts gives a true depth to her work; the past and present mingle harmoniously together. Nunnerley has this rare thing—an "eye." Her eye, believe me, is a gift some fairy godmother dropped into her cradle, back in New Zealand. It makes her special. This is why her intuition, her talent, her sense of proportion, and the way she dares unexpected stylistic moves add up to a unique signature.

One more thing has always struck me as I've examined her work: her complete understanding of a place. She listens well to her clients and carefully considers the site, delivering perfectly tailored spaces that bring substance to her client's wishes. As a whole, her interiors strike me as harmonious and cosmopolitan. Yet her extreme visual sophistication doesn't ignore our need for comfort and well-being. This makes for wonderful atmospheres that are, all at once, soft and strong. This, I believe, is the reason men and women feel equally comfortable in her rooms. To me, that's a remarkable achievement.

Sandra Nunnerley's work is perfectly in tune with how we live. She knows how to add to our surroundings a cool beauty that fits the times, lending to spaces a backbone they often lack and a subtle sensuality that is unarguably chic. And that's what I call style!

—Alexandra D'Arnoux, Paris, France

INTRODUCTION

I had a penguin as a pet when I was a child in Wellington, New Zealand. Our creaky clapboard Victorian house overlooked the beach at Oriental Bay. I used to run down the hill to catch the school bus by the band rotunda, crouching down to look at the sea anemones in the rock pools while I was waiting. One year, a little blue penguin—the color of slate and only about a foot tall—swam up from the harbor and somehow sauntered across the street, found his way to our door, and walked right in. I immediately named him Bluey and was happy to catch fresh fish to feed him. My mother was not quite so thrilled. For some reason, his favorite spot was the floor of her closet. I can still hear her shrieking, "Get that penguin out of my shoes!"

This was not her normal form of address. My mother is an extremely cultivated woman and a former journalist. She took me to see every play, concert, or ballet that came to town. I remember being so astonished by Margot Fonteyn and Rudolf Nureyev when I was seven that I clenched my fists in amazement and my fingernails cut through the palms of my hands.

My mother was my first and most important mentor. When I went off to study architecture at university in Sydney, Australia, I found another in Kym Bonython, who hired me to work at his art gallery. Kym was a remarkable man who opened my eyes to art and to music. He was also a jazz entrepreneur who brought over all the greats. I remember Duke Ellington kissing my hand and Thelonious Monk playing the piano on one of Kym's rollicking harbor cruises.

Many Aussies and Kiwis do a version of the European grand tour and I left Sydney and embarked on my own walkabout. I shared a flat in London's Earls Court, nicknamed Kangaroo Valley at the time. I don't think anyone knew who held the lease; it was just a place to drop your suitcases. I studied art history in Paris and traveled the Continent. Then I decided I wanted to go to New York and work in the art world (it was the place to be at that time), and I ended up at the Marlborough Gallery, which represented artists like Francis Bacon and David Smith. I was the low man on the totem pole, but I met all these brilliant artists and dealers—people

like Leo Castelli, who I adored listening to over lunch at Mezzaluna in SoHo, and Holly Solomon, a great soul and one of the most stylish women I'd ever met. These people became my mentors and shaped my aesthetic sensibilities, encouraging me to believe that I too could create.

Life is full of serendipity. Trusting my eye and my experience with art, family friends invited me to join a team designing their Manhattan townhouse. We expanded their collection and transformed the space. The result prompted a visitor to ask me to design a ski house in Vermont, which landed in *Architectural Digest*. I found that interior design actually brought together everything I loved: architecture, design, art. I opened my own studio in 1986.

Design opened up new worlds to me, and travel continues to be my classroom. Every year I make a point of going somewhere new. I've hiked to Machu Picchu in Peru and floated down the Sepik River in New Guinea. These are voyages of discovery, and although you never know what you're going to get out of them, they're crucial to inspiration. After spending time in India, I nearly filled my apartment with cushions instead of chairs. Sweden led me to incorporate colors that reflect the wonderful quality of the northern lights of a Scandinavian summer. When I returned from Burma, I wanted to paint everything red.

This global perspective may be one reason why my practice has become so international. Architecture has always been my starting point, but I would say the spirit of my style has something to do with jazz. Jazz is all about improvisation and the ability to react spontaneously, to invent and to explore. I like to think I've applied that same freedom to design. I draw my inspiration from far and wide, and free-associate between all things beautiful from different places and periods.

Creating worlds that reflect the way people live is passionate, creative work. I always say that good design never happens without inspiration and imagination, but great design also celebrates reality. Bringing to life spaces that are both beautiful to look at, and that people actually *use*—to me, that's design at its best.

—Sandra Nunnerley, New York

SERENITY

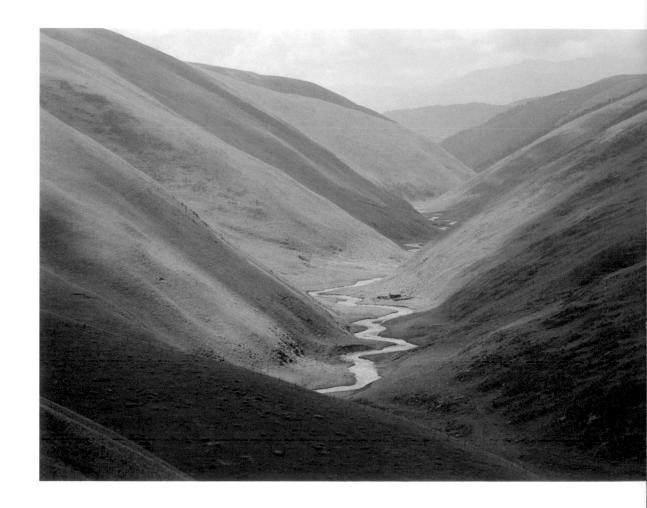

In this high valley on the Tibetan plateau, the grass looks like green velvet.
Opposite and following: In my living room a Kenneth Noland painting accentuates
the modern lines of a Khmer sculpture c. 945 that stands at attention beside
a custom table. A Jean Royère chandelier is reflected in the mirror.

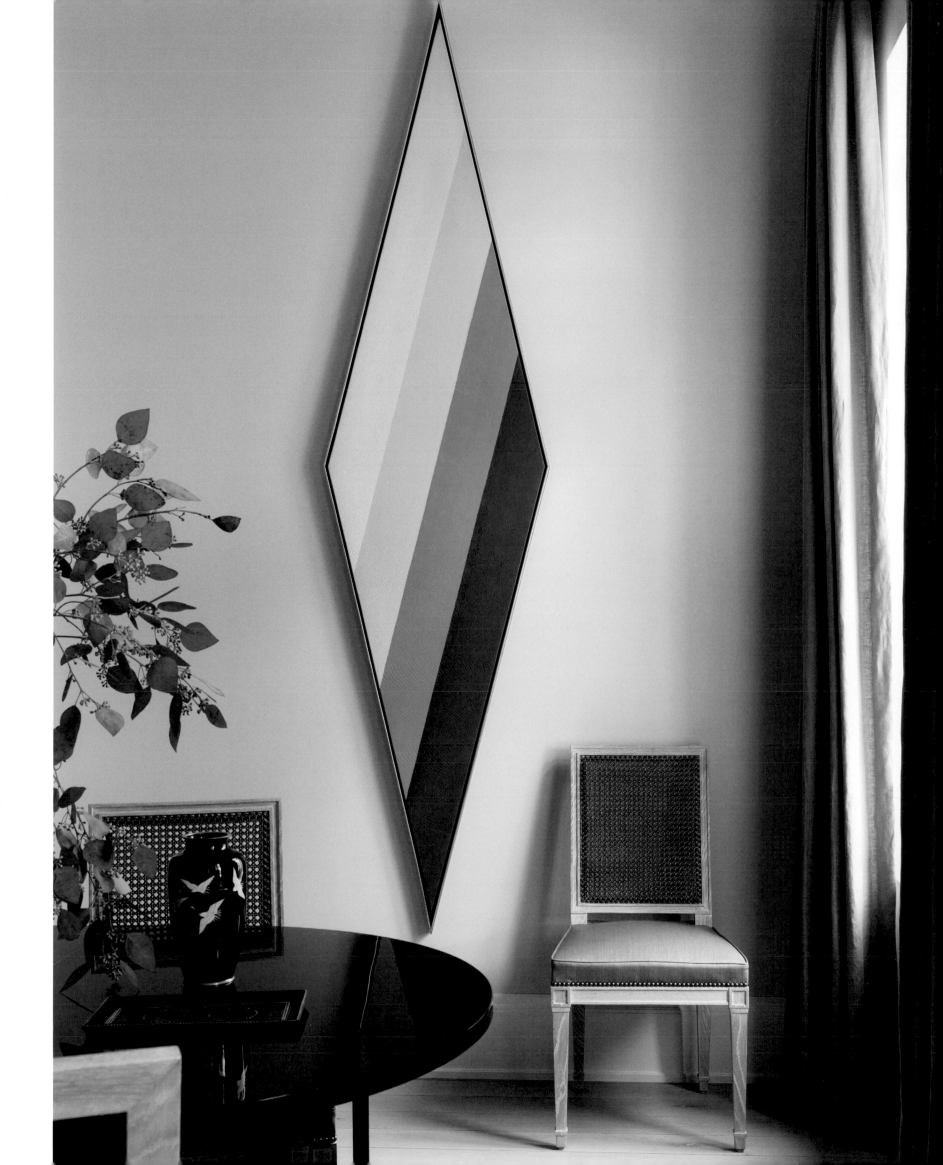

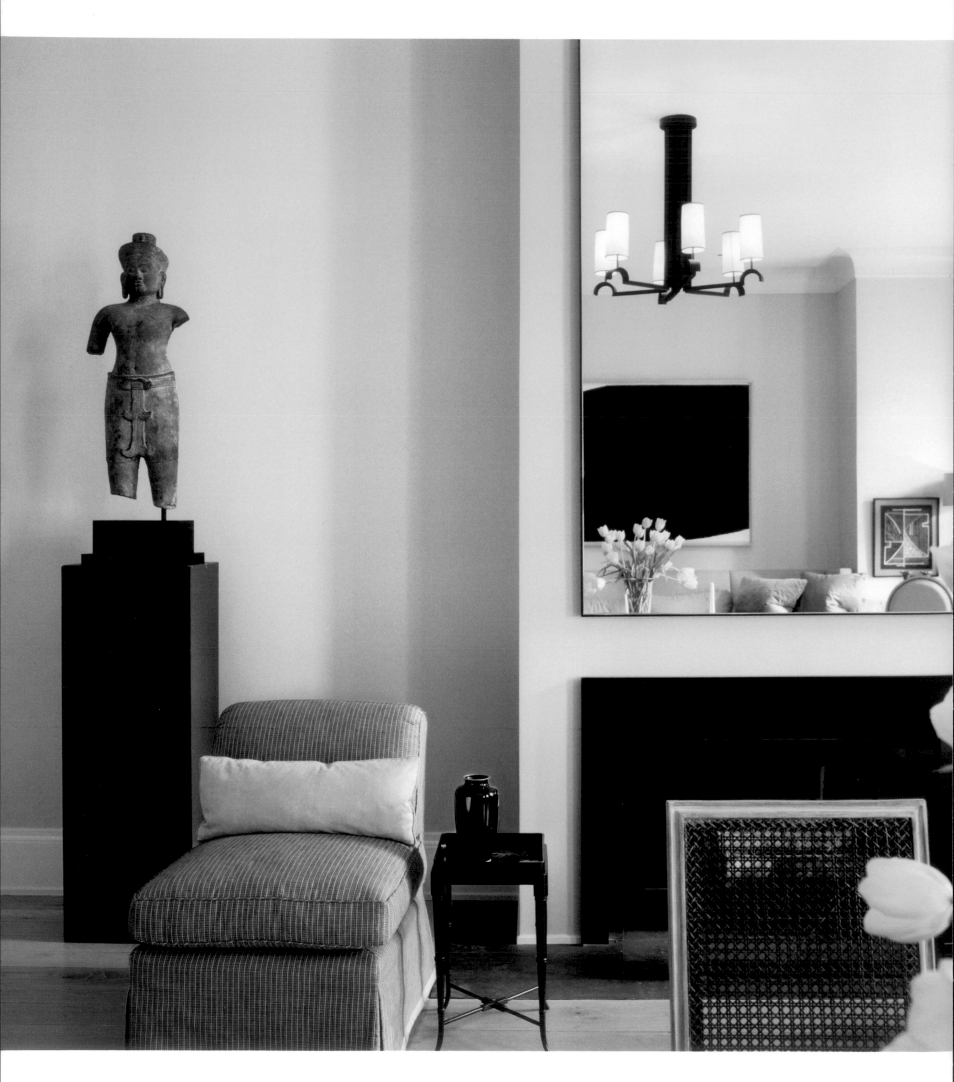

Coming round a bend on a narrow, twisting mountain road in Tibet, I suddenly saw the most dazzling turquoise-blue lake cradled in the green grass of the valley below. And around the next curve, there was another lake and then another. As the clouds swept by and the light changed, so did the intensity of the colors. The lakes shifted from turquoise to azure to a deep cerulean blue.

Tibet is called the rooftop of the world, and now I know why. You can see for miles, all the way to snow-capped mountains that are some of the tallest on the planet. The vastness and solitude of the landscape is overpowering. All I could hear was the flapping of prayer flags in the wind—one of the quintessential sounds of Tibet—along with the chanting of monks, the murmuring of mantras as people spin prayer wheels in their hands, and the tinkling of tiny bells around the neck of a yak.

This is a country that touches your soul. As I stood on that mountainside, I felt a profound sense of serenity. All the tension in my body seemed to evaporate. My thoughts expanded.

I wanted that same kind of feeling in my New York apartment. I was lucky. Two adjacent units in a turn-of-the-century Carrère & Hastings town house on a beautiful block close to Central Park came on the market at the same time. I bought both so I could have the whole floor. The front apartment had exceptionally high ceilings, and I immediately realized that if I took down a wall I could have a large square living room. I've always wanted a square room. There's something restful about the clarity of those proportions. This apartment had been renovated, but not to my taste, of course. The back apartment hadn't been touched in years and was in poor condition.

As I always tell my clients, you've got to get the bones right first. If you don't, you're going nowhere, no matter how hard you try. So I gutted the whole place and replaced the small windows in the bedroom and

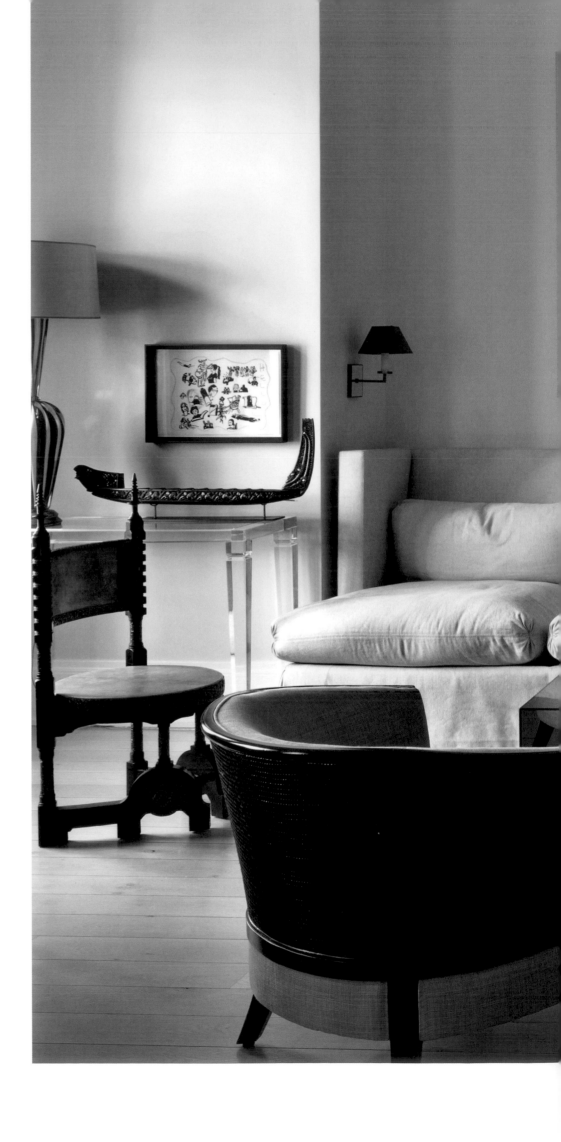

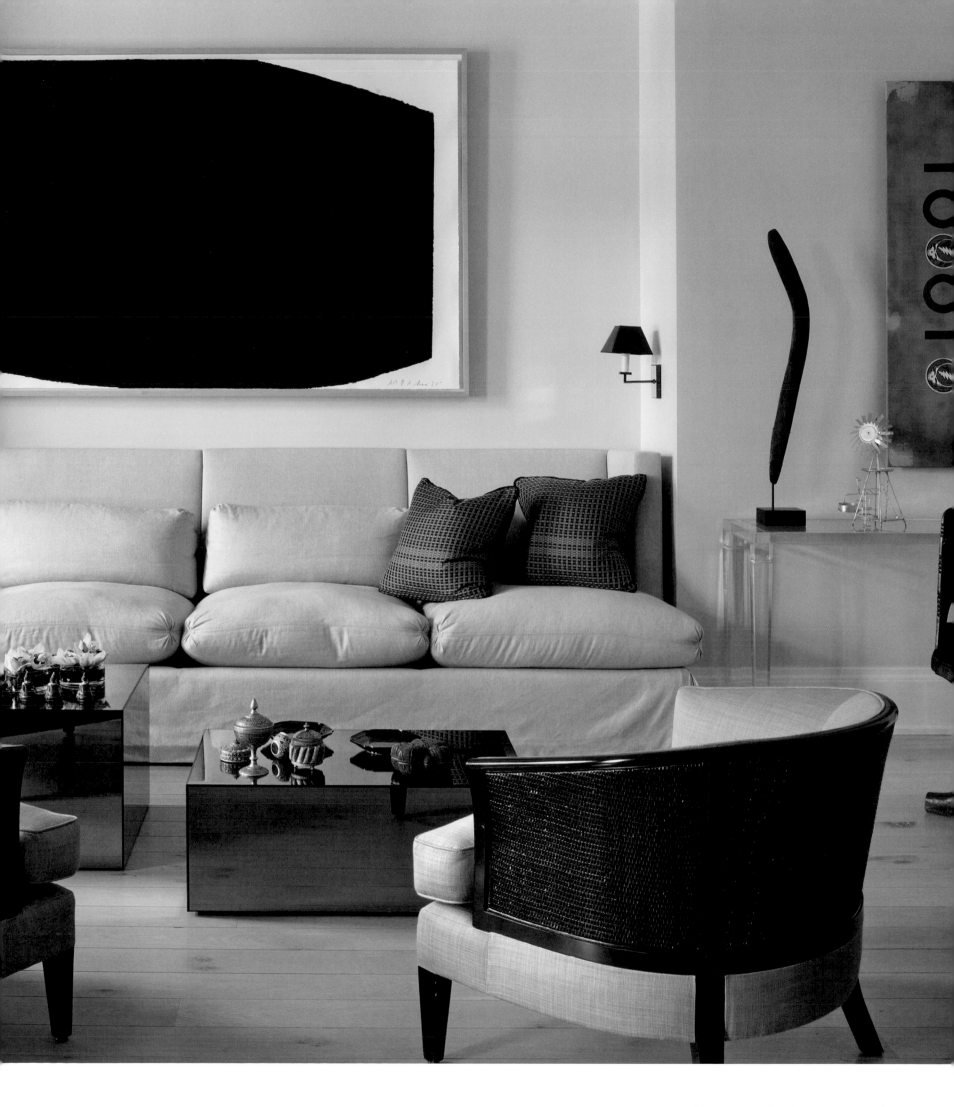

Mirrored tables and a Richard Serra painting frame
this monochromatic seating area, anchored by a custom sofa and chairs.

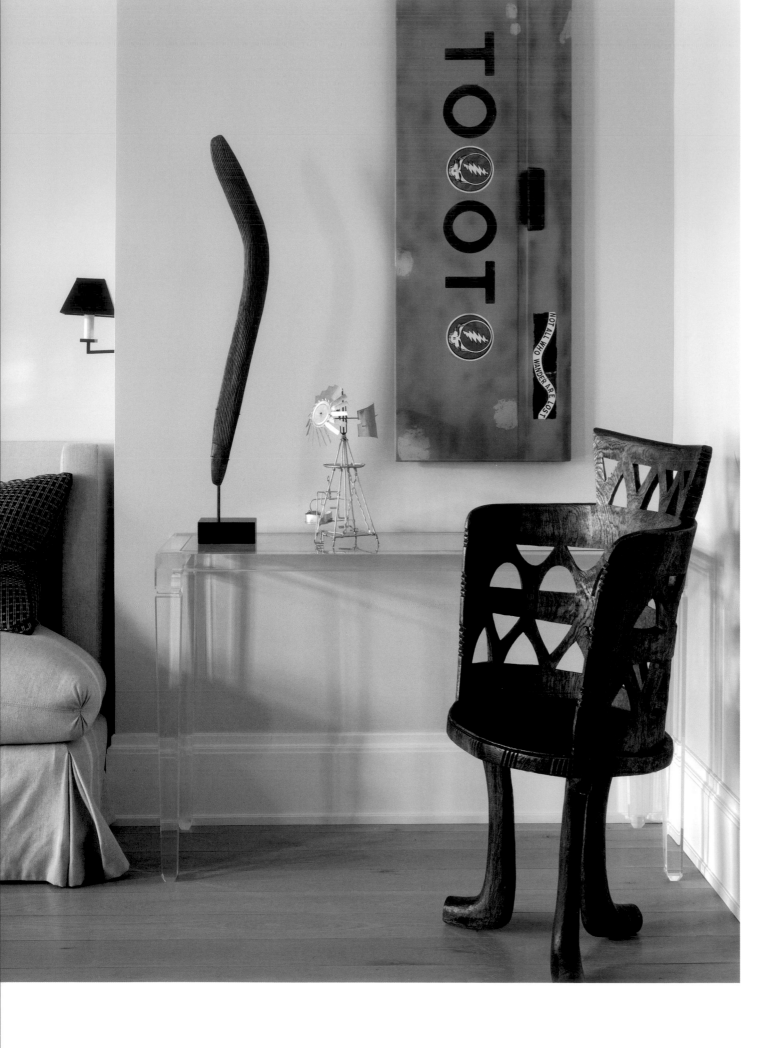

A boomerang and a Kaz Oshiro canvas adorn a 1970s Italian plexiglass console.
The carved wooden chair is Ethiopian.

the study with large French windows to bring in more light. That solved the problem inherent in any town house—with windows only at the front and back, the middle can feel like a long, dark tunnel.

I decided the middle would be the best place for the kitchen. Should I open it up to the living room? That would make the apartment seem more like a loft, and I love the expansive feeling you get in a big open space. But there is one thing that bothers me about those open kitchens. Although they look fabulous in photographs, the reality is that the smells, the noise, and the stacks of dirty dishes can be less than appetizing in the midst of a dinner party.

So I kept my kitchen separate because that's what works for me. One of the major impulses behind all my projects is to get people to really live in their environments by designing something that suits and supports their lifestyles. Before we start drawing up any plans, my associates and I spend a lot of time talking with our clients to find out what they need and how they want to live. And that applied to me as well. I had to do the same kind of analysis on myself, and I realized that I like to have the option of closing off the kitchen.

On the fifth floor of this classic New York building, I created a classically proportioned living room with classical details such as custom-made crown moldings and baseboards. And then I did something a little subversive. I put in wide oak floorboards instead of the usual parquet. And there's a bit of a gap between the planks, as if the wood had shrunk over the years. It looks like something you would see in an old warehouse or an 18th-century home in France or Belgium. Somehow it's antique and contemporary at the same time, which means I could have this classical space that still feels loftlike. I wanted that tension. It makes the room more interesting.

The fireplace was a natural focal point. The previous owners told me that it worked, which is not always the case in Manhattan, and that it burned wood. But when I found out that this was not true, I was so

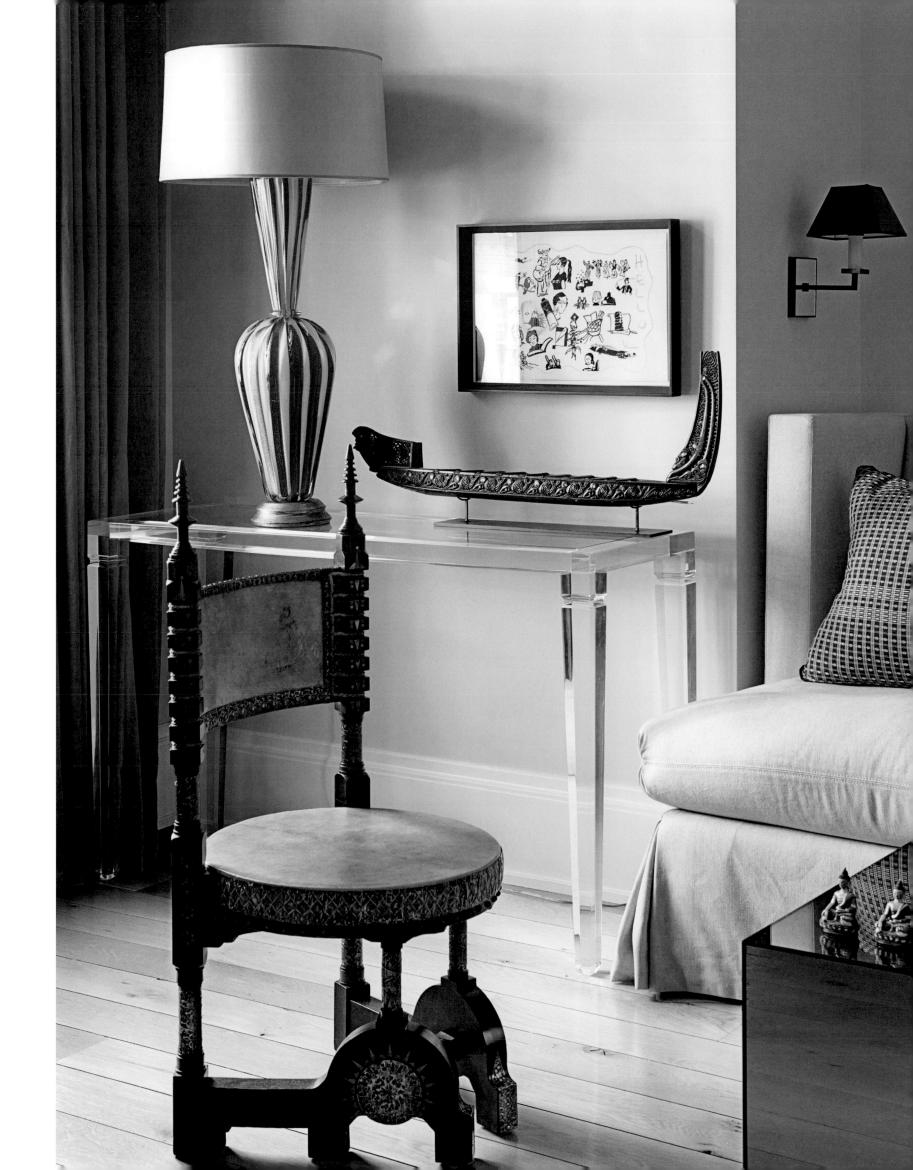

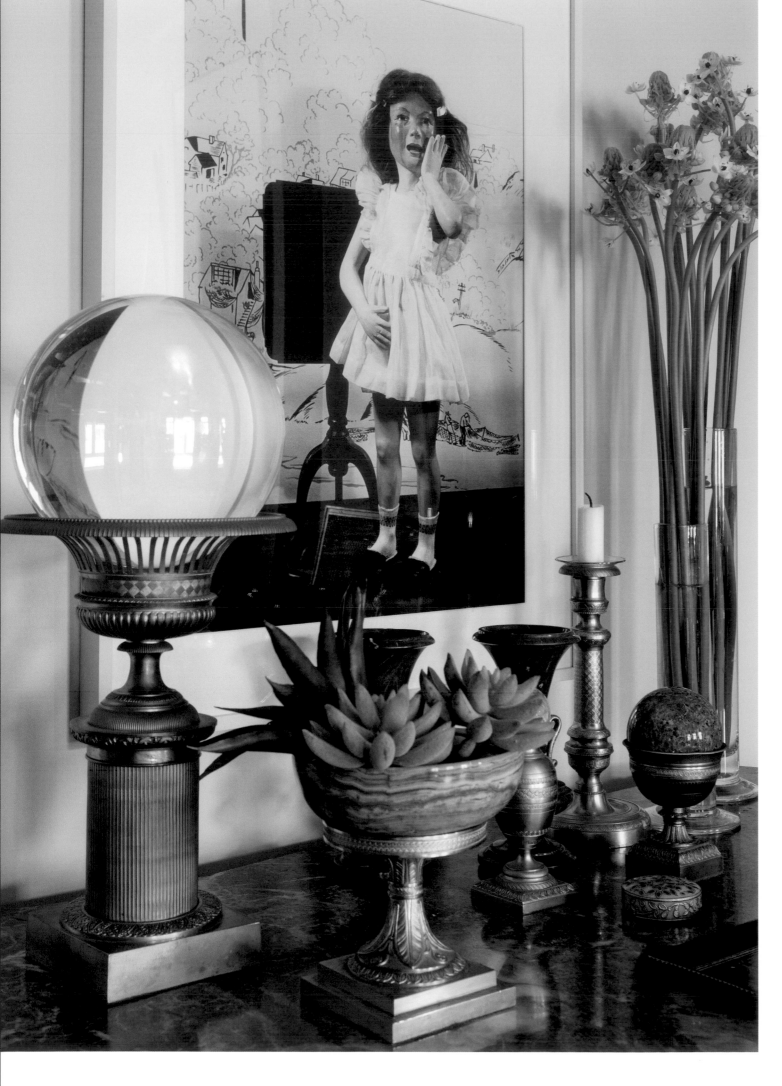

Previous page: The Carlo Bugatti chair is coupled with a midcentury Murano lamp and a Kim MacConnell artwork.
The carving of a Maori war canoe adds another layer to the subtle tableau. Opposite and above: Morton Bartlett
photographs c. 1955 hang in the entryway. The Louis XIV beech wood table is populated by 19th-century gilt objects.

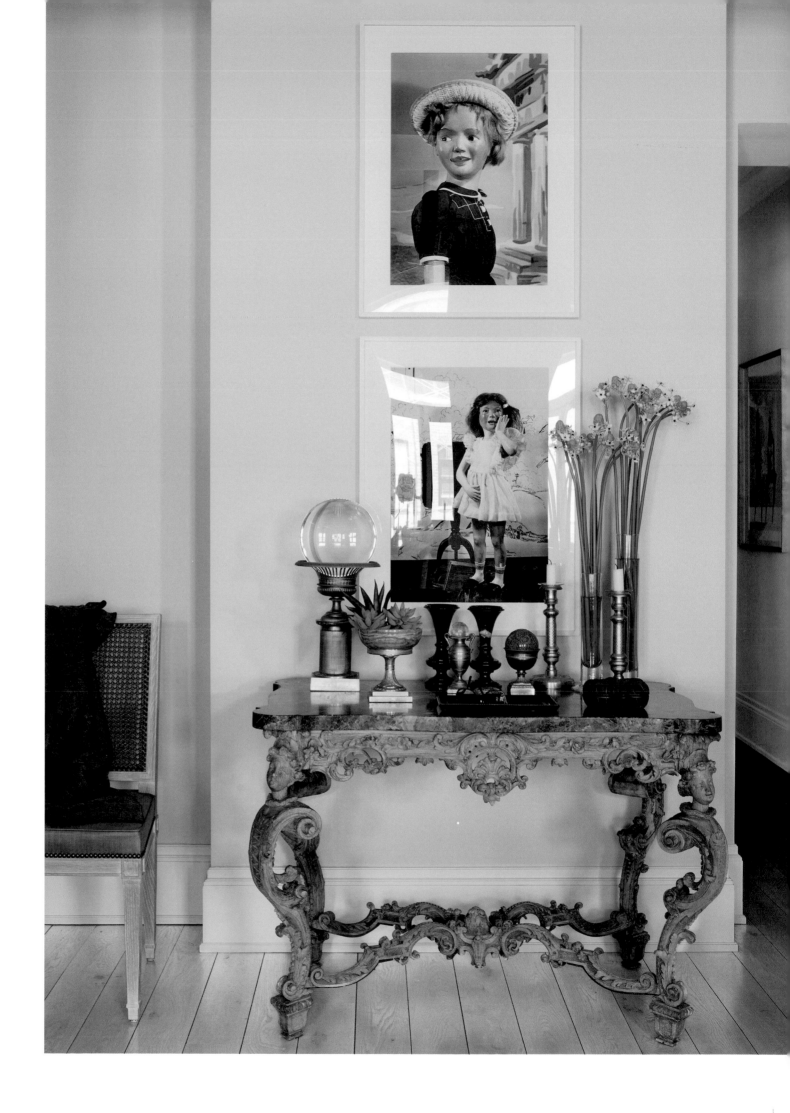

disappointed. A real fireplace was one thing I particularly wanted. I couldn't let it go. My contractor and I did some forensic work behind the wall and found an old flue leading up from the basement, which used to be the kitchen when this was a single-family home at the turn of the century. Because of the angle of the flue, the firebox had to be rather low. A large mantel would have looked ridiculous—too short and squat. Instead, I did a simple bronze metal surround and hung a tall rectangular mirror above it, framed in the same bronze. Even though my work cannot be called minimalist by any stretch of the imagination, I will often use a minimalist detail like this.

The sofa seats six people. It's monumental. I built a little niche for it so it wouldn't jut out so far into the room and interrupt my square. I had it made with a very deep, low seat, almost like a Turkish ottoman. I love a low seat. I like the look and feel of it. You're not upright and uptight. It's very loungy, and it makes people feel more relaxed and comfortable. The other major piece of furniture in the room is a handsome Maison Jansen table that came from Paris. It was made in the 1960s and yet it looks utterly sleek and contemporary—a dark watery oval in black lacquer and steel. It's the perfect table. It expands and contracts to seat ten or two, and it's on casters, which means I can wheel it anywhere. Usually it lives by the windows and I pile it with books and use it as a worktable. If I'm having a dinner party, I'll push it into the center of the room and let everyone pull up a chair.

I knew I did not want a formal dining room. That's not my style. It's much more fun to eat anywhere we like. We can stay right by the fire on a cold wintry night. That's what they used to do at Versailles—just pull up a table and eat in any room. I love that kind of flexibility.

Previous page: In the hallway Richard Pettibone's *Brancusi's Dealer* is a stately crown for the Jacques Adnet armchair.
Opposite: The limed-oak kitchen cabinets are accented by limestone countertops. Left: A portrait of me by David McDermott and Peter McGough graces the hall to the study and bedroom.

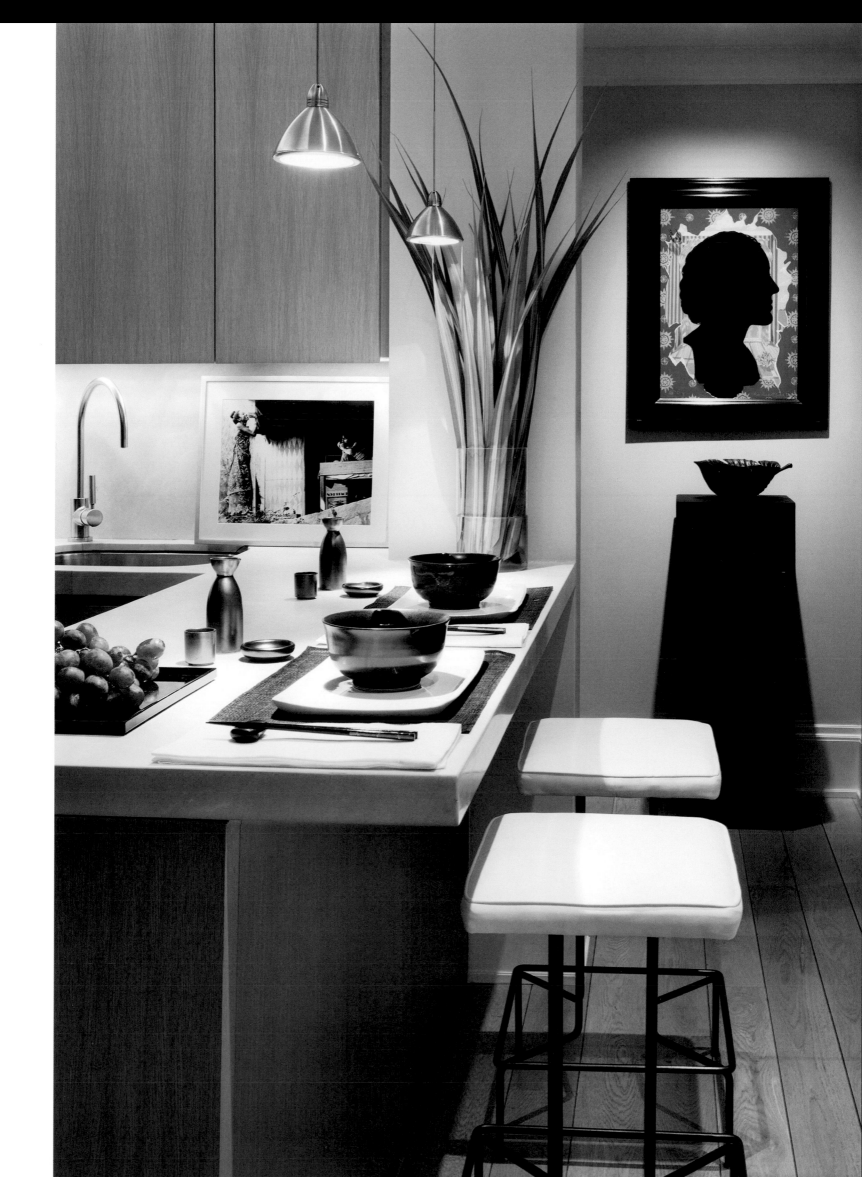

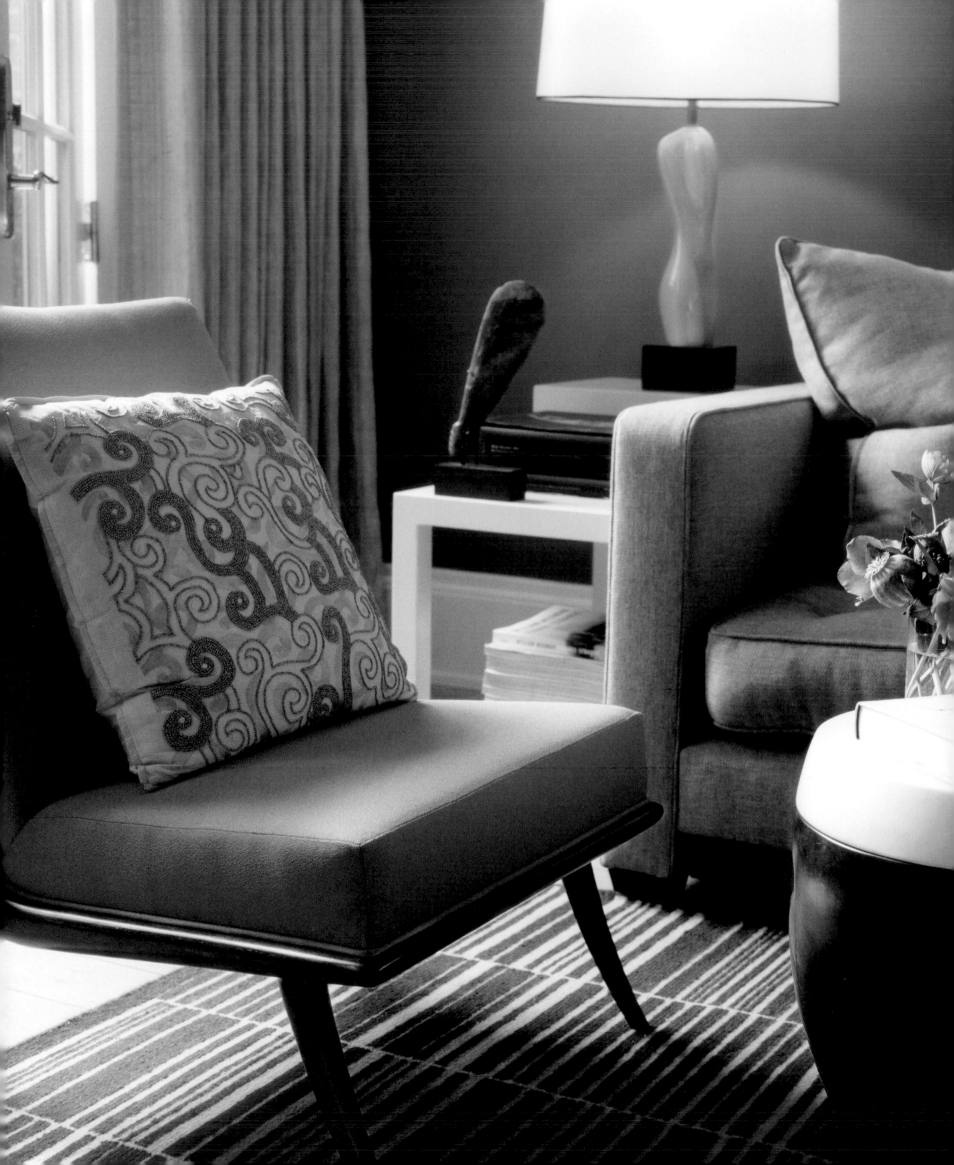

The study's tailored flannel chair is given a touch of whimsy with a hand-embroidered pillow.
Above: The lines of the graphic wool carpet remind me of a Tibetan monastery's tattered curtain.

The table lamps made from 1970's Italian vases
illuminate Kelly McLane's painting.

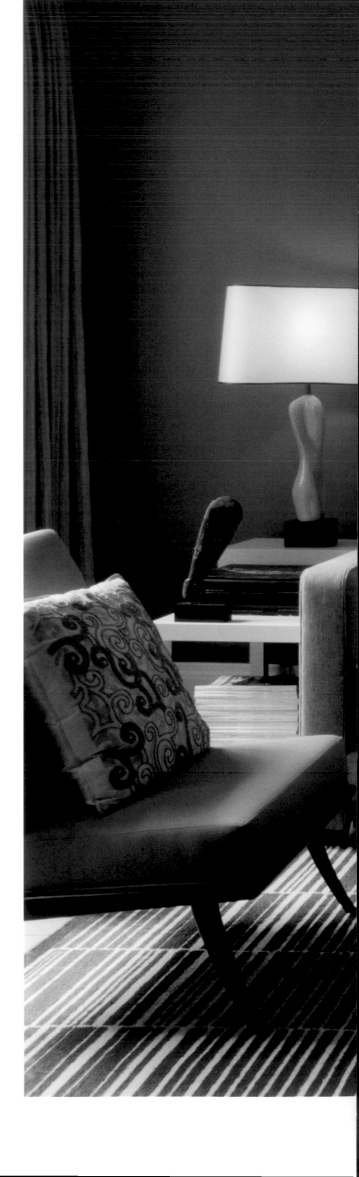

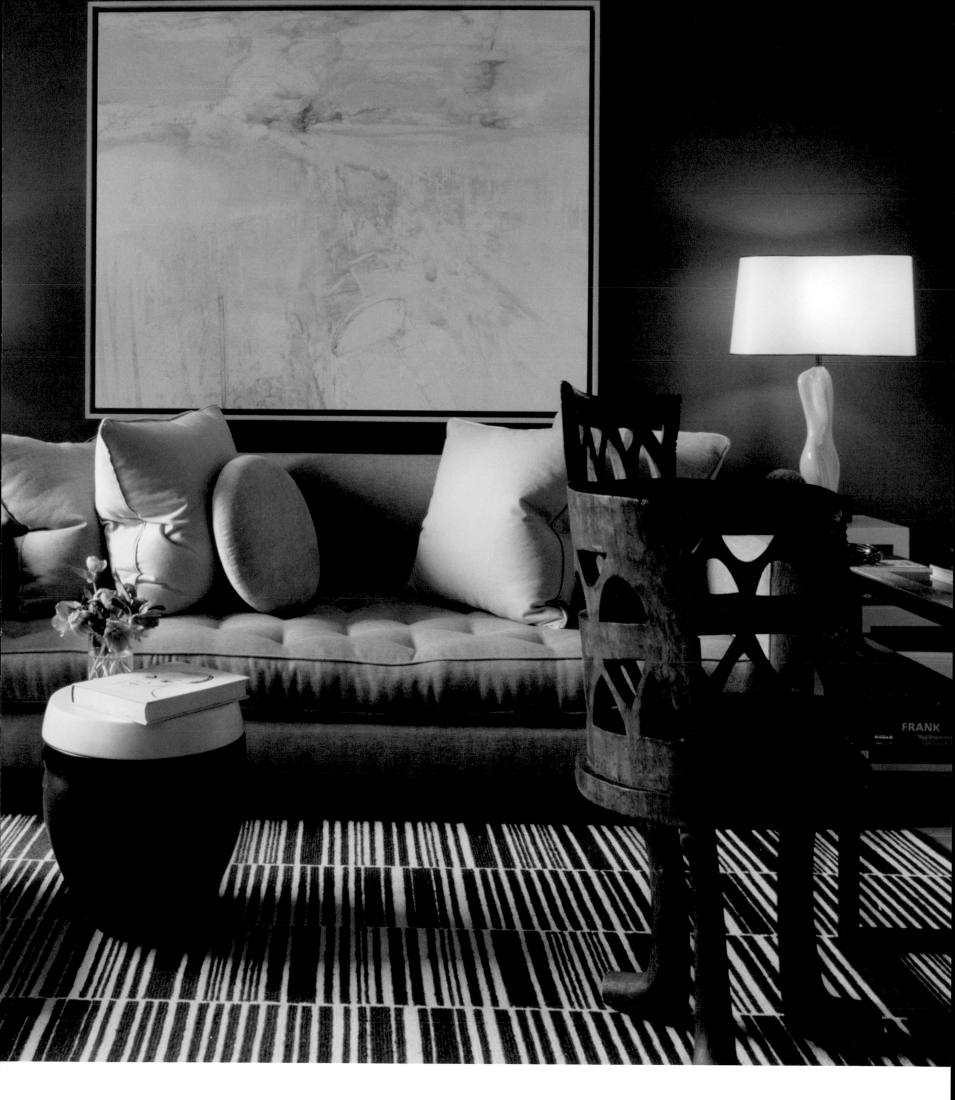

Machu Picchu as seen from the Inca Trail. The vintage Scalamandré fabric
dressing the bedroom's headboard and bed skirt echoes the ancient city.

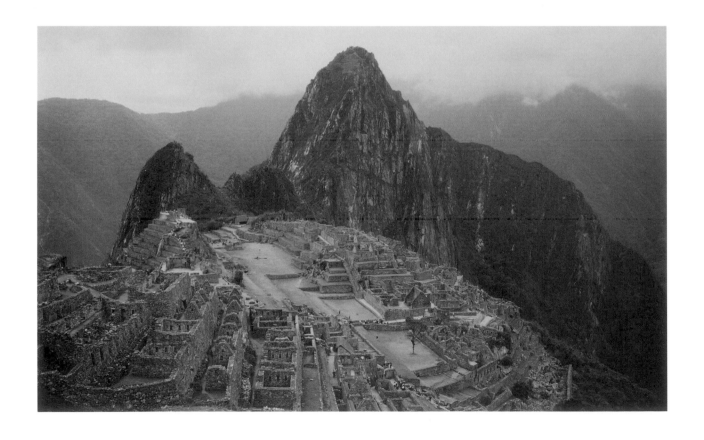

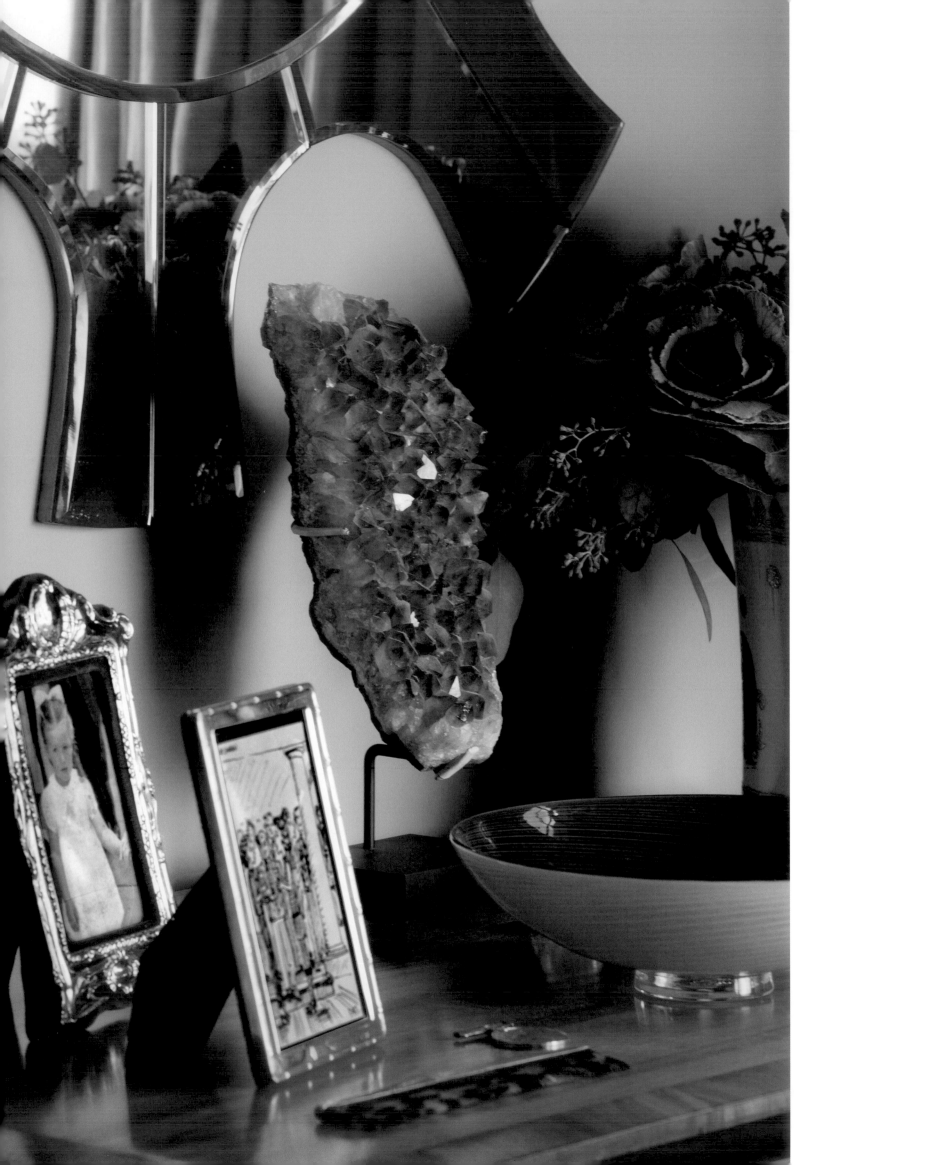

An Irwin and Estelle Laverne Lily chair rests in the corner. Suspended above the Biedermeier chest is a Tommi Parzinger mirror. Opposite: A rock crystal from Andy Warhol's estate.

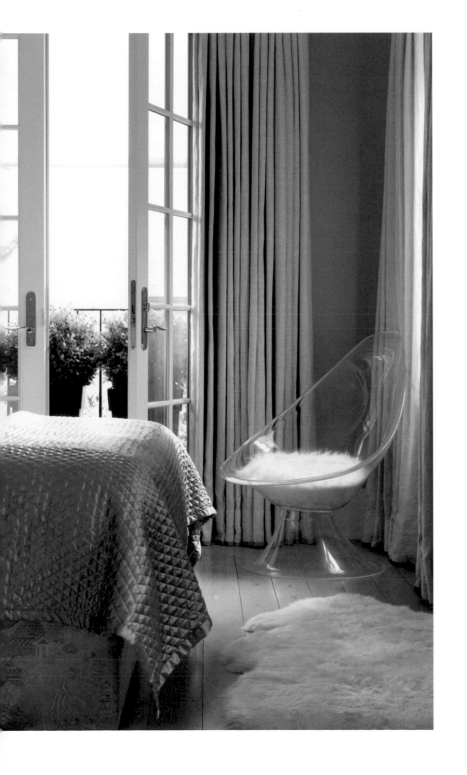

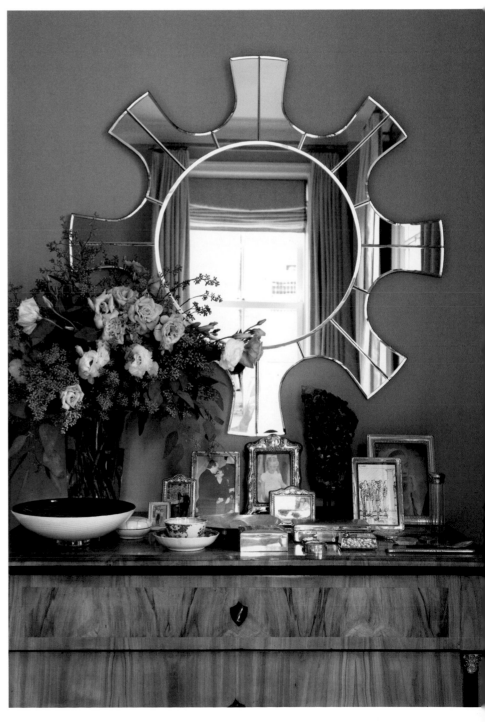

TRANQUILITY

Raindrops create infinite ever-widening circles on a lake. Opposite: Scandinavian stoneware
bowls by Arne Bang c. 1930 alongside a Buddha on the table, and an 18th-century,
six-panel Japanese screen hangs above the sofa.

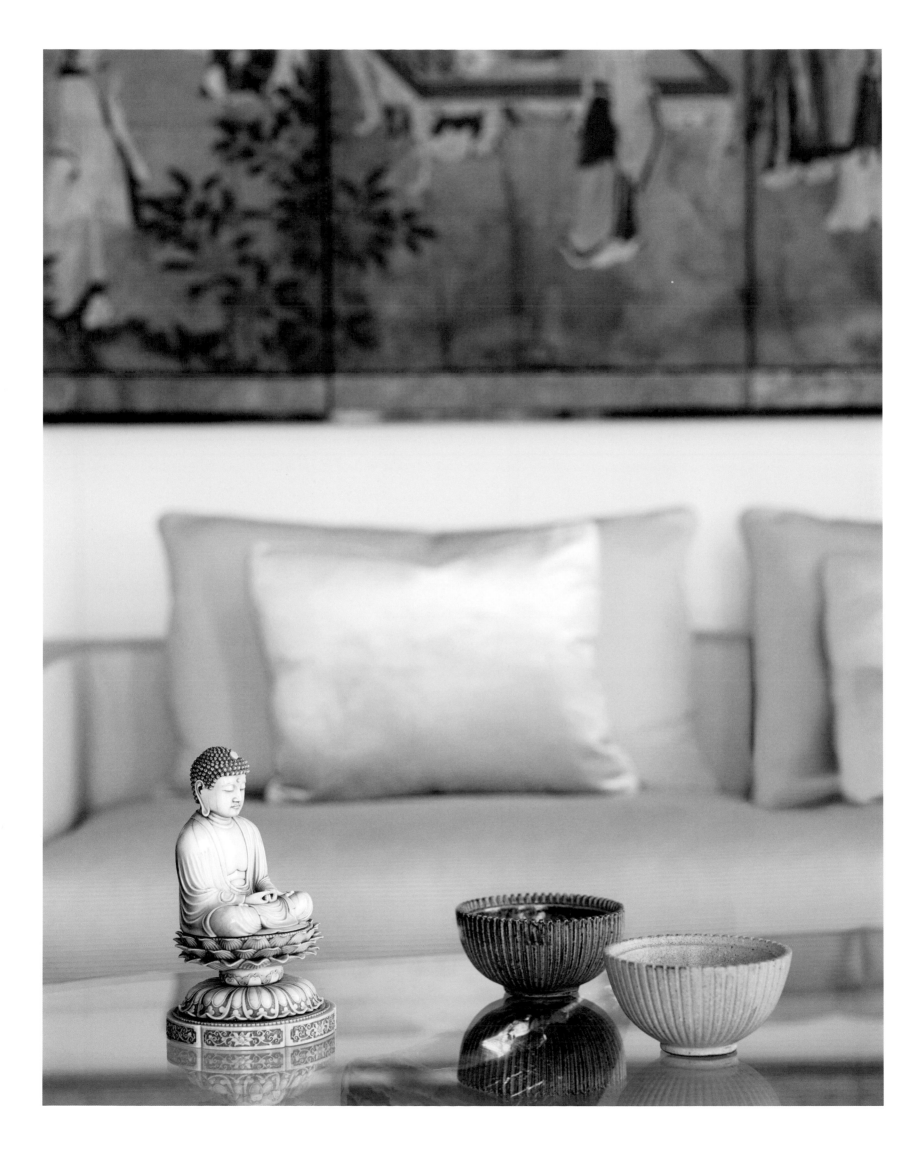

On a hot August day in Beijing almost 20 years ago, I was walking through the house where Soong Ching-ling spent the last years of her life. One of the famous Soong sisters, she was the wife of Sun Yat-sen, who is known as the father of modern China and who became its first president. (Her two sisters married equally well, one to the future president Chiang Kai-shek and the other to the richest man in China.)

There were no other tourists there. Back then, you had to come with a guide and get special permission to visit. The house is a former imperial palace, built on a lake, and when I crossed the threshold I felt as if I were stepping into a sepia photograph of old Beijing. There were rooms full of the most incredible Chinese furniture rammed up against the walls and practically rotting away as the guards dozed in their chairs. Everything was covered in a thin layer of dust, as if time had stopped and no one had touched anything since Soong's death. One wing of the house was a museum that told the story of her life through faded newspaper clippings. For decades, Madame Sun Yat-sen had been the most powerful woman in China.

Outside, I wandered through the vast gardens, neglected but still beautiful, with willow trees leaning over a meandering stream and dense groves of bamboo. Paths led me from one carefully composed vista to another. There were lovely surprises along the way, such as a still, mirrorlike pond dotted with water lilies. And then I saw a little wooden pavilion. The sign said, in Mandarin and English, THE RAIN LISTENING HUT. I sat down on a bench inside and looked out over the water and the trees, and imagined what it would be like to just stop for a moment and listen to the patter of rain on the roof. How peaceful, how magical—a building where you could go to listen to the rain! Who thought of that? What a rare sensibility. It is a gift to know how to be quiet and to be so open to the simple joys of nature.

That moment has stayed in my head as an image of tranquility. It represents the kind of stillness and peace we all crave in our lives, and it's a feeling that I try to build into my rooms. My clients can sense it. When they tell me that they love their bedroom or their sitting room because it feels calm, I think back to that pavilion by the lake and say a silent thank-you.

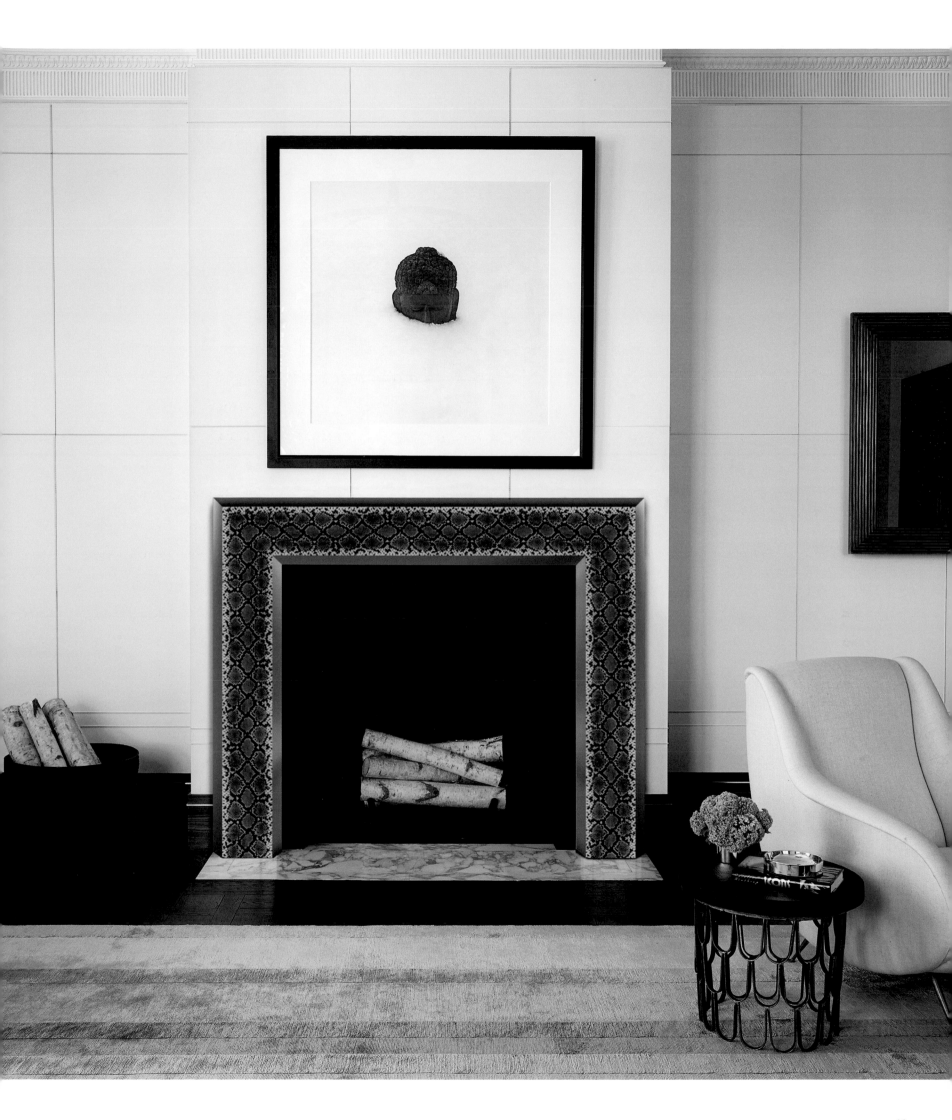

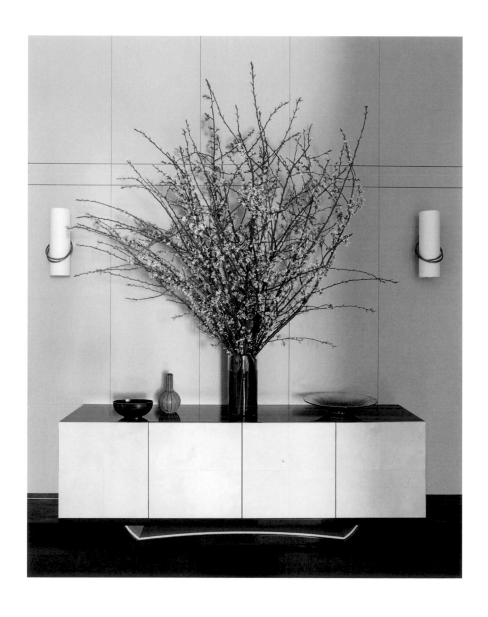

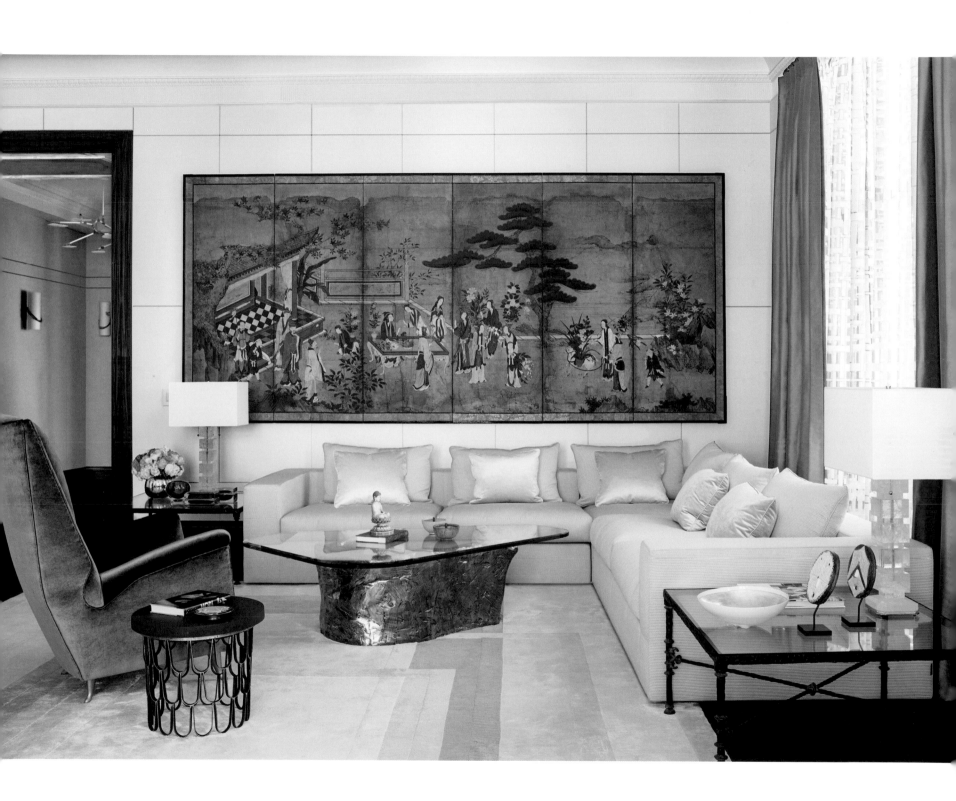

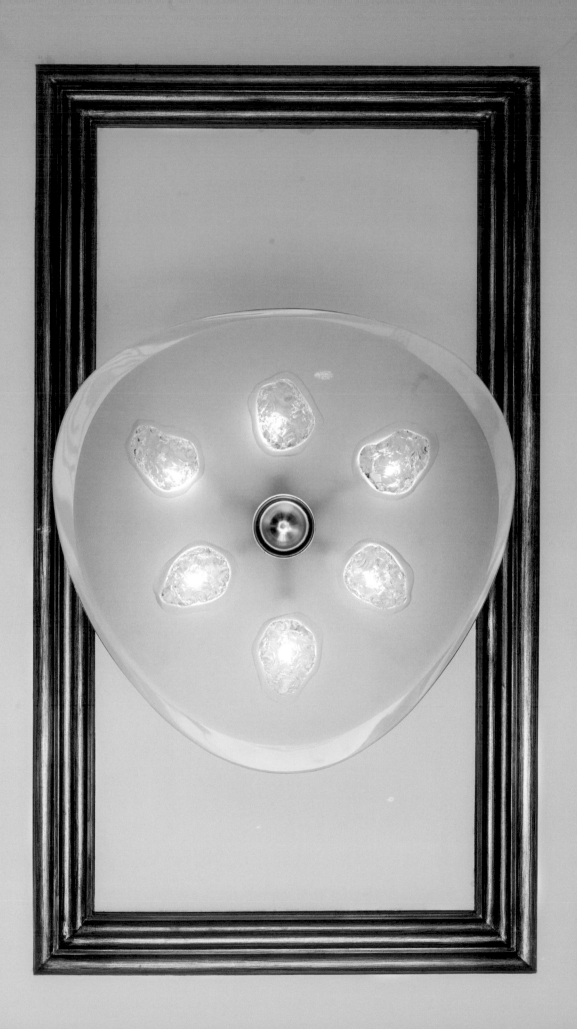

Max Ingrand's cut glass shade for Fontana Arte is designed with six chiseled passages.
The wall panels in the vestibule are hand-applied mica, a mineral found minutely in granite crystals.

Matisse's drawing of a woman suggests the kind of languor and relaxation you want to experience
in a bedroom. Opposite: An Italian table lamp by Roberto Rida shimmers on a custom shagreen bedside table.
Antique mirror panels on the walls double the natural light in the bedroom.

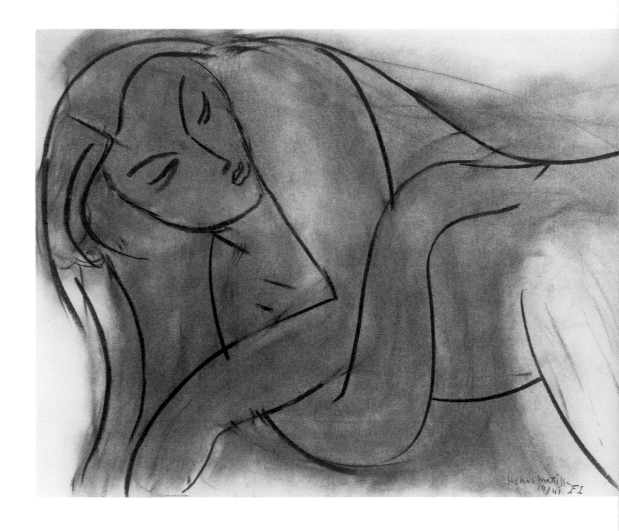

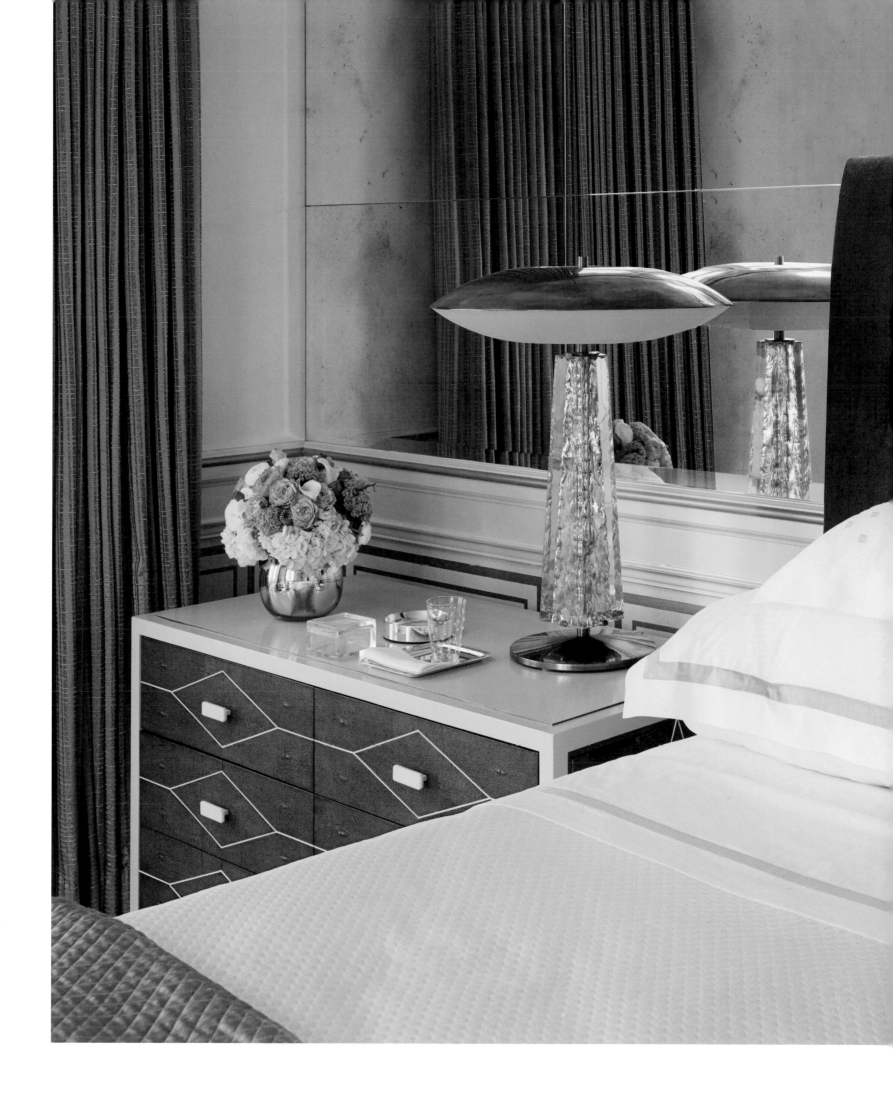

INDIVIDUALITY

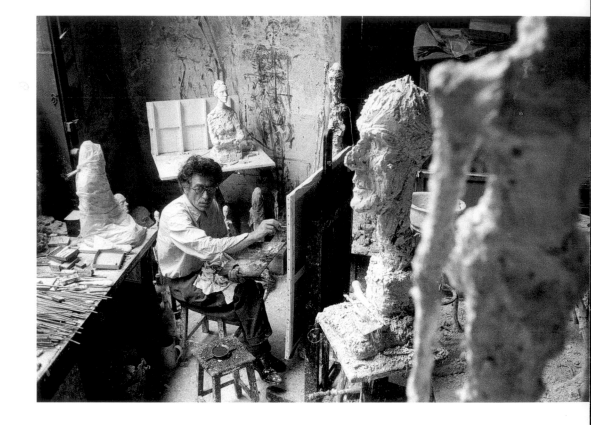

Alberto Giacometti's art was utterly individual, his elongated figures looked like nothing that had come before. He once said that he was sculpting not the human being but "the shadow that is cast." Opposite: Willem de Kooning's *Hostess* is in conversation with a Matisse painting and a Frits Henningsen sofa. The rug is custom.

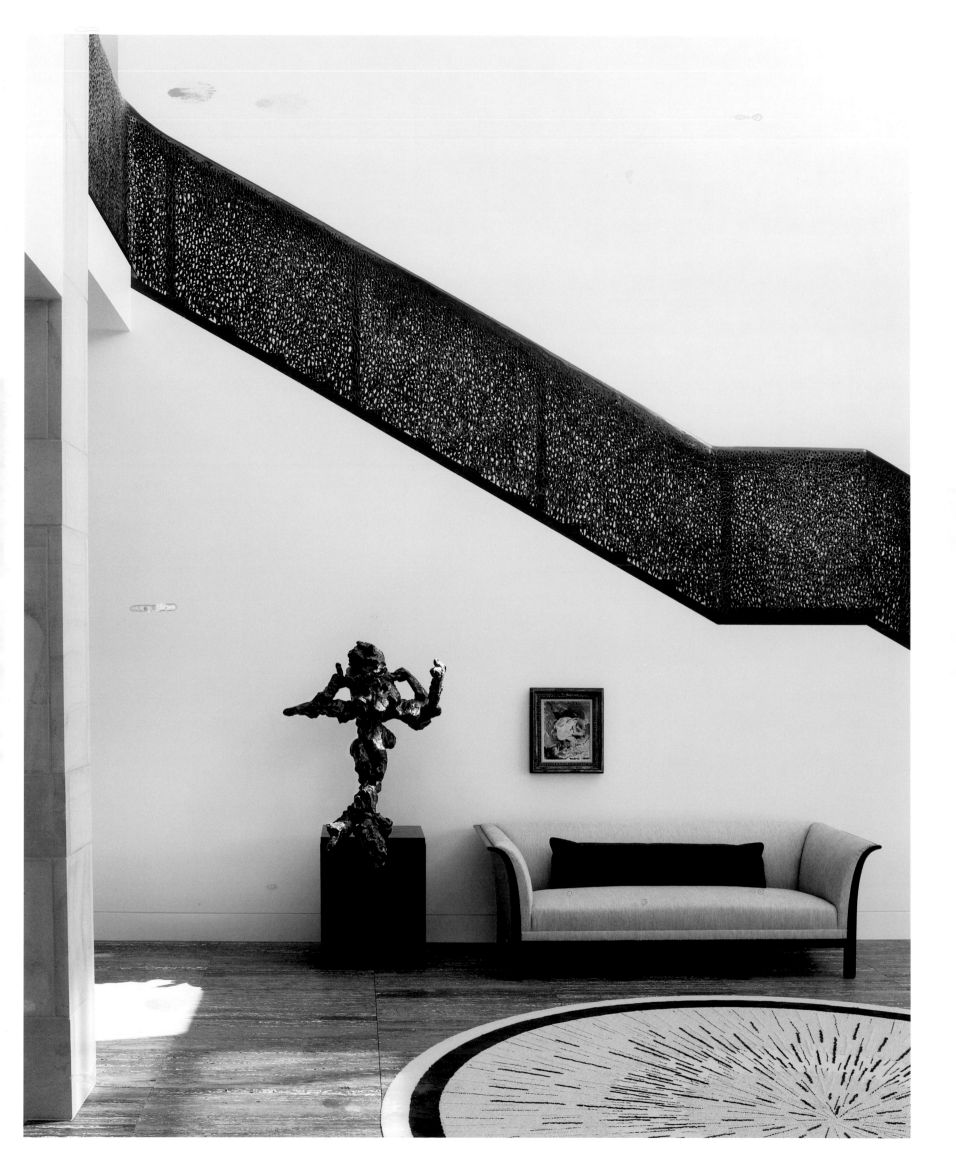

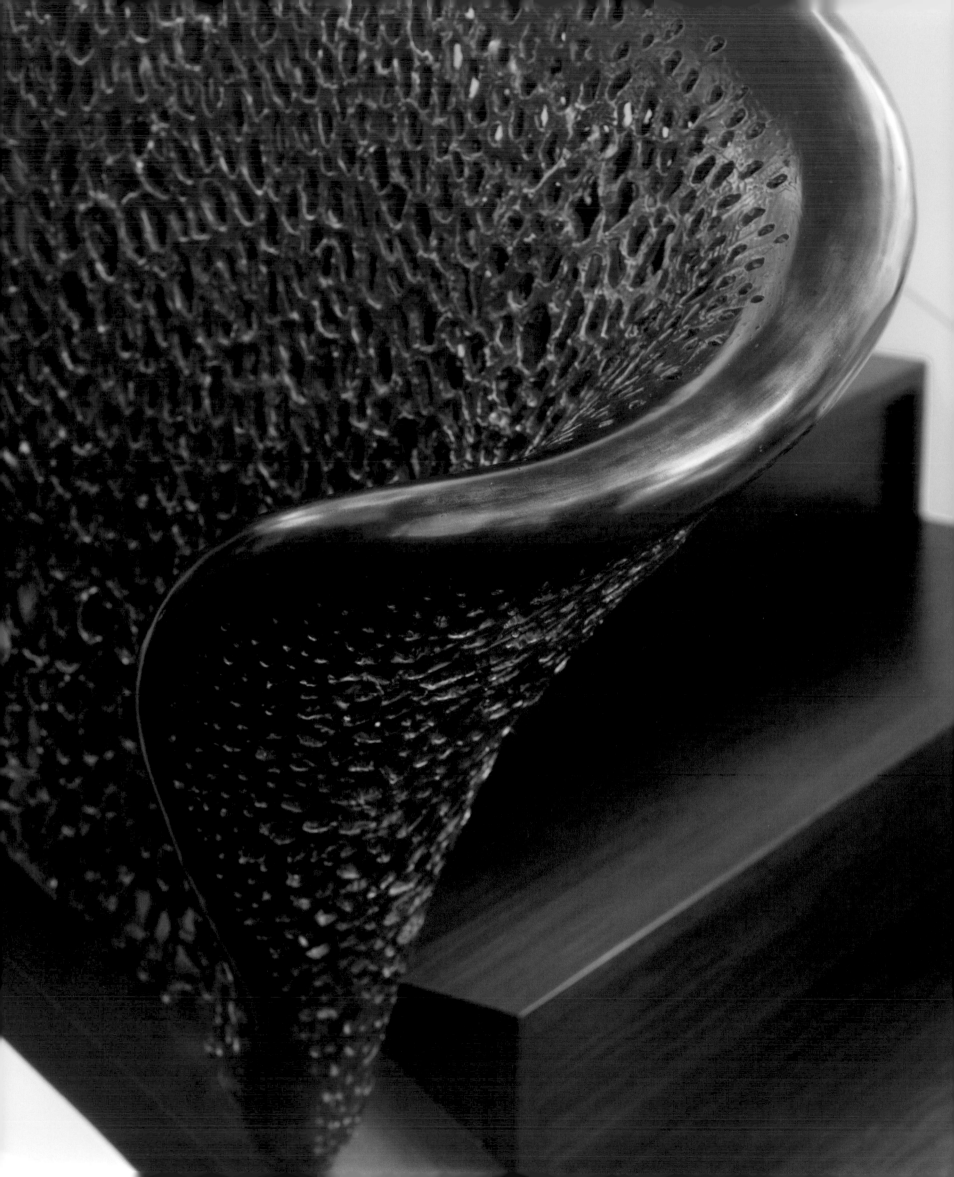

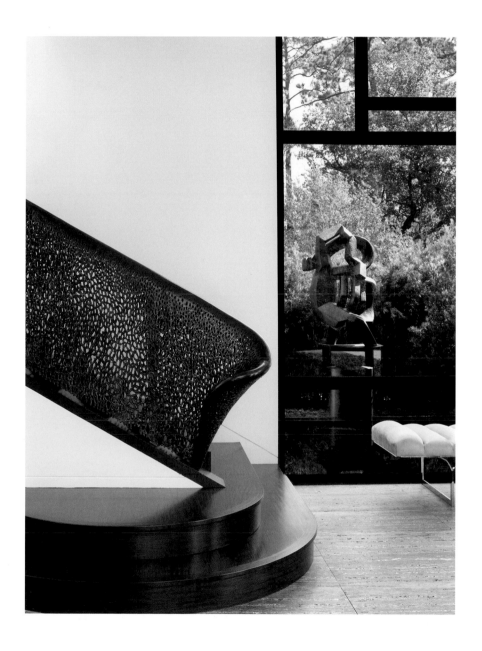

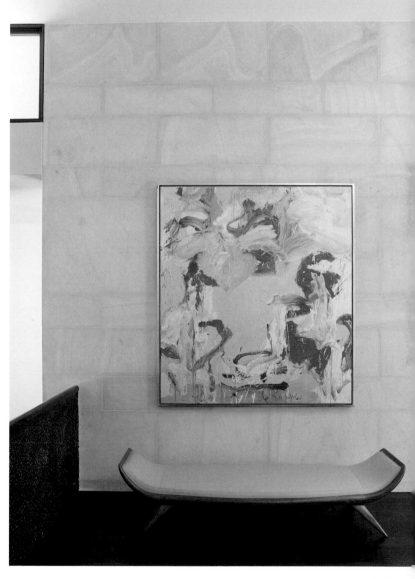

Michele Oka Doner's cast bronze railing mimics the cellular structure of sea grass. The window offers a glimpse of Jacques Lipchitz's *Joy of Life*. A painting by de Kooning and a Paul Mathieu bench enliven the landing's limestone wall.

An artist labors alone in his studio—or at least that's the image most people have in their heads—and eventually emerges with a unique work of art. It could be a painting or a sculpture, but the point is that it stands alone. It doesn't have to relate to anything else. Art is a monologue.

Design, on the other hand, is a dialogue. A room is made up of many pieces, each with its own individual voice. In a house like this—with a magnificent collection of paintings, sculpture, and furniture—my role as a designer is to create an environment that introduces all the elements to one another and brings them together in a conversation. I'm looking for what they have in common—color, texture, even something as intangible as character—or focusing on how they differ in order to play them off against one another. I'm trying to bring out the individuality of each object while still somehow managing to fuse all the moving parts into a beautiful whole.

It's hard to make these parts speak in unison, but when they do, it's extraordinarily powerful. Suddenly you get this exciting synergy between art and design. They invigorate each other and the line between them blurs. That's what happened here.

A great project starts with a great client. This husband and wife are very visual people who were completely involved every step of the way. They know what they like. They are passionate art collectors, knowledgeable about the latest gallery shows and what's coming up at auction. They had already amassed a collection, and as we were planning the house, they were constantly bringing in new finds and fresh concepts. Some of the ideas we used were mine; others were theirs. We had a real dialogue. And they were open to commissioning one-of-a-kind pieces from today's master craftsmen specifically for this house. That takes design to a whole new level. As a result, these rooms are a vibrant portrait of the two of them.

The house they built is as individual as they are. It seems to rise organically out of the landscape, forming a dynamic composition of shifting planes. Solid walls of French limestone or Afromosia wood, an African teak, are juxtaposed with weightless walls of glass. The rich, dark wood has a warmth that domesticates the big loftlike spaces. Rooms segue into each other, and the house opens to the landscape with large steel-framed glass doors that lead to interior and exterior courtyards.

When you walk through the front door, you step into a dazzlingly bright space that soars two stories high. The furnishings are spare and striking, just like the architecture. A walnut-and-glass console, made in 1951

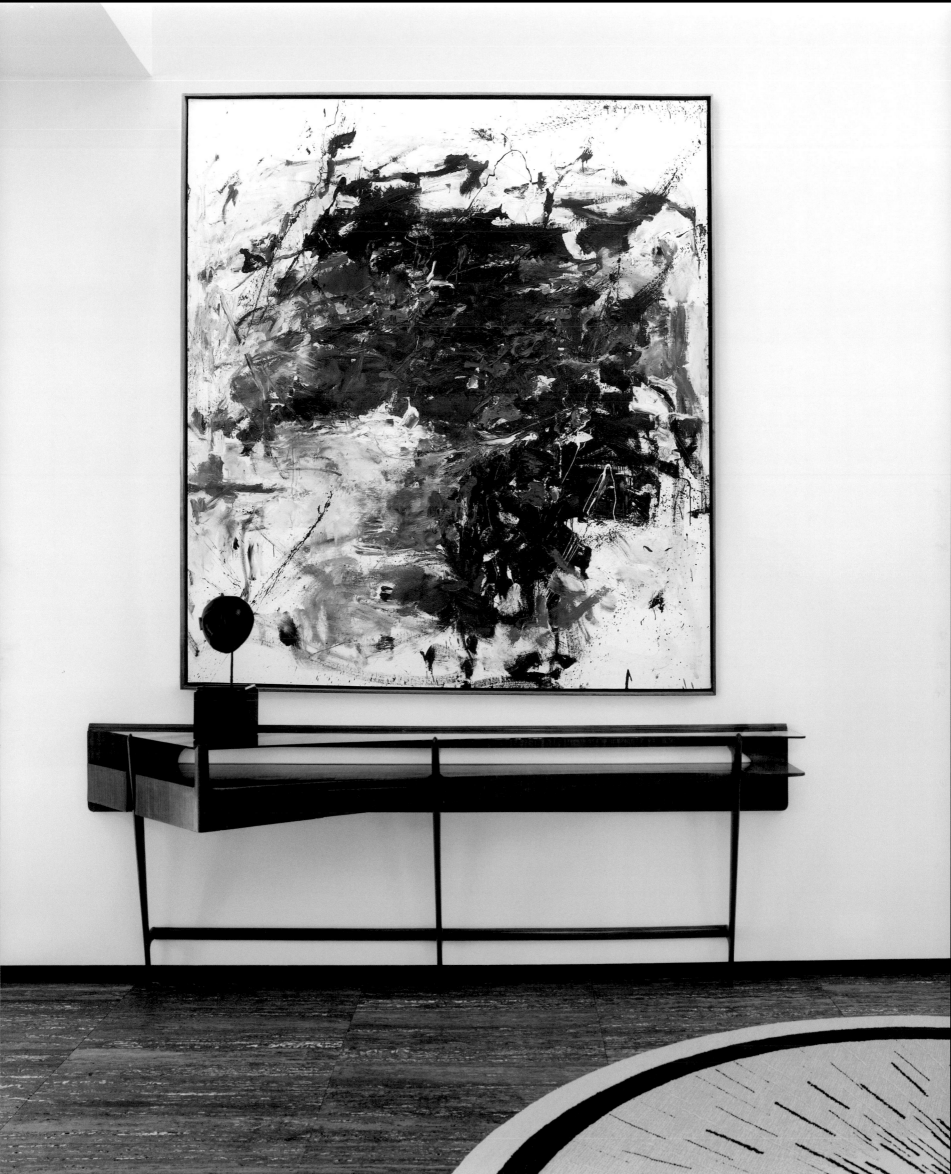

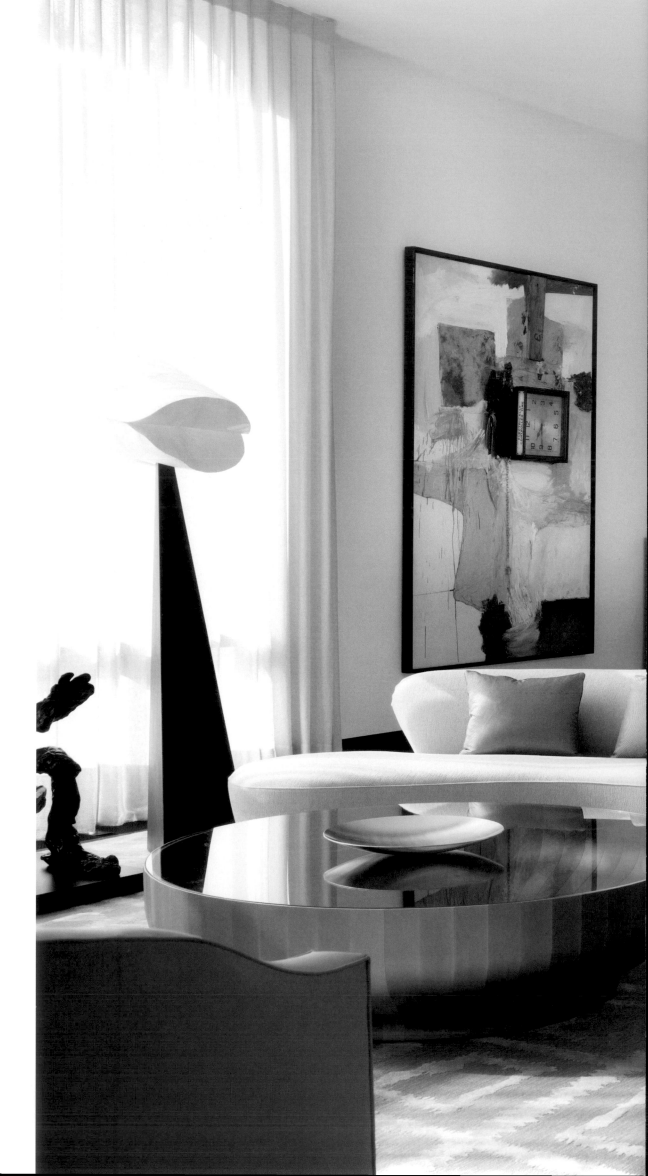

Previous page: In the entryway the gravity-taunting Ico Parisi console holds an African Haviland head c. 19th-century beneath a Joan Mitchell painting. Opposite: Diego Giacometti's angular ceiling light floats above the Vladimir Kagan sofa. The living room is home to a Mauro Fabbro sculptural floor lamp, and paintings, from left to right, by Robert Rauschenberg, Wassily Kandinsky, and Conrad Marca-Relli. The parchment table holds a Malian sculpture.

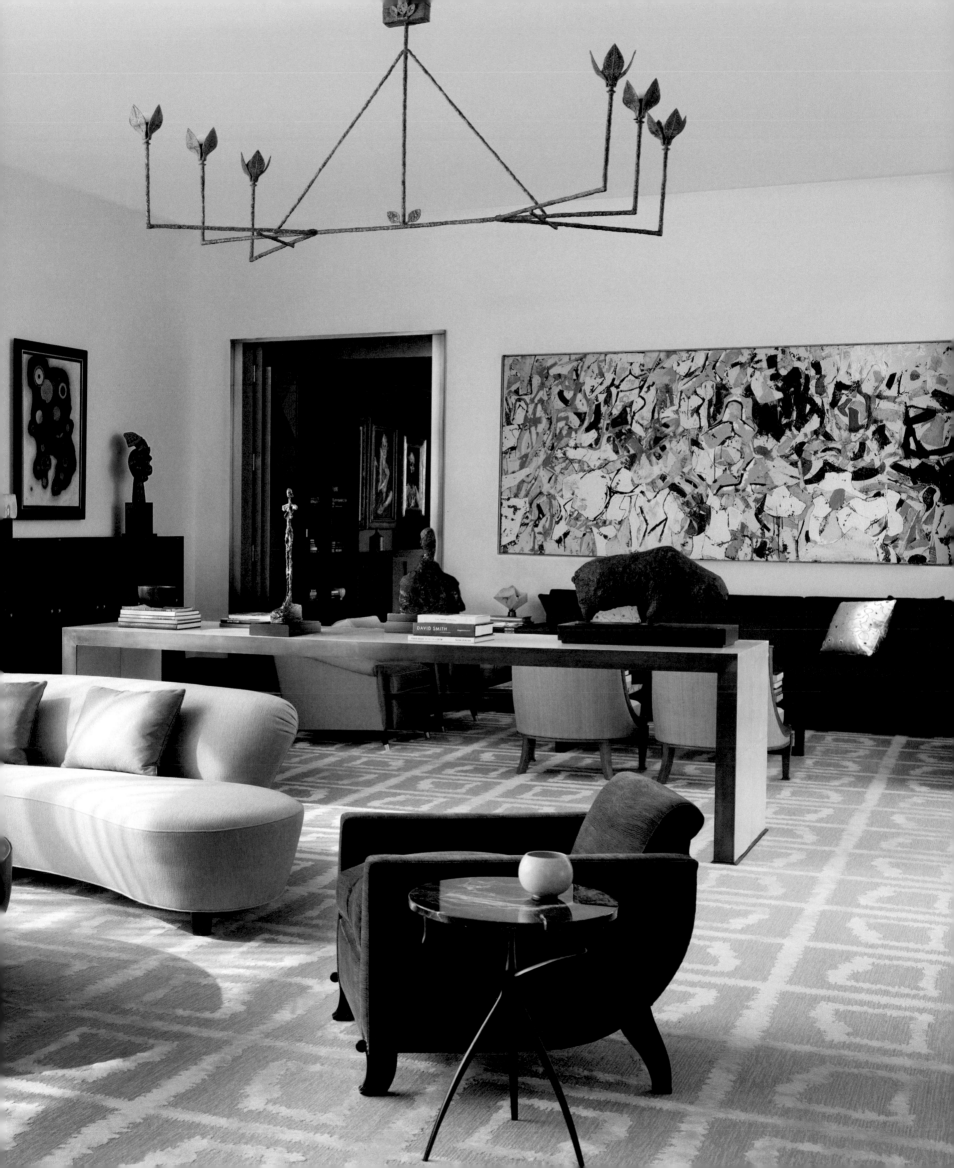

by Ico Parisi, is one of those Italian marvels of design that makes me sigh with admiration. It's a one-of-a-kind piece that looks as if it were in motion just a moment before it was arrested and attached to the wall. In any other entrance hall, it would be the center of attention, but here it has some serious competition from the staircase. The initial thought was to make the stairs out of glass or steel, but the wife had reservations about that concept—too cold, too predictable. Instead, they wanted something that would invite the touch and be more sculptural and warm.

The commission to do a singular, site-specific staircase went to artist Michele Oka Doner, who often takes her inspiration from nature. I liked the idea of bringing natural elements into the house. It's a logical impulse to connect the interior to the exterior when the windows are so large and the house feels so porous, as it does here. The pattern in the railing that Oka Doner designed and had cast in bronze is not immediately identifiable. Is it Queen Anne's lace? A spider's web? The leafy branches of a tree? Actually, Oka Doner was looking at *Thalassia*, a type of sea grass, and zoomed in on the cellular structure. It's an organic motif that embodies the way things grow. It reminds us that we dwell in nature. For the artist, the design is not a literal translation of the microscopic image. It's meant to evoke emotion. For her, it has the feeling of a primal nest.

The dark bronze is a dramatic contrast to the white walls. In the living room, it seems as if half the walls dissolve into floor-to-ceiling windows that make the room feel boundless as they lead your eye out to the view. The room is so large that we decided to divide it in two with a central table, where books and art can be displayed. It's a modern version of a refectory table, commissioned in Paris specifically for this room and sheathed in parchment and trimmed in bronze. It has very contemporary lines, and yet the parchment gives it a patina. It feels timeless and new at the same time—a feeling that extends throughout the house. The table adds a certain weight to the space. Otherwise it could have disintegrated into a ramble of furniture. It's not easy to make a room that can seat large groups of people feel intimate, but we did it by carefully working out the placement of every object to create relationships. And each piece had to be extraordinary so it could hold its own against a very strong background of architecture and art.

The art collection was a huge influence—but not in the sense of matching colors to the paintings. Instead, I like to think that the soul and spirit of the art somehow filtered into the work. I approach a room almost the way an artist approaches a painting, thinking about form and composition and color. If you look at the geometry of the furniture arrangements, you'll see circles and squares, open areas in contrast to clusters of pieces, and the play of dark colors against light. One seating group is basically rectilinear, with long, low lines exemplified by a claret-

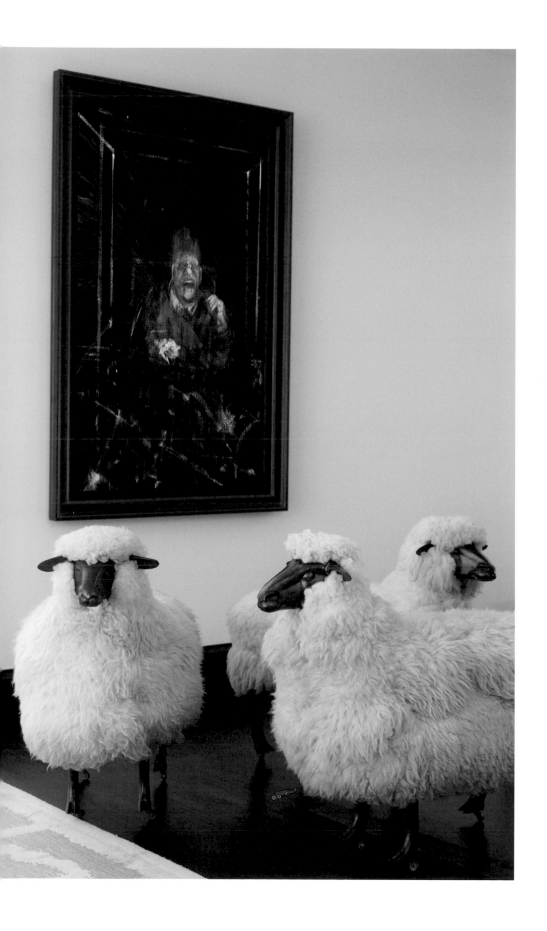

A flock of Les Lalanne sheep sculptures
congregate in front of a Francis Bacon painting.

A David Smith sculpture is positioned
between a custom silk sofa and chaise longue.

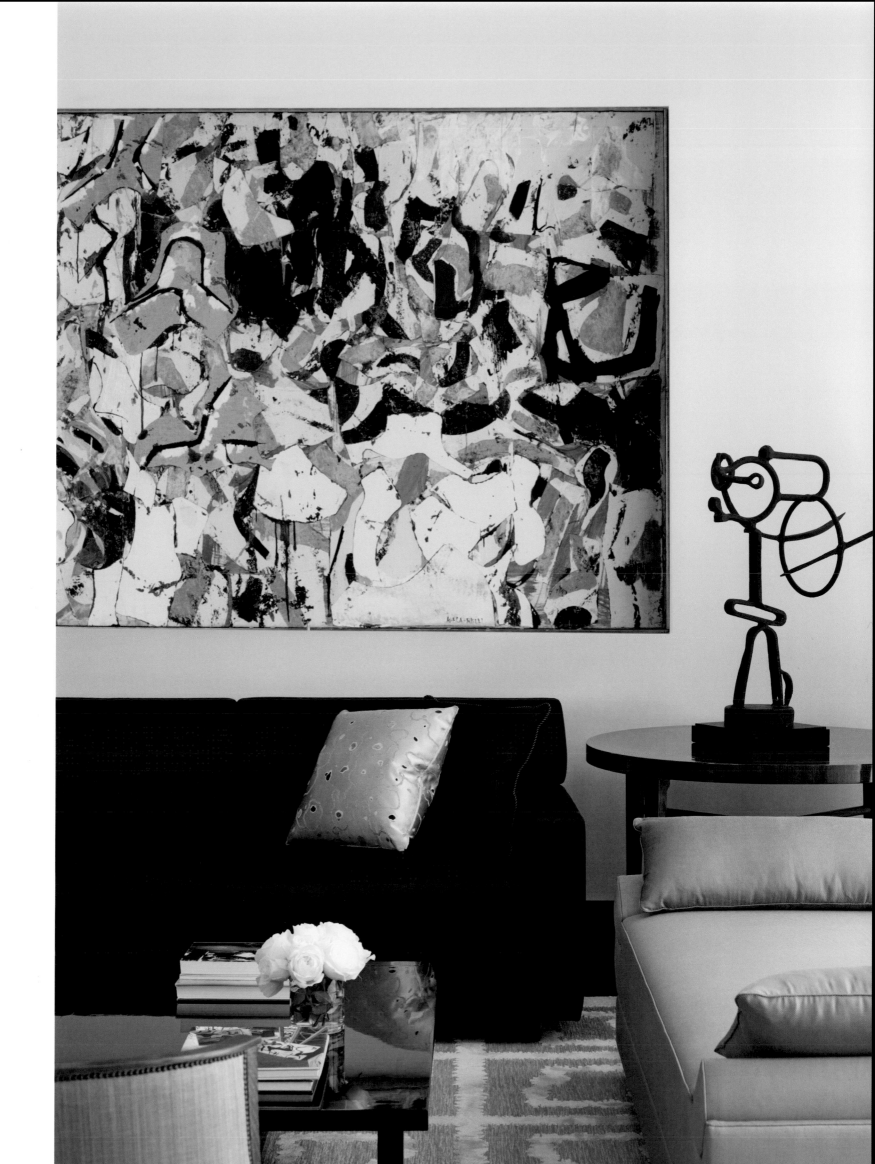

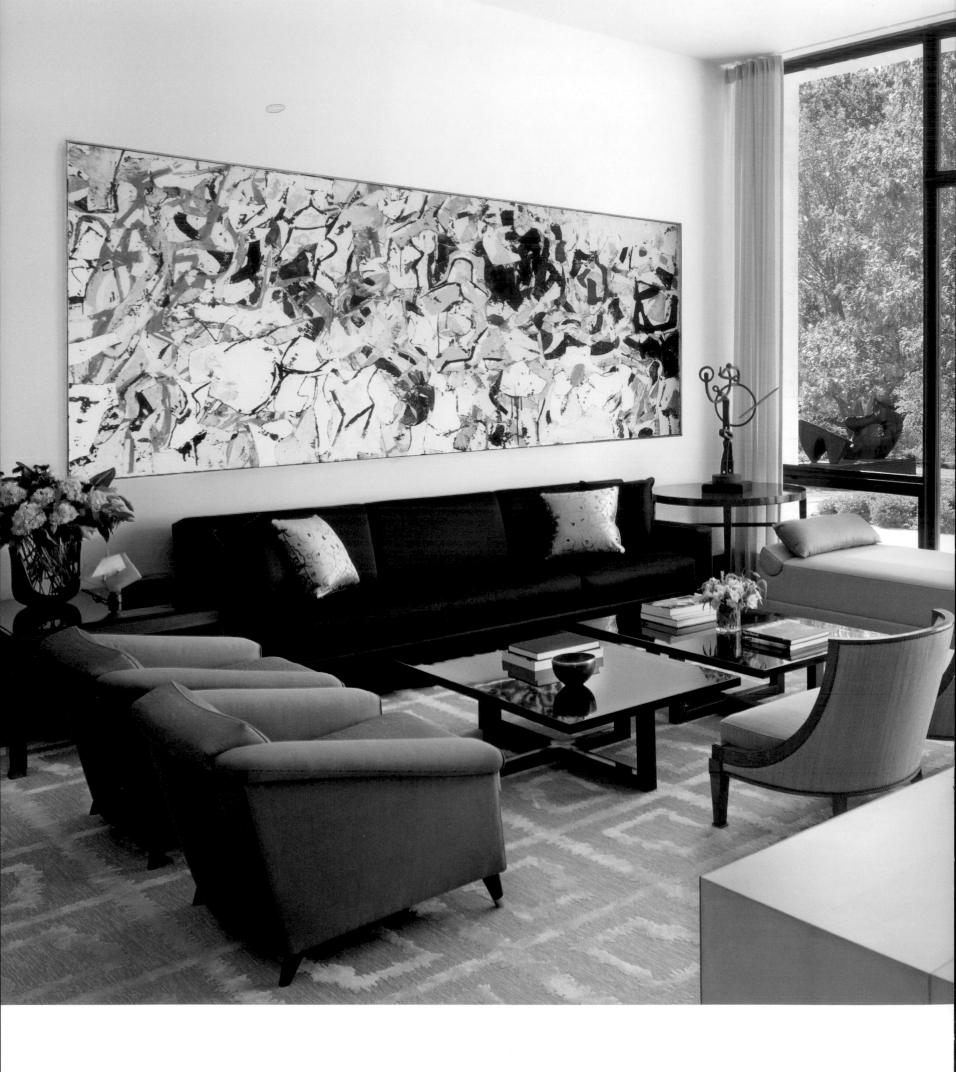

Midcentury chairs by Jules Leleu and André Arbus repose beneath a Marca-Relli painting.
Alberto Giacometti sculptures on the parchment table lead the eye to the garden's notable Henry Moore.

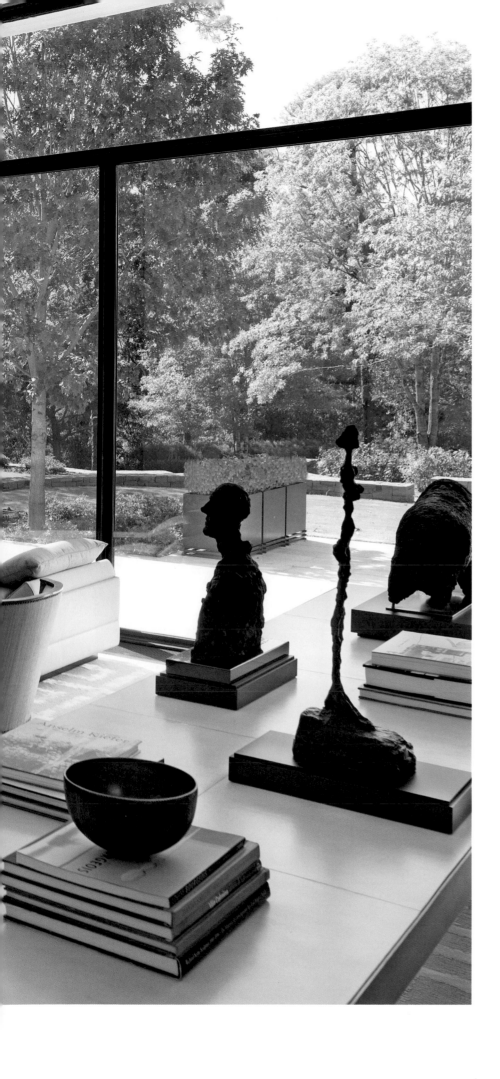

Paintings by de Kooning and Joan Mitchell
are hung in the open floor plan.
The anodized-aluminum Barber Osgerby
table is centered on a custom rug.

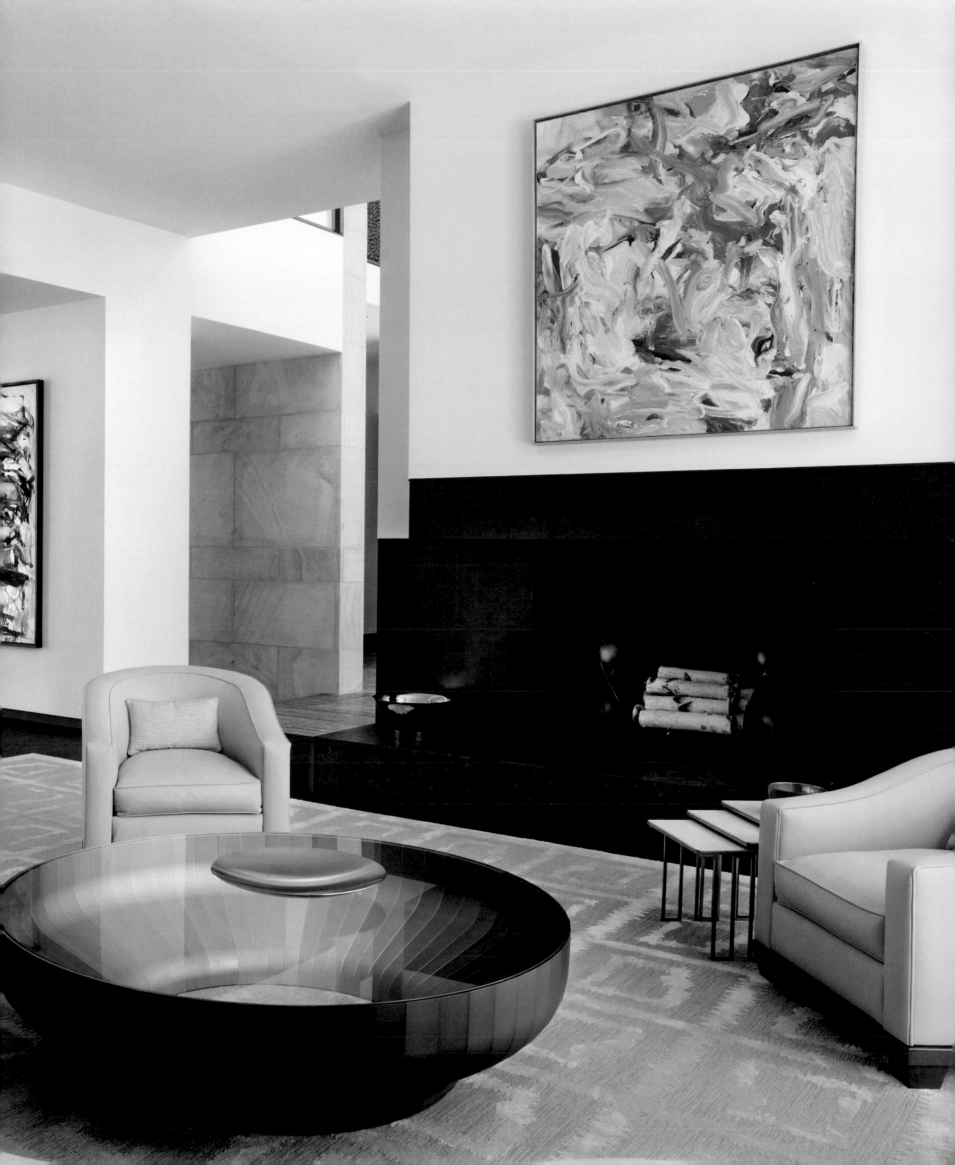

red sofa and a daybed upholstered in sand-colored silk. The other is anchored by a circular, steel-gray aluminum coffee table, paired with Vladimir Kagan's 1950 serpentine sofa that seems to revolve around the coffee table as it subtly echoes its partner's curves.

In order to unify this large space, we wanted one large carpet, and the way the clients and I worked together on its design represents the way we collaborated on the entire project. Initially, I was thinking of a small geometric pattern, but the wife wanted something that felt a little less rigid. We found it in an unexpected place—my closet. I collect antique textiles, and I went through my stash and pulled out a tiny piece of a lovely old ikat. The wife liked it. We scaled up that pattern to work on the floor. The finished carpet is made of silk and wool, all handwoven. The little bit of silk in it catches the light and adds another dimension.

As you walk through this house, you have the sense that the space expands and turns and unfolds. The various public rooms are not separated by doors. The living area is open to the dining area, and only a slight level change—a few steps down—divides the two. That means that each area has to relate to its neighbors and yet have an identity of its own. The dining table picks up on the curves in the living room but then zooms them into the Space Age with swooping compound curves. The clients asked for something more organic than the typical rectangle, and this piece vaguely suggests a smoother, sleeker version of a piece of driftwood or bone. The light above the table, commissioned from the artist Ingo Maurer, is like a ribbon unfurled and frozen in midair.

When you sit in a dining room for three hours, your body isn't moving, but your eyes are. I always try to give people something to look at, and we did that here with the light fixture, the table, and a pair of consoles and mirrors commissioned from the artist Christophe Côme. And it was the clients who chose the most thrilling addition to the room—a larger-than-life-size reclining figure by Henry Moore from their collection. As a designer, it was extraordinary for me to work like this and with this caliber of art. Yet even though the house is filled with all these amazing treasures, it is still very livable. You walk in and feel exhilarated, but you also feel at ease. It was so fulfilling to be part of this project that I didn't want it to end.

An alternate view of the Barber Osgerby table reveals its ribbed composition.
Gerhard Richter's *Matrosen* (Sailors) hangs in the dining room's entry next to a Moore sculpture.

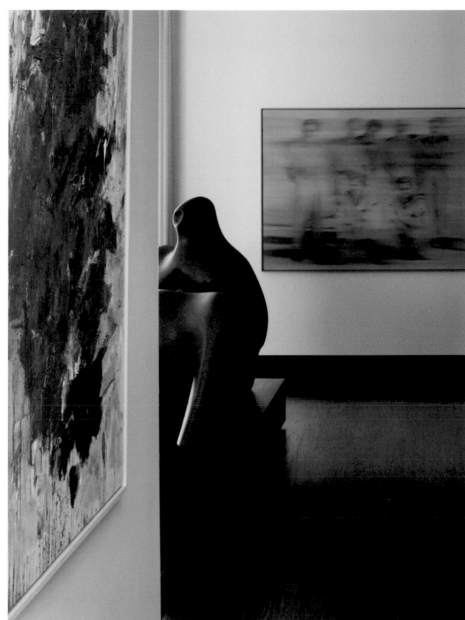

The pale curves of the Ruhlmann club chairs contrast the blackened-steel mantel and Giacometti's *Femme de Venise V*. Royere stacking tables and a de Kooning sculpture complete the living room.

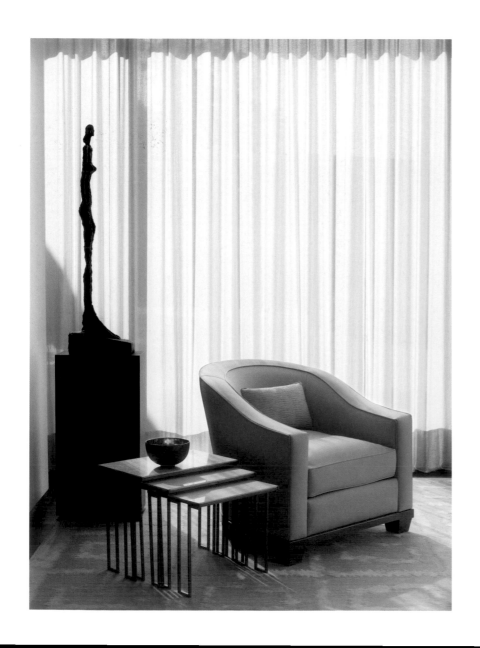

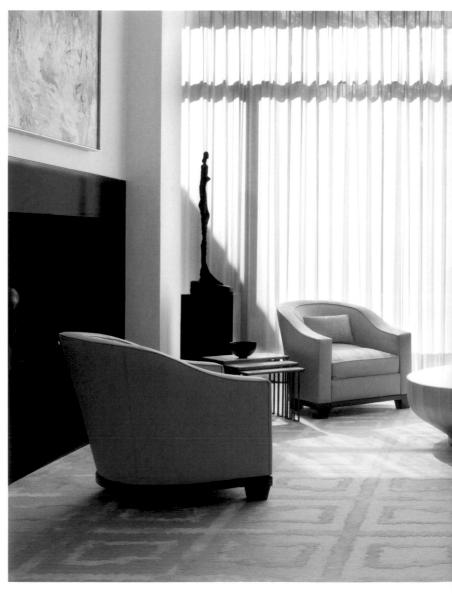

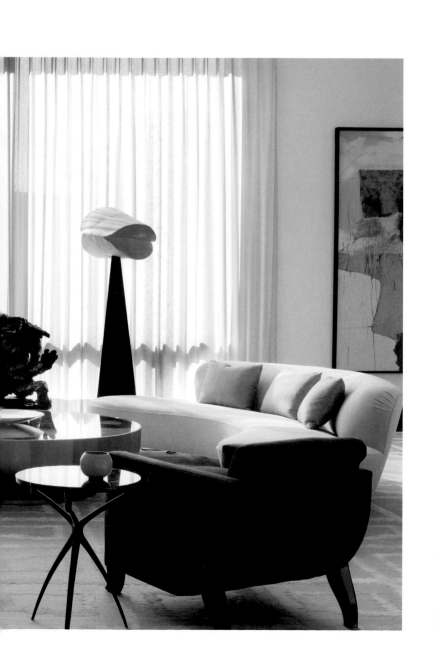
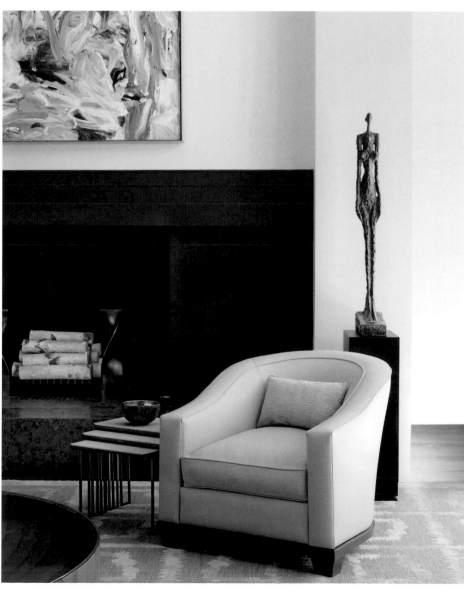

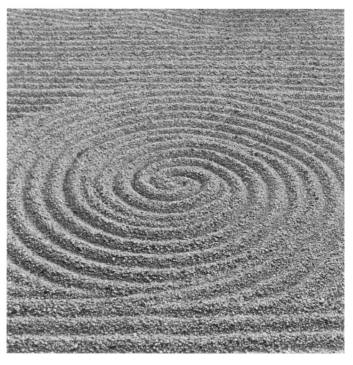

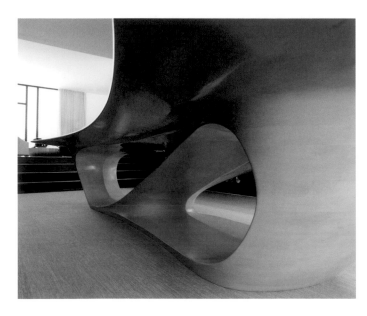

A Zen garden in Kyoto's Tofuku-ji temple informed
the dining room's organic shapes. Opposite: Ingo Maurer's
golden ribbon light floats above the room. The Wifredo Lam
painting and Moore sculpture find a rhythm with
the custom-designed dining room table.

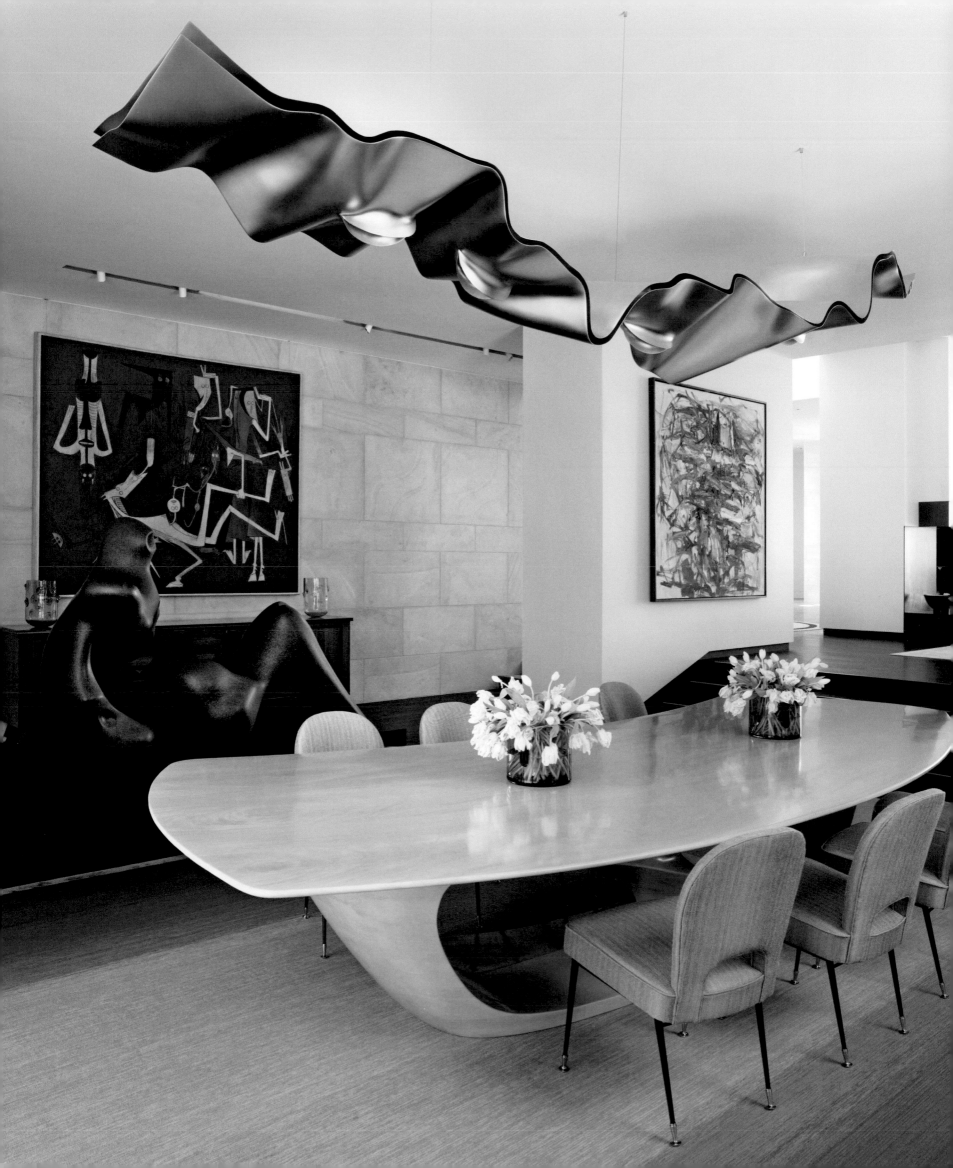

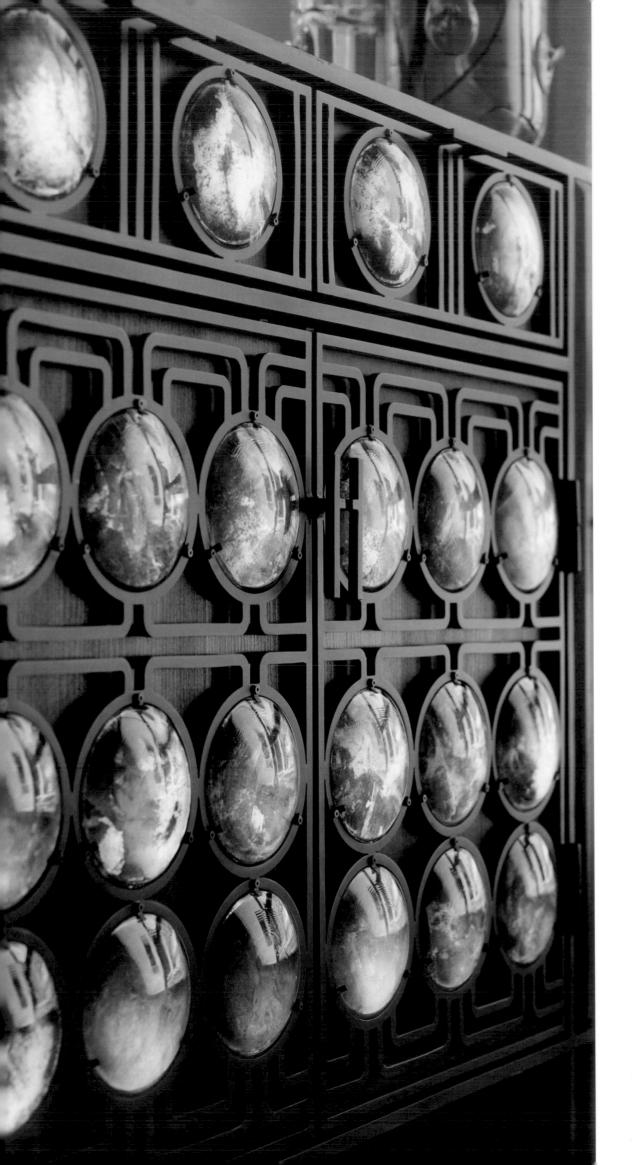

Christophe Côme's wrought iron console gleams with
molten glass under a custom Côme mirror.
Opposite: The vintage dining chairs are by
Jules Leleu and the rug is custom.

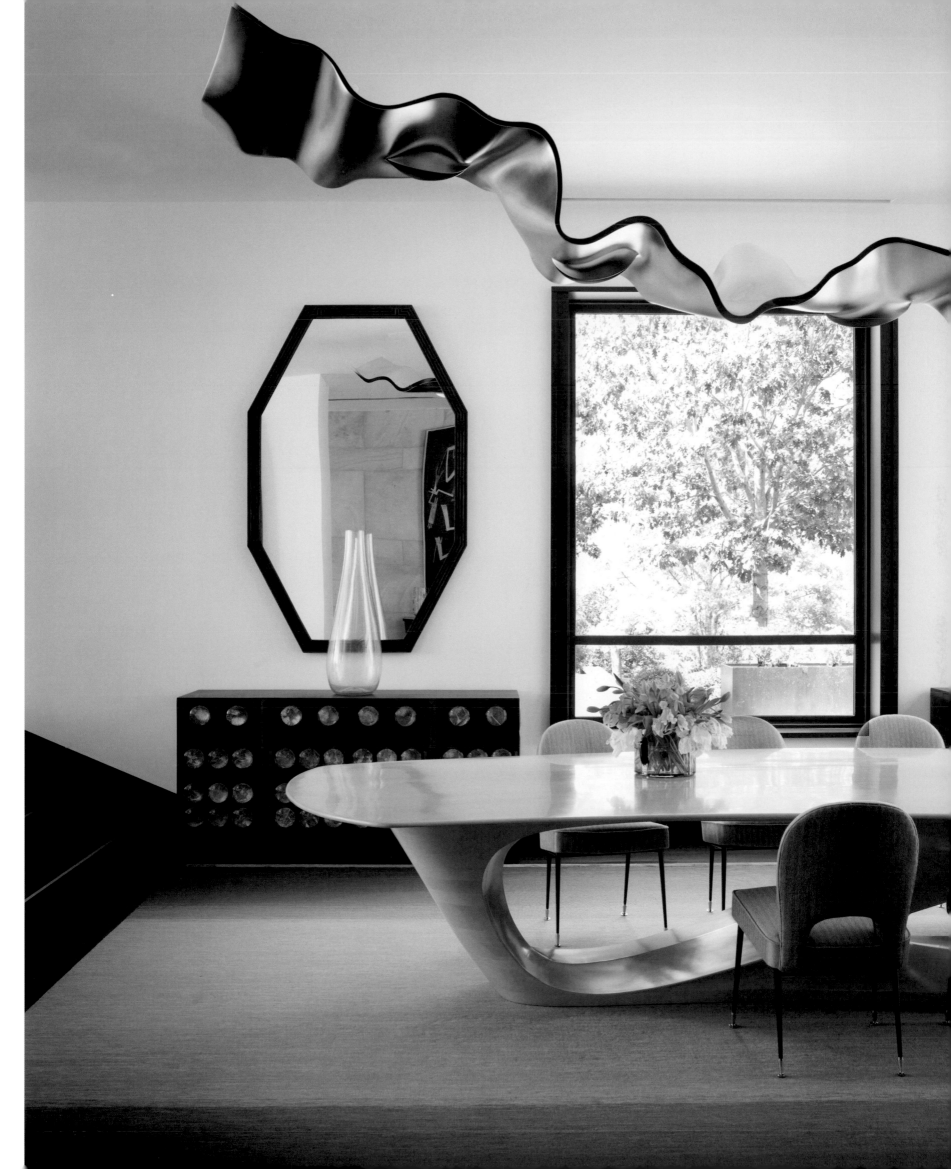

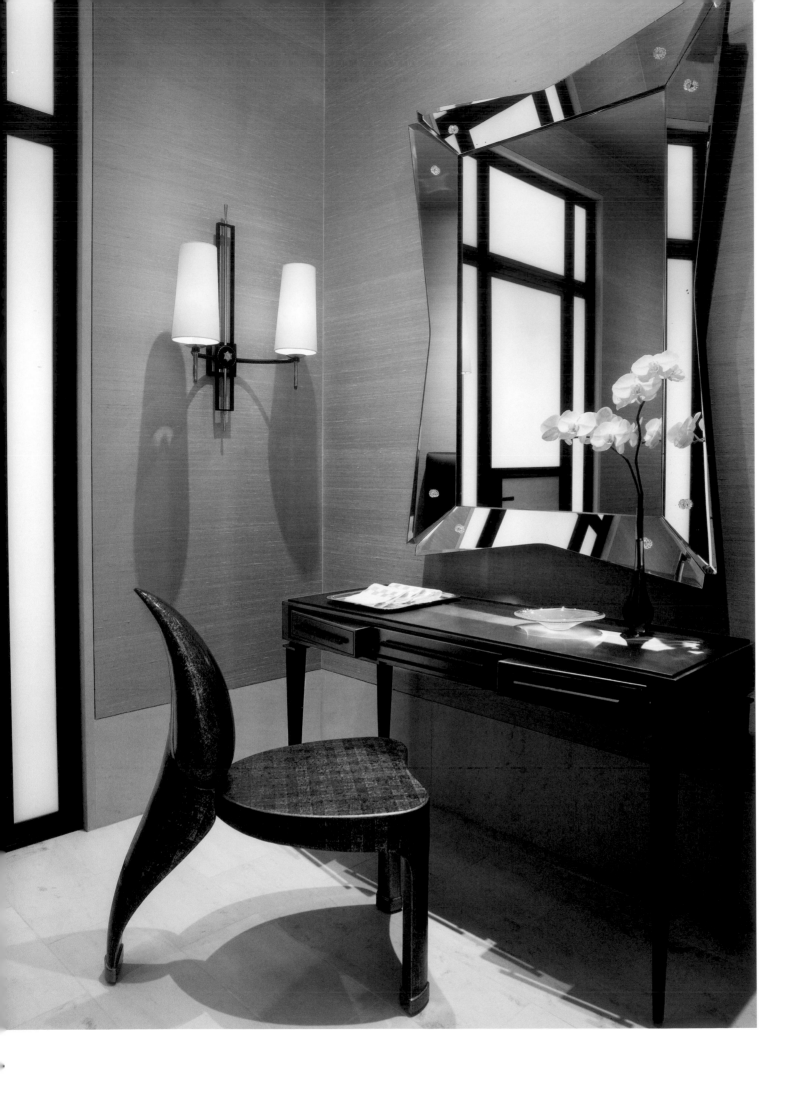

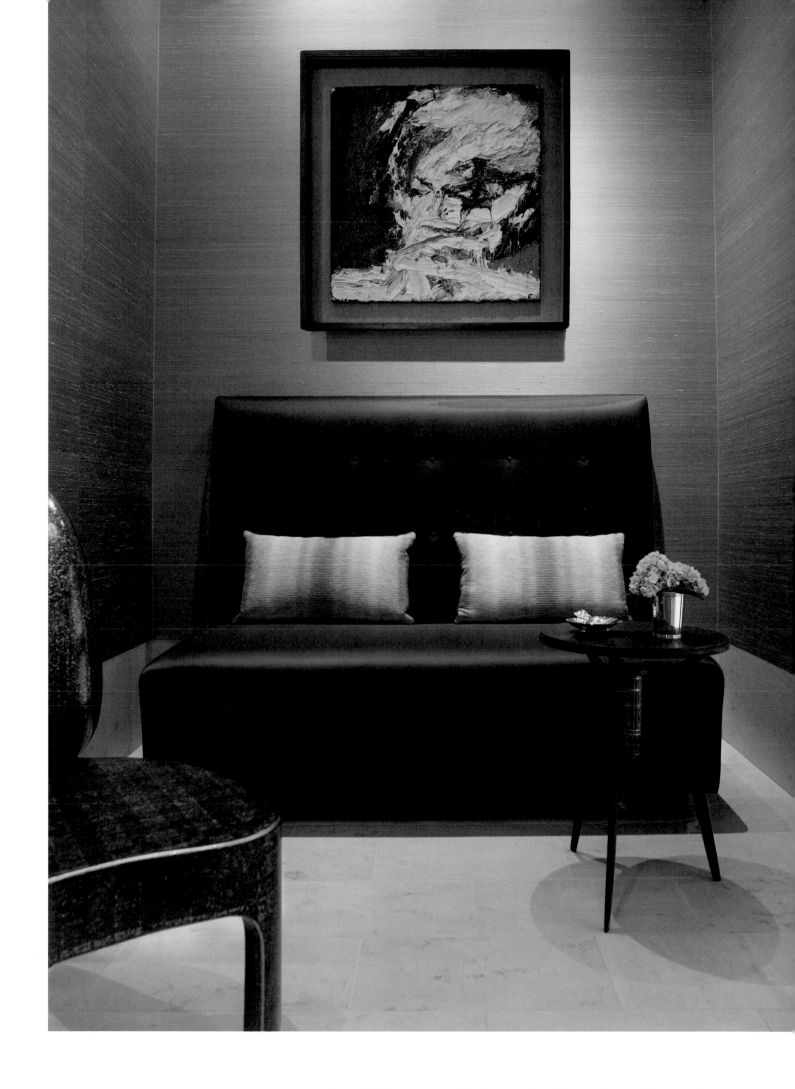

A Frank Auerbach portrait is a focal point above the powder room's custom banquette
sheathed in silk. Opposite: A 1940s French mirror and Adnet sconces are fixed to silk walls.
An Alasdair Cooke chair is pulled up to a commissioned Michael Pohu console.

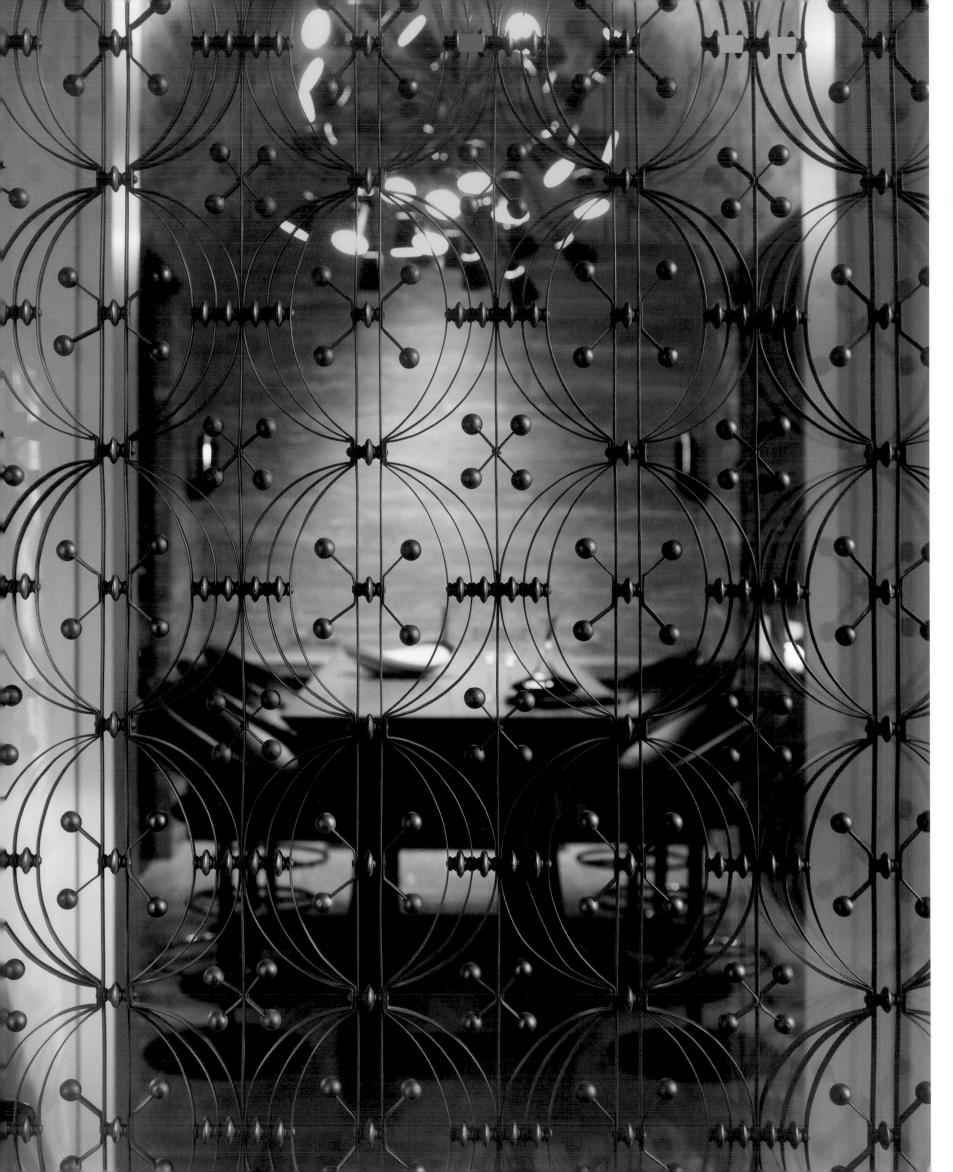

The Adler and Sullivan gate c. 1893 was once an enclosure at the Chicago Stock Exchange. The spherical forms were an abstract representation of seeds, a reference to the grain traded there. Opposite: The wine room is punctuated by an animated Italian chandelier, 1970s sconces, and a Japanese-style custom table. The Ricardo Fasanello bar stools were commissioned.

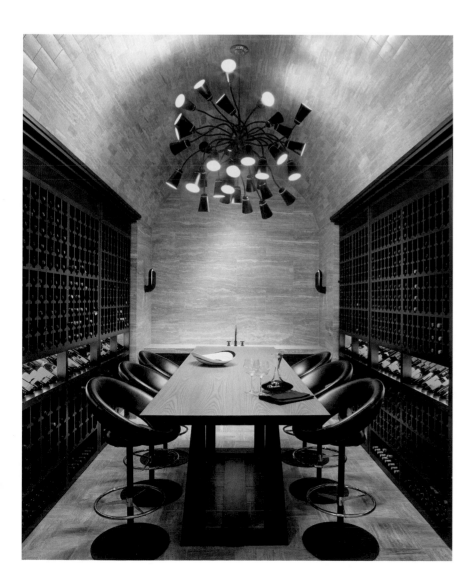

The walls and ceiling of the library were lacquered in a luscious cherry red.
Alberto Giacometti's *Buste de Diego (Stele III)* stands in a curved niche.

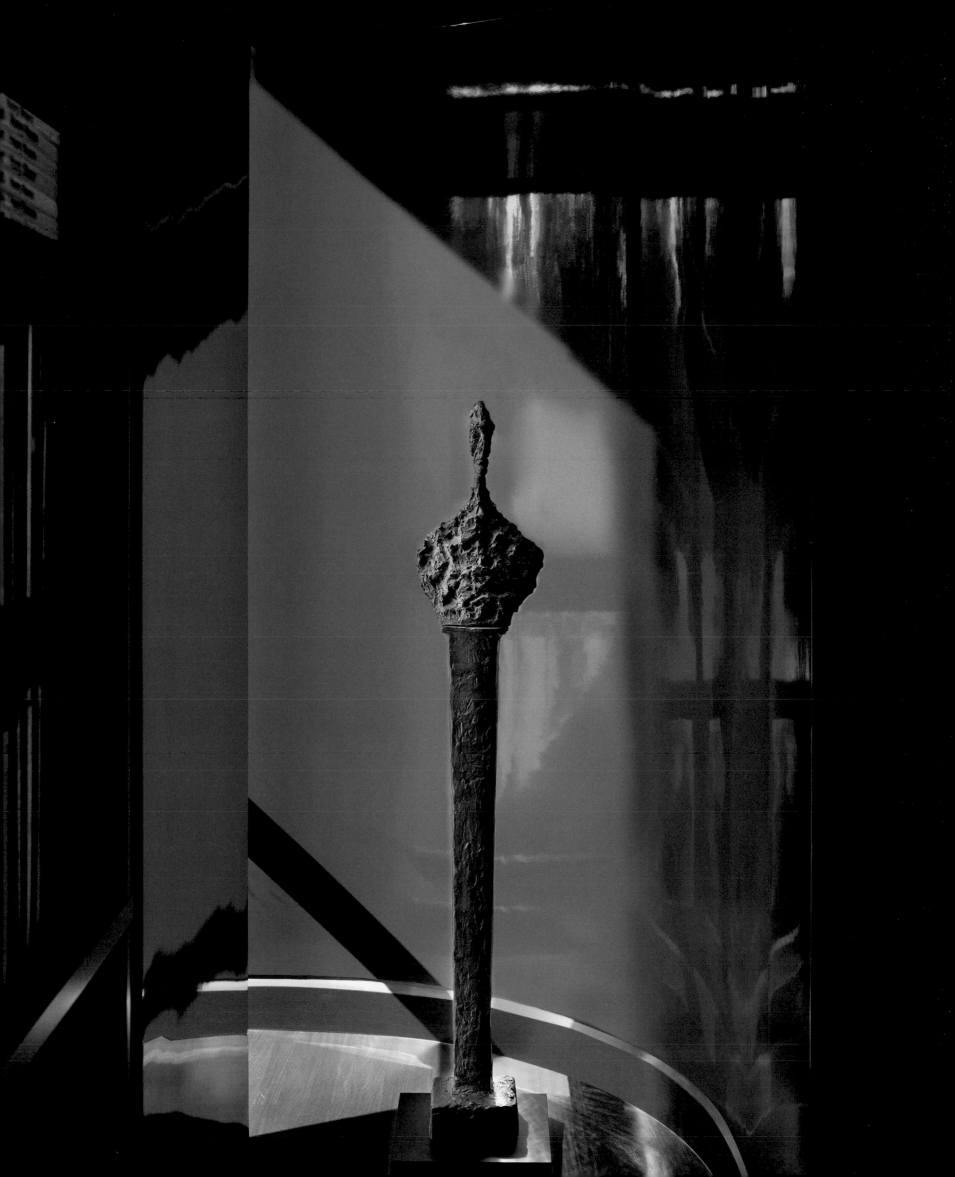

A Van der Straeten bespoke table with an inlaid-bronze marble top and beaten-bronze legs. The chairs are Leleu and the pendant lights are designed by Henningsen. The bookcase houses works by Giacommeti and de Kooning. A pair of Senufo ancestor figures from the Ivory Coast stand sentinel.

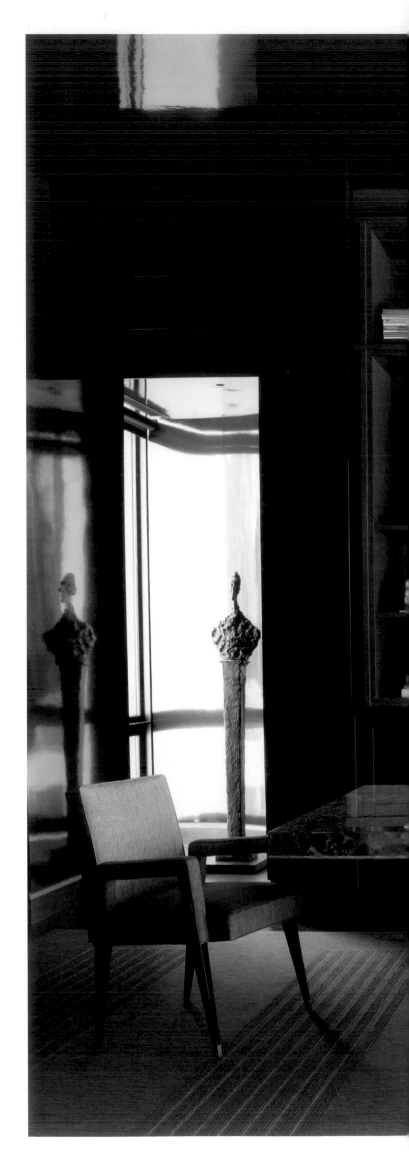

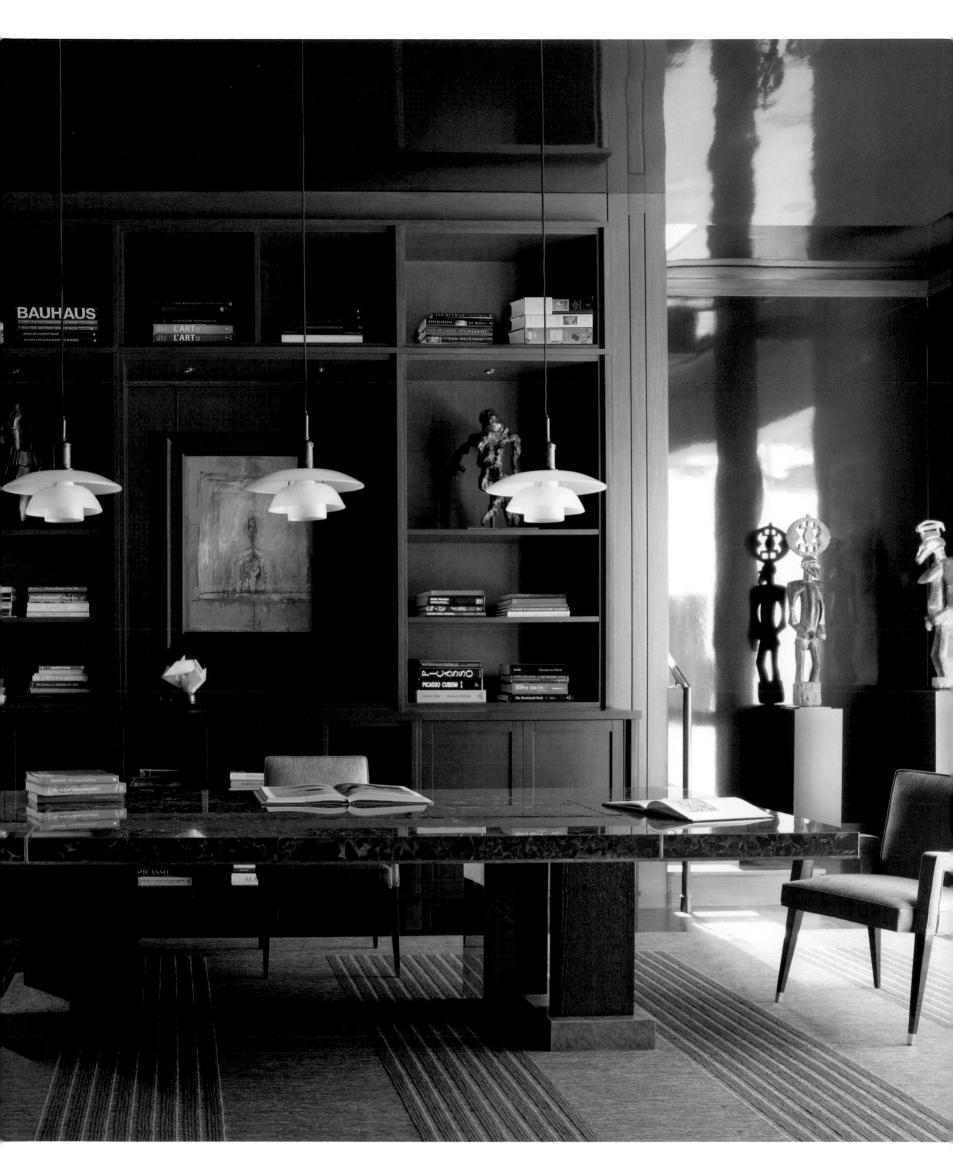

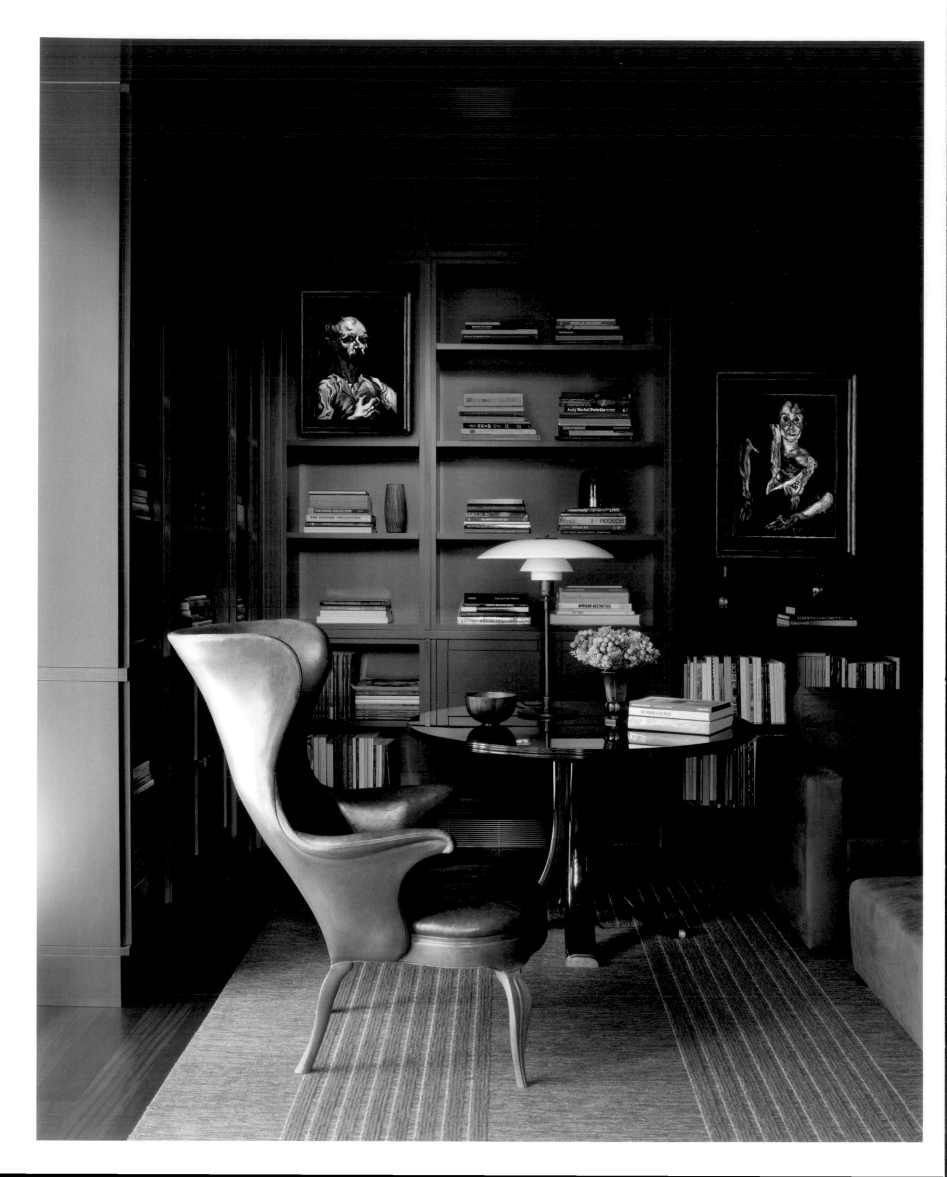

The library's faceted doors are upholstered in leather. A Bamum head crest from Cameroon. Finn Juhl's Chieftains Chair rests under the Chaïm Soutine painting. Opposite: A 1935 Henningsen chair is beside a Borsani table. The paintings, from left to right, are by Ludwig Meidner and Soutine and the rug is custom.

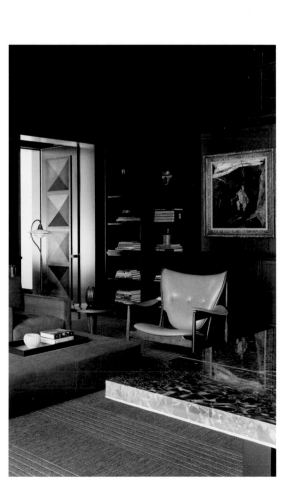

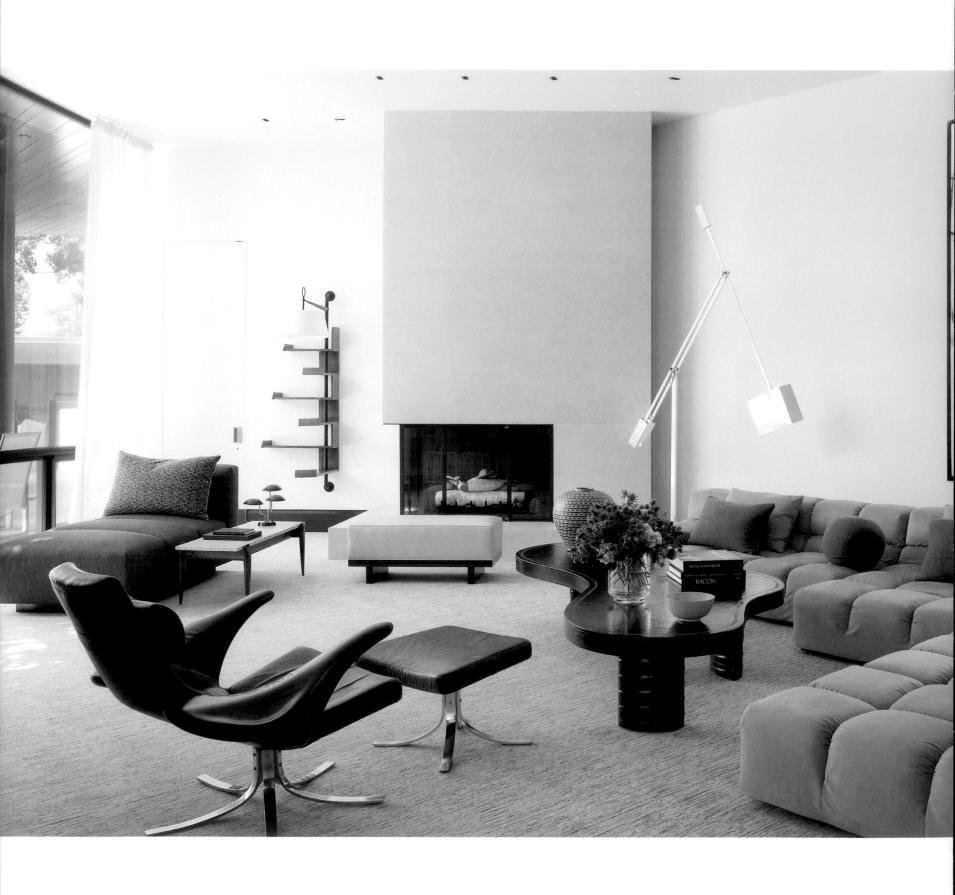

Patricia Urquiola's sofa borders the Joan Mitchell painting and leather-topped
Billy Haines cocktail table. Opposite: A detail of Gusta Berg and Stenevik Erikson's 1968 Seagull chair.

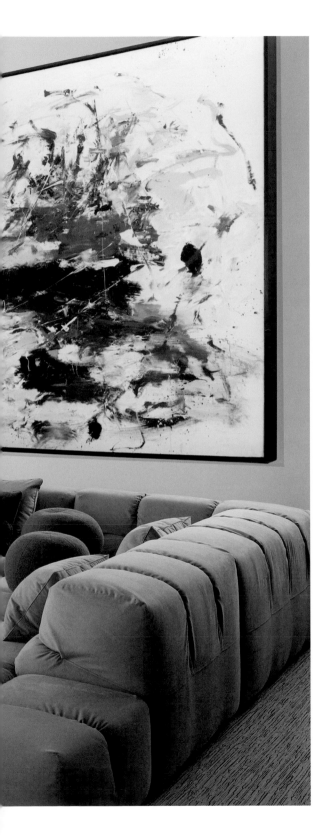

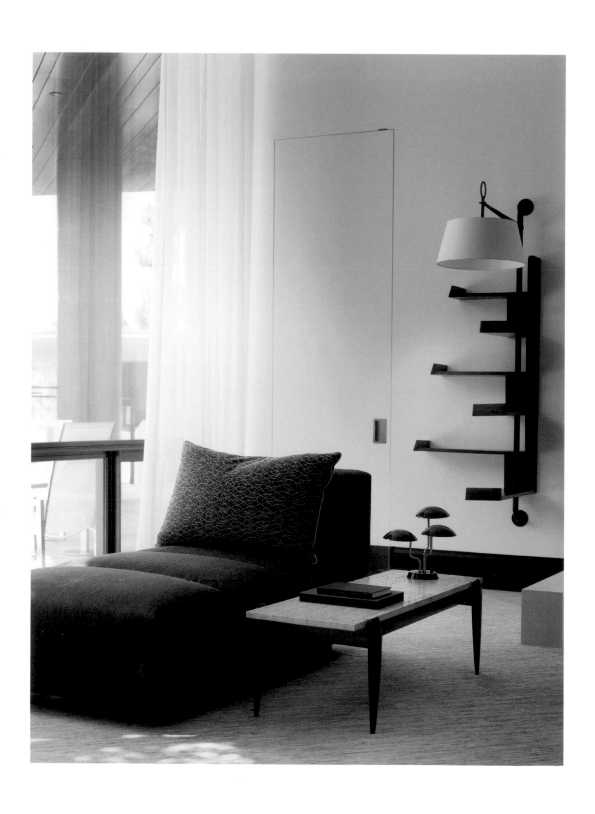

Jacques Hitier's singular shelf-and-lamp unit provides additional lighting for the
custom chaise longue and Giò Ponti travertine-topped coffee table. Opposite: The ribbed
walls of the theater are covered in tobacco felt.

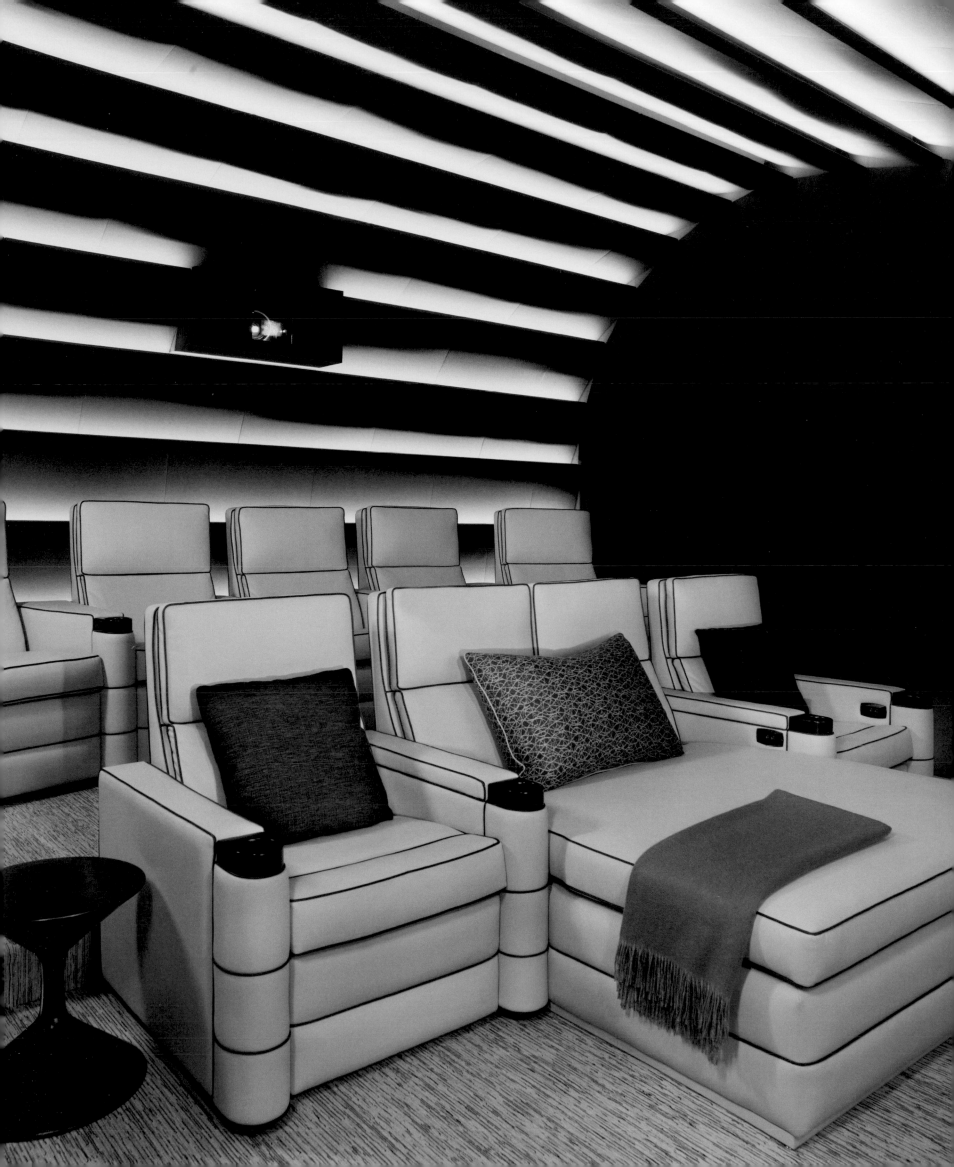

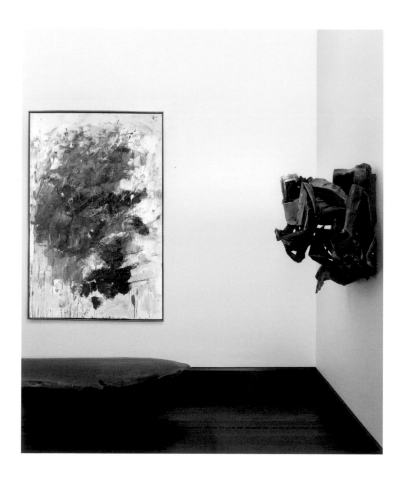

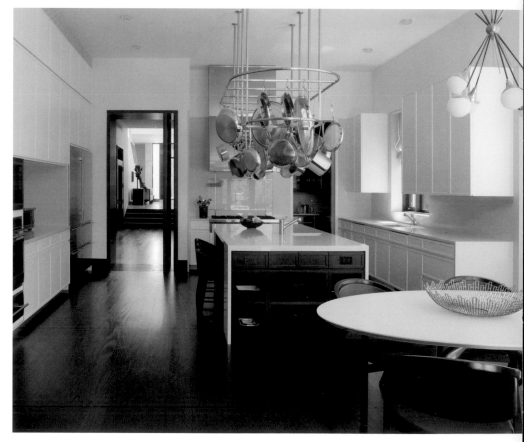

A Joan Mitchell hangs above a Nakashima bench and beside a John Chamberlain.
A detail of the kitchen. Opposite: The pair of Royère sconces are hung together as one.
Gerrit Rietveld's 1935 Utrecht chair is coupled with a Wormley side table.

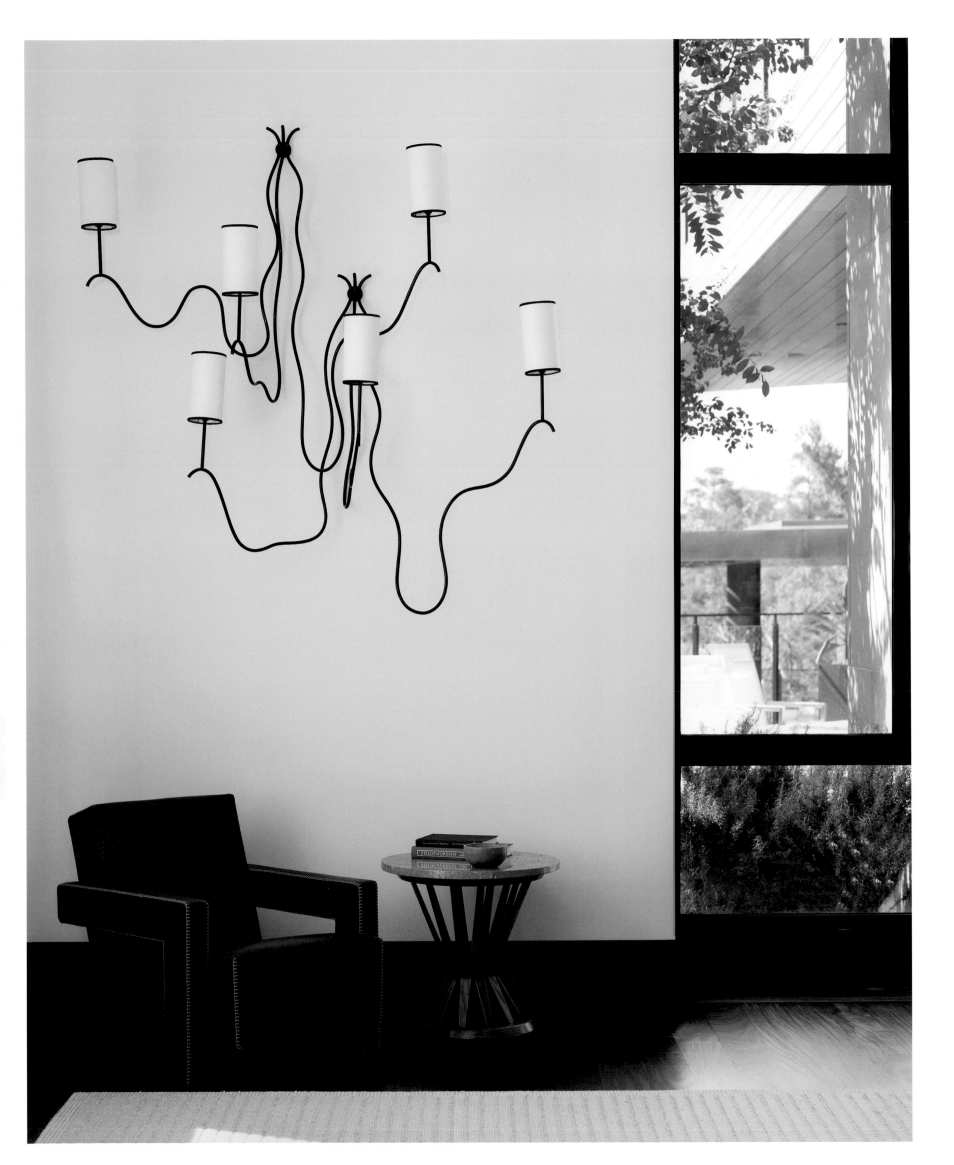

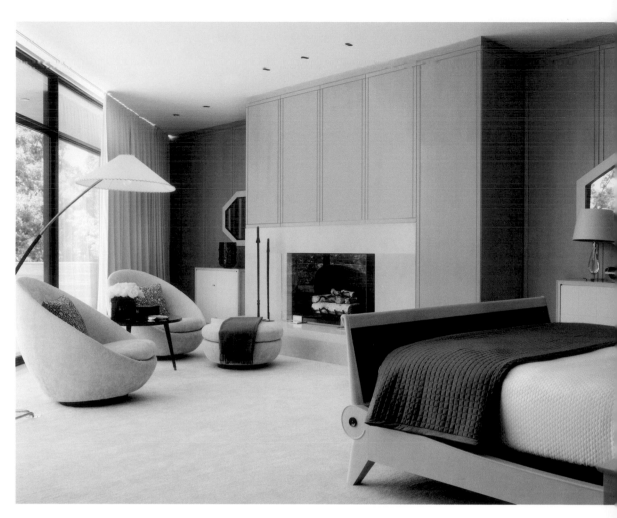

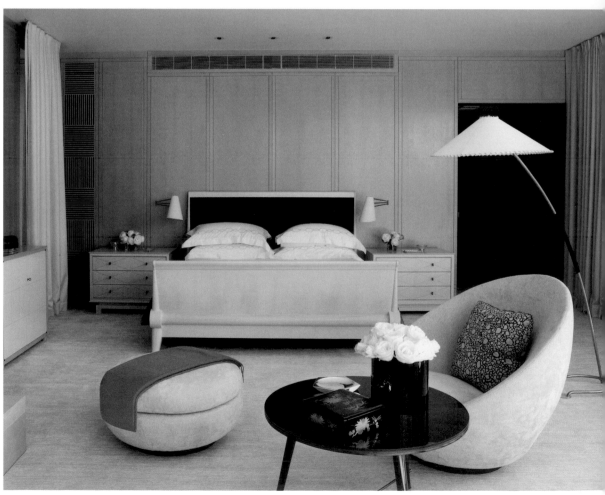

A night table and mohair-accented bed were inspired by Maxime Old designs for the limed-oak-paneled master bedroom. Circular swivel chairs by Milo Baughman and a vintage Italian floor lamp are set beside the fireplace.

A custom table tray neighbors a sculptural tub. Sheer curtains soften the master bath, and the marble floor is custom designed.

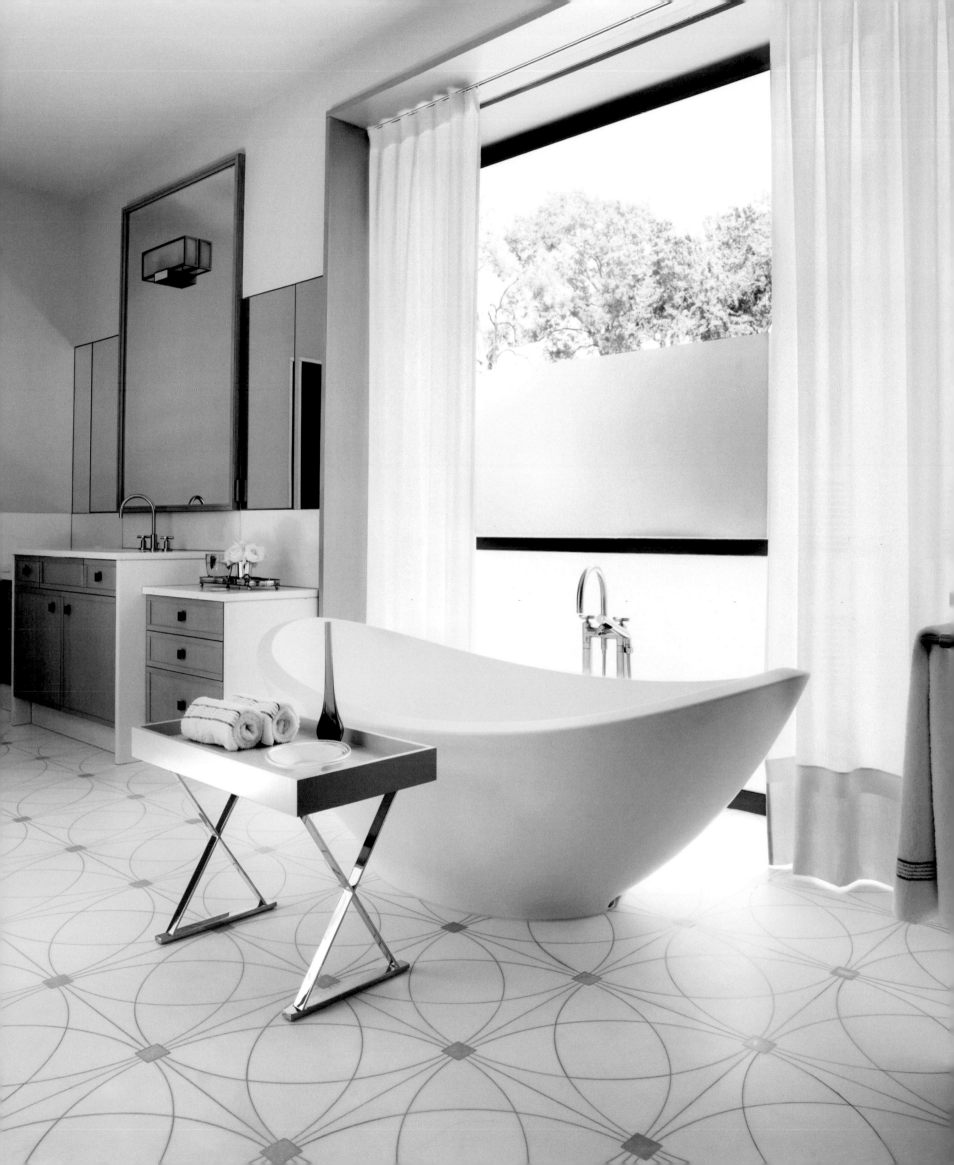

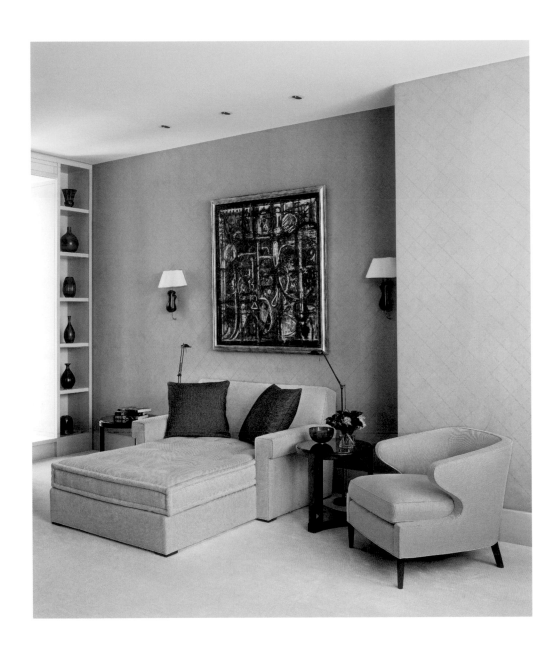

A custom double chaise is anchored beneath Richard Pousette-Dart's *Palimpsest* in the
master sitting room. Opposite: The walls are upholstered in hand-stitched suede.
The Royère chair's curves are echoed in a Georges Jouve sconce. The painting is by Jackson Pollock.

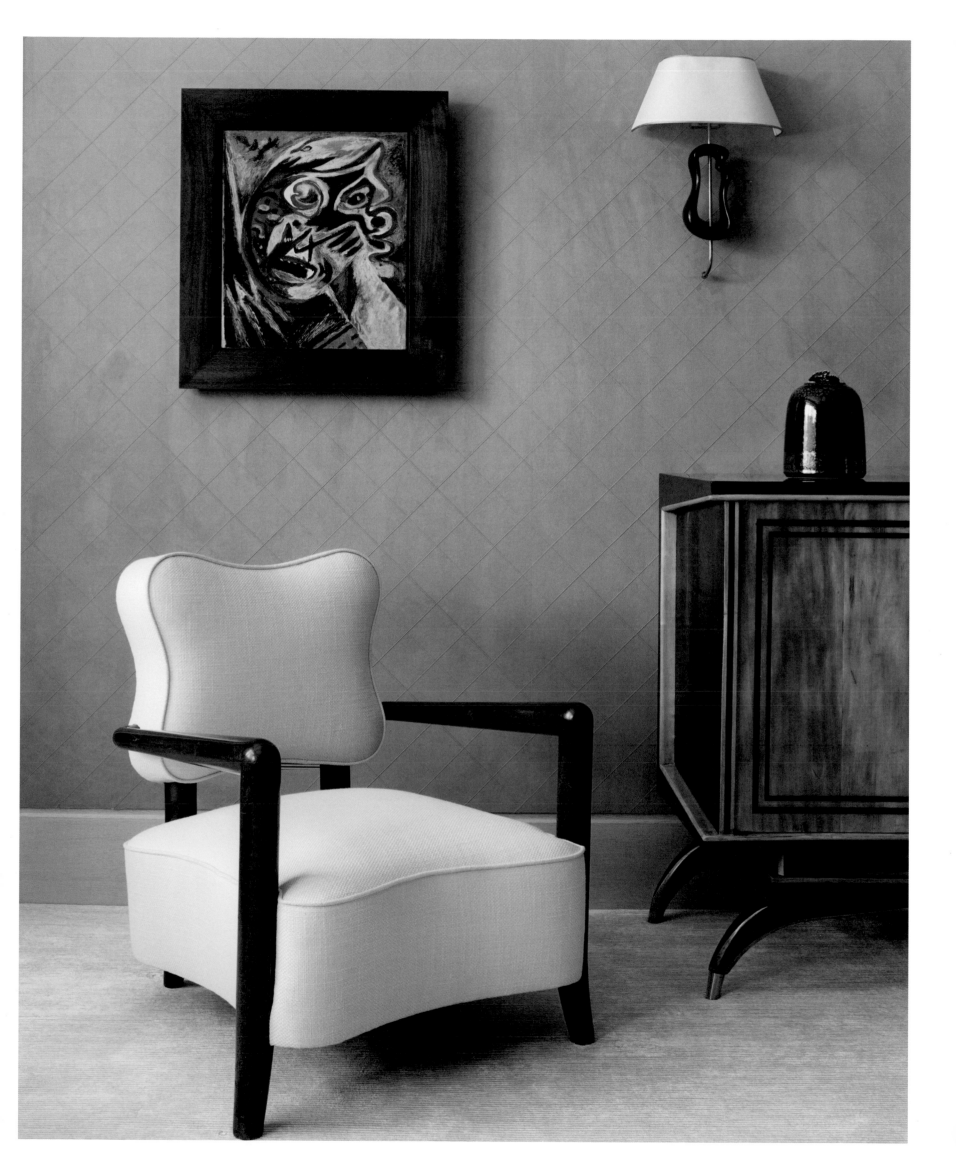

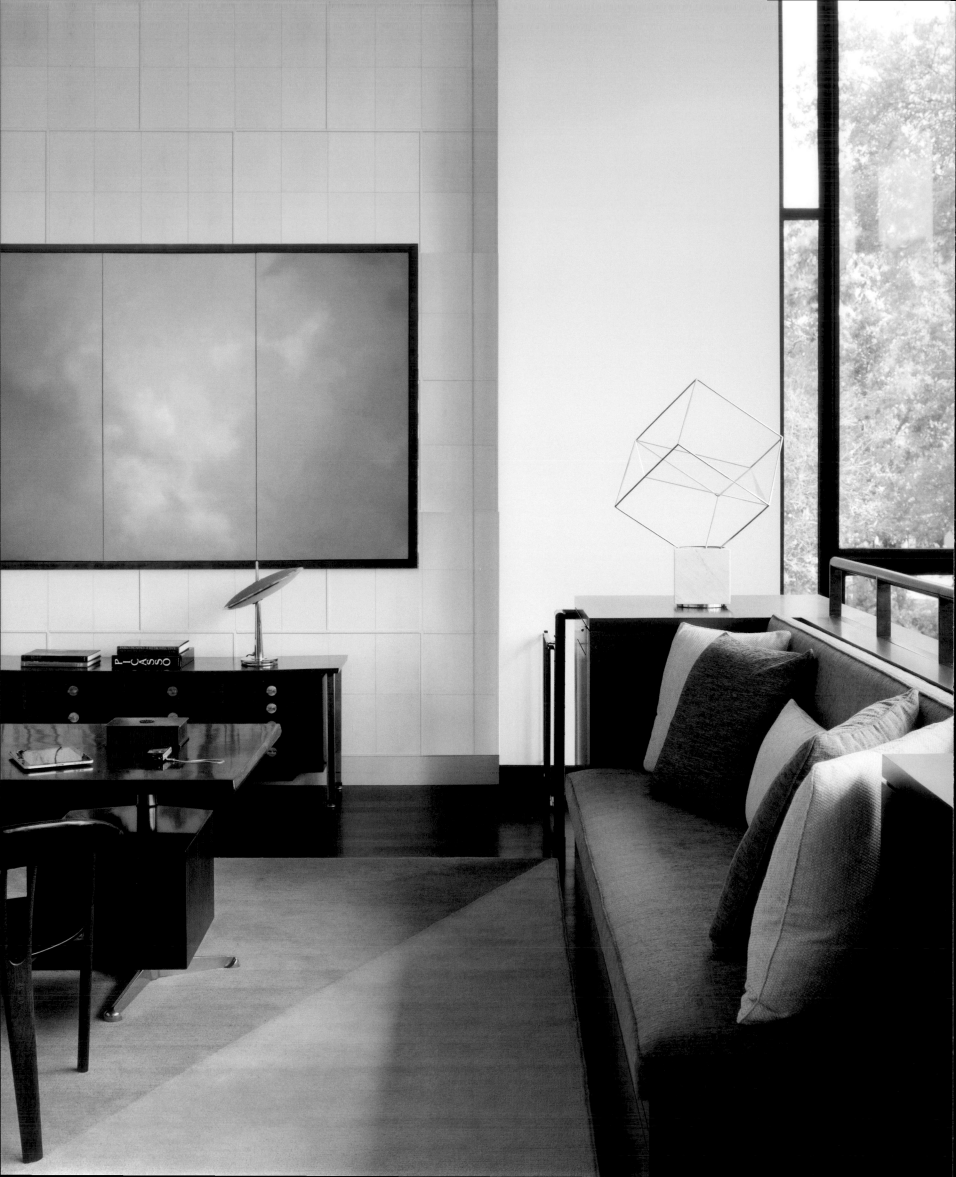

A Richter painting hangs on the shagreen walls of the study behind a Borsani desk.
The remarkable lighting features a Serge Mouille wall light and Claudio Salocchi's Tulpa lamp.

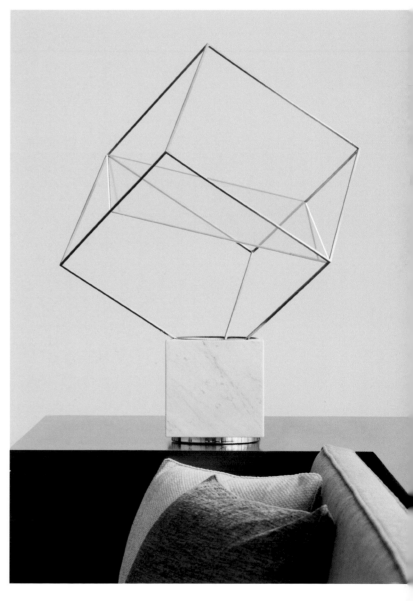

Commissioned parasol light fixtures by Constance Guisset animate the playroom.

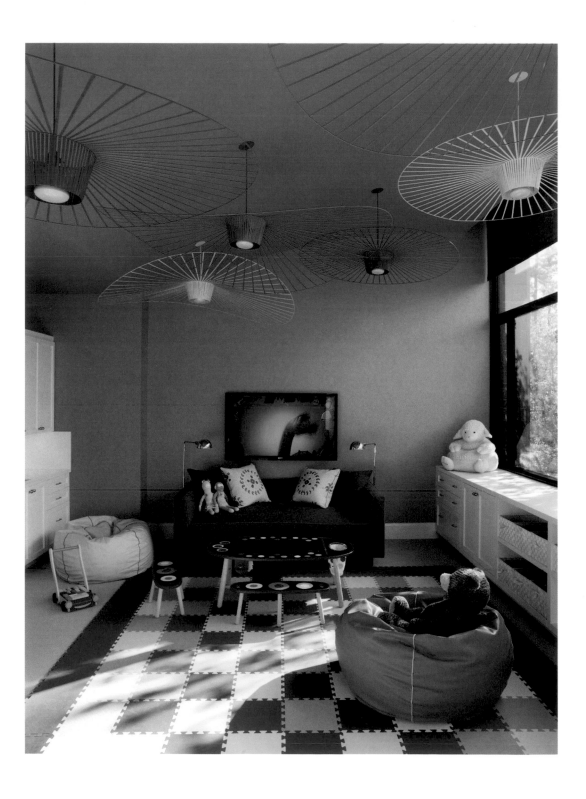

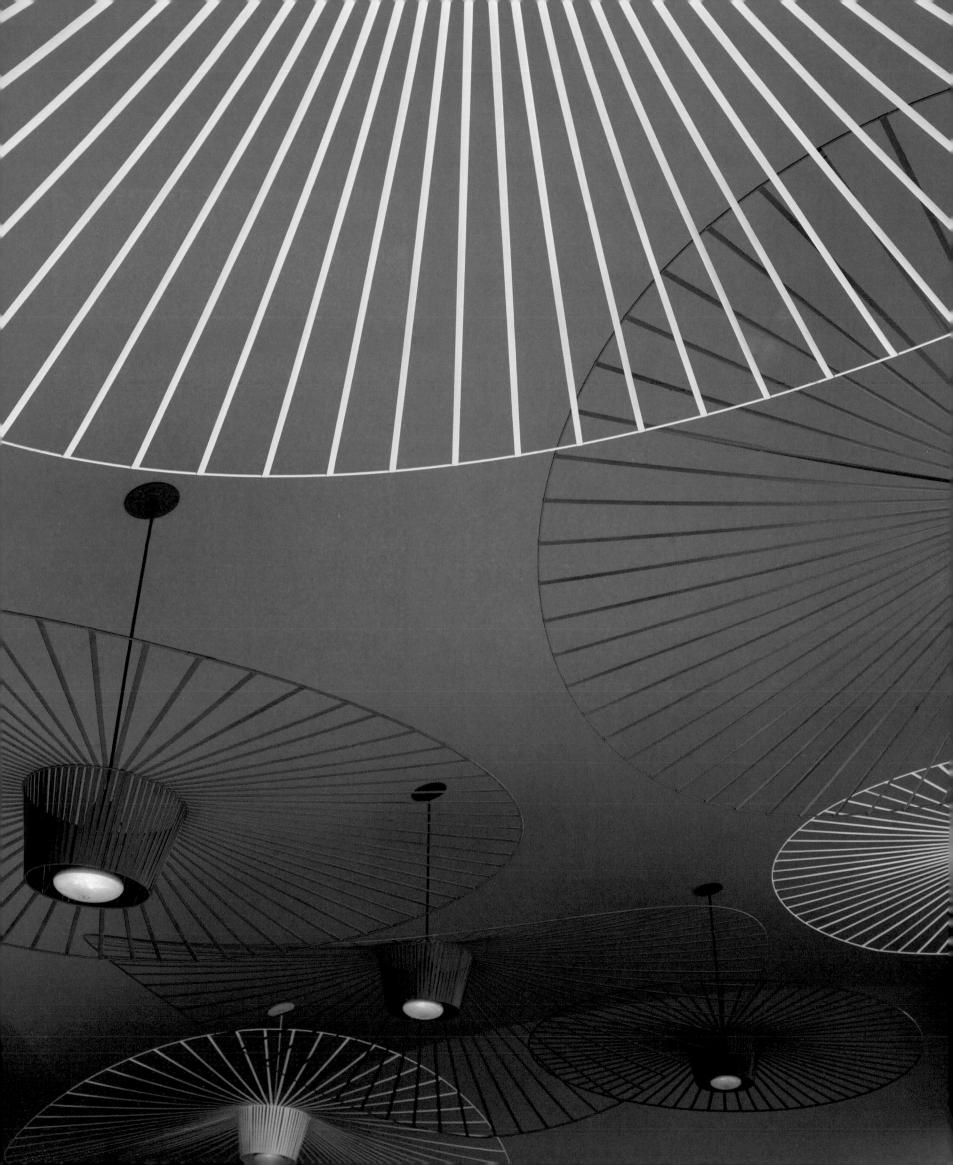

CLARITY

Luxury liners like the *Queen Mary 2* were the inspiration for this apartment,
including the oak staircase. Opposite: Lights outline the sculptural turn of the dark basalt
steps. The transition between ebony and oak on the railing is seamlessly smooth.
To me, it's a modern interpretation of a nautilus shell transmuted into wood and stone.

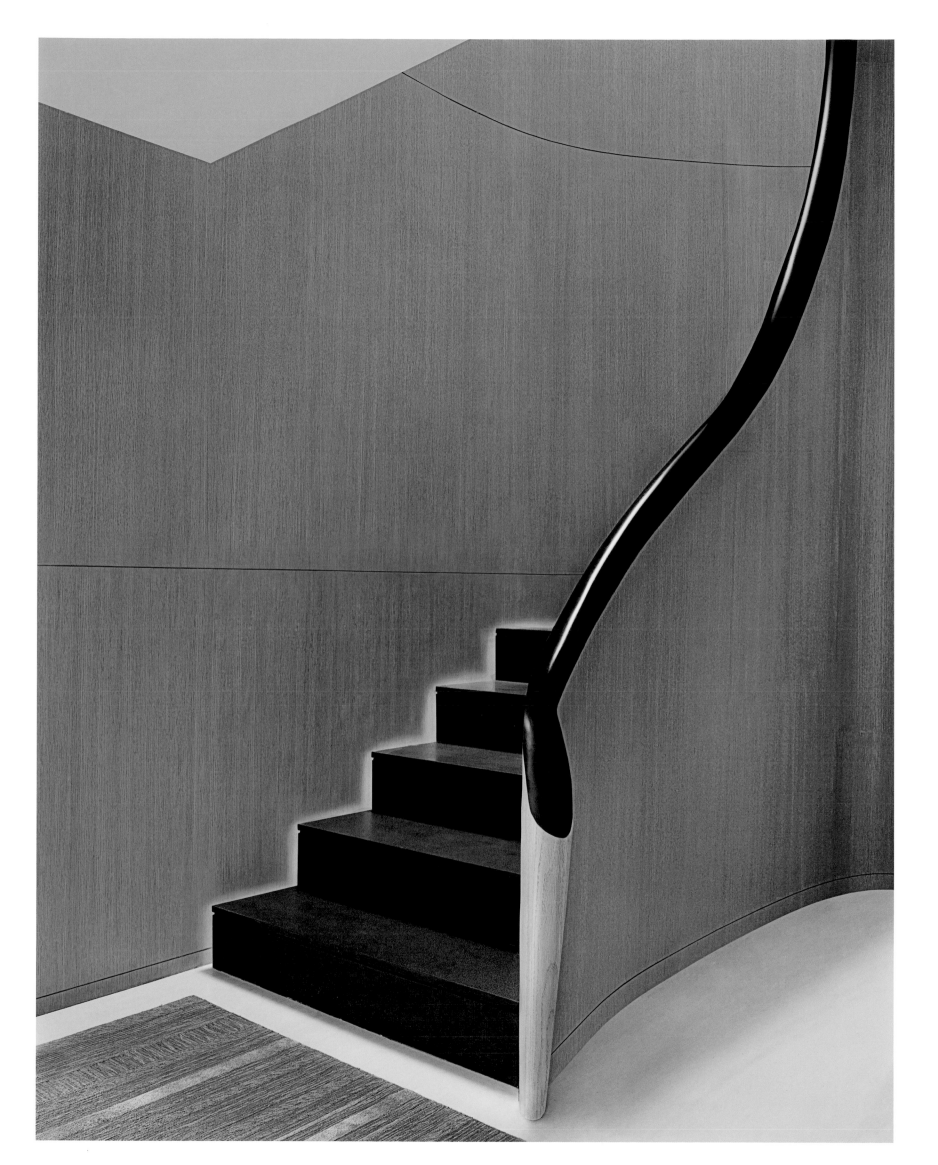

With a wraparound wall of windows overlooking New York Harbor, this apartment at the tip of Lower Manhattan is bathed in light. It makes you feel as if you're floating out over the crystalline water. You can almost touch the sailboats and the cruise ships gliding by. As I stood there looking at the picture-postcard view of the Statue of Liberty and Ellis Island, I was reminded of the time I was invited by *Architectural Digest* to give a lecture aboard the *Queen Mary 2*. When we embarked from Southampton, England, on the seven-day crossing to New York, I felt as if I had stepped into another era. The ship was designed to evoke memories of all those great Art Moderne luxury liners. This apartment was the equivalent of a luxury liner. Wouldn't it be wonderful to give it that same feeling of clarity, fresh air, and light?

So we embarked on the renovation, combining two apartments, and when we were finished, my clients moved in with their two young boys. Then, after a year or so, my phone rang. The couple had bought two adjoining apartments, including a duplex. Suddenly they had doubled their square footage and wanted me to come back and integrate the new spaces into the old. That was a fascinating problem. It was like solving an architectural jigsaw puzzle, and we had the added challenge of doing the work while the clients lived in the original apartment.

The plan we came up with began in the duplex, where we situated the new entry foyer. A staircase down to the lower level was designed as a luxurious swoop of honey-colored oak, topped with a contrasting band of ebony. It established the Art Moderne theme. From the foyer, you proceed down a long hallway, which we couldn't change because of the structural configuration of the building. So we turned it into a dramatic gallery by accenting it with more ebony, blue-gray linen on the walls, and touches of polished nickel. You walk through this shadowy space and arrive at the living room and—boom!—you are stunned by the light and the view.

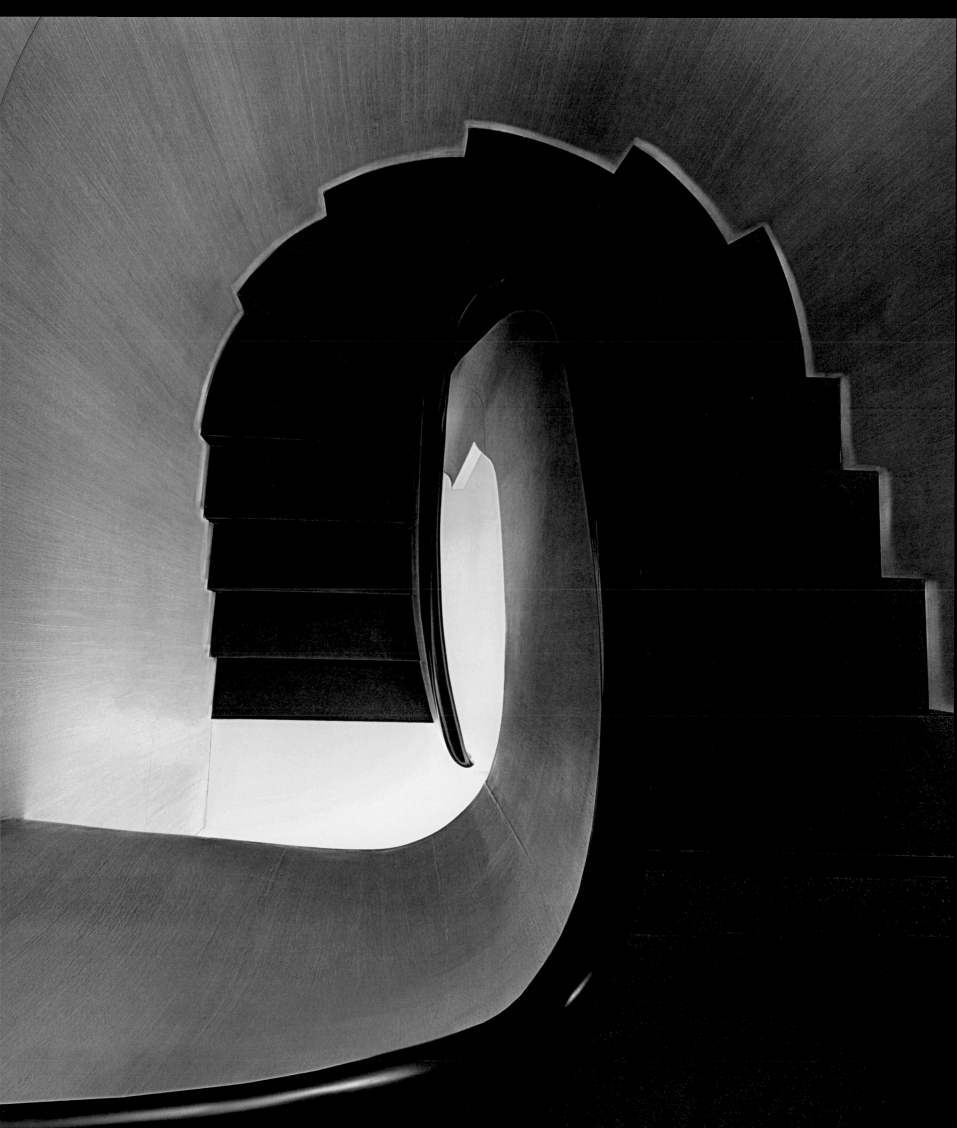

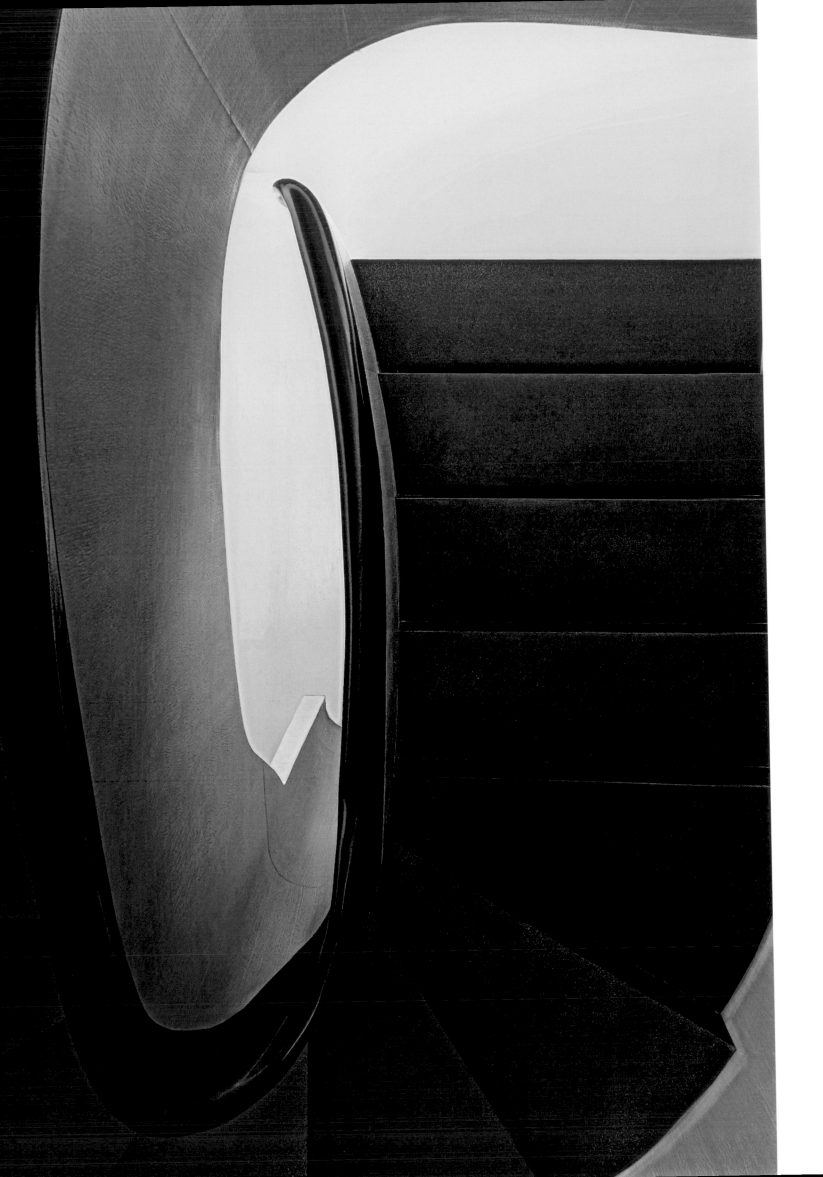

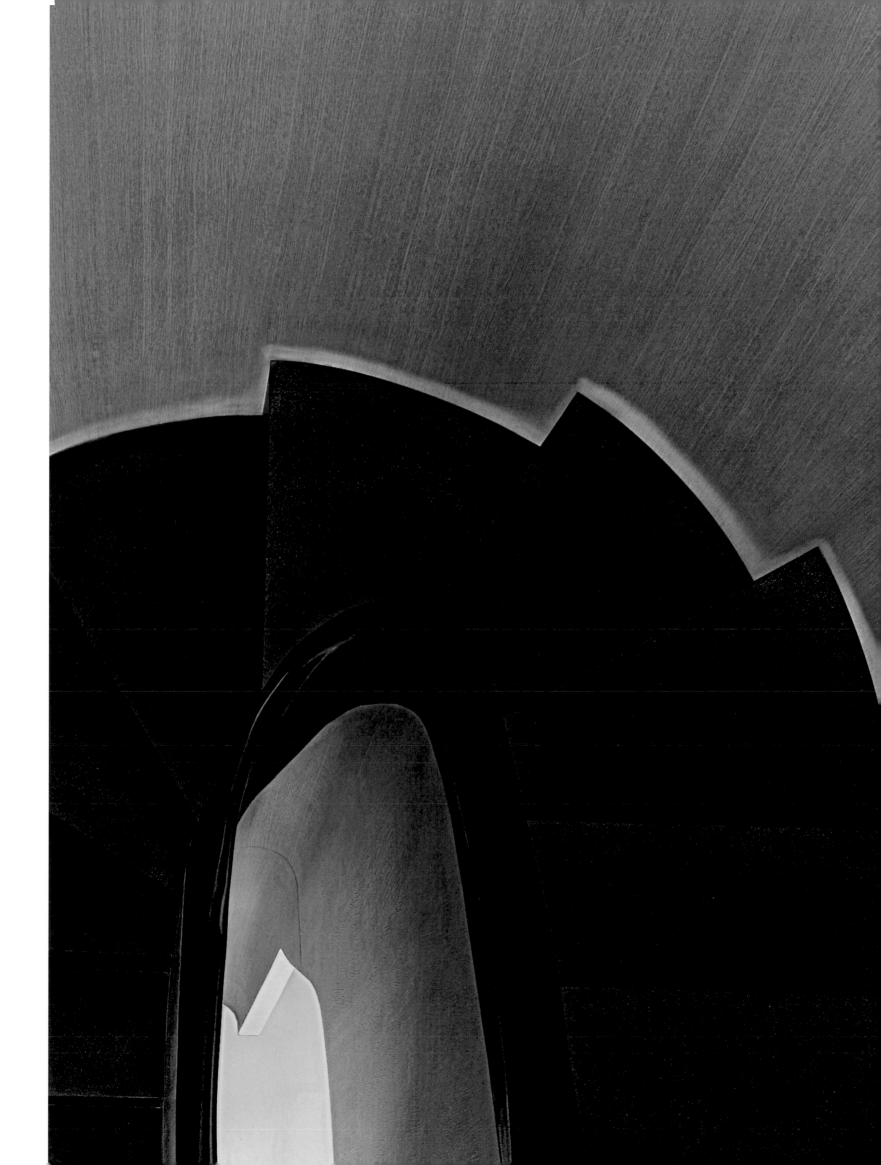

The staircase appears as a Möbius strip. Rectilinear patterns in the honed-basalt floor and the glass-and-bronze door contradict the elliptical room. The powder room's door is hidden in the curved wall. A Leleu girandole mirror is hung directly on the mirrored wall above the floating cabinets. Page 105: A long hallway leading to the living room is broken up into "rooms" by ebony doorways outlined in polished nickel.

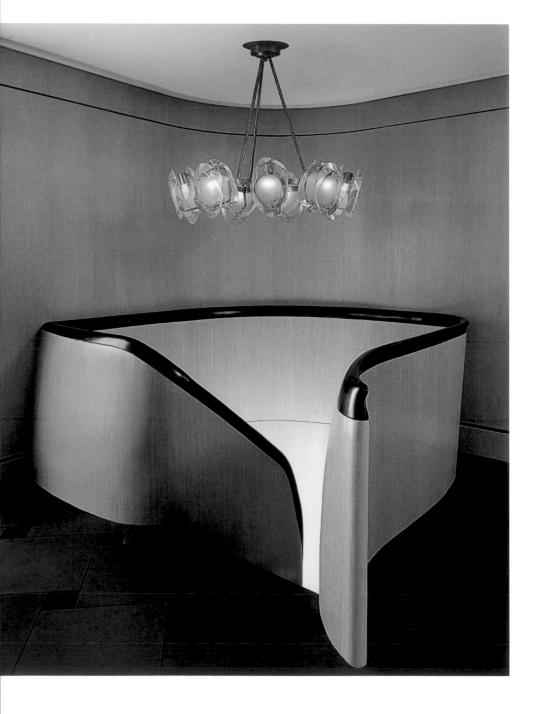

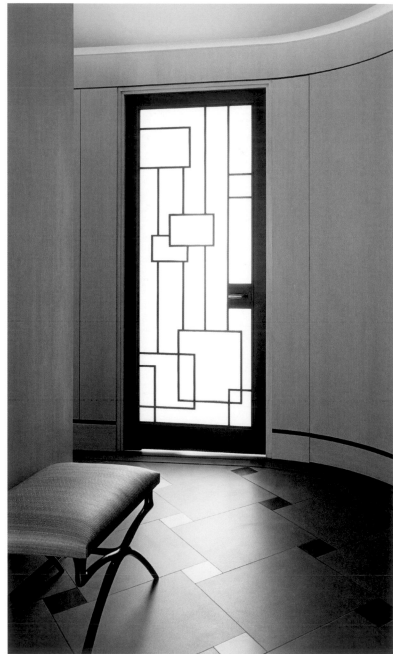

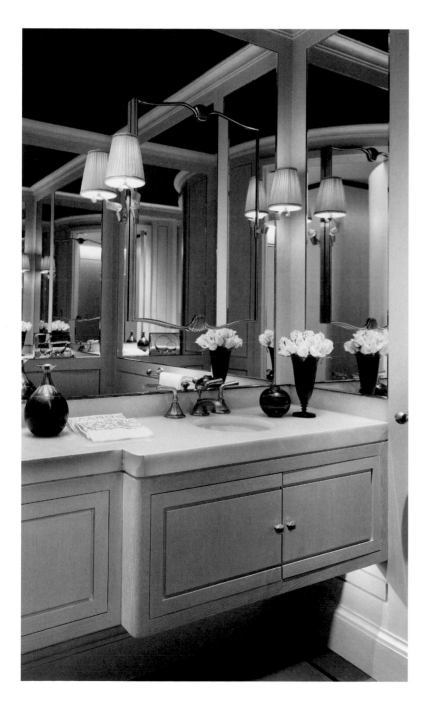

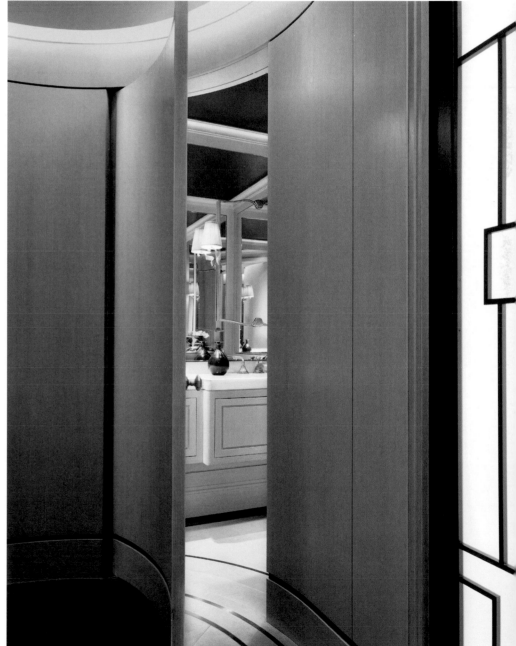

The sunshine streaming through the floor-to-ceiling windows is dazzling. I was worried that if we painted the walls pure white, they would ignite in the light and be too bright and clinical. So instead we enveloped the apartment in a textured, sand-colored plaster that softens the light. It looks like something you might see in one of Le Corbusier's villas in the south of France. We had the window frames custom-colored to match. My clients didn't want decorative window treatments. Nothing was going to get in the way of that view!

Not even the walls. We eliminated several to make one large loftlike area that flows from living room to dining room to kitchen to family room. Color is the binder that ties the whole place together. Beige or greige or sand or taupe—it's hard to define the color because it changes depending on the light. And wood, both dark and light, warms up and dramatizes the space. Colors are muted and they all agree. In the living room, the carpet has a pearlized sheen, and the furnishings are in various shades of beige, ivory, and camel, with punches of watery blue. The forms are familiar. There are echoes of the 1930s in the curve of a chair, but it's a contemporary reinterpretation. My version of modernism is relaxed and soft rather than hard-edged and extreme.

The process of decorating becomes an exhilarating exchange when clients have an open mind. It's very gratifying to introduce people to a certain period such as Art Moderne or a great designer such as Jules Leleu and watch them fall in love. Yet nothing here feels so precious that it can't be used. This is the home of a young family and everything has to be comfortable. There may be alluring echoes of the past, but the apartment is designed to take this family into the future.

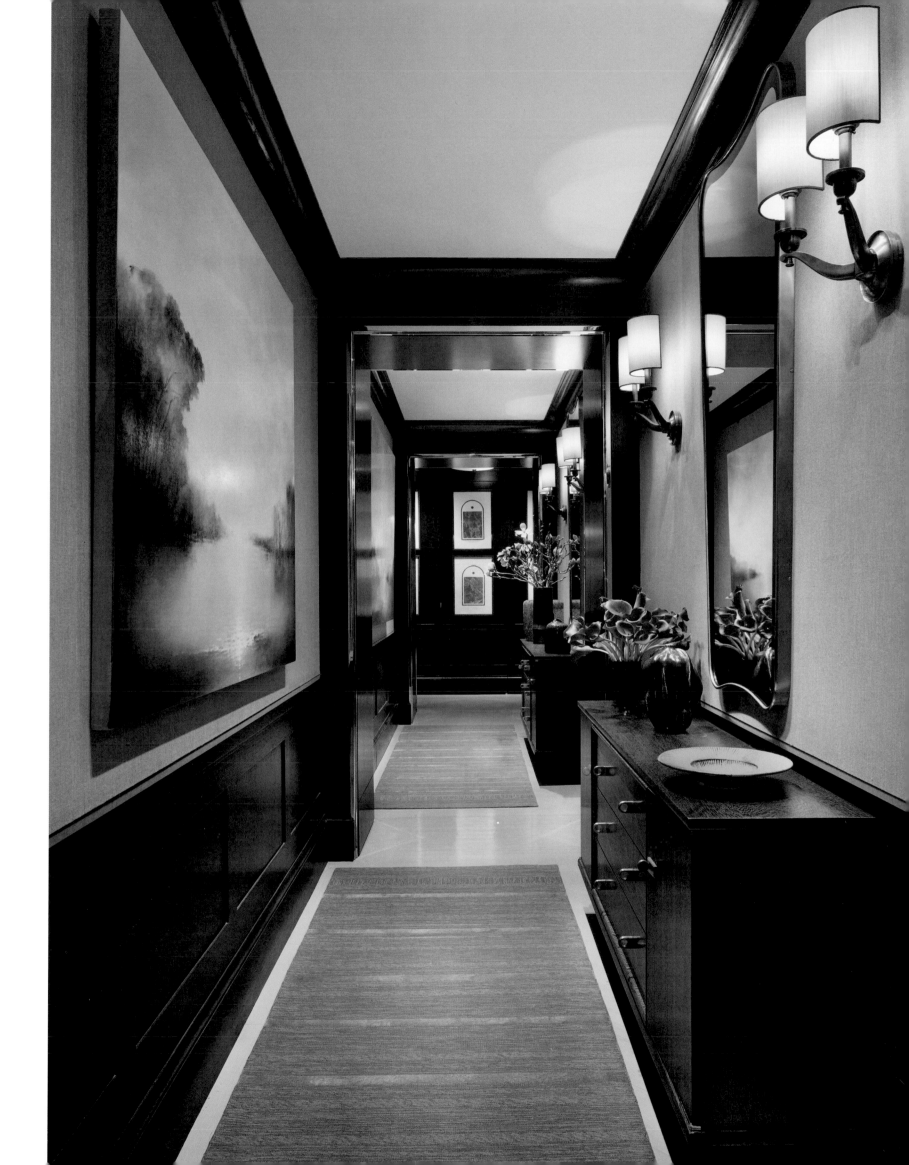

Previous page: A pair of 1950s Italian Crystal Arte mirrors are hung across from Hiro Yokose paintings. The pearwood consoles are custom. Below: Eileen Gray's first project as a designer was this flat in Paris. Opposite: The living room's shagreen screens were inspired by the Gray design. Ed Ruscha's *Air* hangs over the sofa.

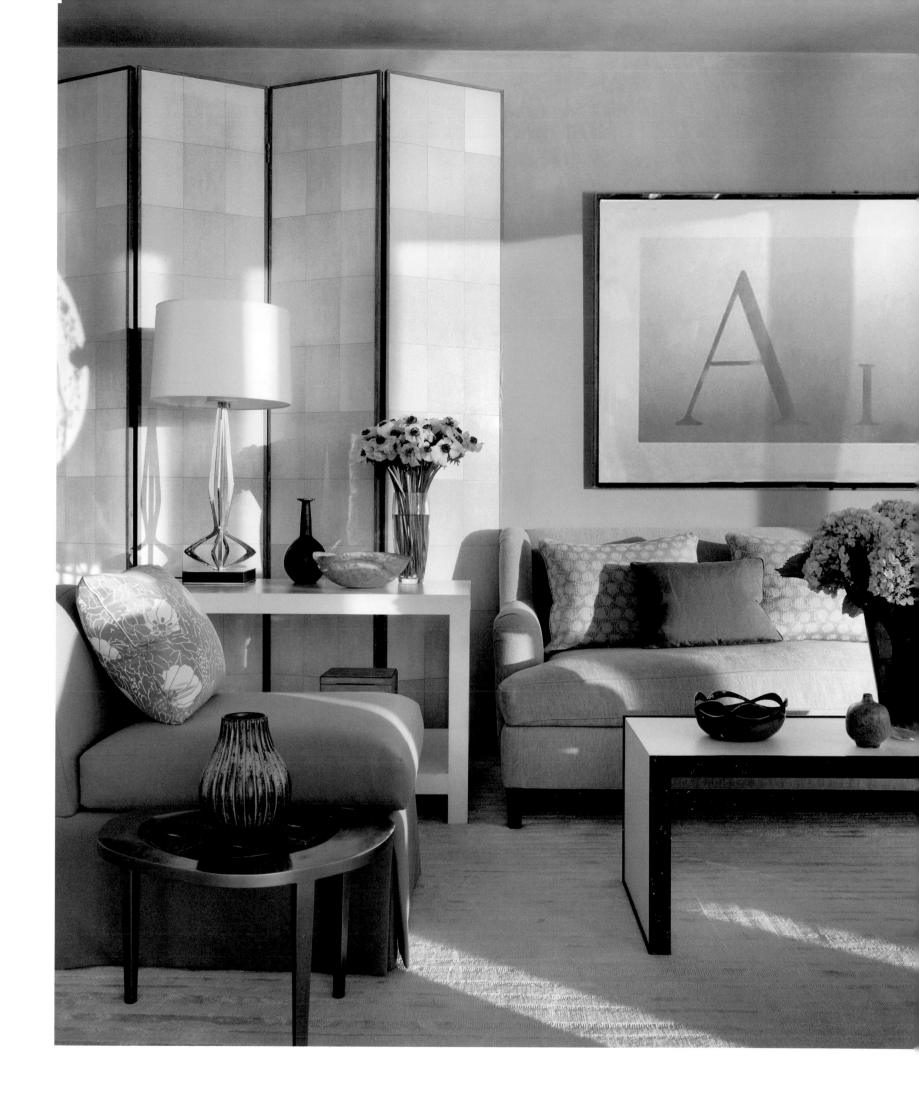

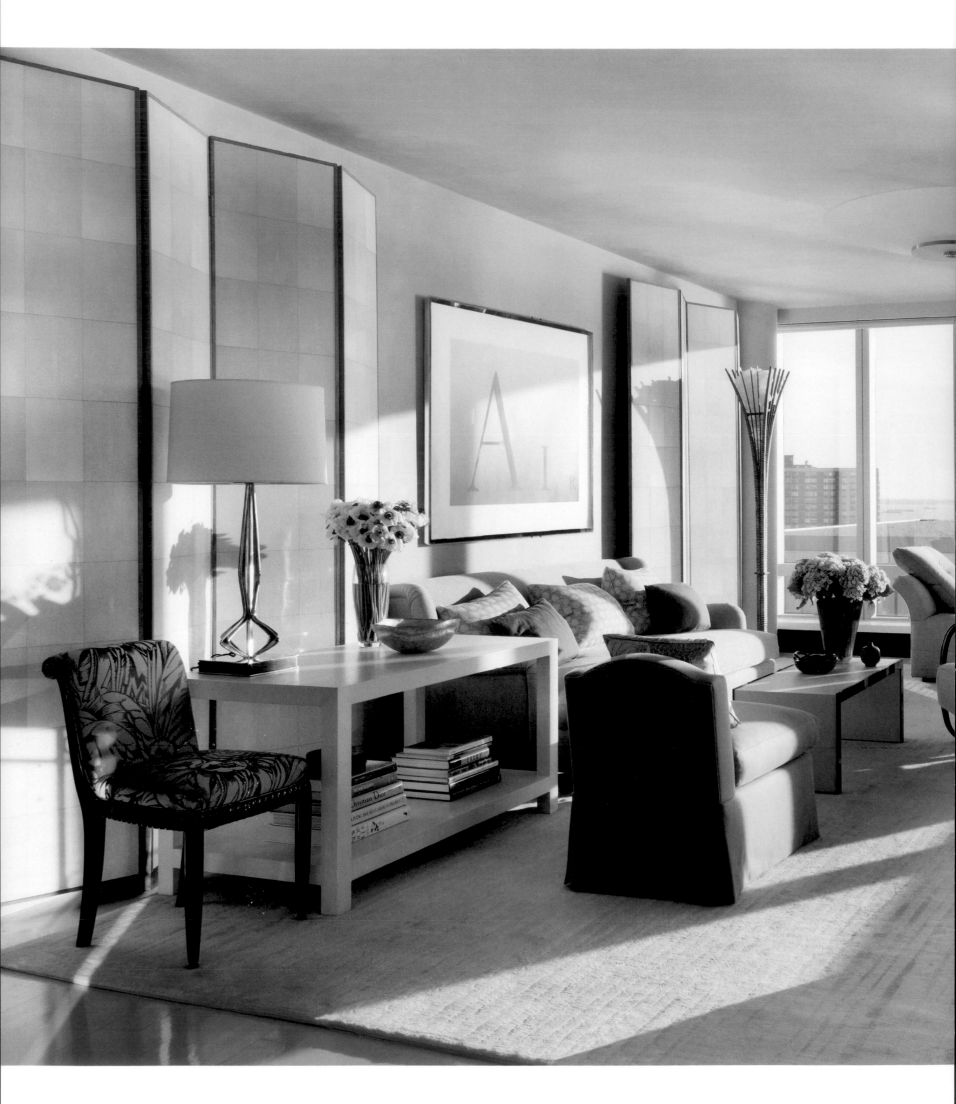

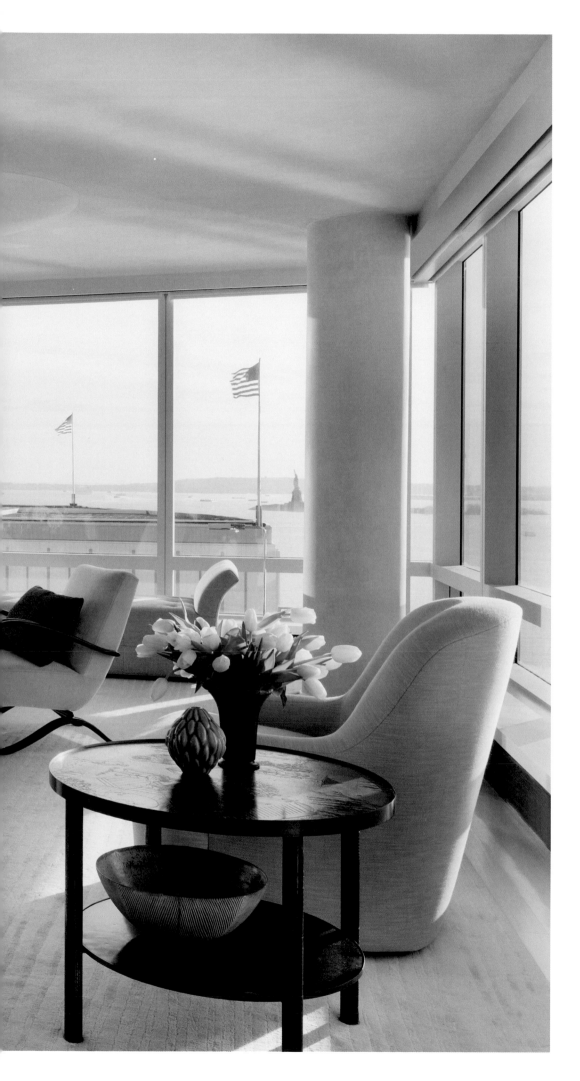

An understated pattern on the Jules Leleu rolled-back chair layers the living room's refined palette. The sleek curves of the Jindrich Halabala bentwood chair and the Sylvain Subervie rock-crystal torchiere call attention to the end of the room, where a chaise leaves the sweeping view undisturbed.

This archival photograph shows how Leleu employed a marble-topped iron-and-brass console in a Paris flat he designed for the Frilet family in the 1960s. Opposite: I hadn't seen the photograph when we used the same console in the living room, flanked by Leleu's sconces and verre églomisé mirror.

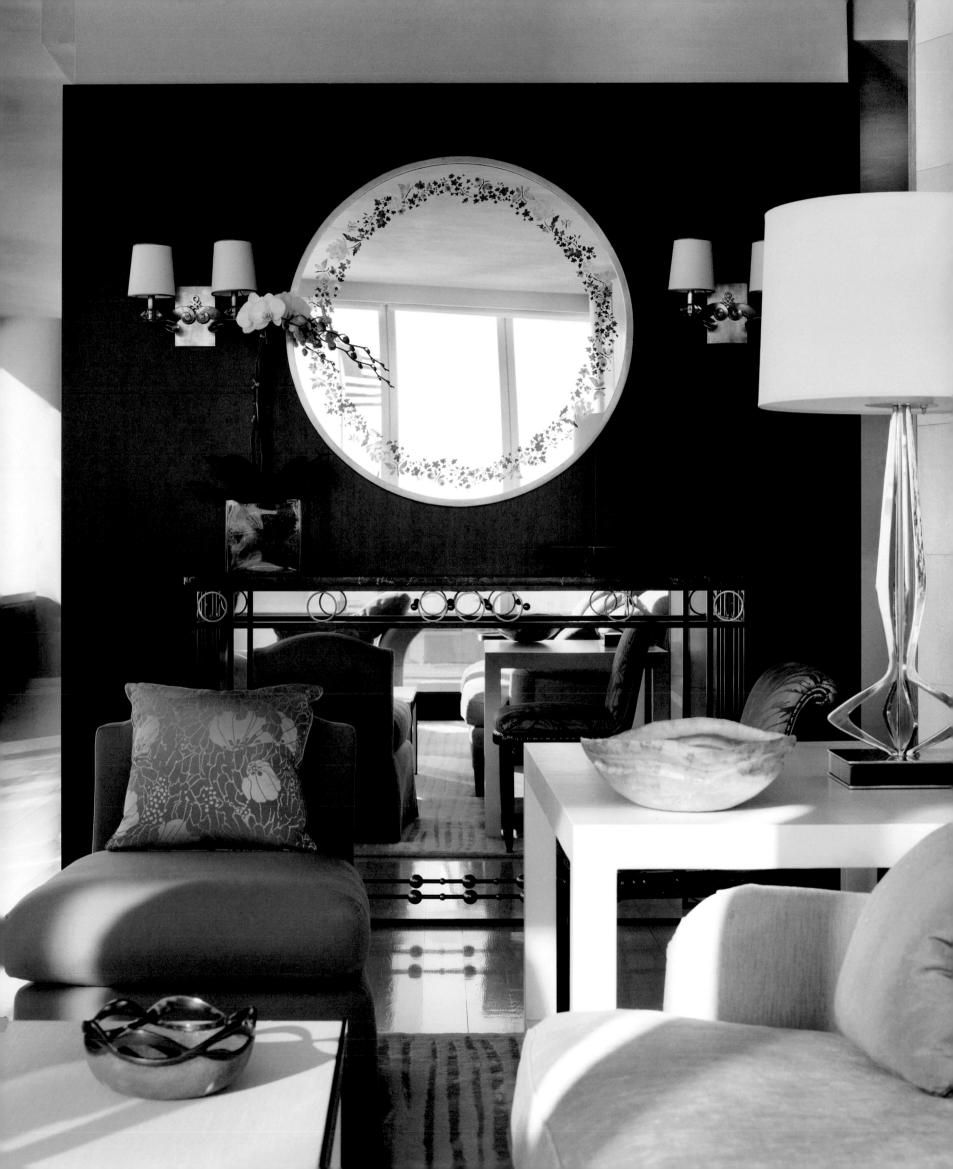

Eero Saarinen Tulip chairs follow the counter from
the kitchen into the family room, where it becomes a table.

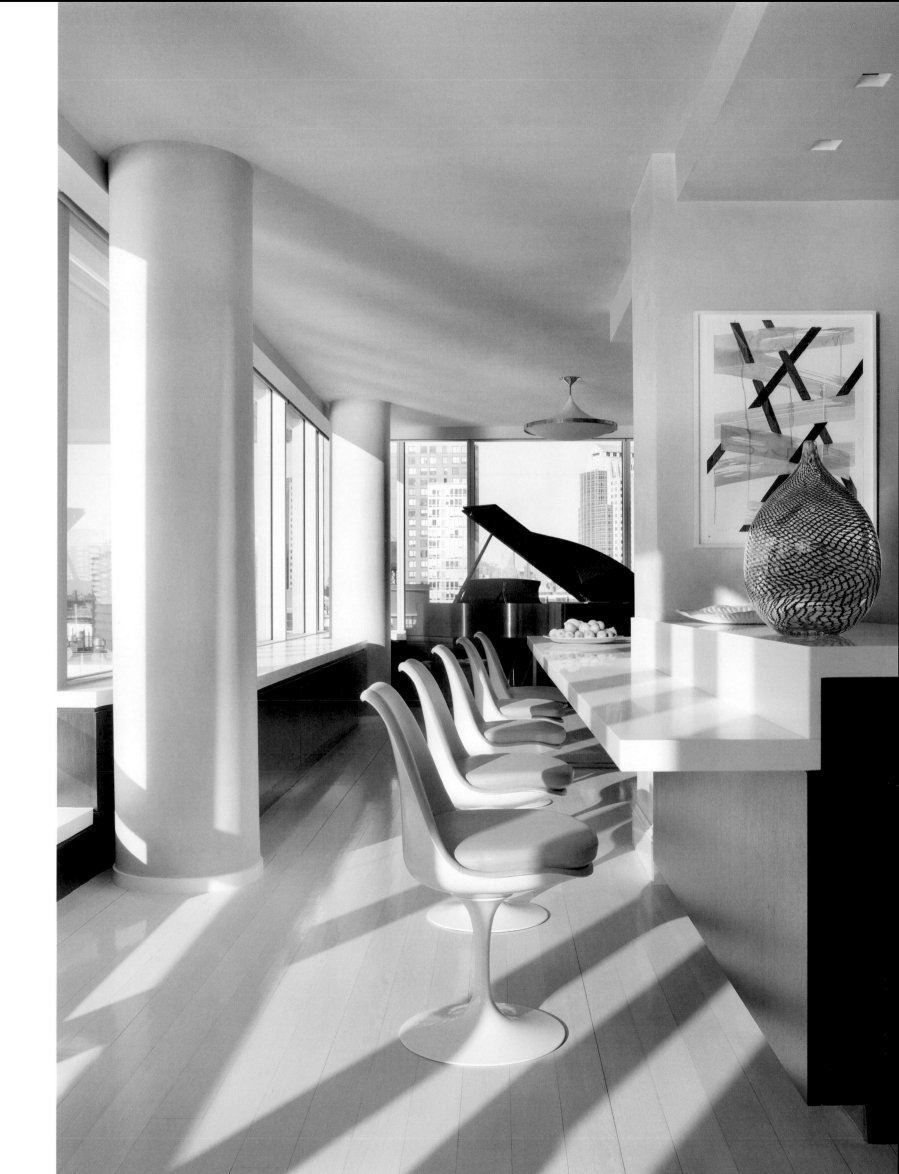

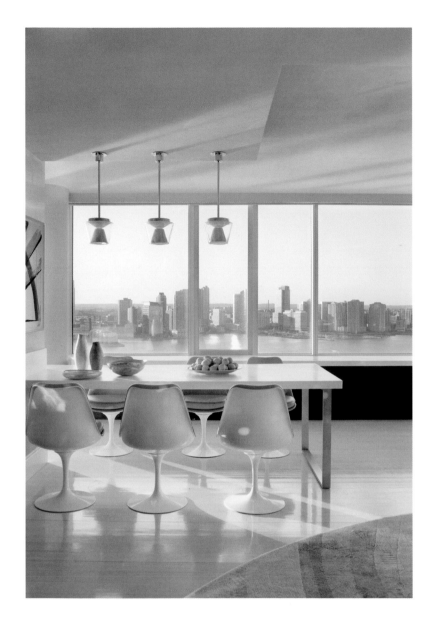
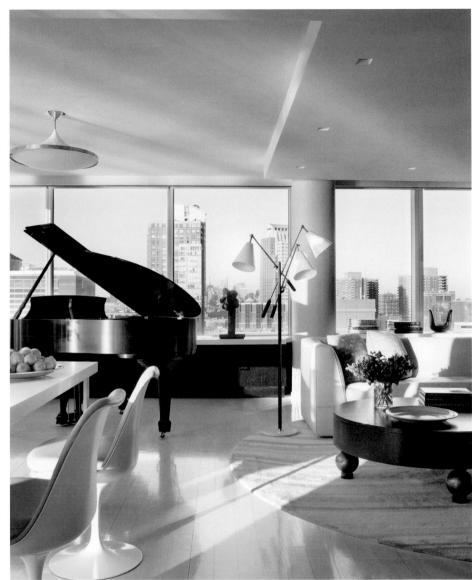

An ebonized and polished nickel doorway and a watercolor by Andreas Kocks echo the chromatic reflections on the Willy Guhl stools. In the family room a custom-made coffee table, circular rug, and piano share dramatic curves. A Tom Otterness sculpture rests on the windowsill.

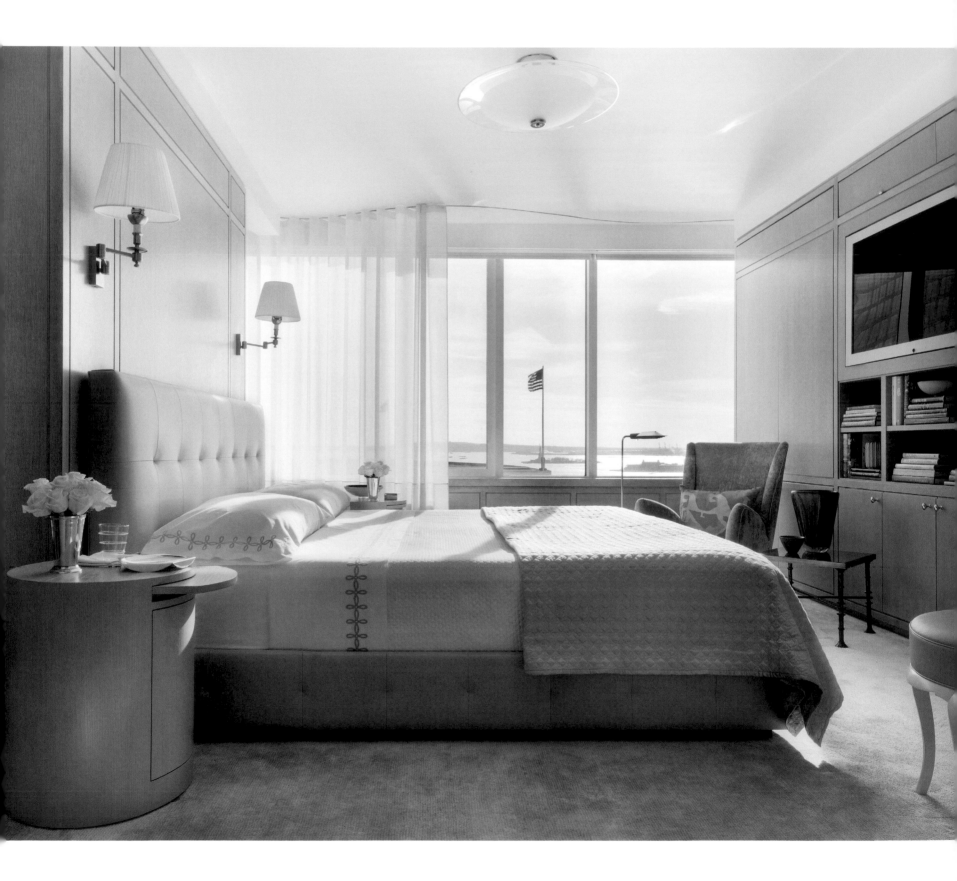

Sheer ivory curtains filter sunlight in the paneled bedroom. A frosted-glass ceiling light by FontanaArte is centered above the pale blue leather bed. A Ruhlmann burled-elm stool sits before a vanity in the wife's dressing room.

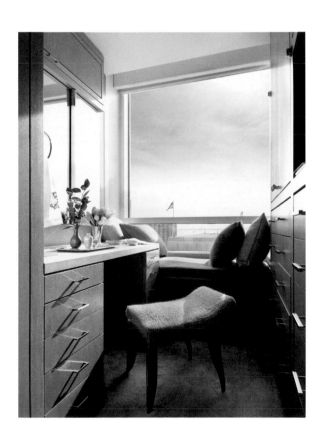

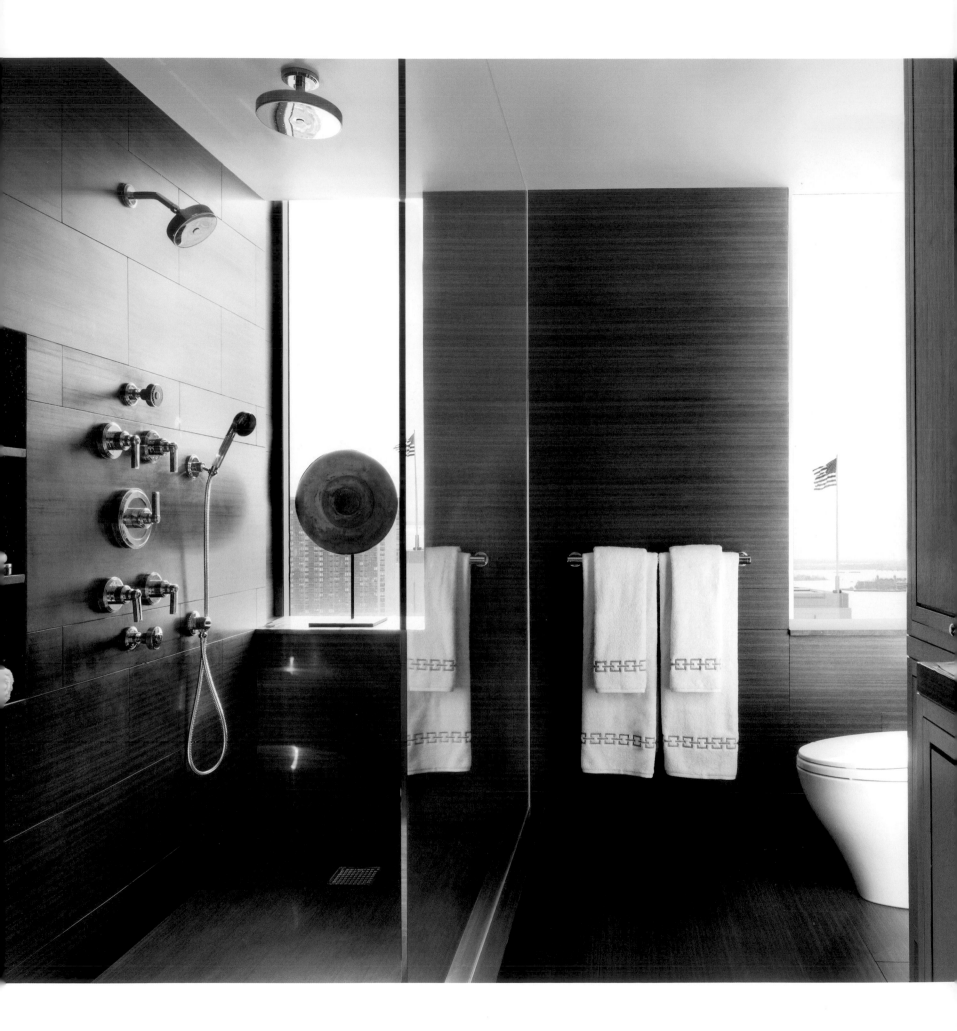

The bath is composed of slabs of chocolate brown wenge marble, limed-oak
and ebonized cabinets, and a polished-nickel framed medicine cabinet.

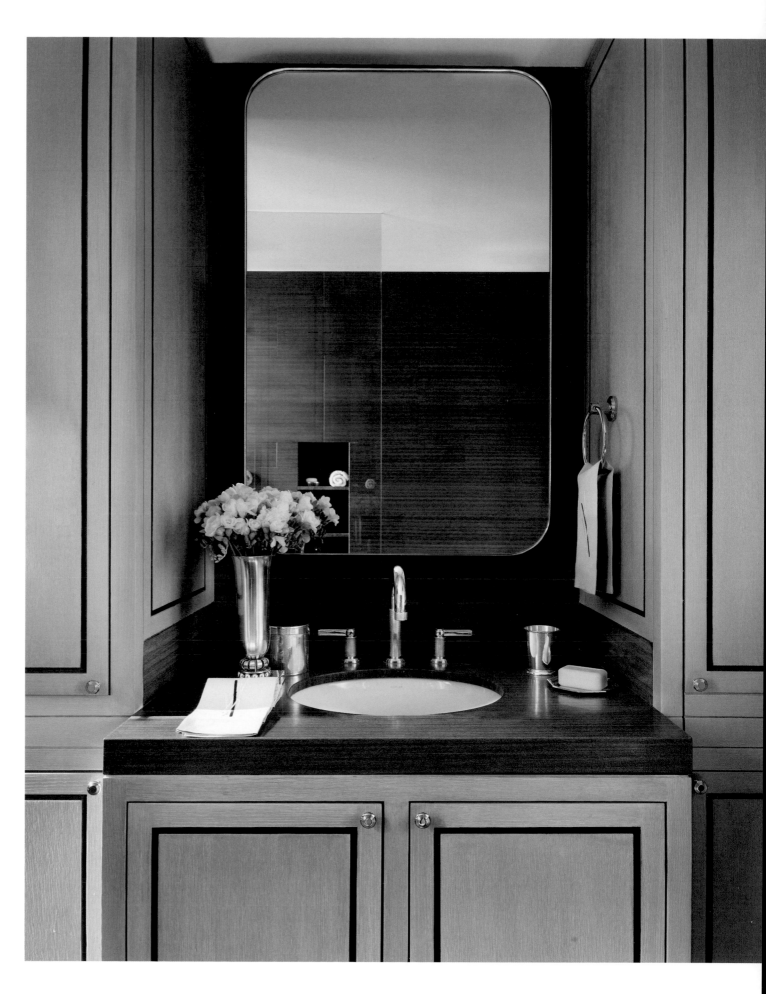

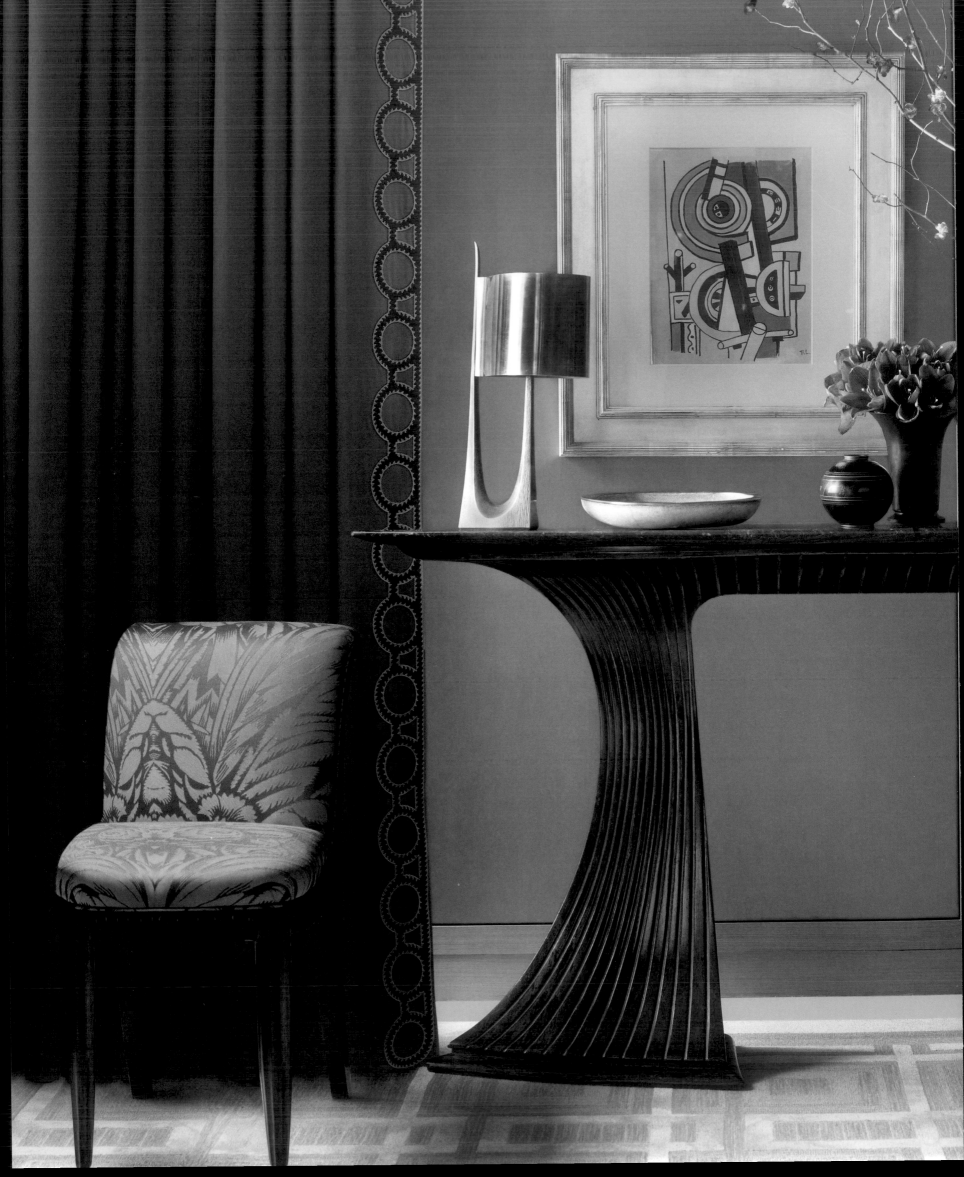

Sage green leather-paneled walls meet tobacco-colored curtains for an unexpected twist on a traditional library color scheme. A Léger painting hangs above a Borsani console.

The fireplace, at left, is encased in bronze and the rug is custom.
A vibrant Alexander Calder painting. A game table's round top flips from polished wood
to green felt and storage is hidden behind leather-paneled walls.

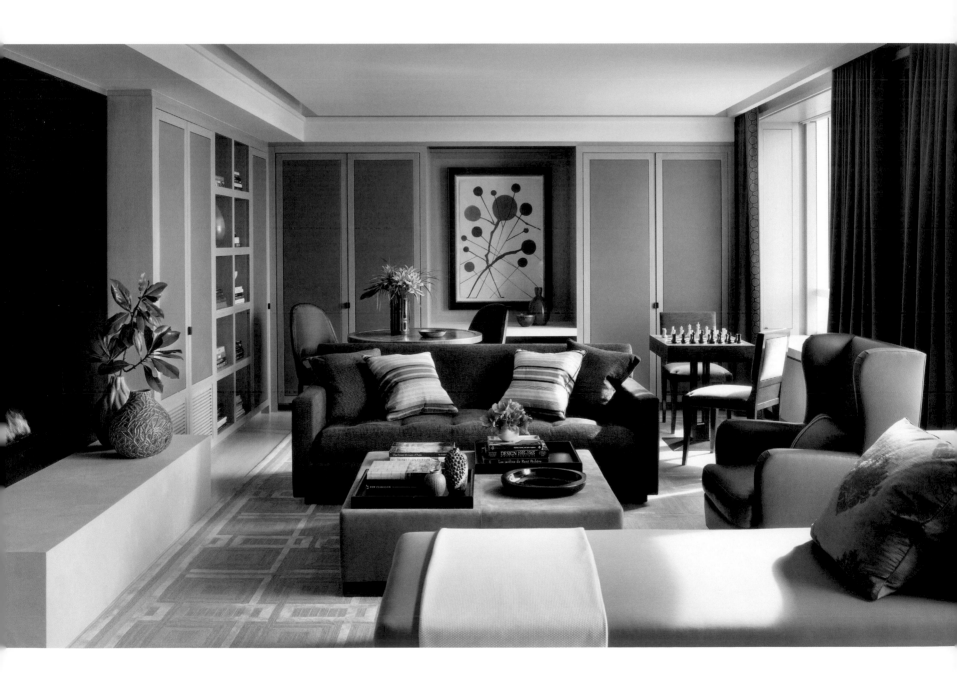

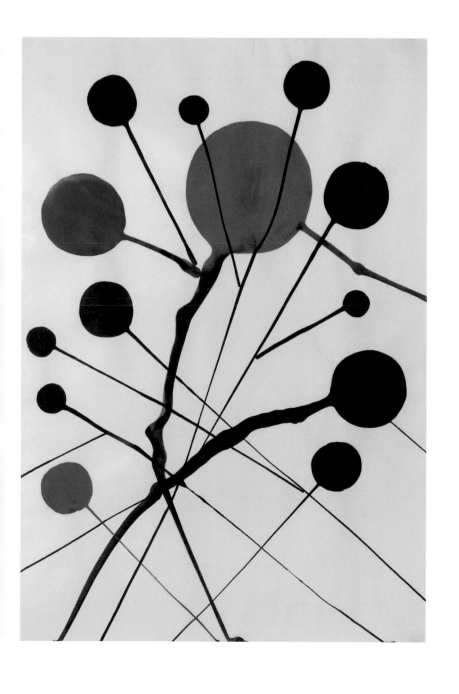

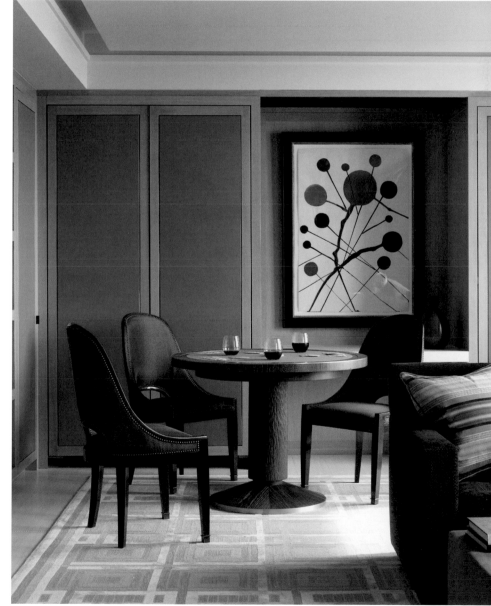

Raymond Parker's *Untitled*, 1980, is as spirited as the playroom itself.
The whimsical red chair and ottoman were designed by Cheick Diallo and the
large blue swivel chair was built for two. The Cloud table is by Jacques Jarrige.

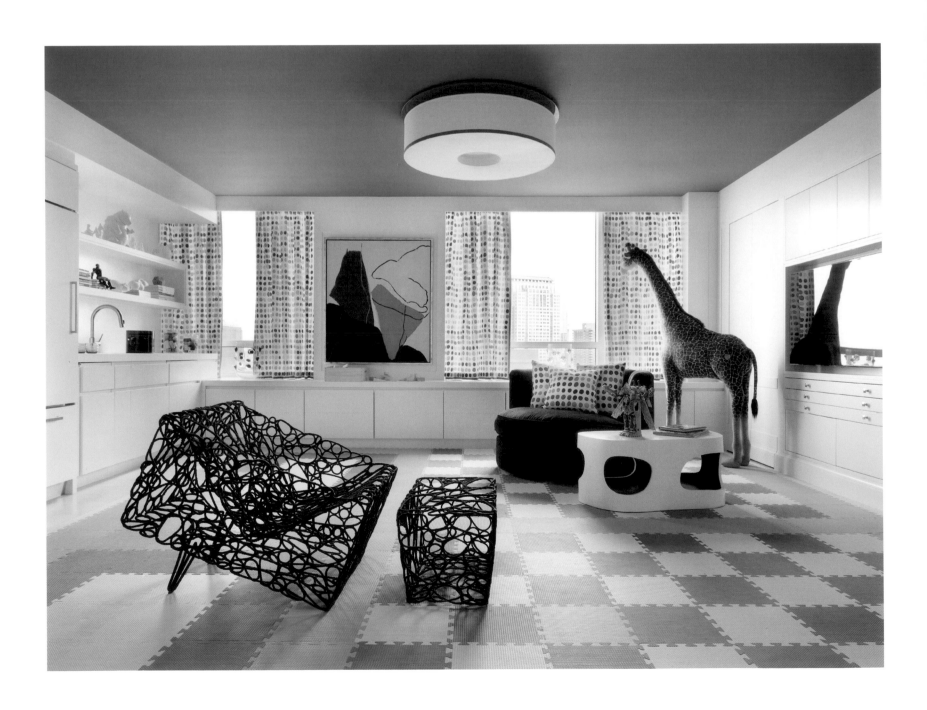

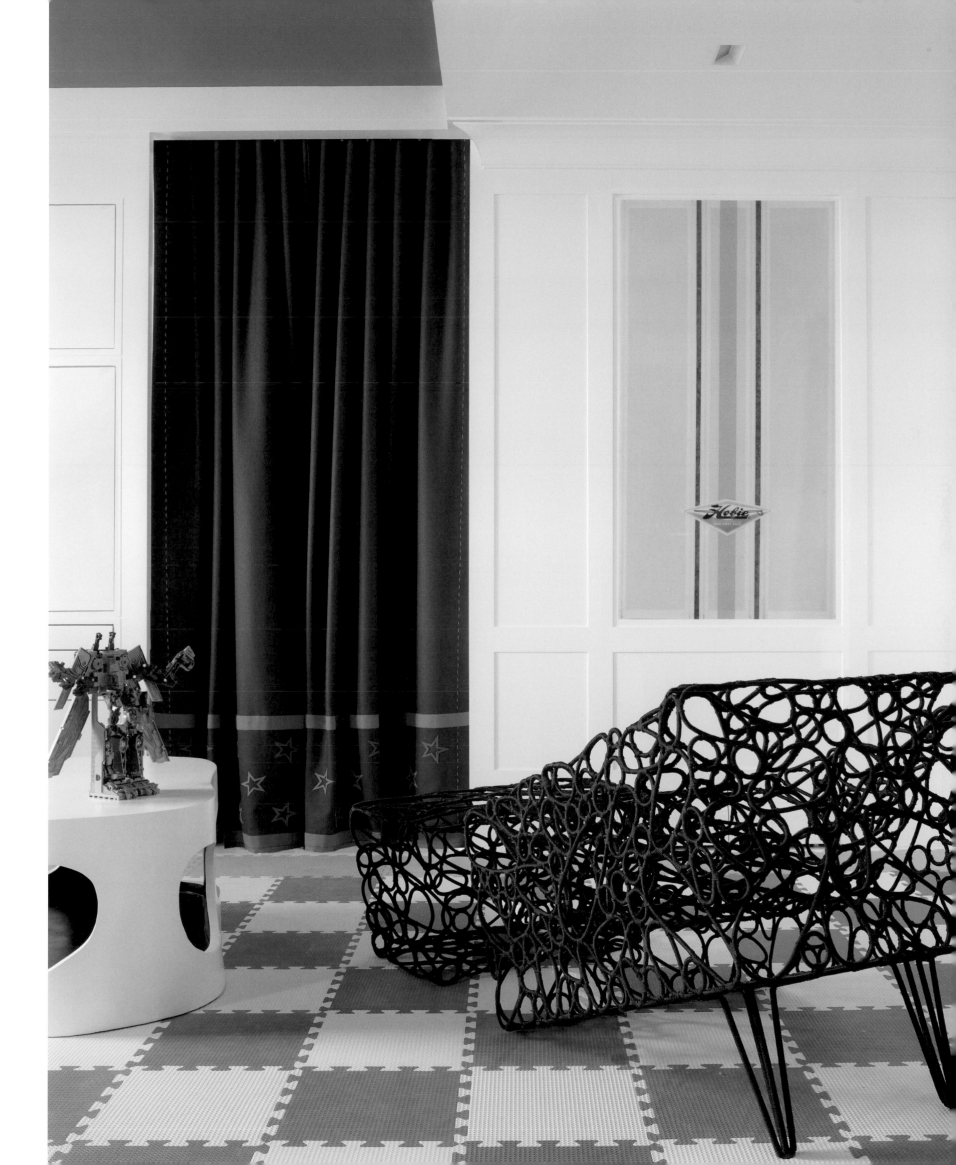

REFINEMENT

Nº 11.832 SALLE DE CONSEIL

Jean Royère's design of a dining room c. 1945, characterized by bold lines and a refined simplicity.
Opposite: A Dan Colen triptych hangs above a Royère console. In the foreground the
dining room's bronze-banded table and Royère chandelier. The chairs are by Ruhlmann.

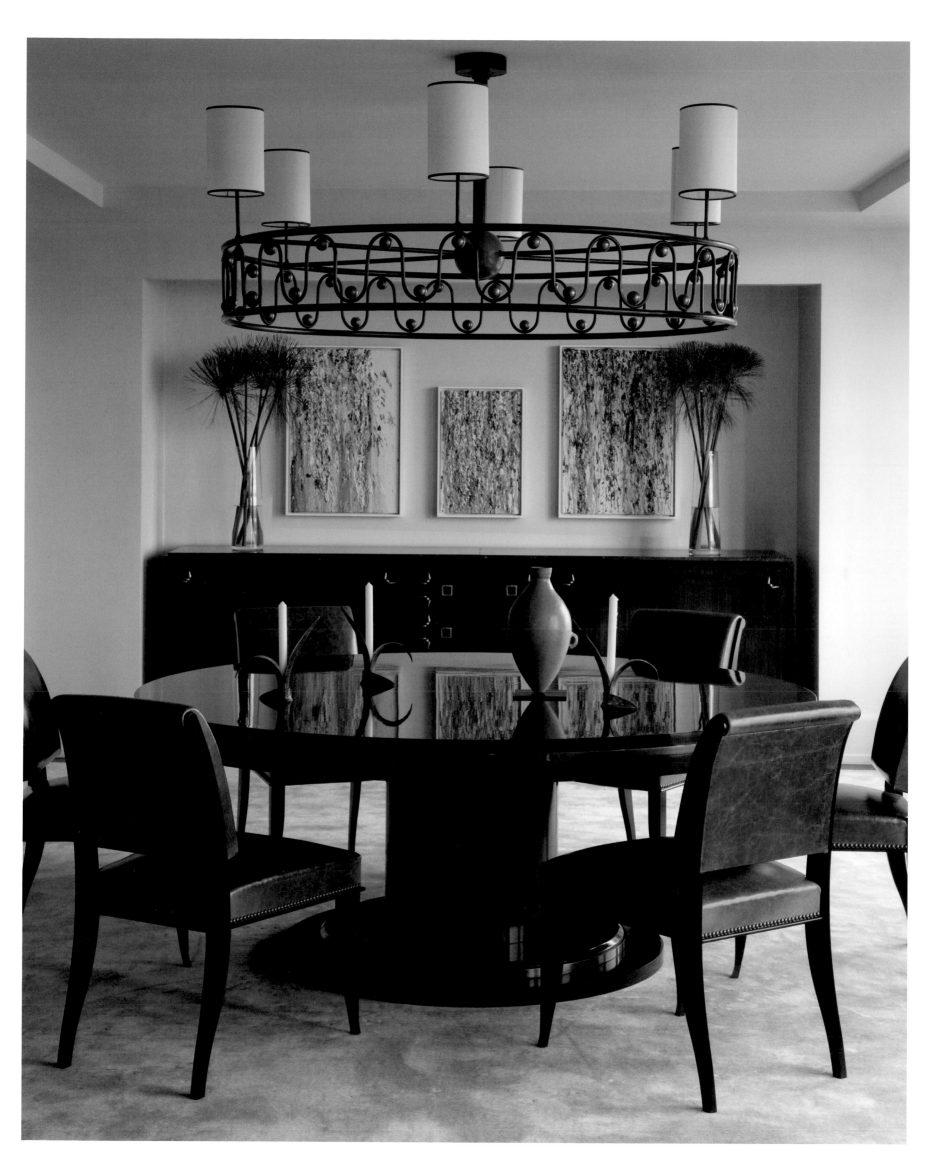

When I walked into this apartment for the first time, I understood exactly why my clients had purchased it. The view of Central Park is extraordinary, looking out over the calm, gleaming waters of the Reservoir to the dowagers—those grand old apartment buildings along Fifth Avenue. At night, the lights from the windows across the park sparkle, and the white spiral of Frank Lloyd Wright's Guggenheim Museum stands out like a flying saucer landed in their midst.

Clearly, it was all about that view because the place itself had problems. The previous owner had put two apartments together and the resulting layout was awkward. When you came in the front door, you had to walk around the staircase in order to get to the main rooms. It was obvious to me that we should reconfigure the space and rebuild the staircase entirely. But there was one aspect of the floor plan that had possibilities. Because of the way the rooms were laid out, one after the other, there was something that felt very Parisian to me—a gracious enfilade where you can see all the way through from one room to the others.

Perhaps that's when the idea of midcentury Paris first came to mind. I love the look of French Moderne furniture against traditional walls and moldings. There's a refined and exquisite sense of style to the furnishings designed during this time. The clients and I went shopping in Paris for antiques and contemporary pieces because none of us were interested in creating a purely period interior. You have to mix it up a bit in order to make something that feels of our time.

We found some amazing museum-quality antiques, like the Jean Royère chandelier that now hangs in the dining room. It's bold and graphic, yet it also has levity and wit. It energizes the space. There's a strength to the design. I like simple, substantial pieces with intriguing shapes.

As your eye travels through this sequence of long, narrow rooms, you notice that most of the furniture floats in the center. It's not pushed against the walls. So that means it has to be interesting from all sides. The vintage Jules Leleu armchair becomes a sculptural element within the living room. All the different shapes create a rhythm. I like to set up a counterpoint between curves and straight lines.

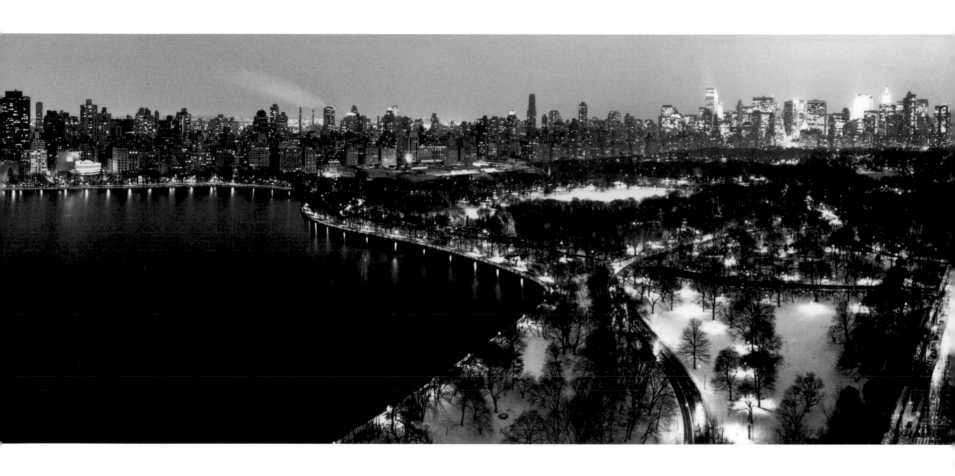

Captured by Bruce Davidson, the unparalleled view from the Central Park
apartment at night illuminates the Guggenheim Museum, across the waters of the reservoir.

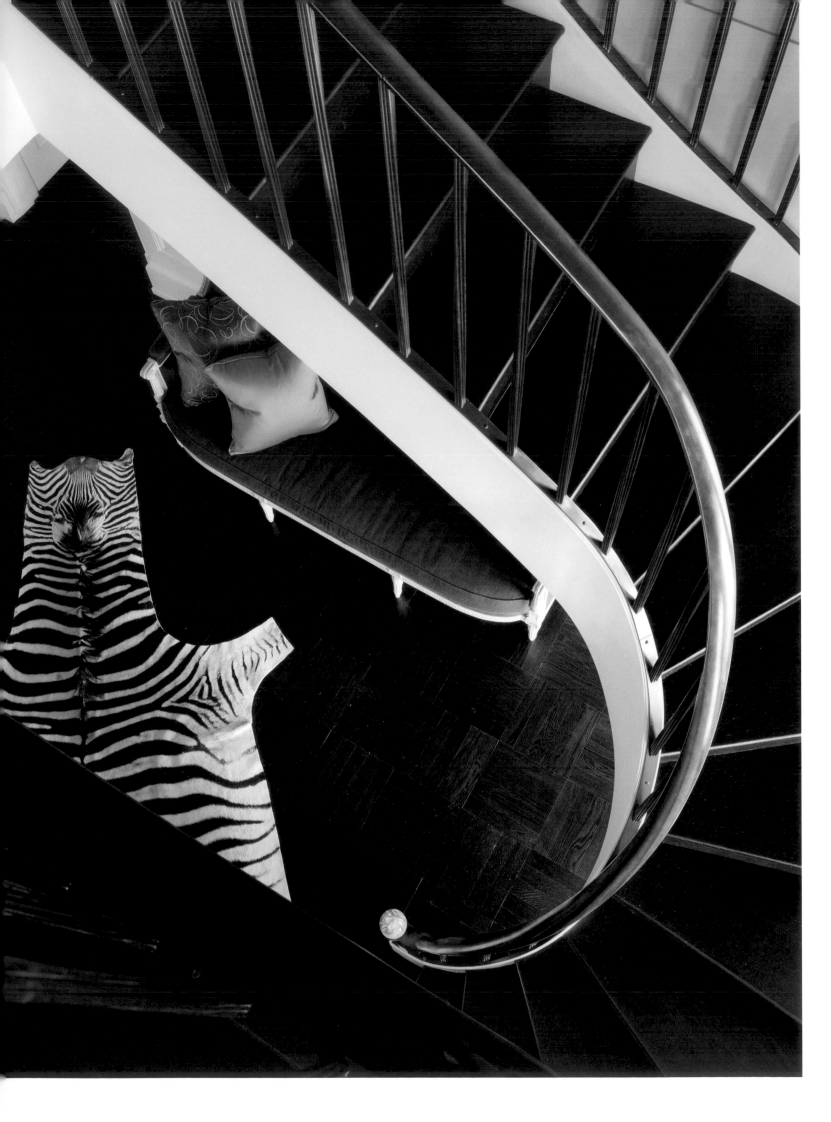

Rock crystal finials catch the light on the sculptural stair rail. An elegant Louis XVI canapé gives
pause between the dynamic lines of the Yun Gee oil painting and zebra-skin rug.

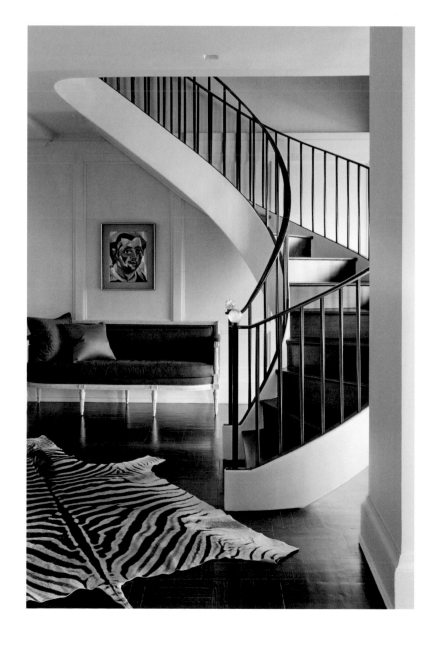

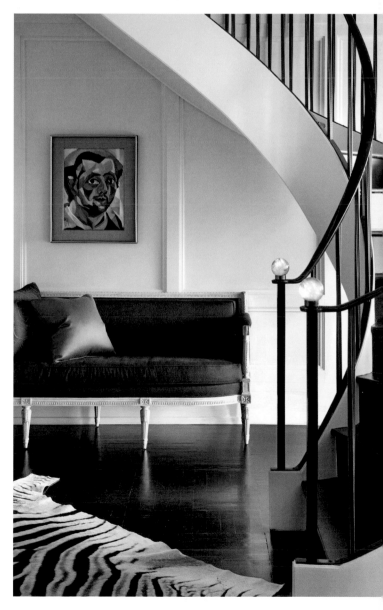

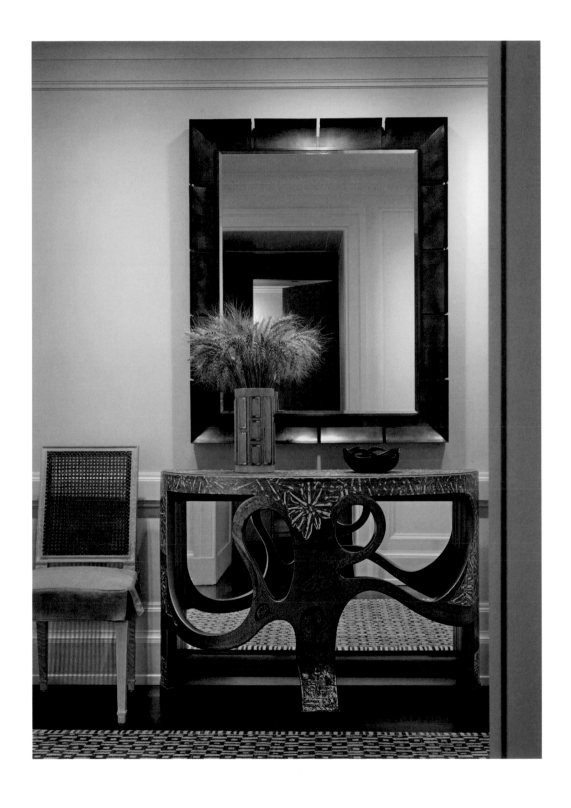

A deep peacock blue introduces a vibrant note of color. It's on the chairs and the chaise in the living room and the coffee table in the library. It's like a chord in a piece of music that keeps repeating. Color is a melody that runs through the rooms.

For me, designing is a bit like being a jazz musician. I'm working with the basics of shape, line, and color, and then I start to improvise. Thelonious Monk once said that he was looking for the music between the notes. That describes what I'm trying to do with all the various repetitions and juxtapositions.

This apartment is subtly sumptuous. Like a Savile Row suit, it has a surface simplicity that belies the thought and craftsmanship that went into every detail. The special finish on the plaster walls has a depth and richness that you just can't get with ordinary paint. The custom-made silk rug in the living room has an arc woven into the pattern that echoes the other circles you see in the room. The color is so subtle—and made up of many different threads—that it's almost indescribable. To me, it's like wet sand. The custom-made coffee tables have tops made out of rare shagreen.

Refinement in design is an art and a craft, and you have to master both. Anyone can throw ideas around, but they will amount to nothing unless you know how to execute them. I am lucky. I have a network of artists and craftsmen—upholsterers, seamstresses, woodworkers, painters—who take pride in their work. Every project brings us a new challenge. It's always exciting to do something that we have never done before.

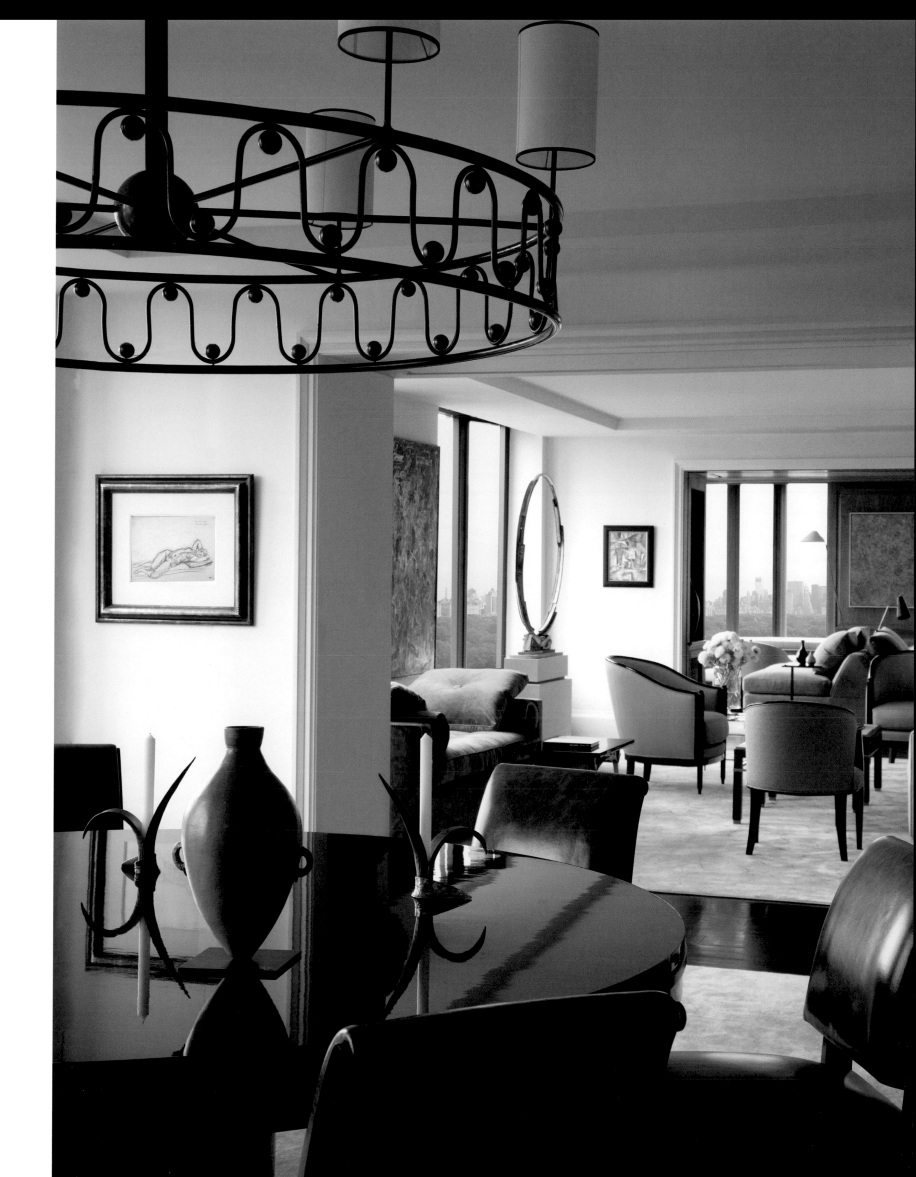

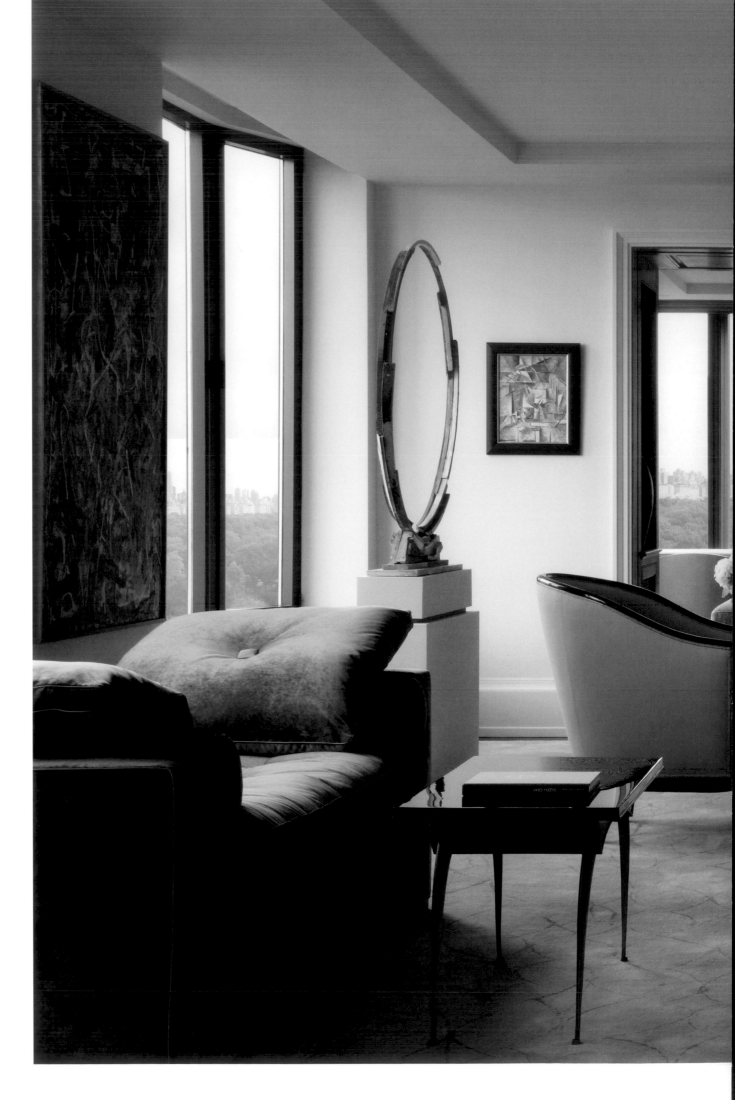

Previous page: The use of the color blue unites this enfilade of rooms; Bruno Romeda's circular sculpture picks up the form of the dining room's Royère chandelier. Opposite: A pair of Art Deco chairs upholstered in blue silk and a vintage Leleu chair hold court beneath an Adrian Ghenie painting. The grisaille oil painting is by Emil Filla, and the rugs, throughout, are custom. The painting at left is by Alfonso Ossorio.

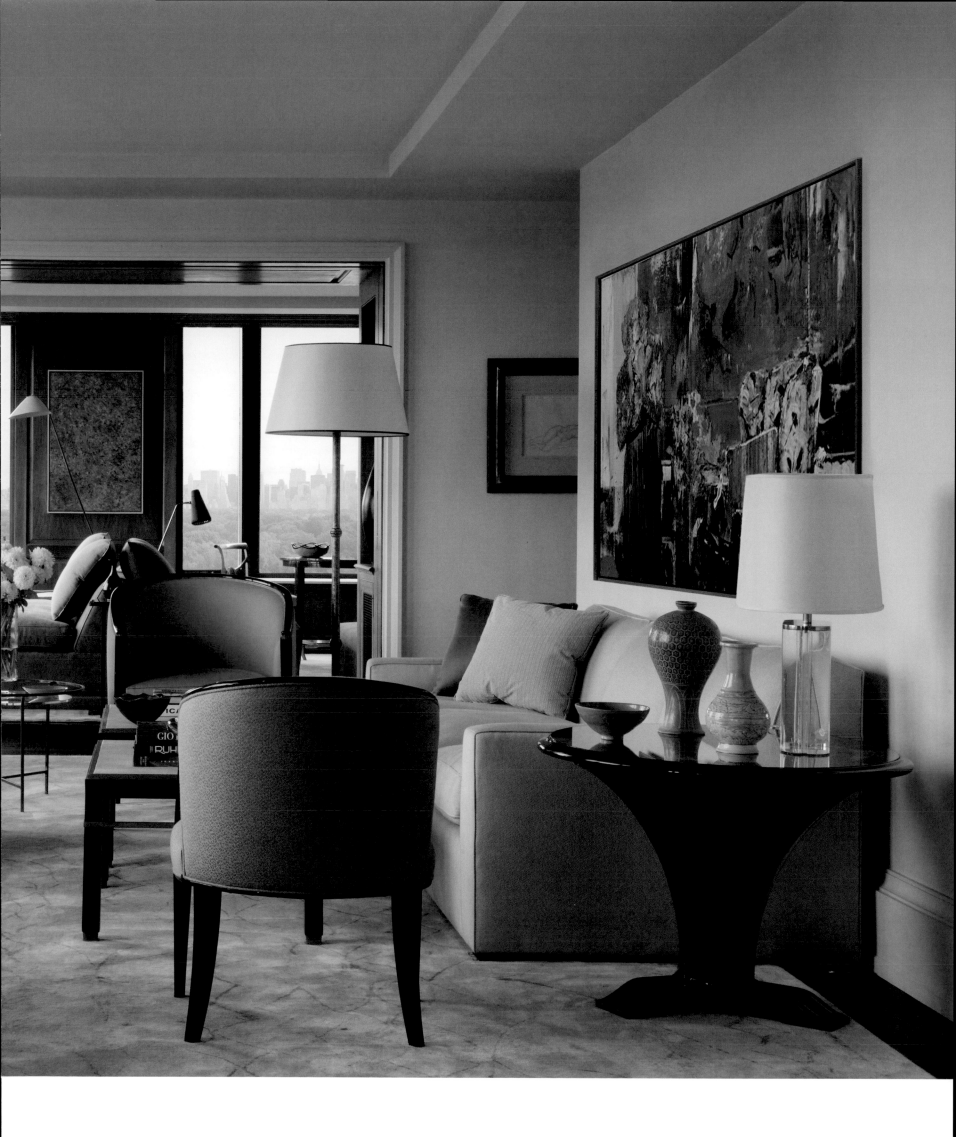

The client loves color—when we chose the blue I wanted it to be as vibrant as a peacock.
A black-lacquered coffee table with gazelle-like legs, designed by Dominique in 1937, is the epitome of
French refinement. The blue velvet on the chaise echoes the water of the reservoir in central park.

Low furniture grants a universal sightline in the study, where design highlights include the 1948 André Arbus games table and the 1951 Disderot floor lamp. A Borsani bench is pulled up to the custom double sofa, and paintings by Norman Bluhm and Milton Resnick complete the room.

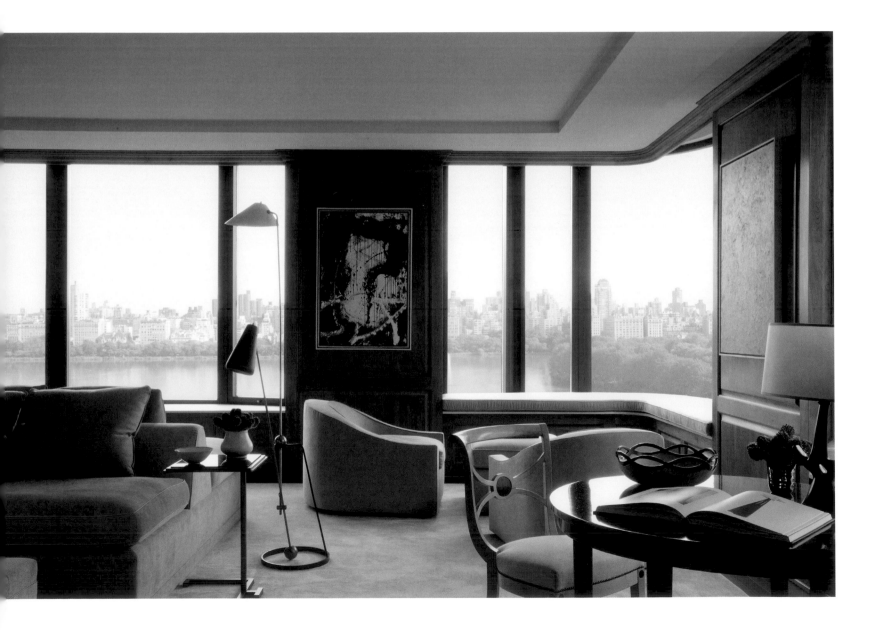

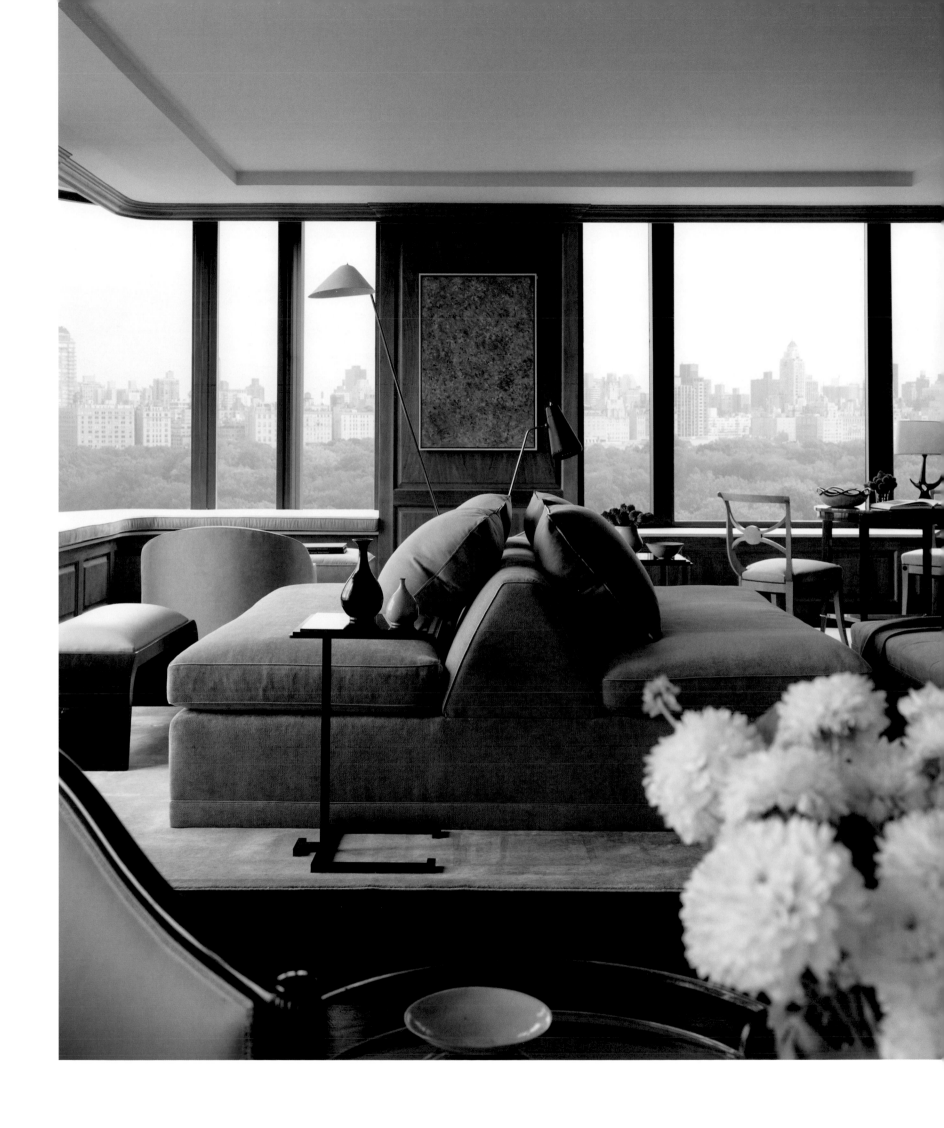

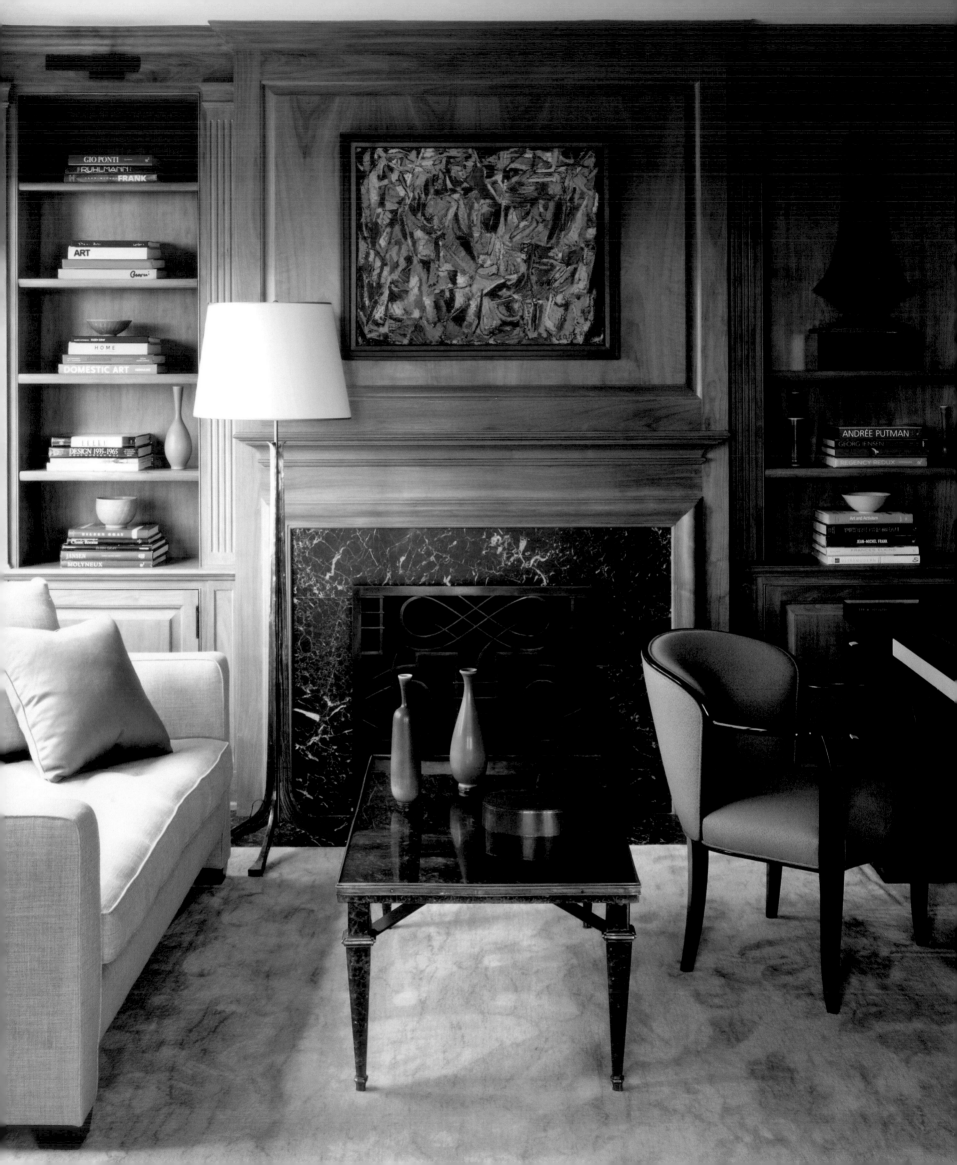

A detail of the library's Maison Jansen table, designed for the Shah of Iran, made of blue and green resin to suggest the colors of the peacock, which was Iran's ancient symbol. Opposite: A painting by André Lanskoy and Beverly Pepper's sculpture adorn scrubbed walnut paneling. A Leleu chair flanks the Art Deco fire screen.

Squares of parchment upholster the walls of the powder room, where a Bugatti chair
sits on a stone floor. The ceiling and sink are bronze and look ancient and modern at the same time.

Squares of parchment upholster the walls of the powder room, where a Bugatti chair
sits on a stone floor. The ceiling and sink are bronze and look ancient and modern at the same time.

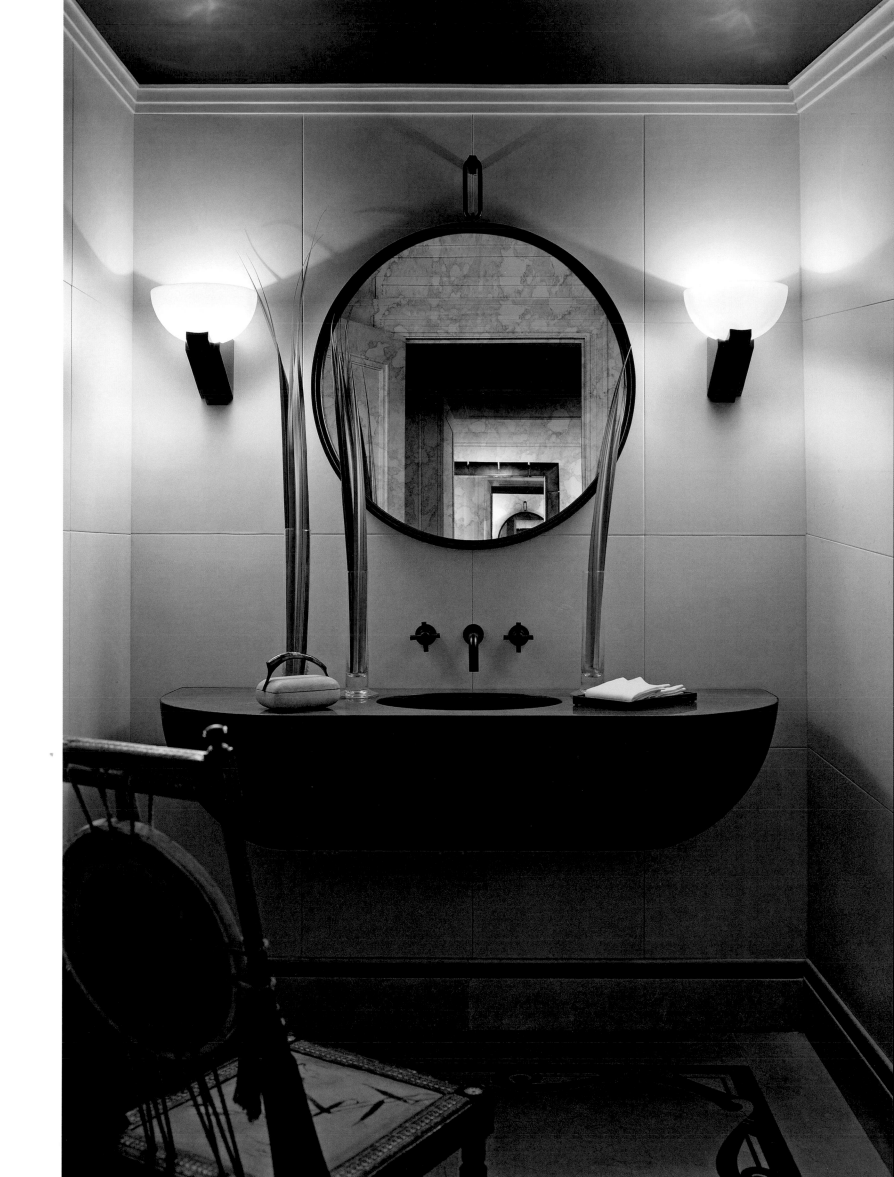

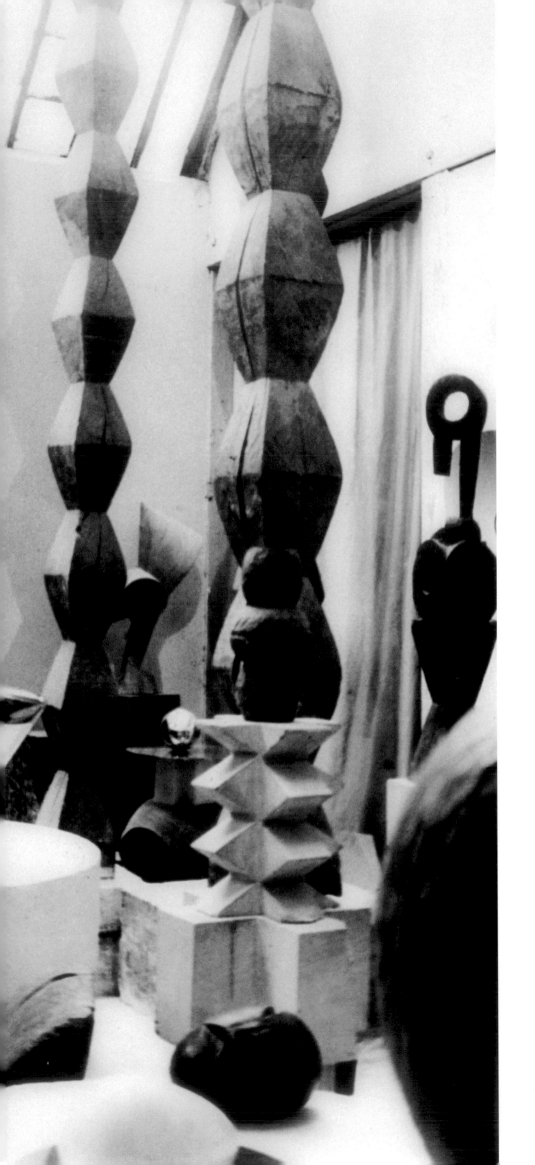

The 1950s lacquered-wood topped Leleu console stands on
bronze legs. 1940s Arbus sconces bookend a photo of
Constantin Brancusi's studio c. 1927 on the limed oak paneling.

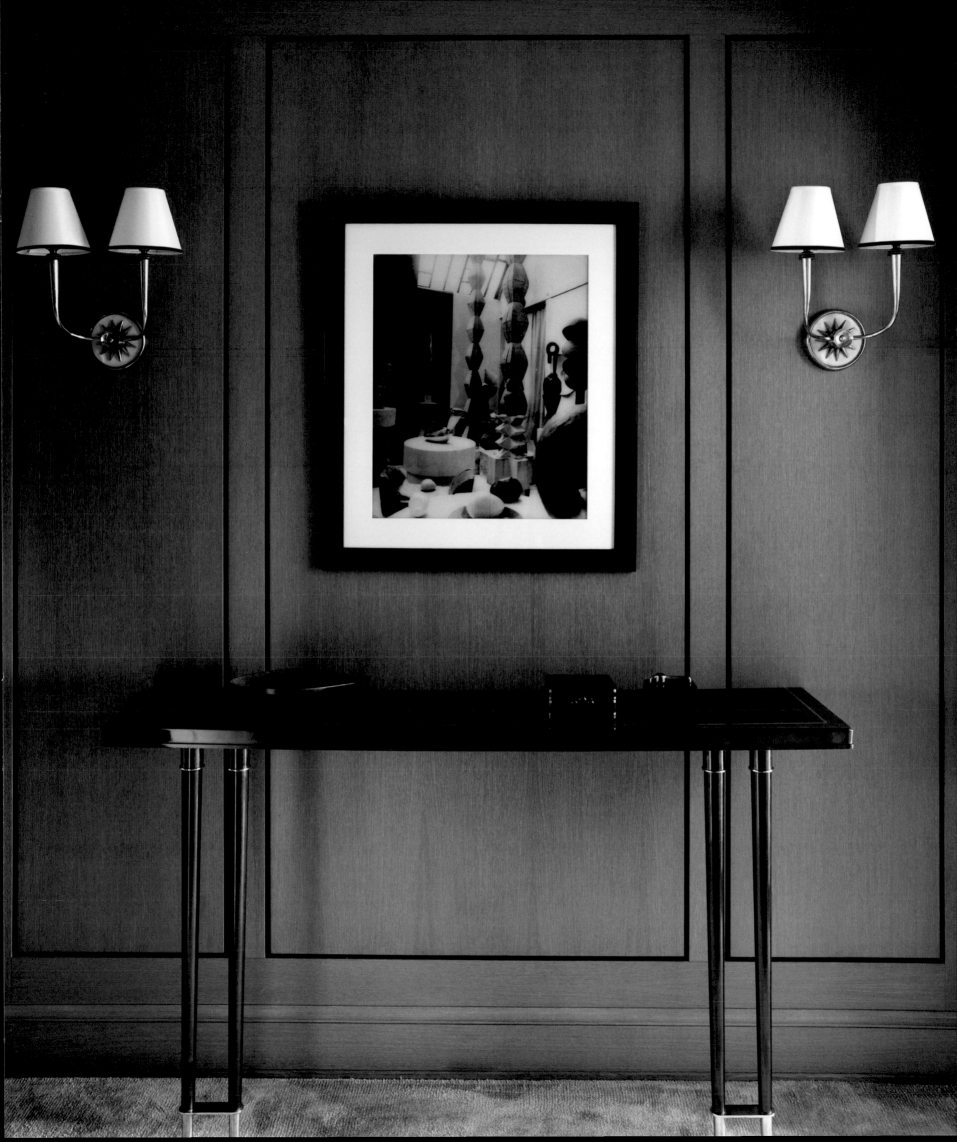

A 1970s Italian mirror hangs above the master bedroom's De Coene Frères cabinet. Frères designed the bedside tables, which support midcentury Seguso glass lamps. An Arredoluce torchiere accompanies the Jensen armchairs and ottoman. Artwork by Michal Rovner hangs above the custom double chaise and Royère wrought-iron floor lamp. The walls are enveloped in a pale blue fabric.

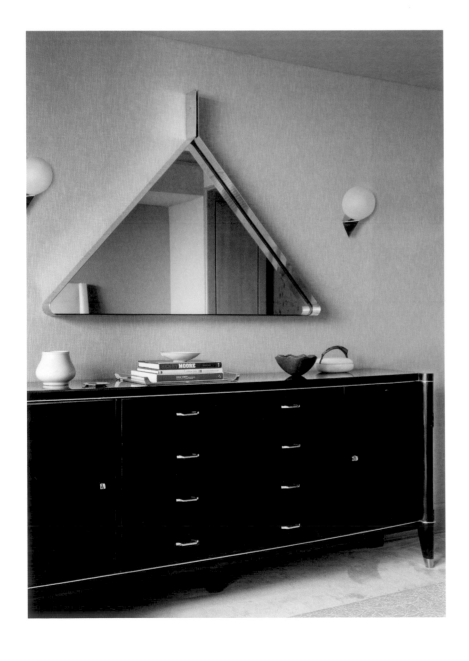

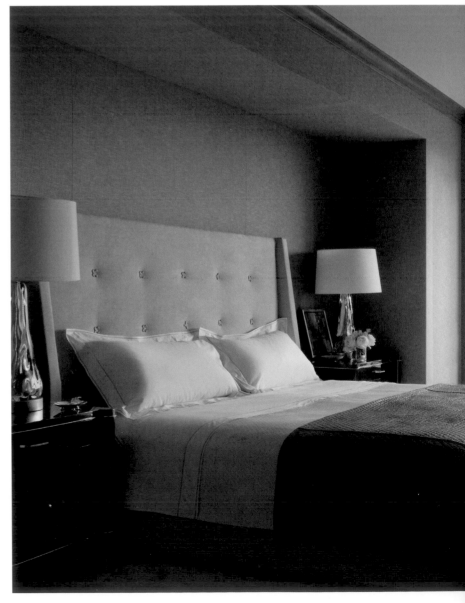

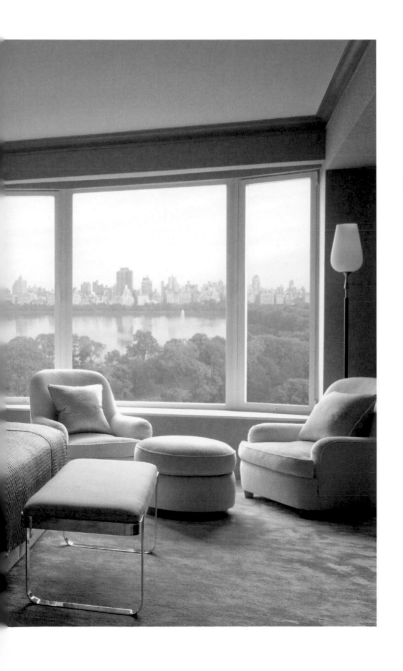

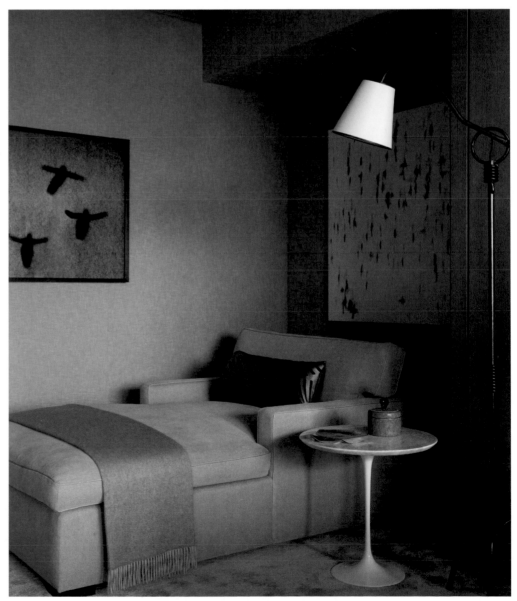

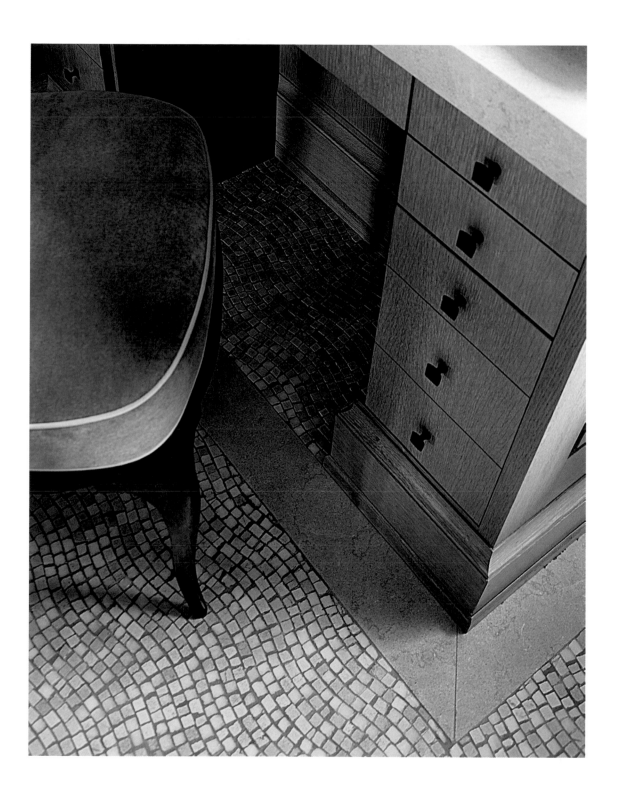

Bronze hardware accents the master bath's entry
and dressing table with a detail of the mosaic stone floor.

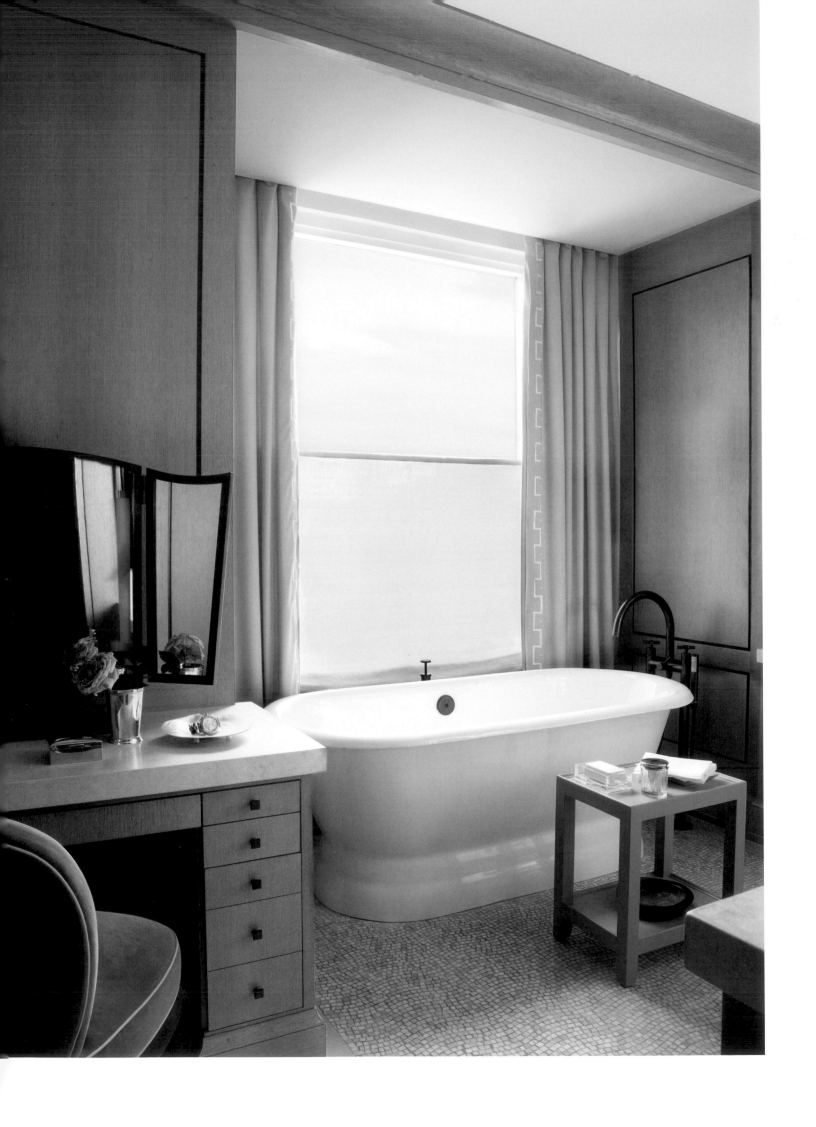

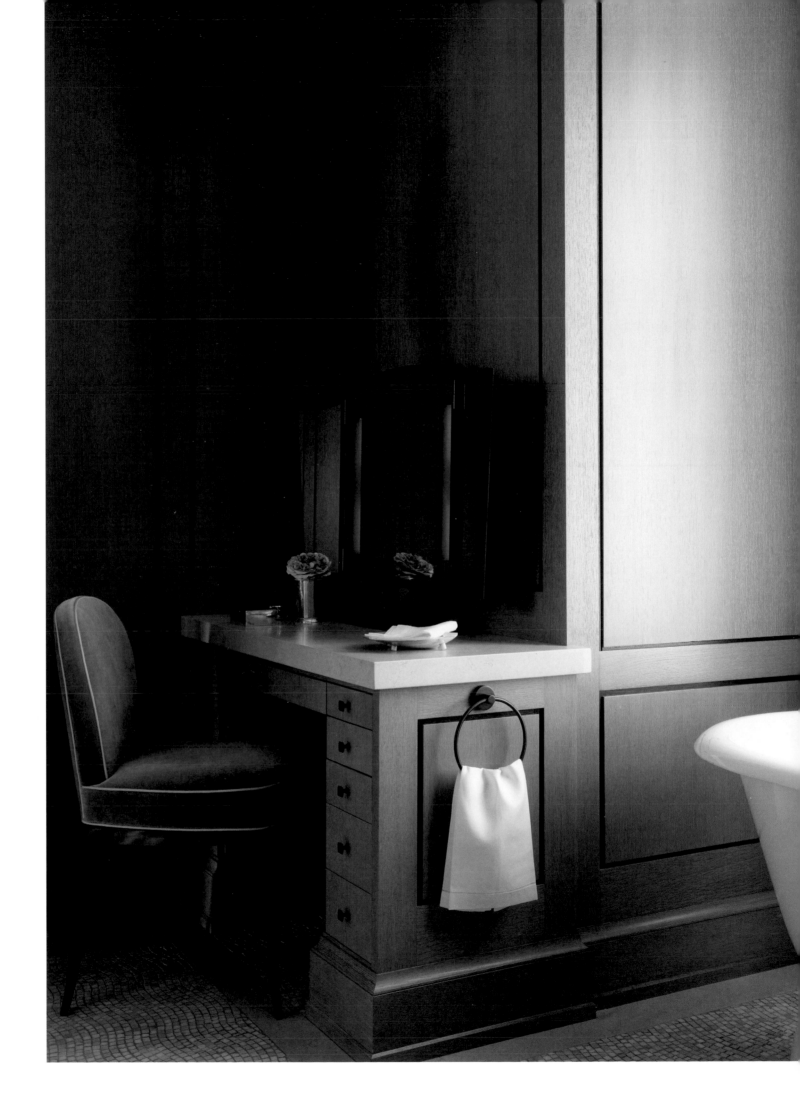

Limed oak paneling with ebonized detailing is reprised in the master bath.
A René Prou chair is pulled up to the limestone-topped dressing table.

GLAMOUR

The elevator vestibule's frosted glass and stainless-steel
doors give way to the apartment's 360-degree views, which are as opulent
as the photograph (above) of New York City, the epitome of glamour since the 1920s.

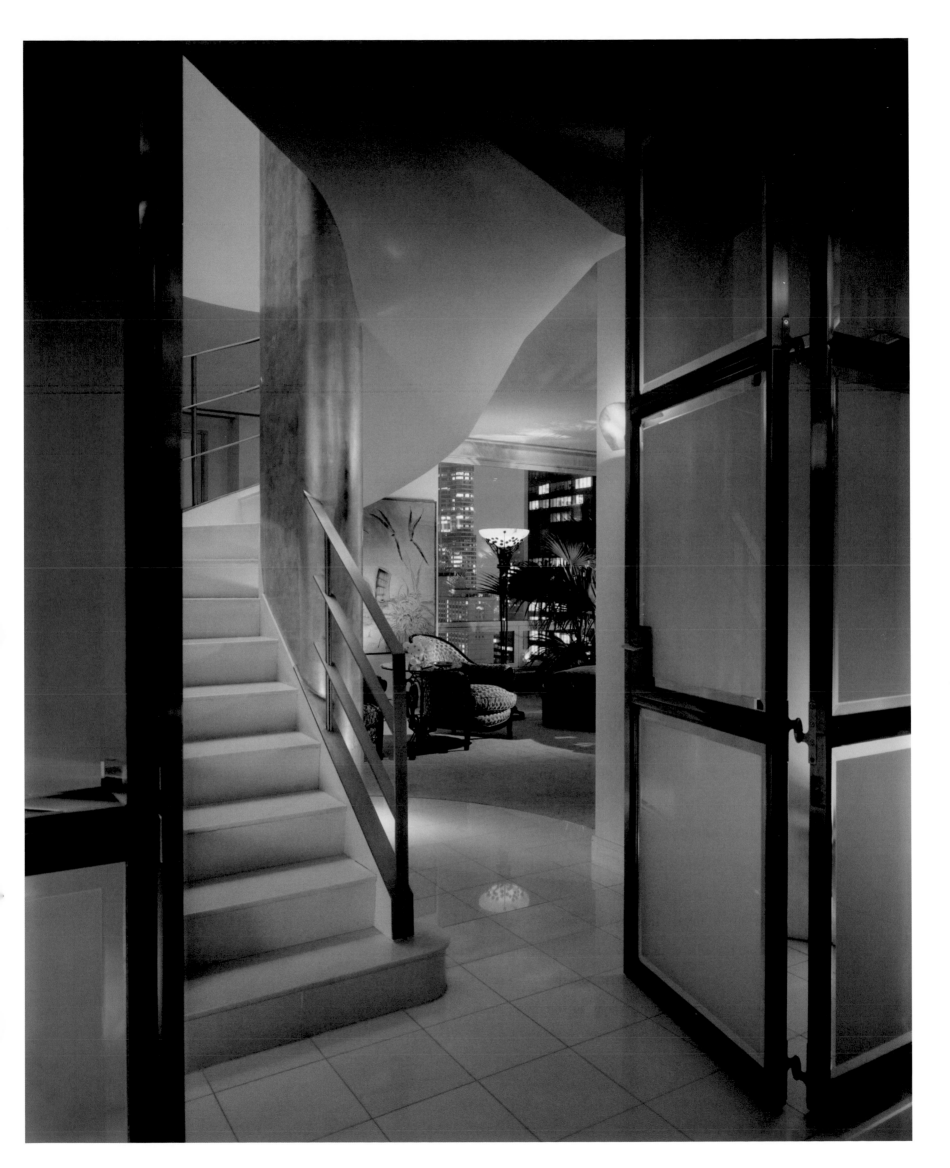

This project was in one of the most unique spaces in New York—a duplex apartment with 360-degree views, on the top two floors of the Sherry-Netherland hotel. Cecil Beaton once lived here. Jack Warner, the president of Warner Brothers, had the huge plate-glass windows installed. It's the height of luxury—a private home where you can pick up the phone and access all the amenities of a great hotel that has been synonymous with style and sophistication since it opened in 1927.

I collaborated on this with Frank Grill, one of Australia's leading designers, and by the time we walked through the doors, all the Art Deco details were gone. The apartment had been gutted down to the concrete floors, and the roof was leaking. Yet I still felt a thrill when I saw the twelve-foot-high ceilings and the dazzling panorama of the city spread out below. What a shame, I thought, if we had to put back all those walls and break it up into little rooms again. Frank and I thought, "Why not think of it as a loft?" It would be a spectacular place to give a party.

The wife got right into the spirit of things, and we decided to go all out for glamour. We wanted her to feel like Ginger Rogers gliding down a staircase into the arms of Fred Astaire. I used to watch all those old movies back in New Zealand with my mother, and I had images of Cole Porter and smoking jackets and champagne cocktails dancing around in my head. The staircase was going to be the centerpiece of the space, and it had to live up to this fantasy.

What should it look like? We thought of a photograph of an apartment in Paris designed by Le Corbusier with an extraordinary staircase that curved up in a white stucco spiral around a glass pole. It had a strong shape and a sense of movement, which was exactly what we were after. The staircase should be a piece of sculpture, not merely a way to get to the upper floor.

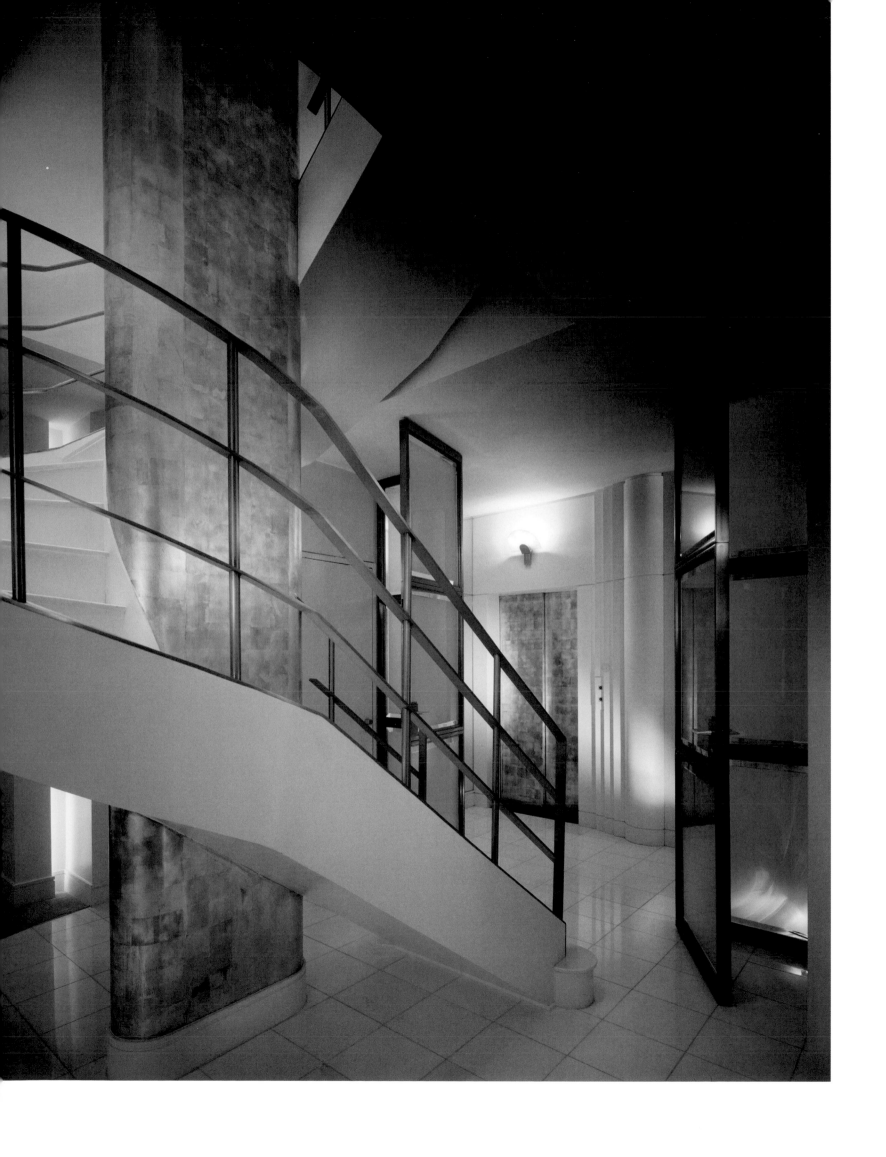

Previous page: A marble-and-stainless-steel stairwell turns around a
silver-leafed column. Below: The spiral staircase was inspired by Le Corbusier,
from an iconic flat he designed in 1930 for aesthete Charles de Beistegui.

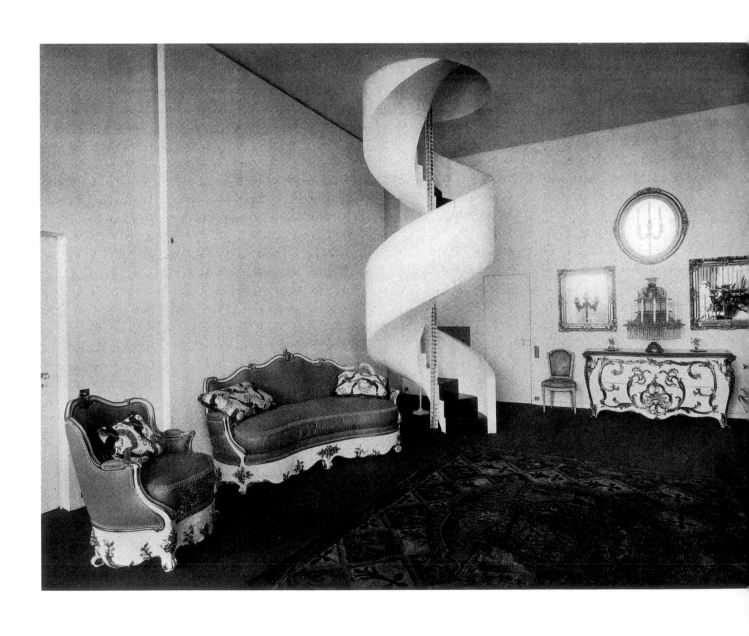

Now it's the first thing you see as you enter, and it creates a feeling of adventure—you instantly know that this is not going to be the typical New York apartment. The style is our version of Art Deco, updated with a clean, contemporary spin. The staircase looks like something you might find in the grand salon of one of those fabled 1930s ocean liners. The steps are pure white marble, rimmed by a brushed stainless-steel railing, and they spiral around a silver-leafed column. These are the kinds of sleek, sophisticated materials I associate with the period. They reappear throughout the apartment and establish the palette—cool and luminous. The silver leaf and stainless steel catch the light and come alive at night.

As you walk past the stairs and turn to look around, you can see all the way from one end of the apartment to the other. To the right is a dining area centered on a zebrawood table, and to the left is a living area with a sofa and chairs gathered in a loose circle. The space is differentiated into zones rather than rooms. Hanging on the wall straight ahead is an Art Deco painted panel that looks as if it could have been done for the *SS Normandie*. It's the focus of another seating area, this one more intimate, with only a pair of chairs designed by Sue et Mare in the 1930s. They're covered in a vintage handwoven silk that we found in Paris. It picks up the same shades of pale gray that you see in the soft mohair covering the sofa and the pearlized leather on the dining chairs.

That silvery gray has a quiet shimmer, and it's like a thread of conversation that continues through the whole apartment. The consistent palette unifies a large space that could have felt intimidating, and the reflective quality of the materials keeps it light and airy. The place has an ethereal feel, as if you could float right out into that fabulous view.

The loftlike floor plan serves wall-to-wall views.
Twin Edgar Brandt torchieres offer
additional light to the custom dining table and
chairs and a pair of Sue et Mare chairs.

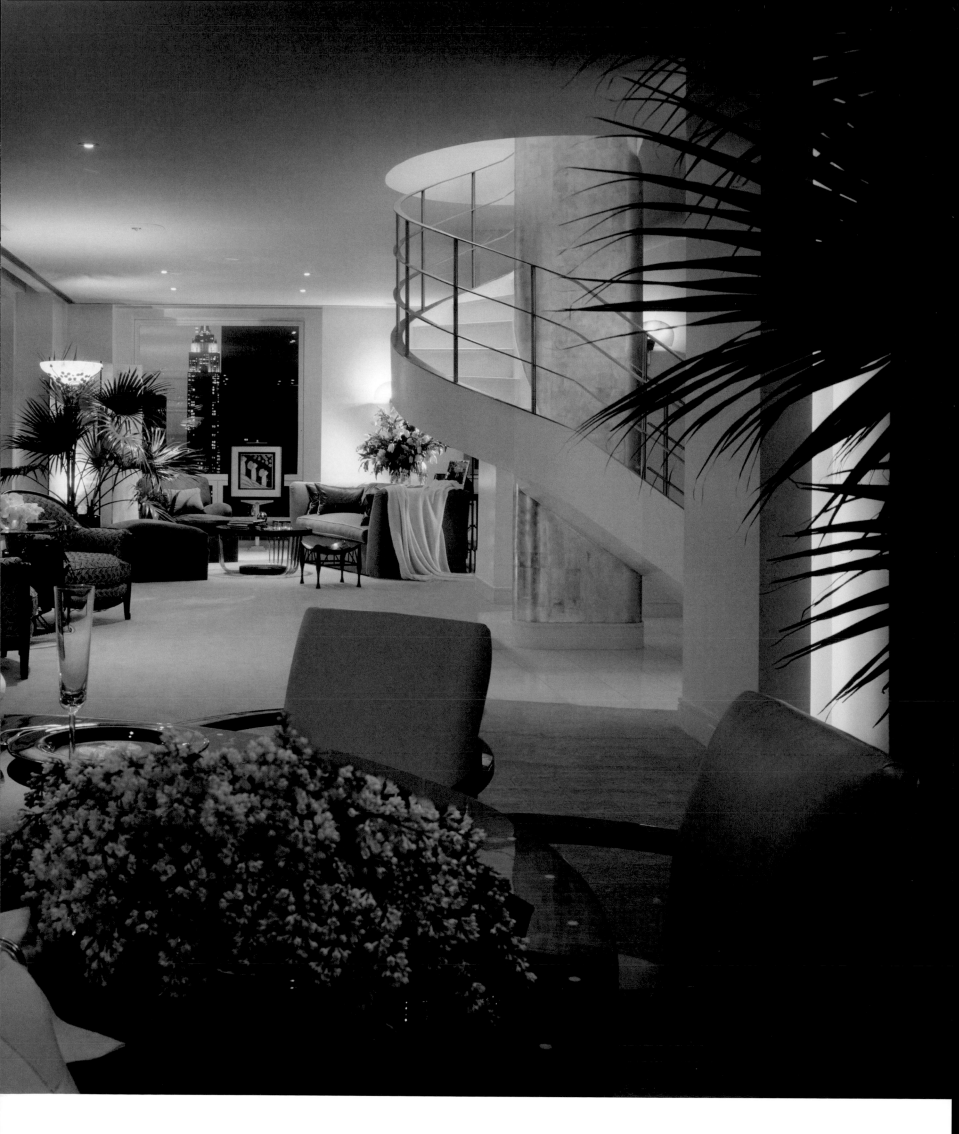

An alabaster sconce gleams against the black-glass walls of the powder room.
A René Lalique mirror hangs above a customized Art Deco console.

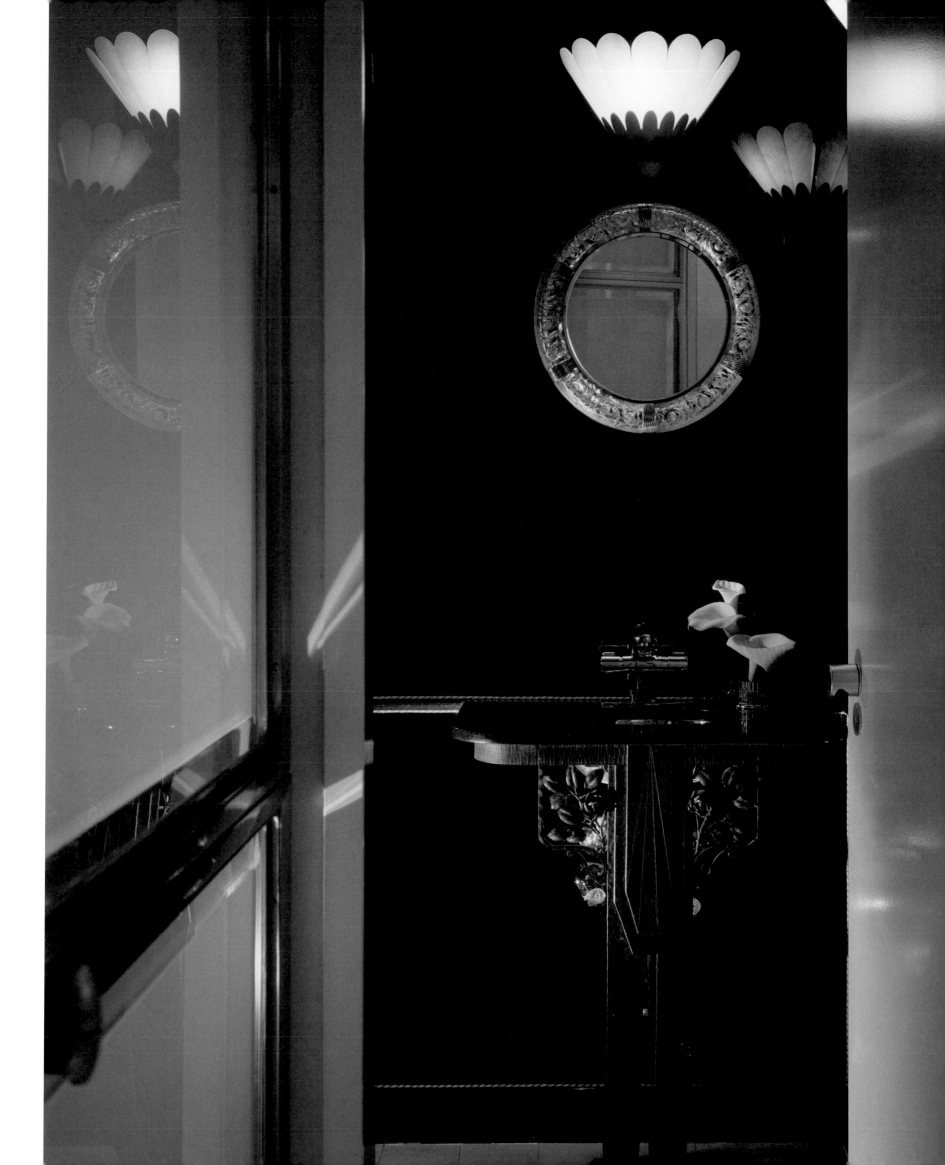

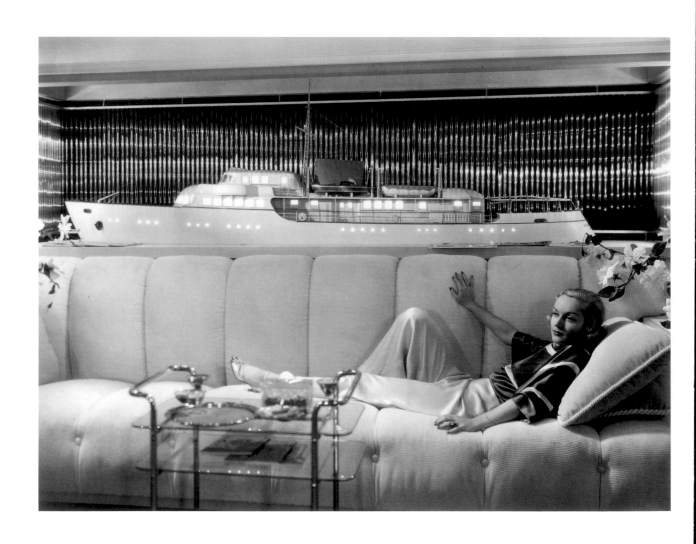

We imagined Carole Lombard reclining on the study's silver-gray mohair banquette.
Custom pearlized leather chairs flank an Art Deco desk. A charcoal by Jean Dunand hangs on the right.

A composition of lustrous finishes, including a silver-leaf screen
and snakeskin ottoman, frames the Central Park view.

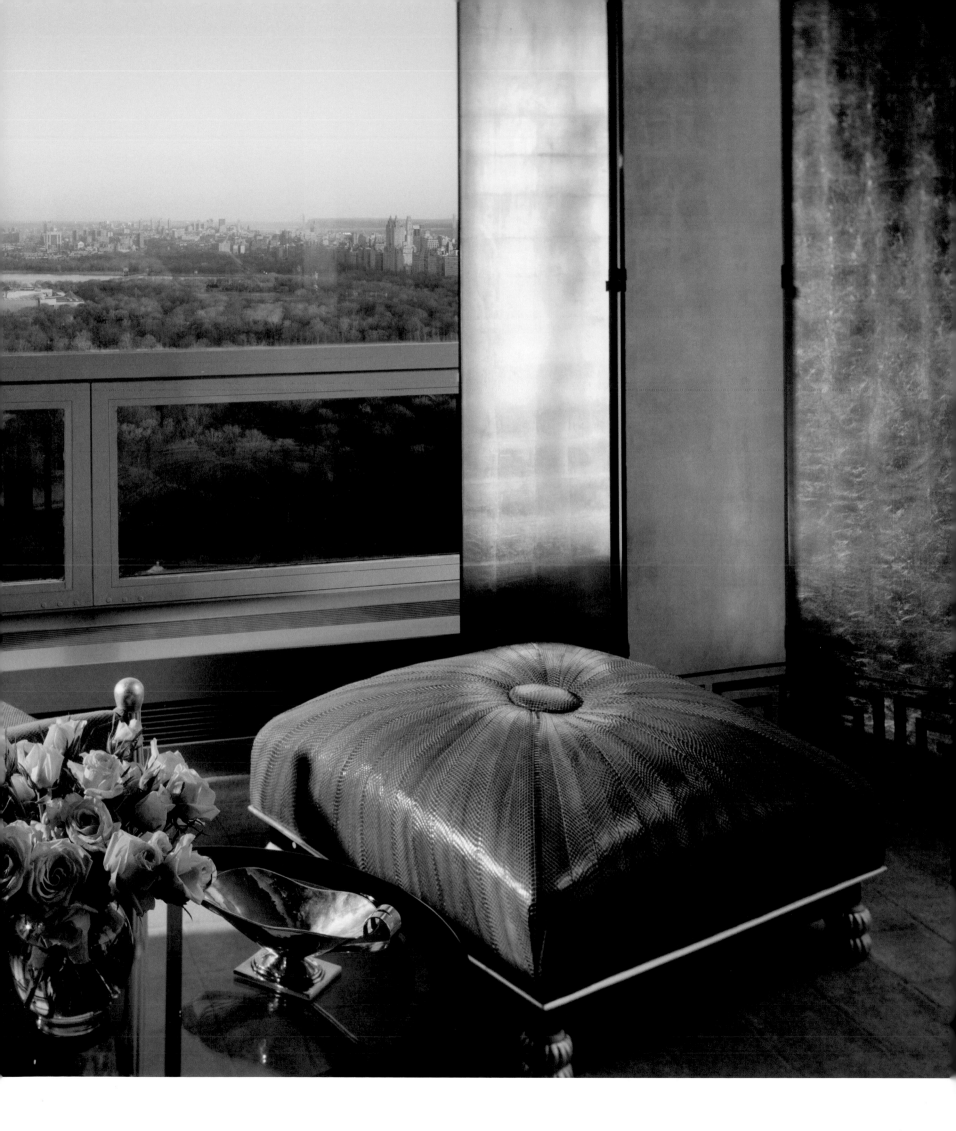

Dark wood, marble floor, and a wall mosaic inspired by the leaf motif of a 1930s textile make the kitchen an appropriate setting for après-theater champagne and caviar.

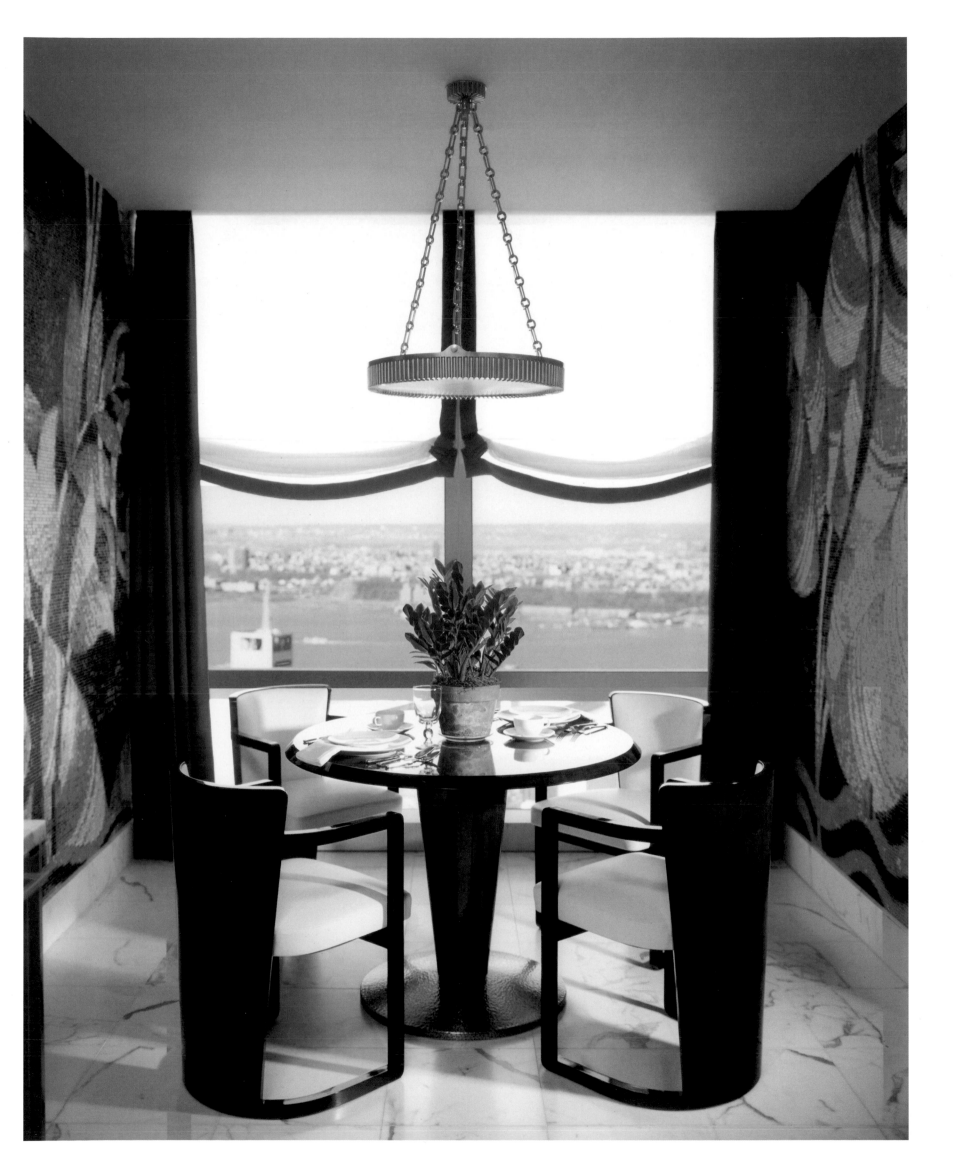

ELEGANCE

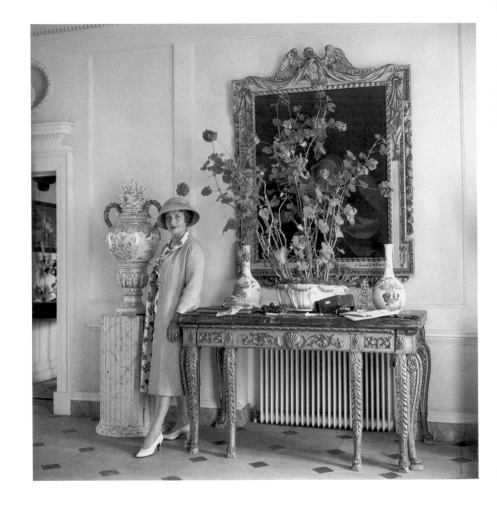

Nancy Lancaster was born into an old Virginian family and elegance was bred into her bones. When she moved to England, she charmed the aristocracy, and as a partner in the influential decorating firm Colefax & Fowler, she showed them how to make the traditional English country house comfortable and warm. Opposite: An alabaster light fixture is reflected in a mahogany center table. The side chair is Queen Anne.

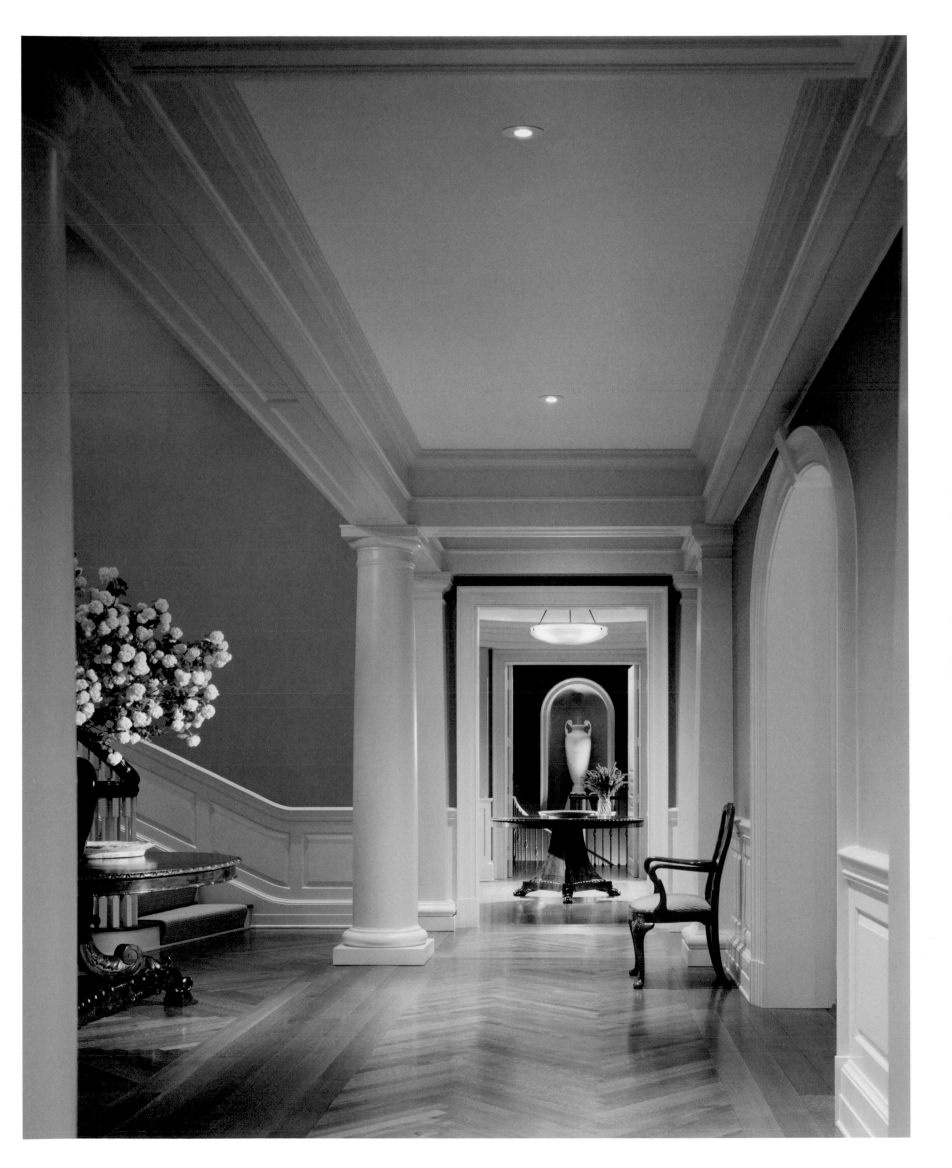

Cut—drape—baste. It's amazing what a fashion designer can do with a few lengths of fabric. Geniuses such as Christian Dior or the legendary American designer Charles James could start with a simple concept and create a whole new silhouette. They knew how to make fabric do anything they wanted—cling to a curve or skim over a body. If you examine any of their dresses now, you will marvel at the originality, the elegance, and the craftsmanship.

I'm always looking at fashion, although its influence on my work is not necessarily direct. It's more subliminal. It may be a mood or sometimes a color that morphs from the runway into a room.

If you think about it, an interior designer's work is like haute couture for the home. We design and make all our curtains specifically for each room and use dressmaker details such as hand-stitched pleats and tucks. Every fabric has its own particular weight and texture, and that will determine how it folds and falls—the drape, in other words. And, of course, with curtains just as with a dress, it's all in the drape.

Most of our furniture and upholstery is custom-made, and I like going to the workrooms to monitor the progress. I always ask my clients for creative license because when you see the reality of something that previously existed only on paper, you often find a place where you can tweak it to make it better. I work with very talented artisans, and we can spend hours obsessing over the turn of an arm on a chaise or the details on a cabinet.

It's exciting to commission a piece from an artist, because you're suddenly part of the creative process. I've learned so much about how things are made, and my clients get something that's uniquely suited to their taste and their space.

But in the pursuit of something special, I never forget one thing. I think true elegance is also about being comfortable with yourself and gracious toward others. And that applies to the rooms I design as well. They're not fussy or formal. Although all the details have been carefully thought through, the look is still relaxed. For me, it all stems from comfort—the key ingredient to an interior with true, timeless elegance.

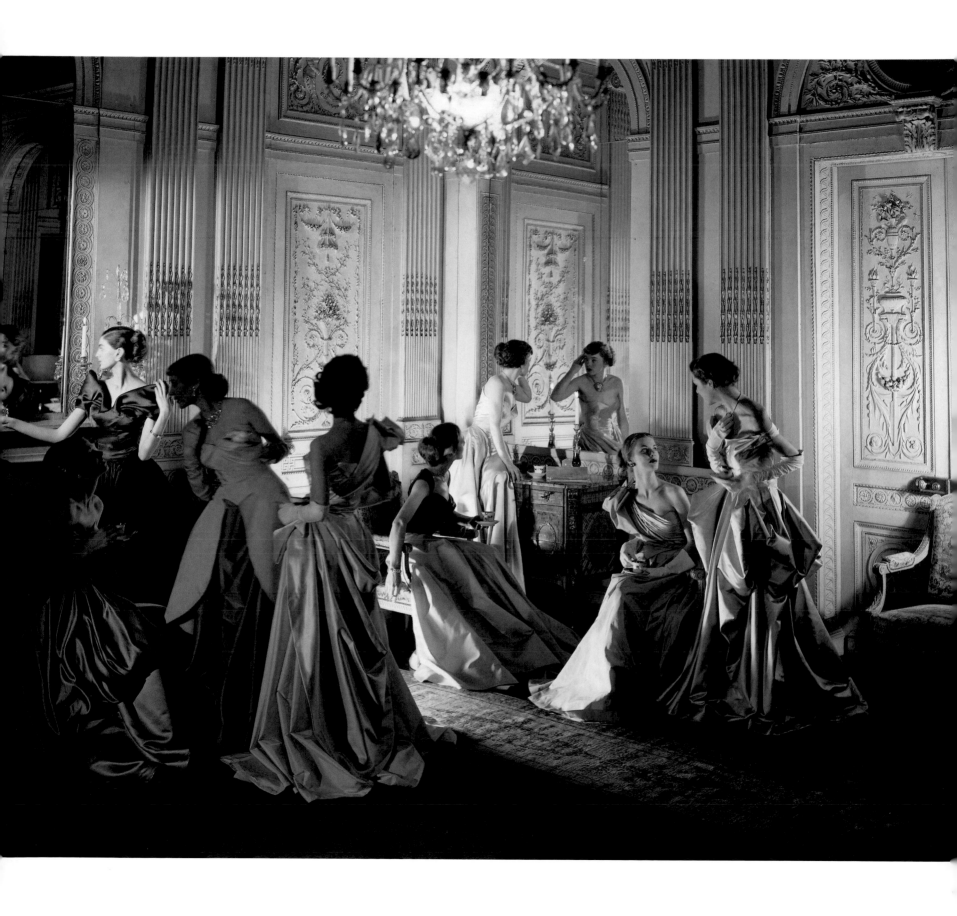

This photograph of models in elegant ball gowns by Charles James was taken in 1948 by Cecil Beaton.
To truly appreciate the power of silk taffeta you need to see it gathered and folded in the light.

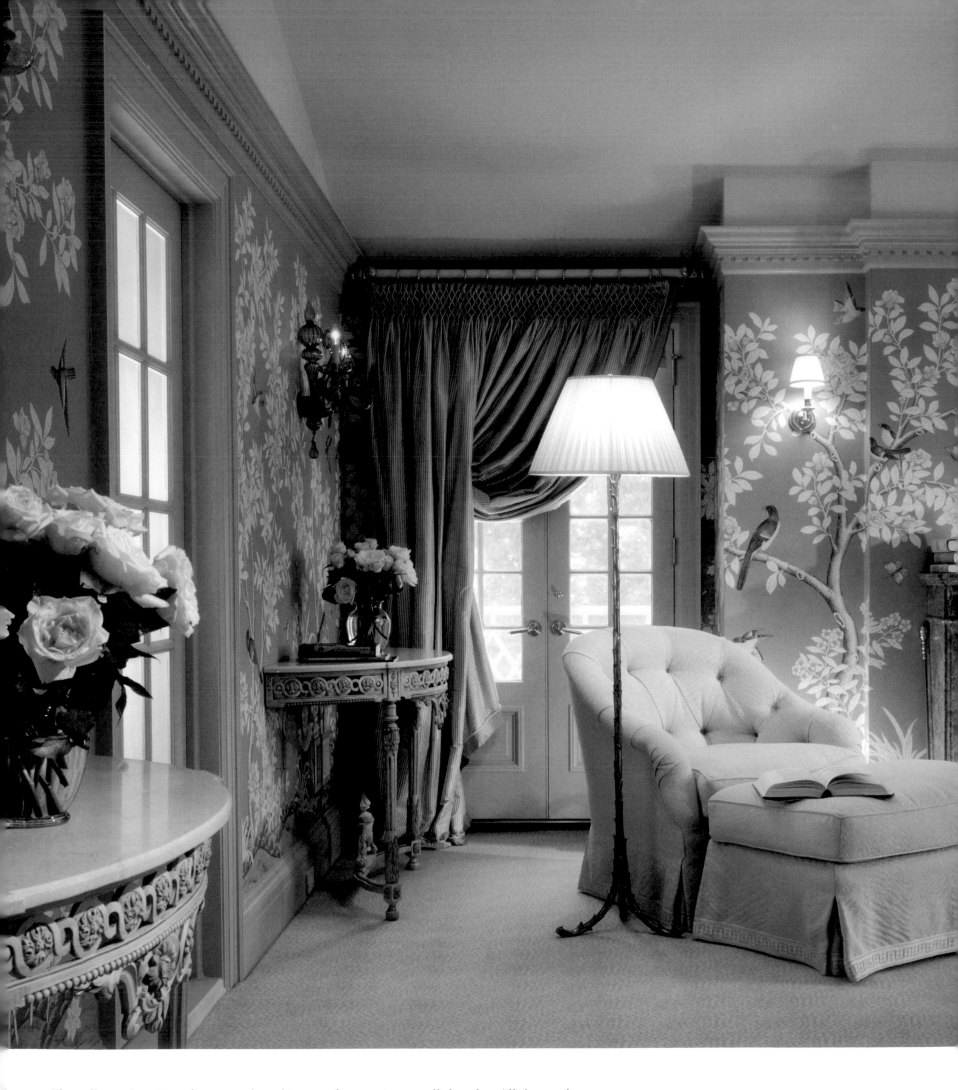

The wallpaper here is an elegant touch, and it turns the room into a walled garden. All the panels were configured to fit the walls and then hand-painted. A Venetian mirror sits with Scandinavian pottery above the Louis XV fireplace. The demilunes are Louis XVI and the floor lamp is Bagues.

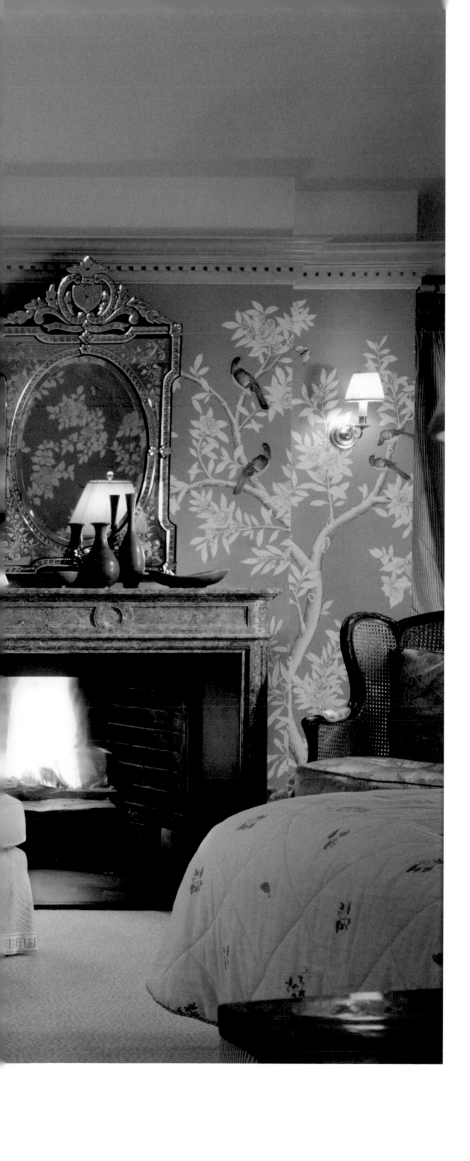

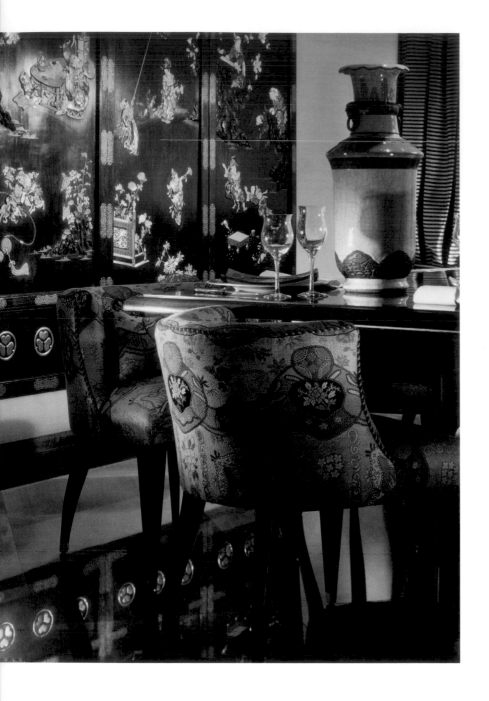

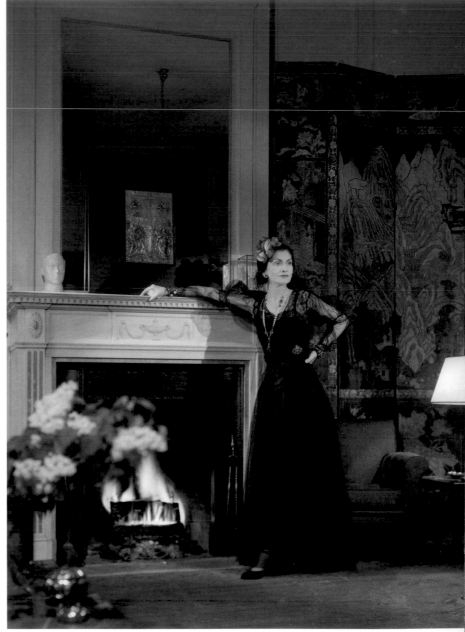

A Coromandel screen provides elegant focus in a dining room.
The inspiration for this dining room was Coco Chanel and her collection
of Coromandel screens at her Paris flat in the Ritz.

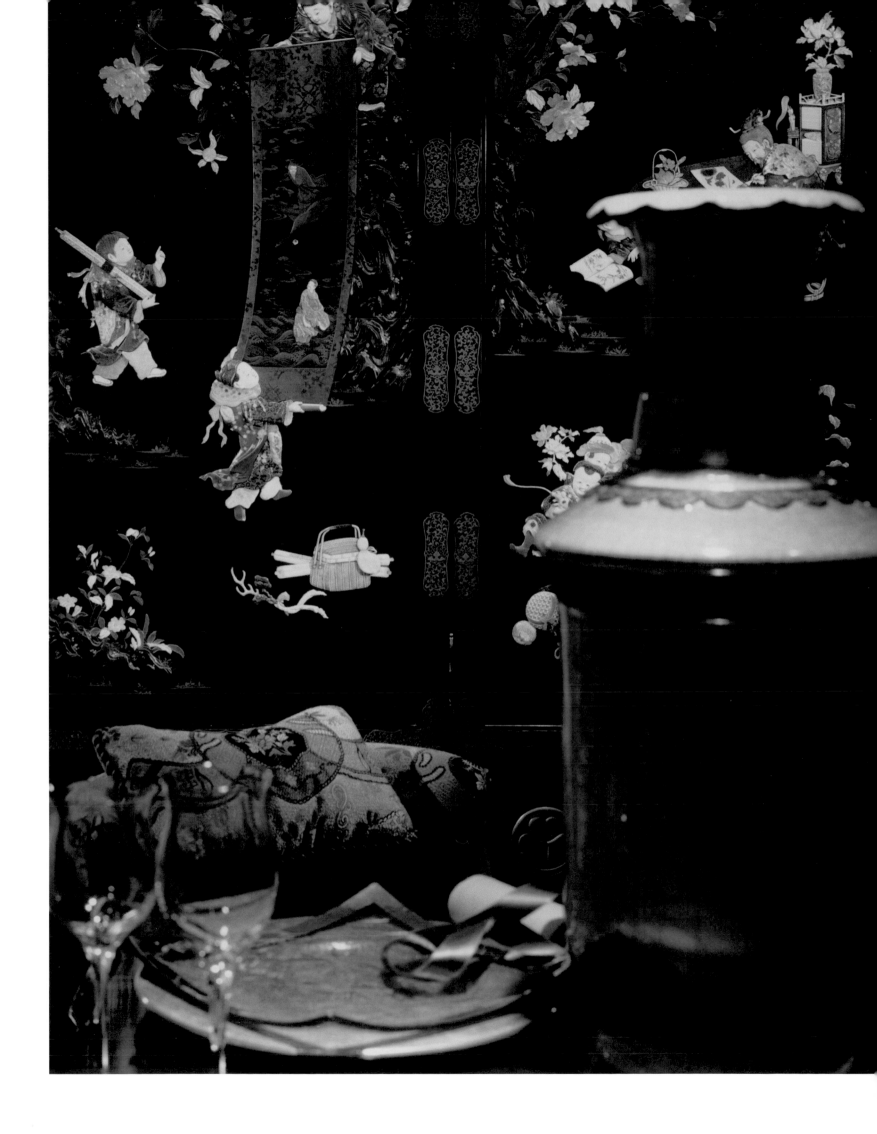

A monochromatic bouquet provides timeless elegance to a dining room. Opposite: In the octagonal
shaped room, a Russian chandelier hangs above the Directoire table, which is surrounded by white-painted
Louis XVI chairs. Graceful windows and French doors draw attention to the garden beyond.

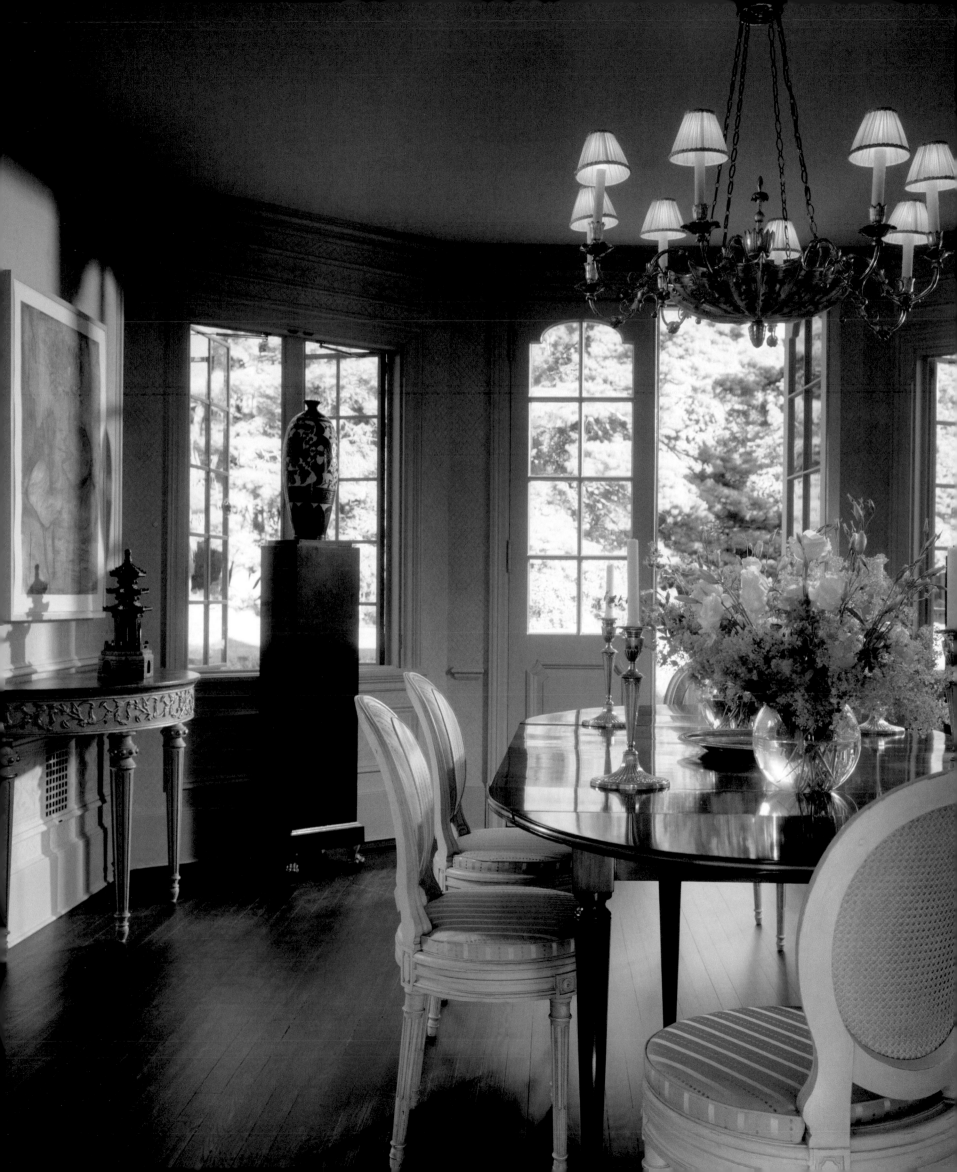

SUBTLETY

Mark Rothko's *Untitled*, 1969, inspired the wall in the master bath
that looks like a waterfall of tiny mosaic.

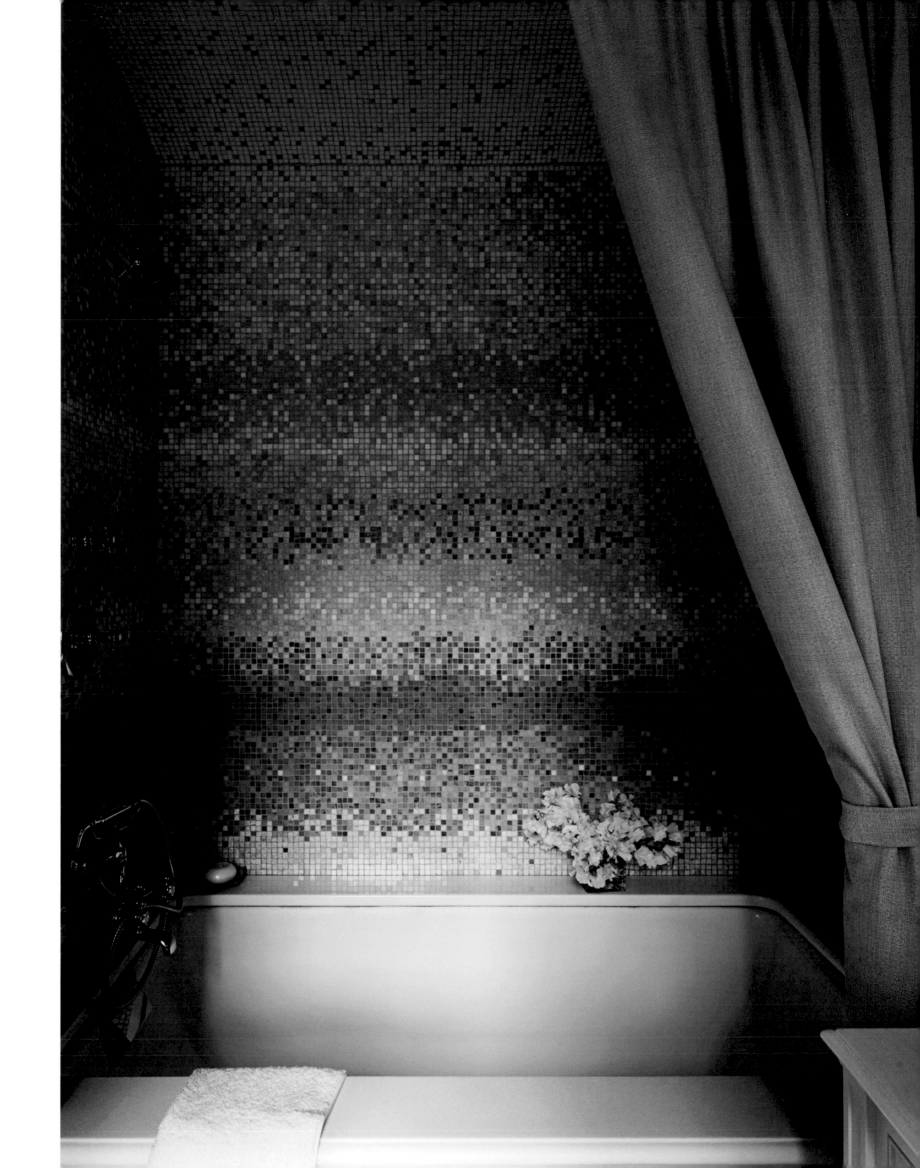

How can darkness be so radiant? There is something about Mark Rothko's work that has always attracted me. I'm not sure where I first saw his paintings—probably on slides in an art history course at university. But nothing prepares you for the experience of actually standing in front of one. The painting takes over the space, and the blocks of color become almost palpable as they float before your eyes.

Whenever I'm in Houston, I try to visit the Rothko Chapel. It consists of one large octagonal room. You walk in and suddenly you're confronted by these huge, dark canvases. At first they don't register as anything more than black. But if you sit down on one of the benches and keep looking, as clouds pass over the skylight and the light changes, you'll see the colors change as well. Subtle differences in the washes of pigment become visible. Black bleeds into purple. The experience is very emotional. People break down and cry.

Color unlocks all sorts of feelings. In some of Rothko's paintings, the colors are so vibrant they almost pulsate. You're ecstatic and energized. He can create light out of darkness, and darkness out of light. Other canvases seem to consist of infinite variations on a single tone. They shimmer. You feel a sense of peace and quiet.

I've learned so much about color from looking at his work. In this Park Avenue apartment, I wanted to create a similar kind of subtlety and strength. I thought I might do something with the finishes on the walls so they would have a kind of shimmer. But first we had to solve some major problems with the layout. The apartment was designed for a lifestyle that no longer exists, with a rabbit warren of little rooms in back that only the servants were meant to see. But those servants are long gone, and no one in New York can afford to waste even a foot of space. So the architects—Ferguson & Shamamian—worked with us to reconfigure the floor plan to function more efficiently for a young, active family. We created a big kitchen and family room in back. But then what usually happens is that no one ever goes into any of the other rooms. The family ends up living in those back spaces, which often look out on a brick wall. So you never sit in the main room in the apartment—the living room, with its bright light and good views.

That makes no sense to me.

I'm tired of doing beautiful rooms that people walk past and never use. I was determined to pull this family out of the kitchen and into their living room, and that means I had to give them lots of reasons to want to be there. I put a large TV in that black-lacquered cabinet and a twelve-foot-long sofa against one wall so they could invite friends over to watch football or a movie. There's a table with two chairs by the window, where someone could work on a laptop or share a quiet dinner. A baby grand piano occupies one corner and tempts people to sit down and play. Two love seats flanking the fireplace offer the perfect spot for a cocktail before dinner.

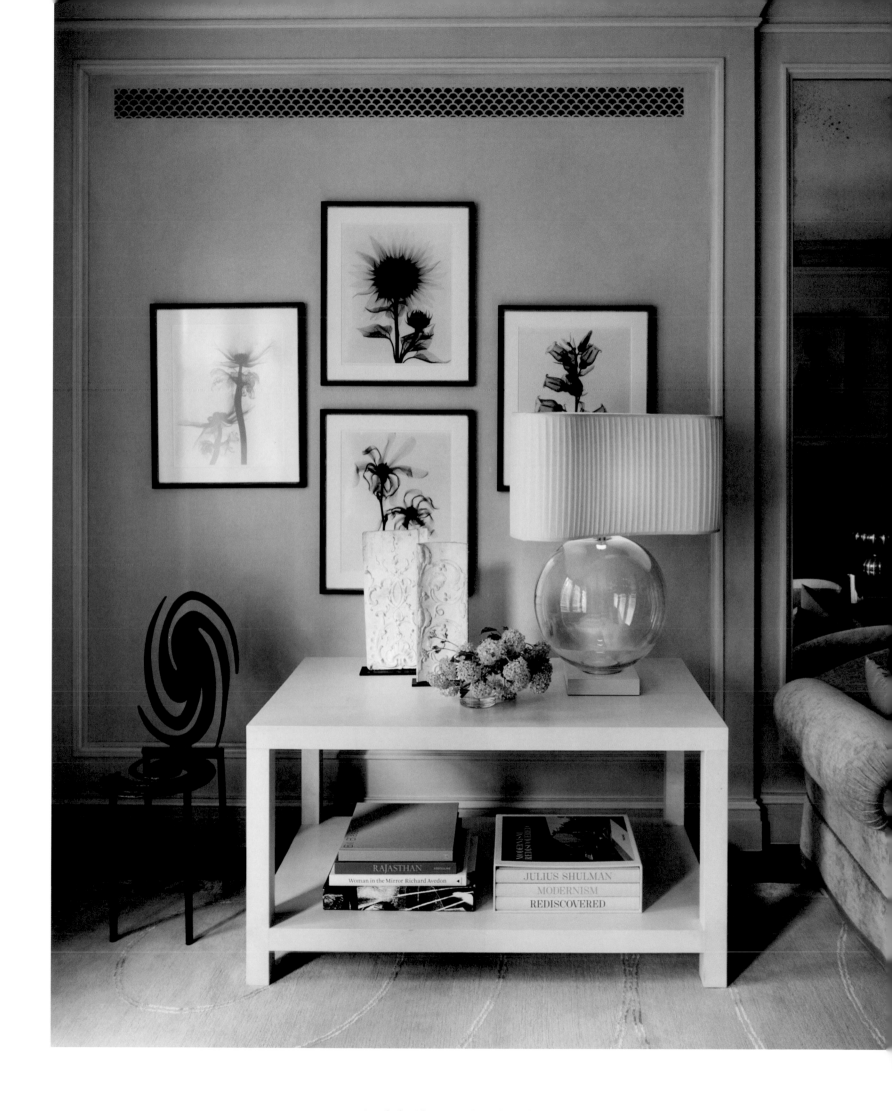

Michele Oka Doner's Celestial chair draws a parallel to Judith McMillan's gelatin prints.
The parchment-covered side table contrasts the silvered rug.

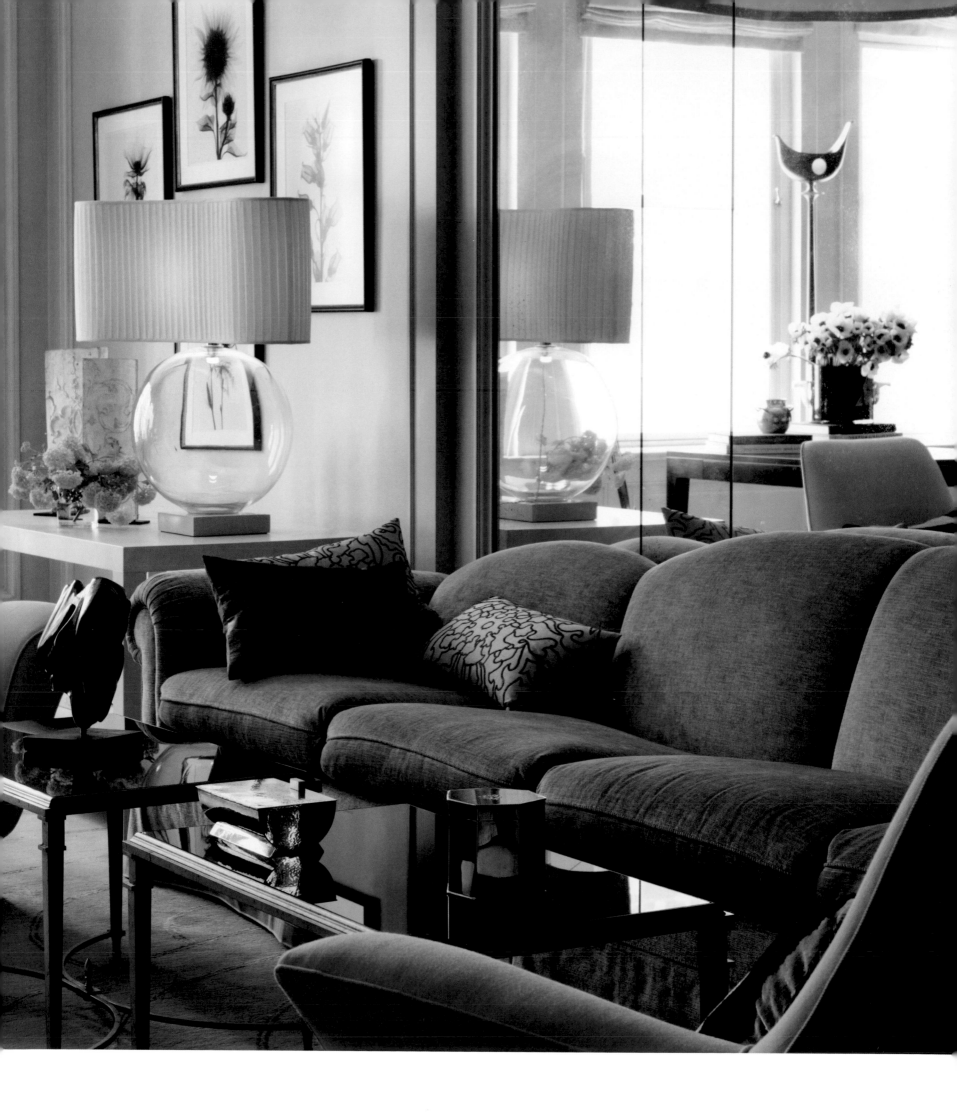

A detail of McMillan's gelatin print. The Patrick Naggar torchiere is reflected in a mirrored niche behind the custom sofa. The two Parisi armchairs are c. 1950.

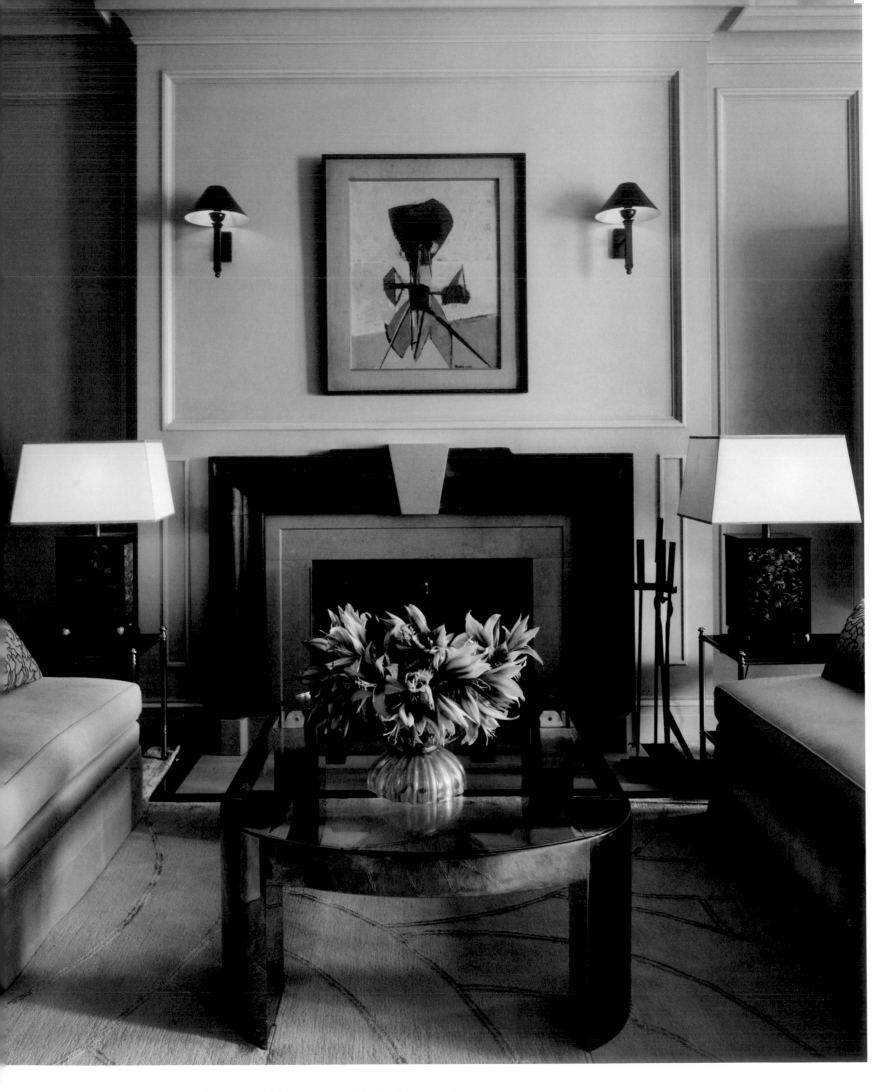

A Raymond Parker artwork hangs over the keystone marble fireplace, which was modeled after one in Doris Duke's New Jersey estate. Marble specimen lamps stand on either side of the Karl Springer table.

The palette runs from ecru to ebony, but the color you remember most is a silvery gray, with the same shimmer that you see in Mark Rothko's work. It starts on the walls, where the paneling added by the architects was painted the color of a pearl. The only man I know who can make a wall look that luminous is Jean Carrau. He's a French decorative painter who uses a technique called *patine*, which is similar to glazing. It produces a transparency you could never achieve with regular paint. The base colors and the translucent top coating are juxtaposed rather than mixed. It's the eye that blends them, creating a finish of great subtlety and depth—what the French Impressionists called "broken color." I followed the same principle with the upholstery, juxtaposing various subtle shades of gray. The play of color and texture—the cashmere curtains are cuffed in silk—is warm rather than cold. Everything looks pearlized.

The luminosity carries over into the dining room, which is also multifunctional. One of the first questions I ask clients is "How many dinner parties do you usually give during a year?" If the answer is only a few, I'm not sure a formal dining room is practical—unless you also plan on eating there every night. Think about it. Does it really make sense to let the second-largest room in your home stand idle? This dining room doubles as a study. And instead of putting a huge table smack-dab in the center of it, we brought in two smaller squares, which can be pulled together for a large dinner party or split apart. It feels lighter, less formal, and more versatile.

I think the room will age well, just like the pieces in it. The furnishings throughout the apartment are an intriguing mix—everything from Louis XV to Biedermeier to 1970s Italian. And then there are the custom pieces, such as that black-lacquer TV cabinet meticulously crafted in the Art Deco style. Having anything custom-made today is costly so you want to make sure it has integrity. I think of these pieces as the antiques of the future.

Decorating to me is not about the latest trend. It requires a major investment, and I'm constantly aware of the commitment involved. You want to create something that expresses your clients' interests and feels utterly right at the moment. Yet it also has to have a certain timeless quality because people are not likely to change their decor from season to season as they would their clothes.

The Yangpu Bridge in Shanghai is more than a bridge, it's a marvel of engineering and a work of art.
There is no reason why something that functions brilliantly can't also be beautiful.
We applied the same logic to this bone inlay cabinet.

The dining table is one of two which can be pulled together for a large party.
I like to thread certain motifs throughout a space, and the diamond pattern that first appeared on the TV cabinet is echoed in the rug and on the curtains.

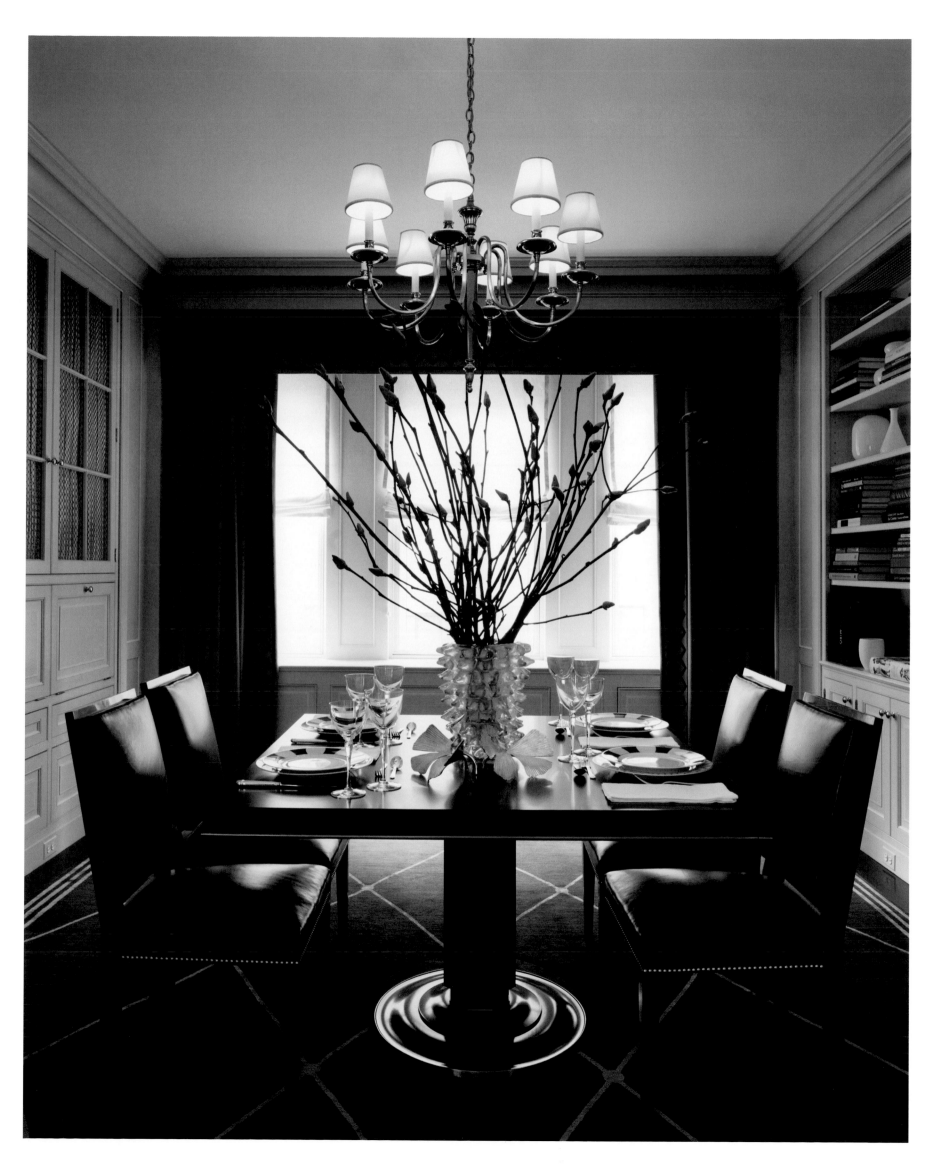

A matte-bronze Van der Straeten bullseye mirror contrasts the pearlized paint on the walls. Carved-oak and marble lamps join c. 1922 Leon Jallot side chairs.

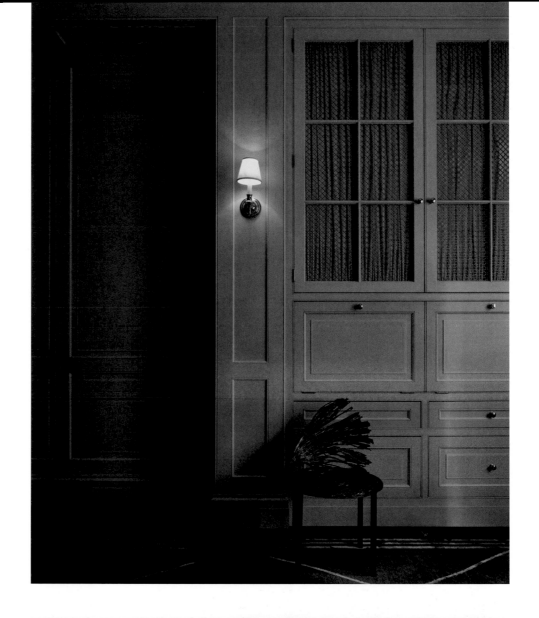

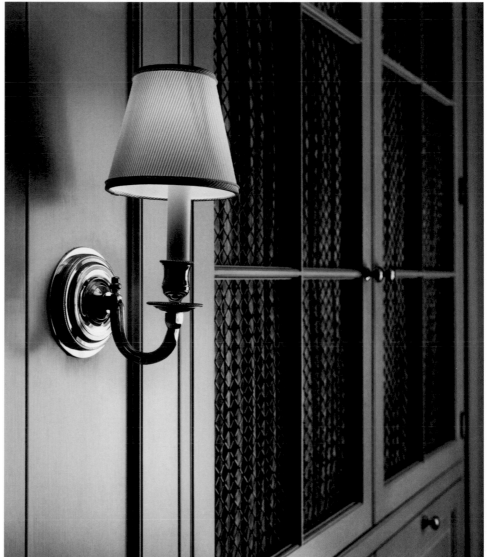

The dining room is also a library and study.
Part of the customized cabinet pulls
down to function as a desk. Pearlized paint
and the Palm Cosmos chair by Oka Doner
add radiance to the room.

 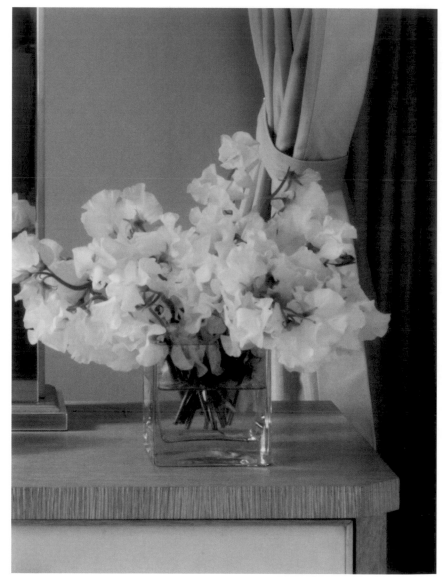

The custom mirrored table lamp and cerused-oak-and-parchment bedside table
pick up the apartment's Moderne theme. A half canopy on the bed provides a sense of enclosure.

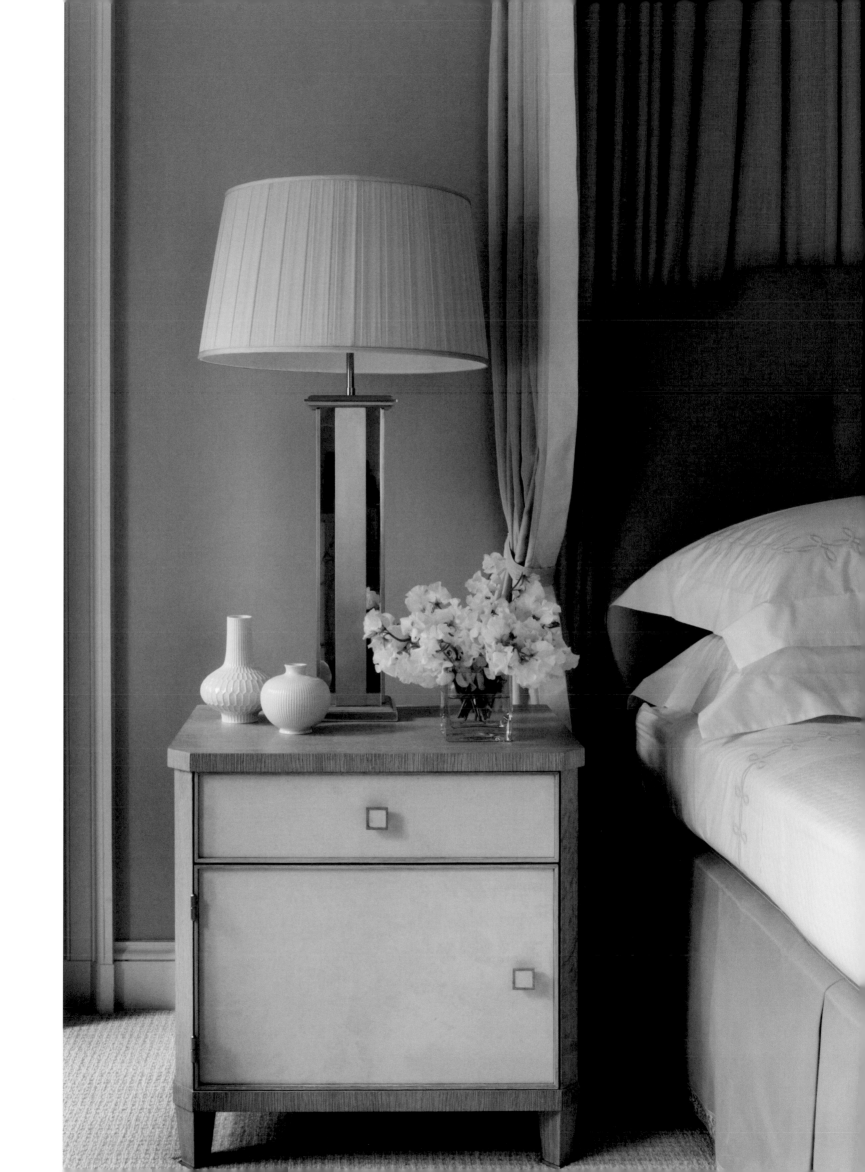

TRADITION

Rex Harrison, seen here in the Cecil Beaton-designed *My Fair Lady* film set, inspired the
two-tiered oak library. This quintessential gentlemen's library is furnished with stately antiques
including the English mahogany partners desk inset with tooled leather.

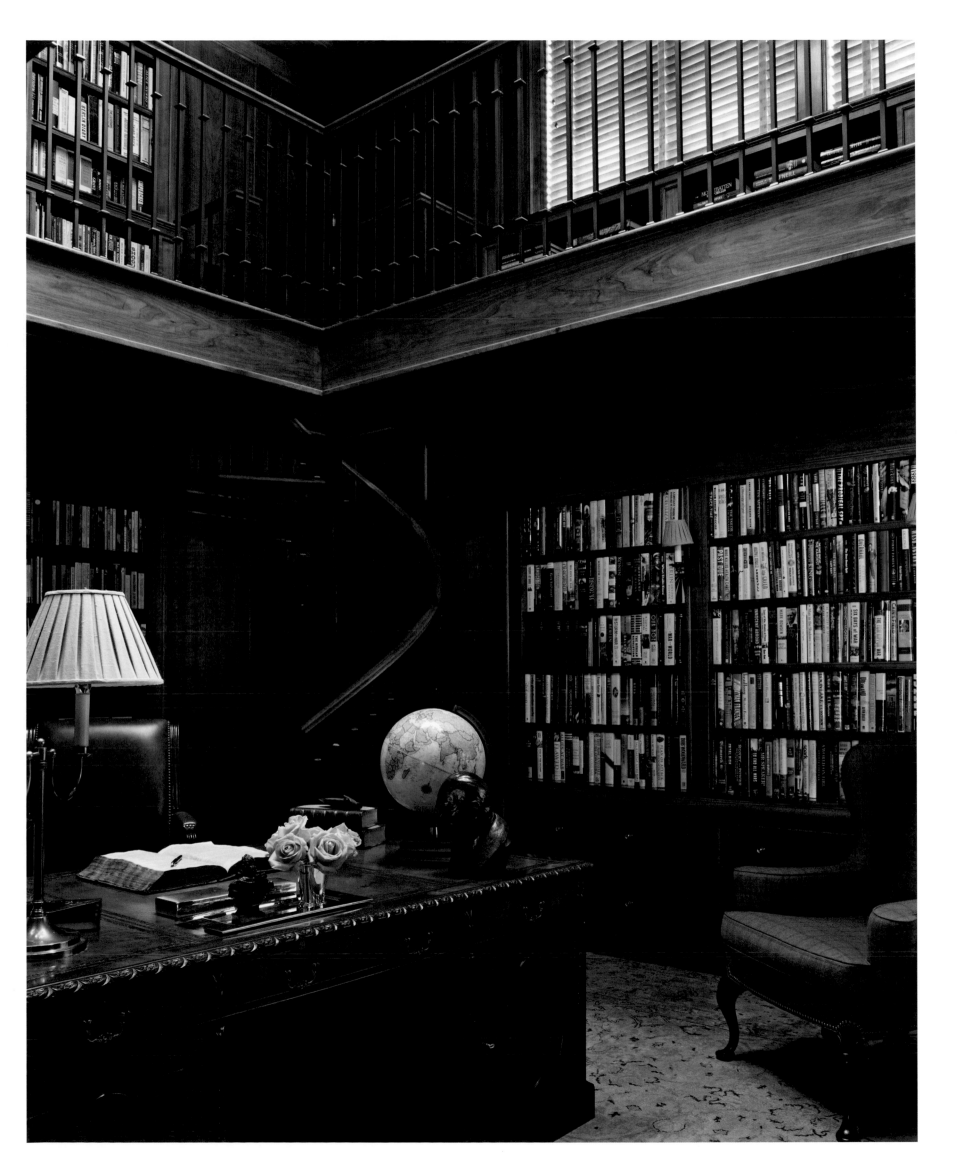

While other women swooned over Rex Harrison in *My Fair Lady*, I went weak at the knees for his library—the traditional paneling, the two floors of bookcases, the spiral staircase. The great Cecil Beaton designed the movie set and modeled it after the library at the Château de Groussay, which he had visited as a guest of its owner, the famous aesthete Charles de Beistegui. I thought back to Henry Higgins and his library when I was renovating a house for a client who loved books, and reinterpreted it. It's not an exact copy of Beaton's, but Beaton's wasn't an exact copy of Beistegui's, for that matter.

Tradition is constantly being reinvented. Each new generation takes what inspires it from the past and then adds another layer, creating its own interpretation. And that makes for interesting juxtapositions. You can see several aspects of what I mean in the work of the artist Candida Höfer, who photographed the Long Room in Dublin's Trinity College Library as part of a series. The room itself is actually layered, in space as well as time. Originally designed by the architect Thomas Burgh, it was built between 1712 and 1732 with only one floor of bookcases, and then the second floor and the barrel-vaulted ceiling were added in 1860. The barrel vault and the columns were inspired by Roman architecture, but here they're made of wood, not stone as they would have been in the Mediterranean.

And then Höfer adds another layer to the experience, because her photograph is on a huge scale, measuring almost six by seven feet. You feel as if you're entering right into the picture. And you see the building in a different way than you would if you were in the space itself, where your eye can only focus on one section at a time. The one-point perspective makes the room appear to be even longer, and since you don't see the source of light from the side aisles, it has a sense of mystery.

I'll often use contemporary art to bring another dimension into a traditional space. In the entryway, a photograph by Diane Arbus hangs above a William IV mahogany hall bench. The muted floral wallpaper is part of the house's traditional vocabulary, yet the pattern is so large in scale that it becomes almost abstract. The palette is monochromatic—all dark wood against light walls—which feels modern, and yet the furniture is antique. In a sitting room, I almost did the opposite: we gutted it and opened up the ceiling, so the room feels lighter and more modern. Then I grounded the space with a George I pine mantelpiece from London and a painting by Norman Rockwell, perhaps the quintessential American traditionalist, who so perfectly captured American culture and a way of life. So what would you call these rooms, contemporary or traditional? I'd say they're neither one or the other, but both.

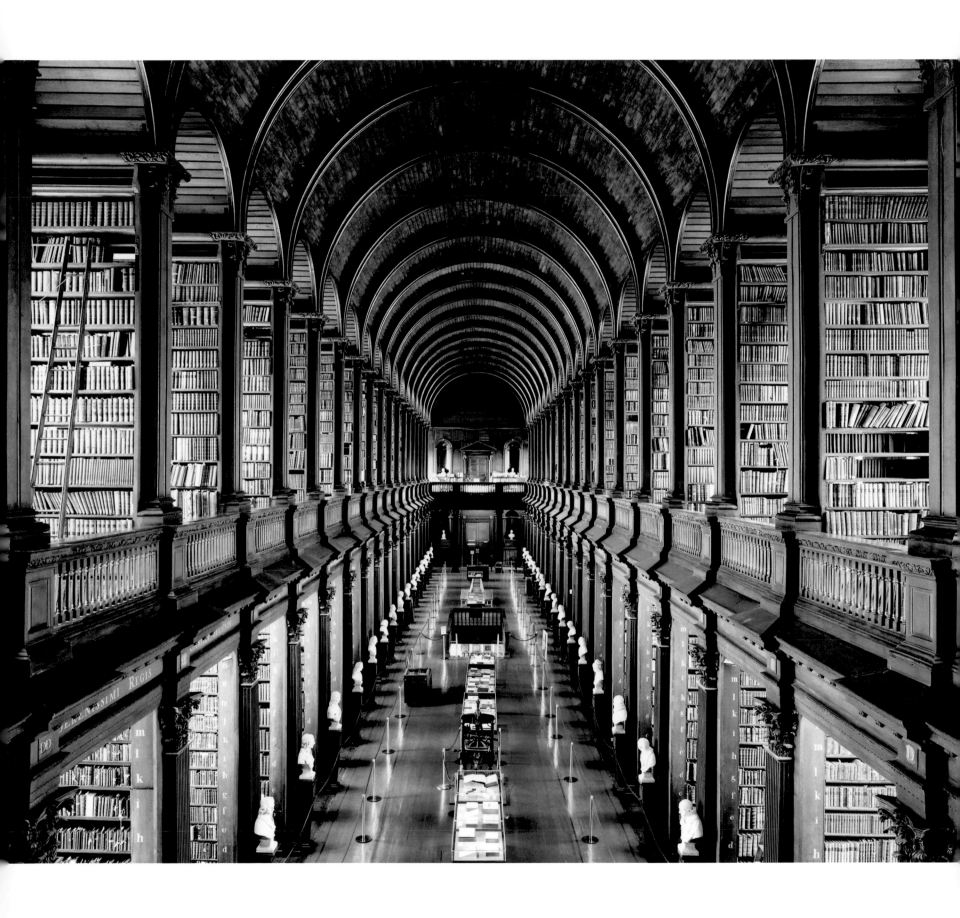

A photograph by Candida Höfer of the library
at Trinity College, Dublin.

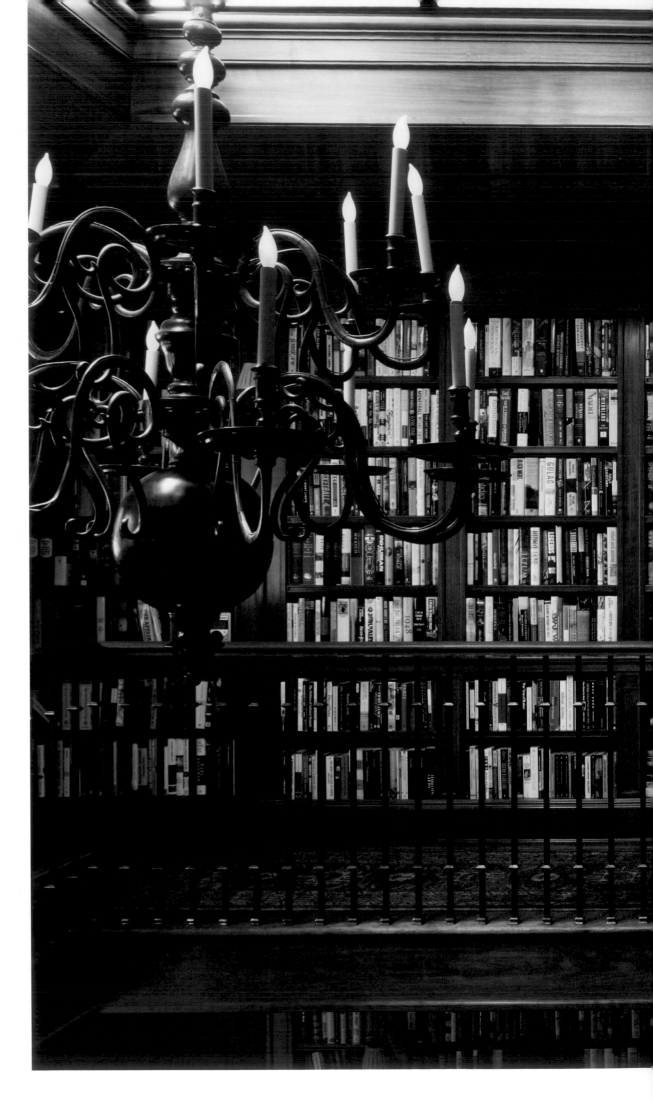

A skylight provides
natural light to the
double-height library.
At night the painted bronze
Dutch chandelier is
illuminated.

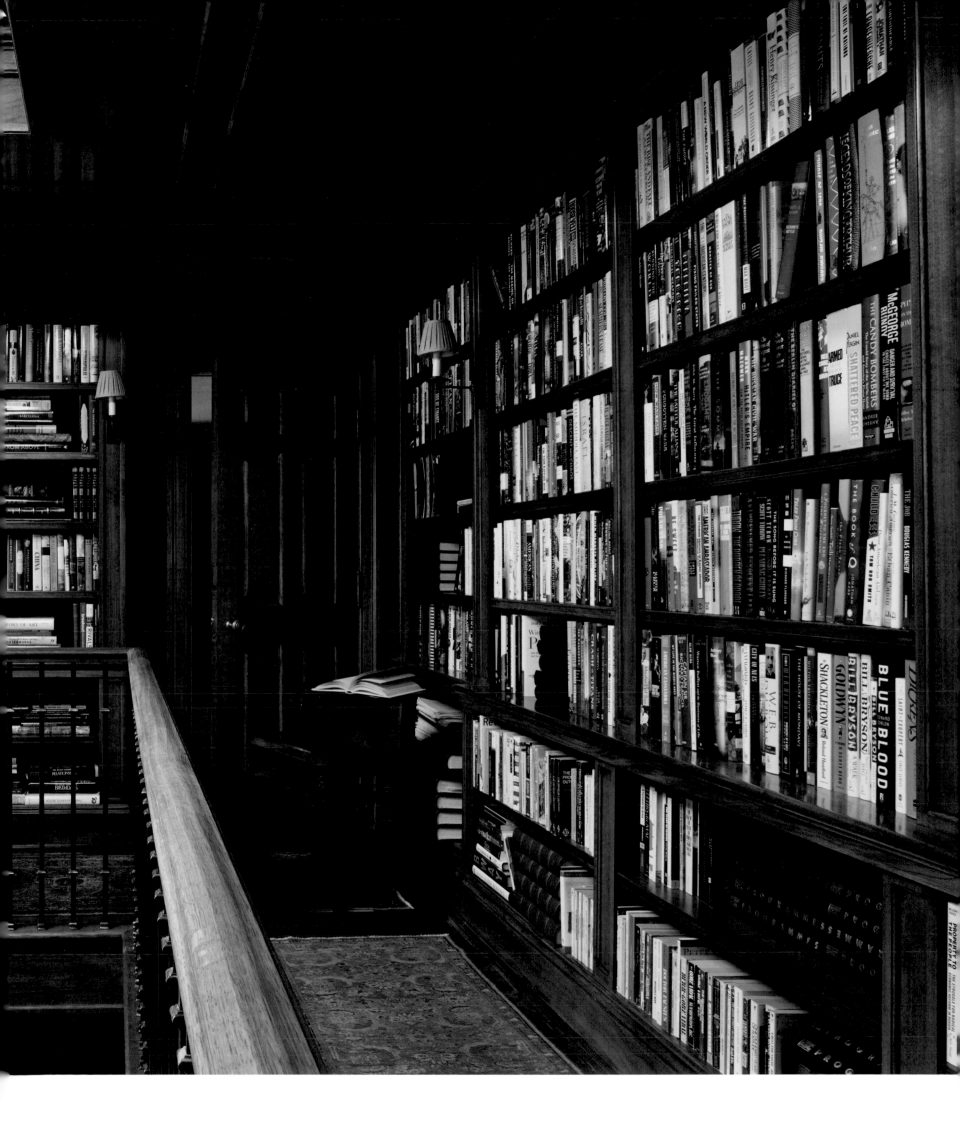

In the entryway, a William IV mahogany hall bench establishes the home's spare and sculptural leitmotif. A Diane Arbus photograph hangs above. Opposite: The Gottfried Helnwein painting hung on the muted floral wallpaper modernizes the traditional setting.

In the sitting room, the George I pine mantelpiece was purchased in London and
inspired the panelled walls. A painting by Norman Rockwell hangs above the fireplace.
Deep seated sofas are set on a traditional English tattersall carpet.

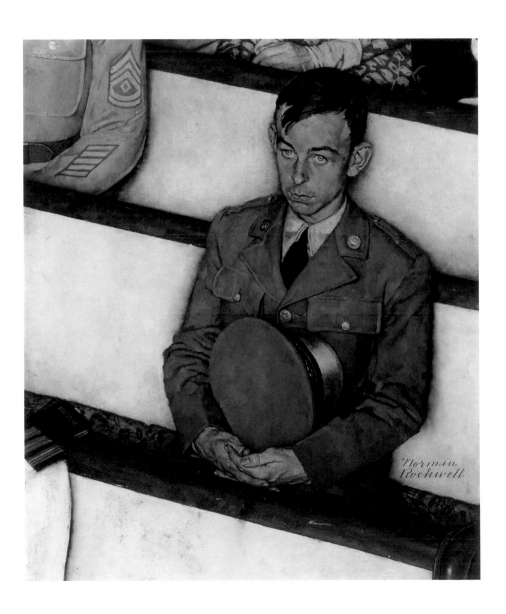

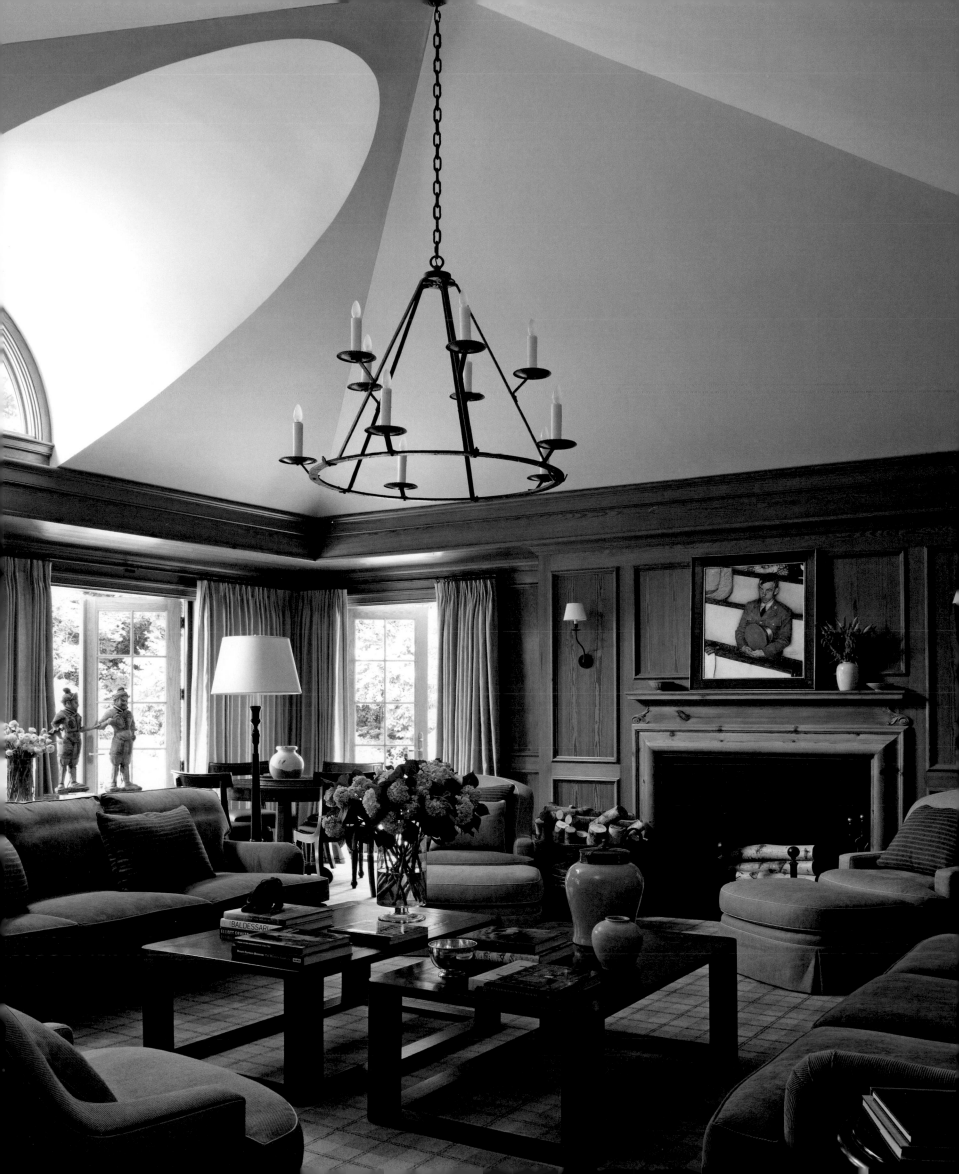

AUTHENTICITY

A study by Leonardo da Vinci portrays the anatomy of the horse with scientific precision.
Opposite: A leather bridle hanging on a wooden post is a kind of simple beauty.

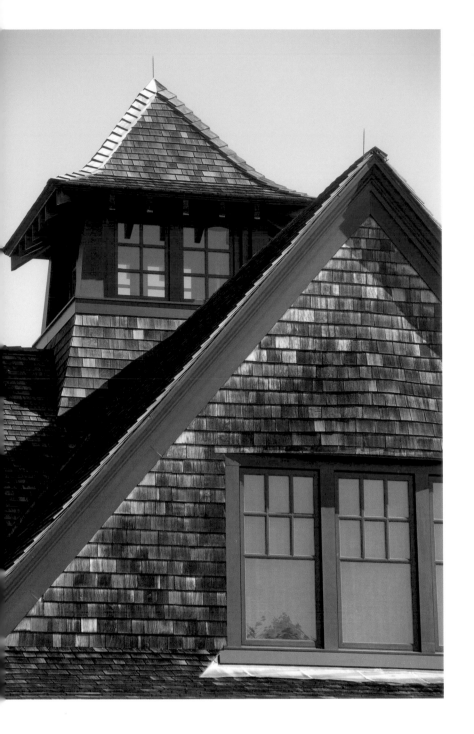

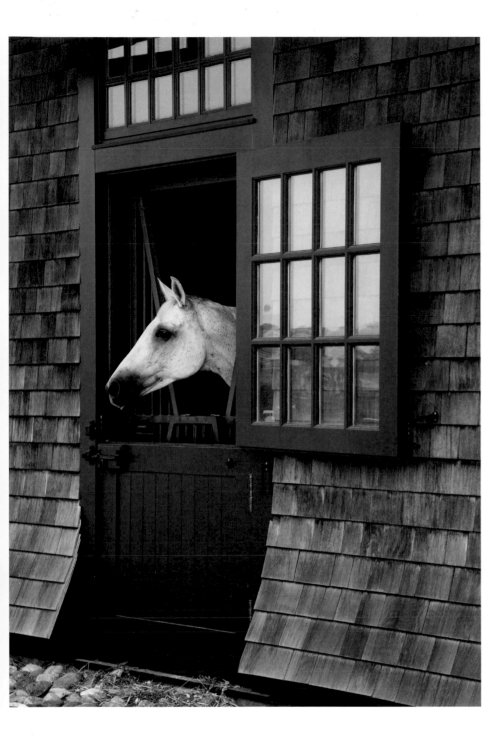

Architectural firm Shope Reno Wharton married the Shingle Style barn to the
landscape by way of natural materials and colors. An *allée* of trees is the entry to the property.
The horse stalls are made with traditional hand-wrought iron and wood.

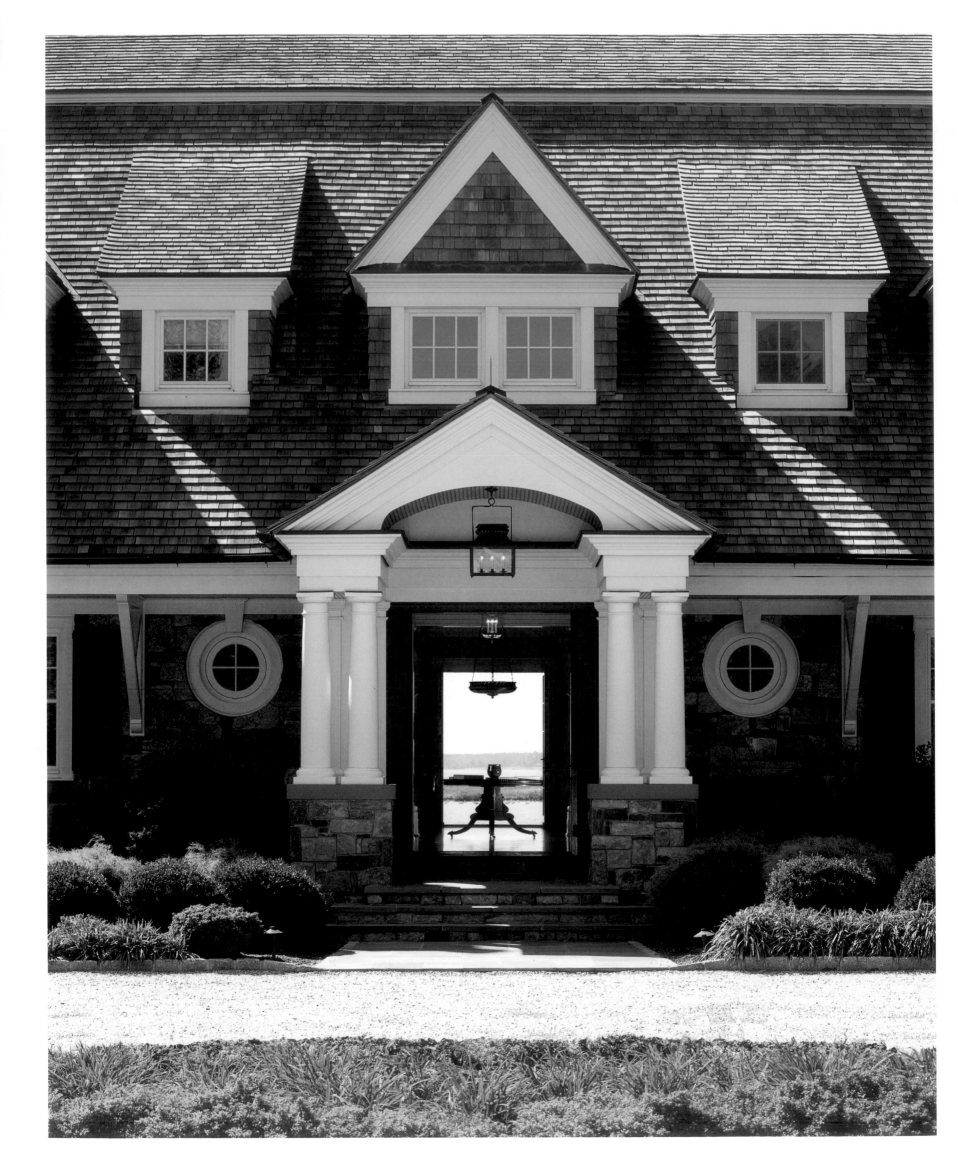

On the Eastern Shore of Maryland facing Chesapeake Bay, gulls wheel over the water and life moves to a slower rhythm, marked by the push and pull of the tides. This house, designed by the architecture firm Shope Reno Wharton, was built for clients who breed Oldenburg and Hanoverian horses for the sport of dressage. These noble creatures are only one of the many types of animals that live on the property, which used to be cornfields. Stay in the neighborhood long enough and you'll spot bald eagles and nesting ospreys, swans, geese, ducks, deer, muskrats, and the flash of orange-red that signals a red fox.

The approach to the house is stately. First, there's a long drive through an *allée* of trees, with a turnoff to the stables, before you come upon the main house. It may look grand on the outside—a brilliant hybrid of classic Shingle Style and every modern convenience—but my job was to make sure it still had the warmth and intimacy of a centuries-old house, because this place, a working horse farm, is all about authenticity. It's owned by a family that wants to maintain those fine old traditions and share them with friends who come down to ride, hunt, fish, and reconnect to their roots.

When you walk in the front door, you see straight through to the bay, and the room is infused with a crystalline light that is reflected off the water. The large center hall is crossed by another hall, which forms the main axis of the house. If you're lucky enough to have a hallway as generous as this, you want to make an effort to furnish it so it becomes more than a passageway. We put a Regency pedestal table at the cross point and flanked it with two settees, where you can drop a hat or coat. The walls are painted a pale sludge green, set off with ivory moldings. This green is one of my shadow colors, the kind that changes—from celadon to khaki to gray-green, in this case—over the course of a day.

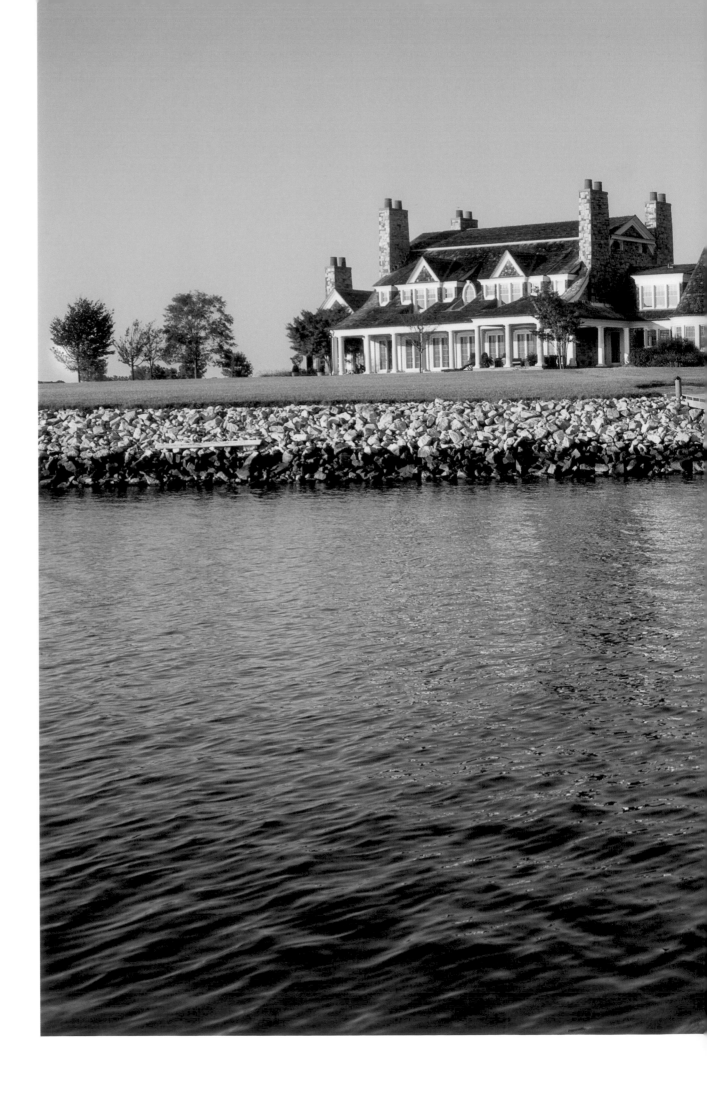

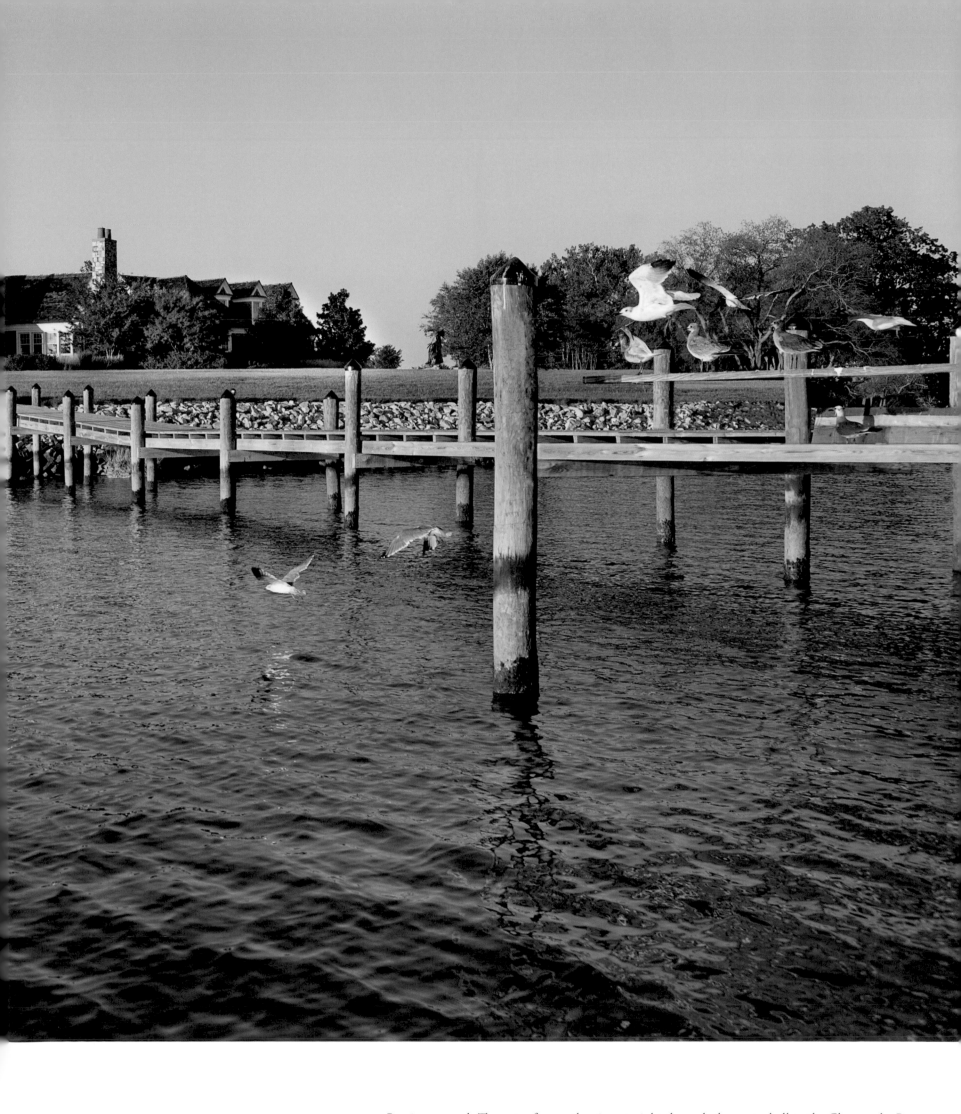

Previous spread: The entry frames the view straight through the center hall to the Chesapeake Bay.
Above: The rear of the Shingle Style house with a wall of French doors opening to a view of the bay.

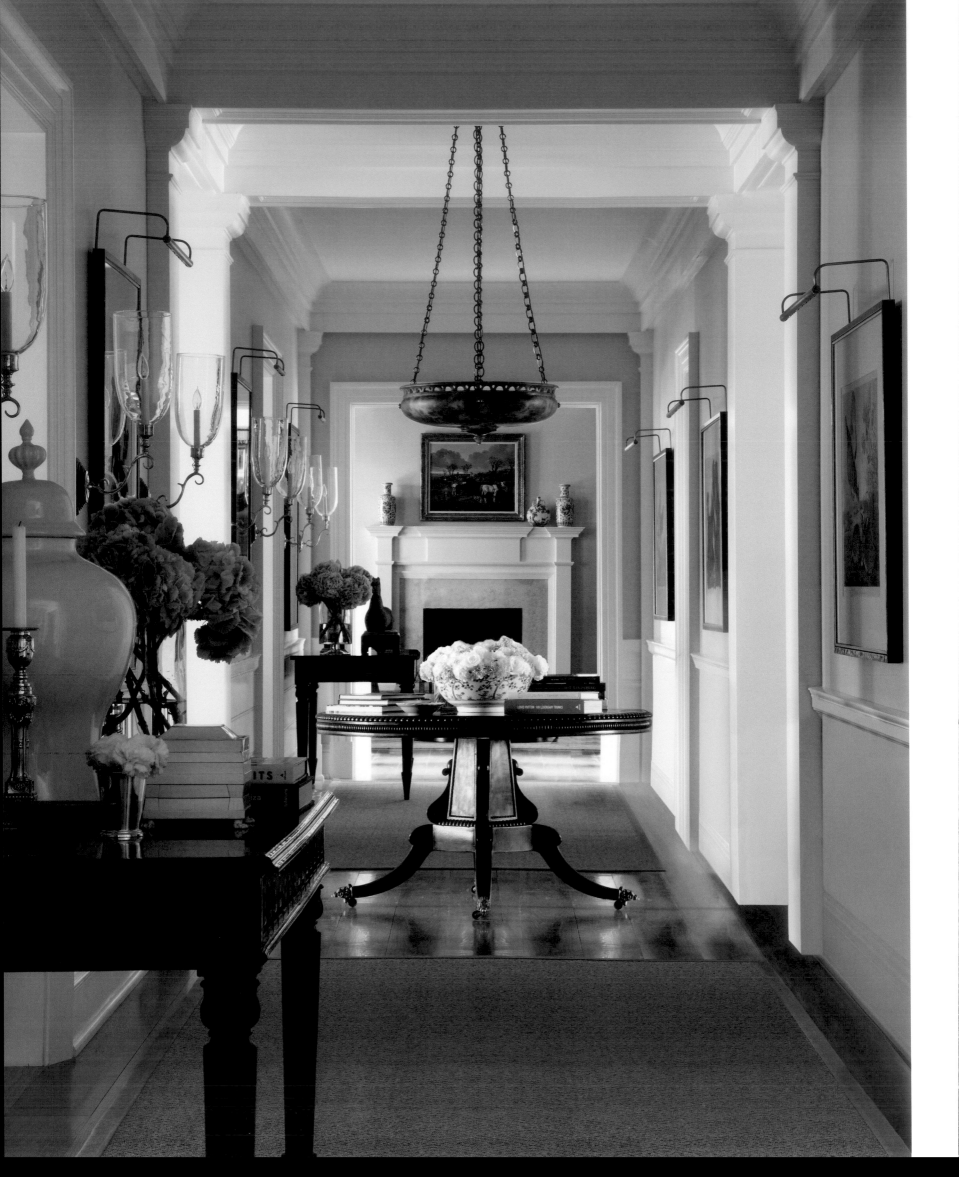

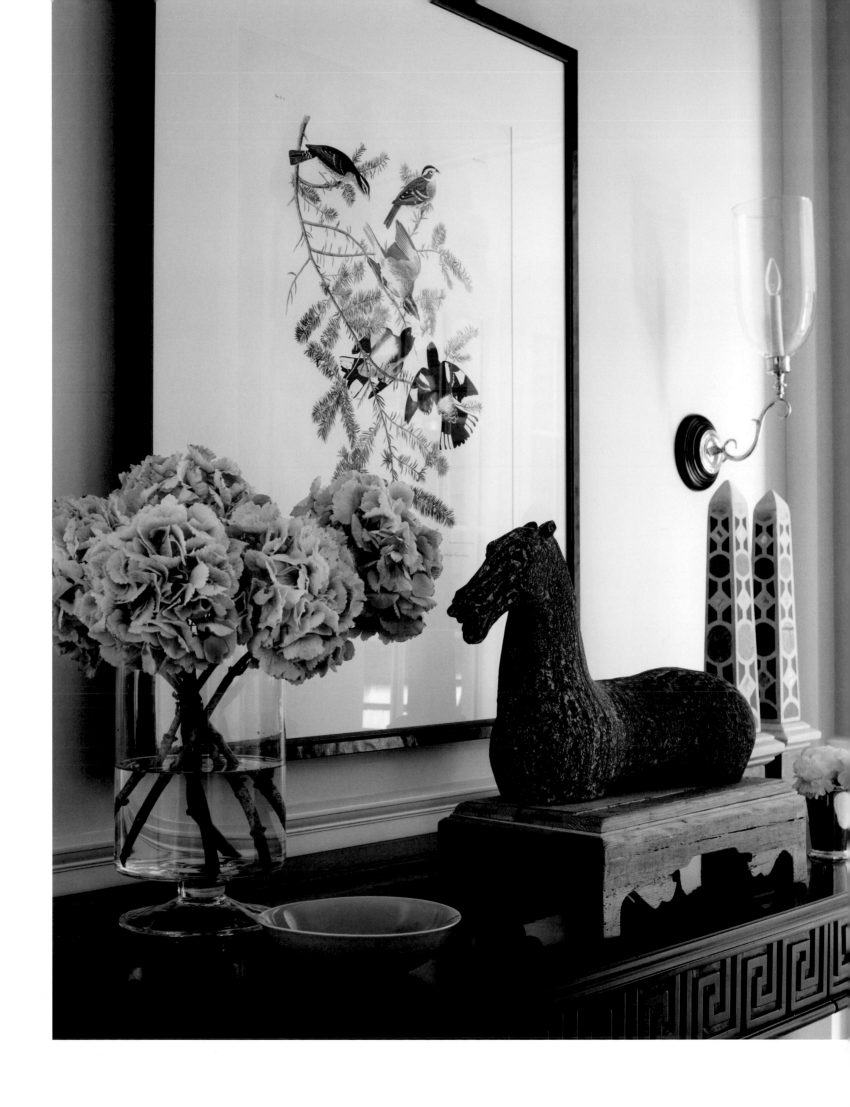

Artwork by Audubon and a Tang horse complete a tableau on one of the gallery's Regency-style consoles.
Opposite: An alabaster light fixture and Regency pedestal table mark the convergence of the center hall and the gallery.

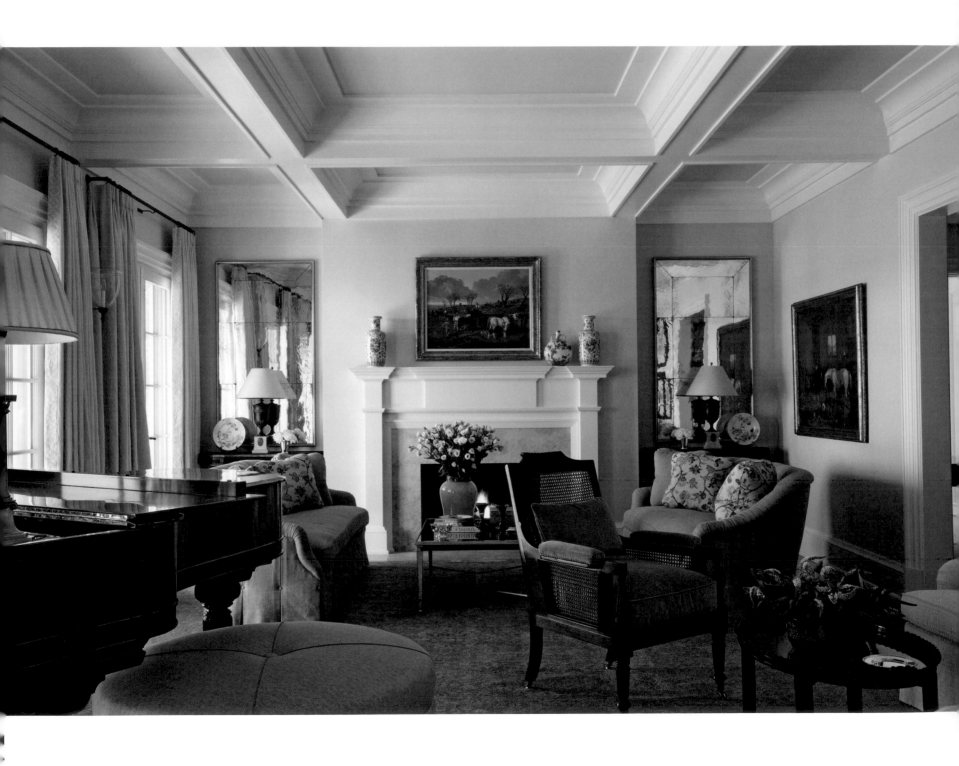

Two 19th-century John Frederick Herring, Jr. paintings hang on the living room's buttercup linen walls.
Hand-rolled mirrors on either side of the fireplace catch the light. The rug is Turkish Oushak c. 1920.

In the living room, an English landscape painting over the mantel portrays a farm with a hunt going on in the distance, a pastoral scene that is suited to this equally peaceful place. The clients own some very good English furniture, but the object is not to impress you with antiques. Everything looks comfortable. There is something cozy and old-fashioned about two sofas facing each other in front of a fireplace. It's a great place to sit, and I made sure there were plenty of others, including a big L-shaped sofa in one corner. When I first came to see the house, I noticed that the clients weren't really using this room. They were spending all their time in the kitchen. So in order to entice them in here, I needed to make it more inviting.

One way to accomplish that is through color. Now the walls are covered in a pale buttercup linen that not only adds warmth but also quiets the space. Fine architectural details—like the living room's tray ceiling—suggest solidity and substance, and contribute to the integrity of the house. To draw your eye up to the ceiling, we painted the center of each tray in the same yellow as the walls, with a little pink thrown in to give it a glow.

The apricot paint on the dining-room walls was mixed on-site so we could get just the right intensity of color to suit that particular room with its particular light. There's really not that much to do in a room that's blessed with three sets of French doors opening onto the water. The clients already owned the mahogany dining table, and we found some nicely carved Georgian chairs and had them slipcovered in a herringbone linen. They're very comfortable, which is fundamental. You don't want a dinner party to break up early just because people can't bear to sit any longer.

In the reading room, the vaulted ceiling soars sixteen feet, and a huge Palladian window fills one wall. Some people might be intimidated by the sheer volume of the room, but this is the fourth house I've done with these architects and I understand their logic. I want to pay homage to their work while making sure it functions for the clients. The architecture is strong, the wood paneling is strong, the whole room is strong, and that called out for a strong color on the walls. The deep blue paint—a color I took from the salt marshes—is not only cozy and warm; it also helps pull the large space together. It's an intense color and it fills the room. Suddenly it does not seem cavernous but the perfect gathering place for reading and conversation.

Imagine how good it would feel to plop down on that big, generous sofa and put your feet up on that rustic coffee table after a long horseback ride. Naturally, there would be a great fire crackling in the fireplace and a glass of wine close at hand. Those are the moments that we treasure. And that's why this family built this house—to enjoy those moments together.

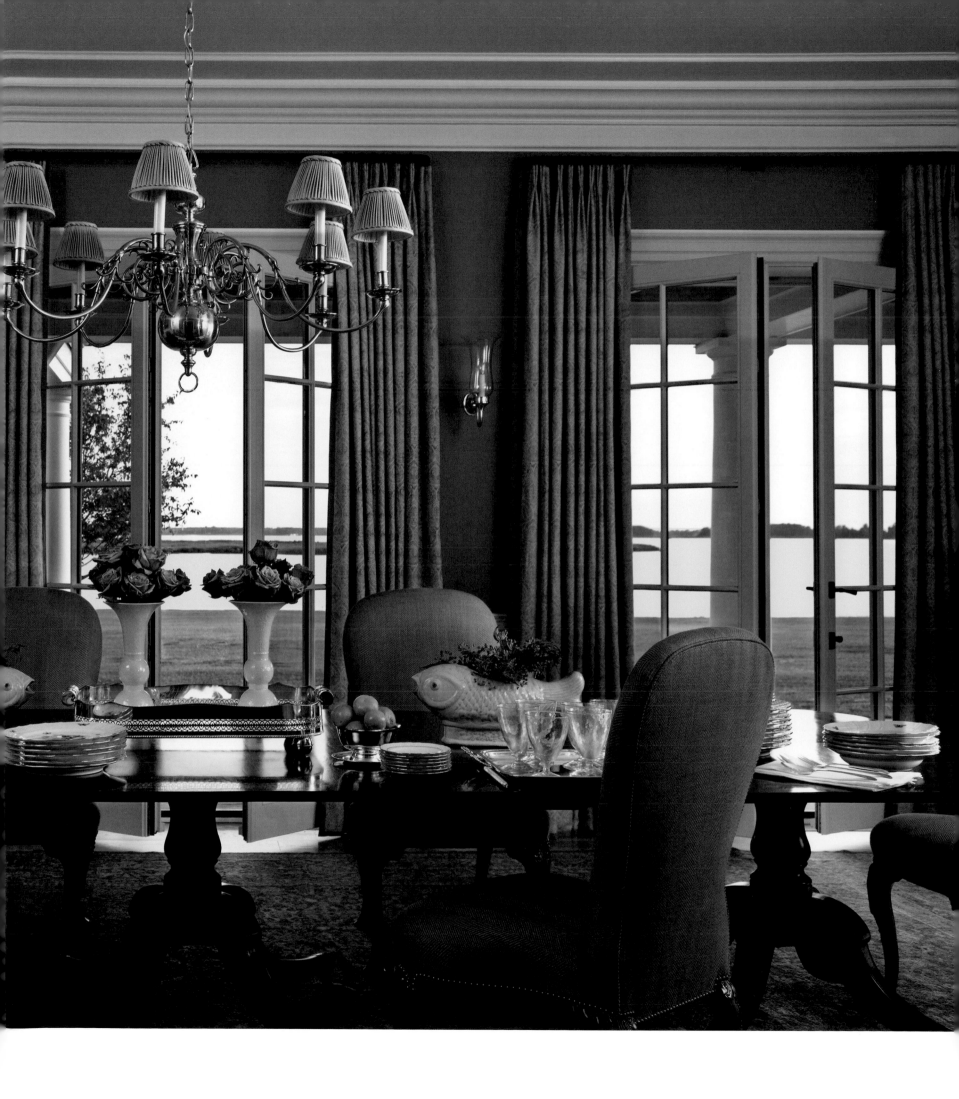

The Dutch-style chandelier's silvery finish shines against the dining room's apricot walls.
Georgian chairs stand on an antique Pakistani Sultanabad.

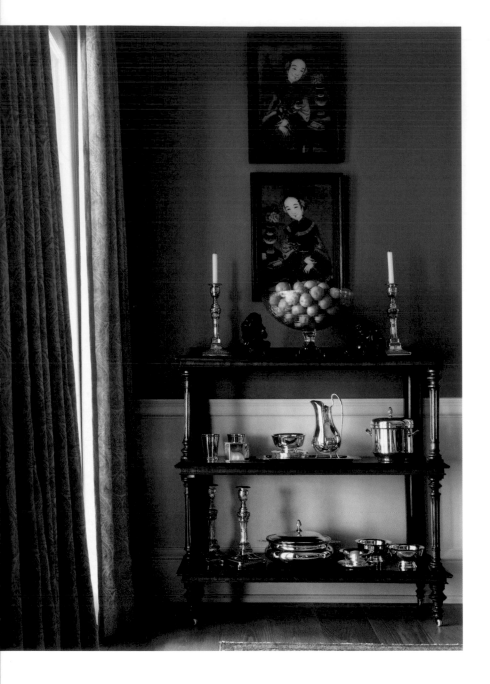

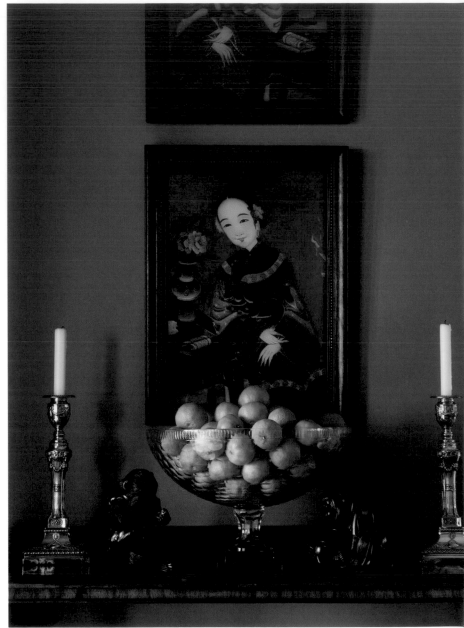

Beneath a pair of Chinese reverse paintings c. 1790 on glass, silver candlesticks
and serving pieces are grouped on an étagère. Opposite: An 18th-century Chinese, lacquered
wood figure of a female deity presides over a side table in the dining room.

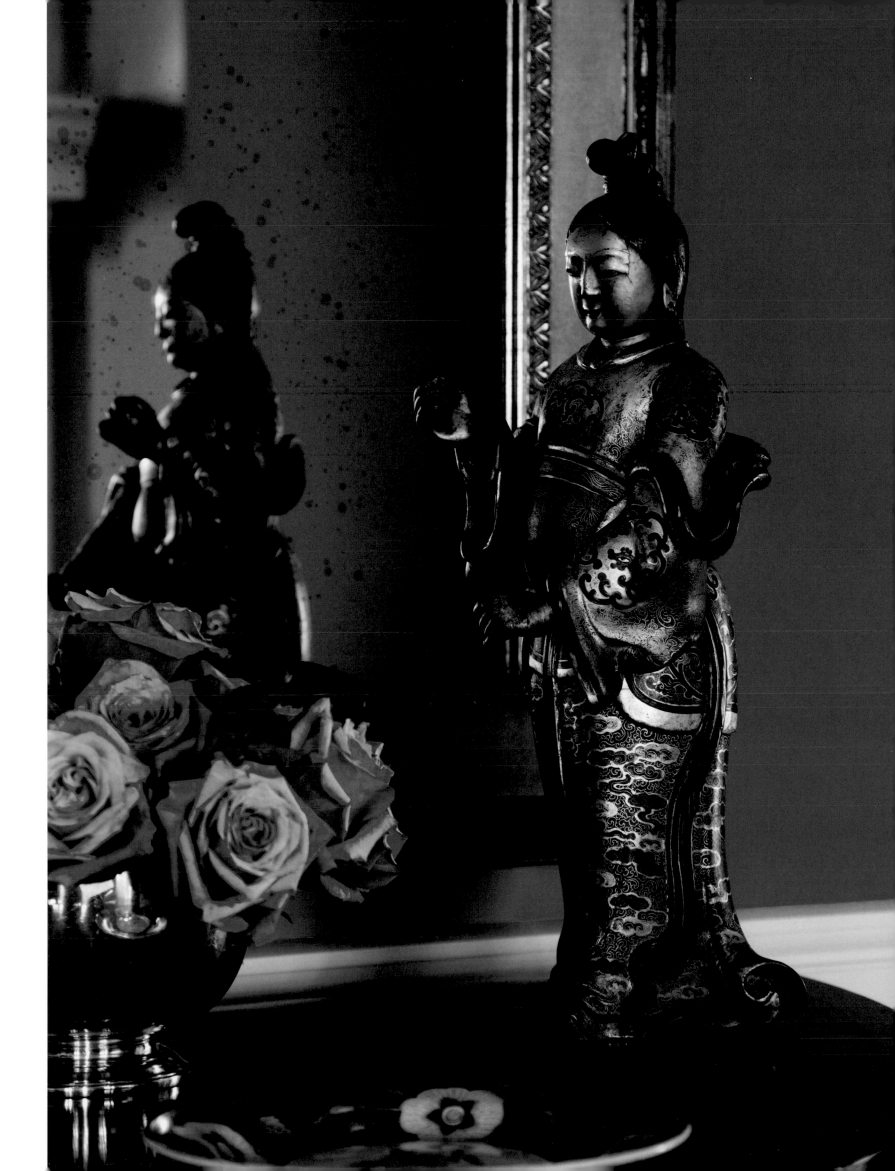

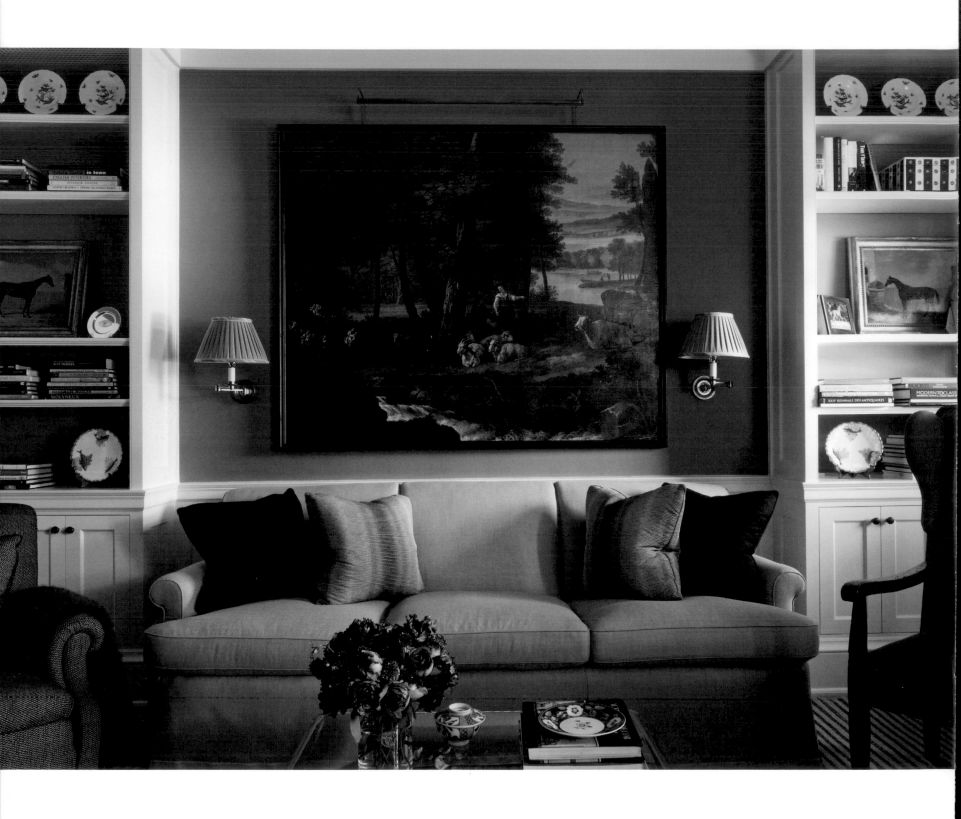

A pastoral English landscape hangs above the oyster-white linen sofa, which is
accented by merlot pillows. Opposite: A detail of the chinoiserie desk in the wife's study.

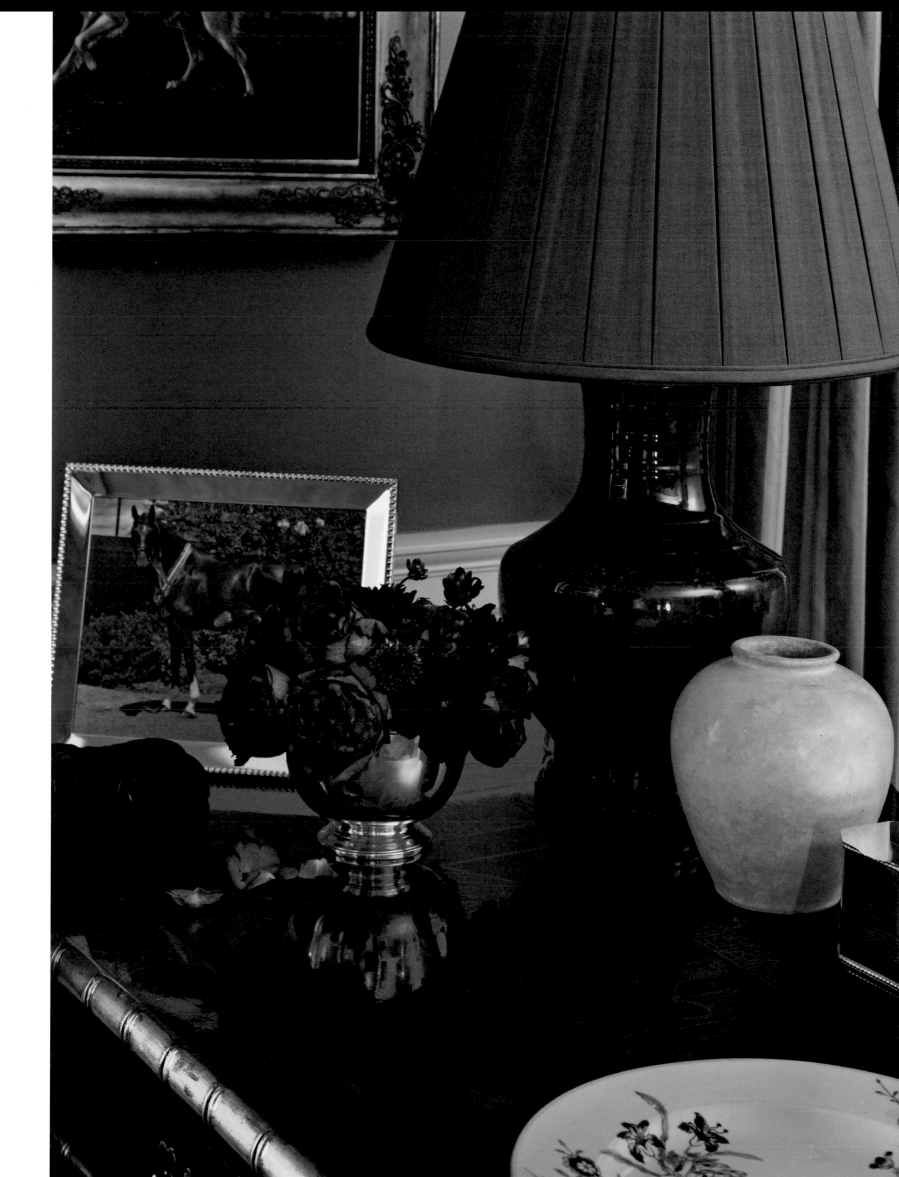

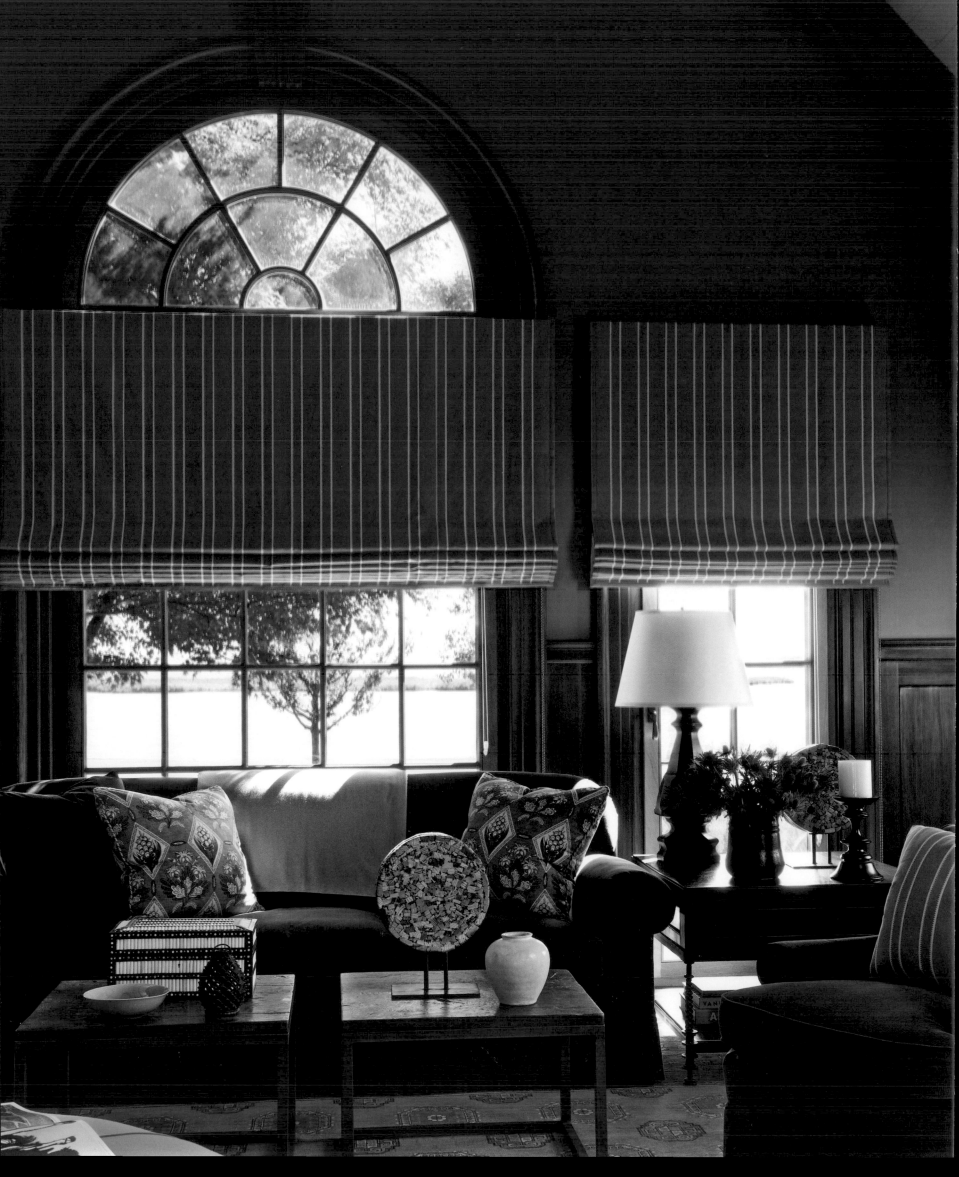

Elsie de Wolfe who virtually invented the profession of interior decorating, did many striped tented rooms like this one at the Villa Trianon, her house on the grounds of Versailles. Opposite: Stripes address the verticality of the space, while the wainscoting humanizes its scale.

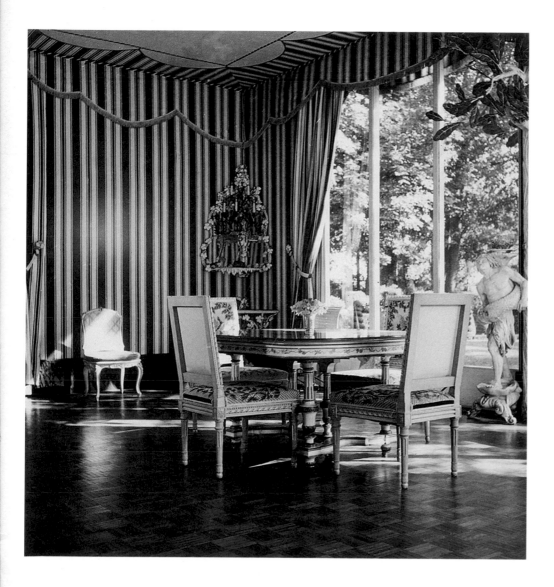

The husband's study is classically wood-paneled and furnished in
suedes, leathers, flannels, and tartans and includes an English partners desk.

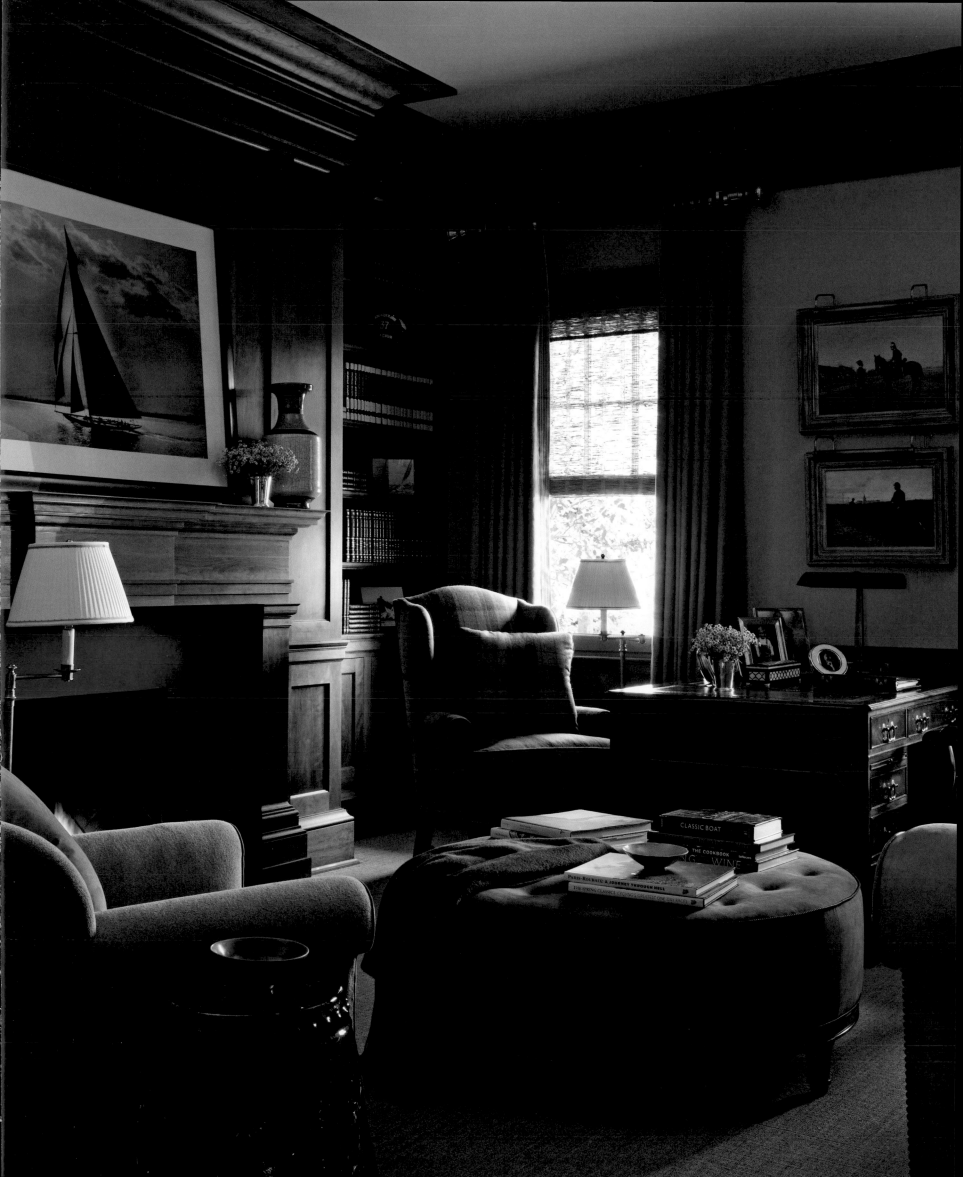

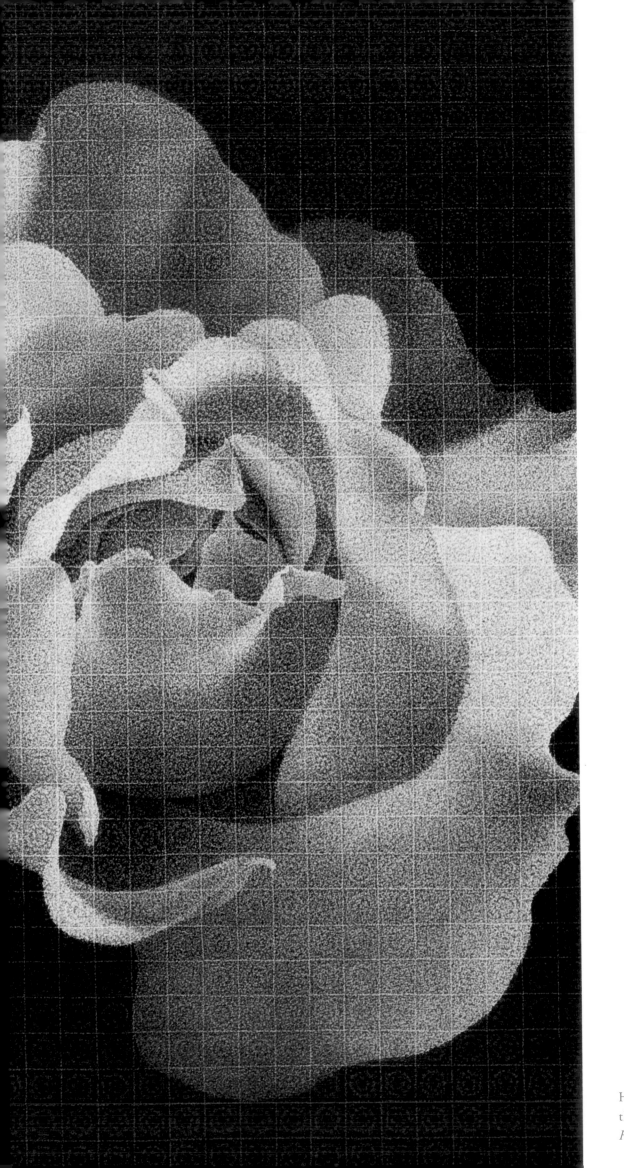

Hand-forged-iron canopy beds in a bedroom divide
the space into two separate realms. The scale of Chun-yi Lee's
Hundreds of Blooms expands the space.

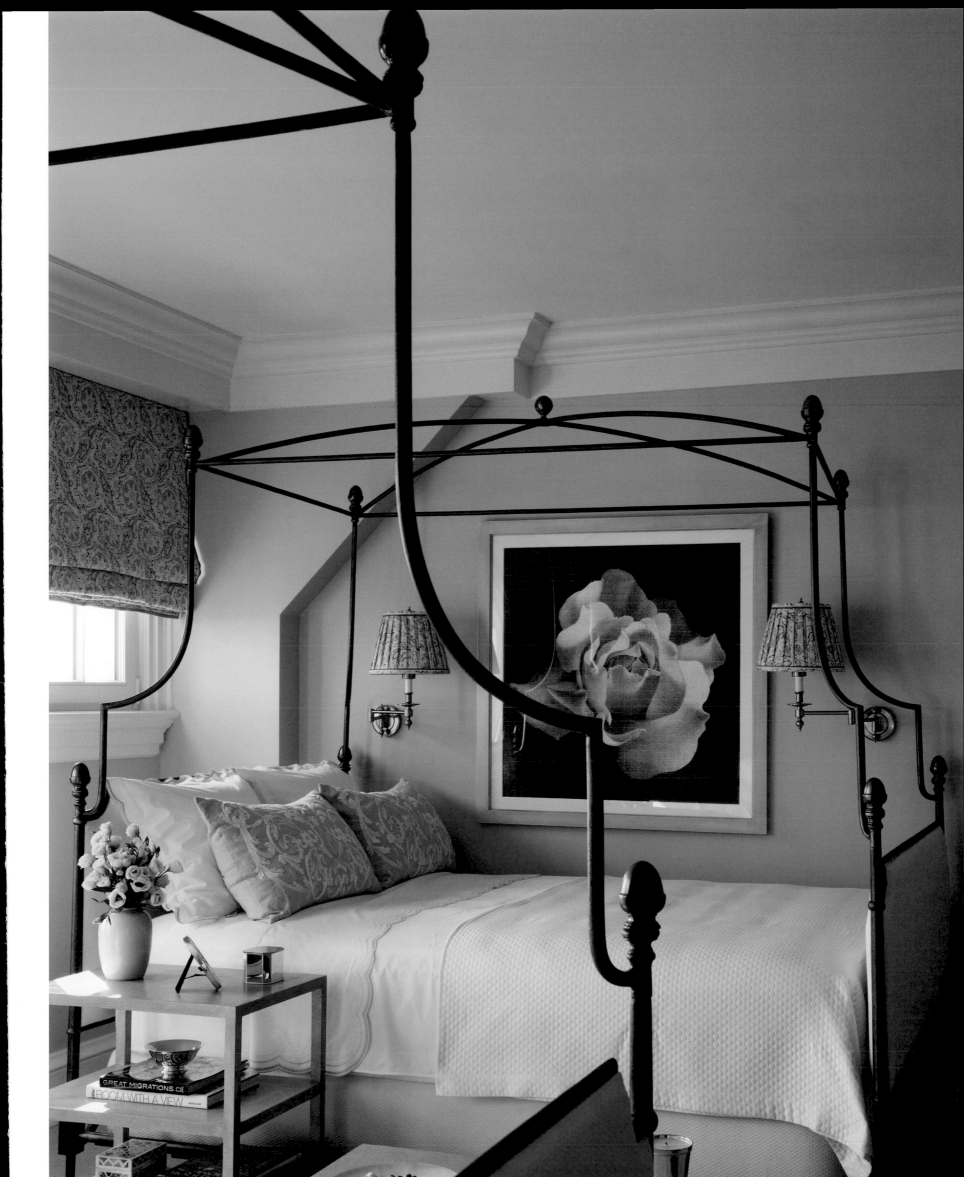

The interior of the canopy is shaped into a rosette design. Swing-arm lamps are an elegant solution for reading lamps. Opposite: The view calls for an equally beautiful window and window seat.

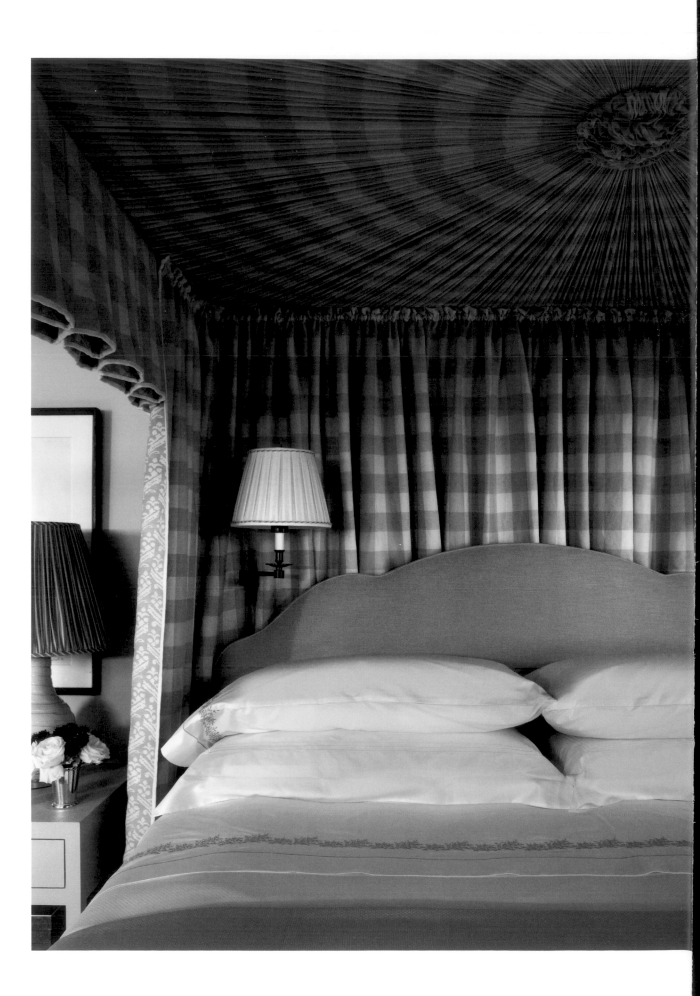

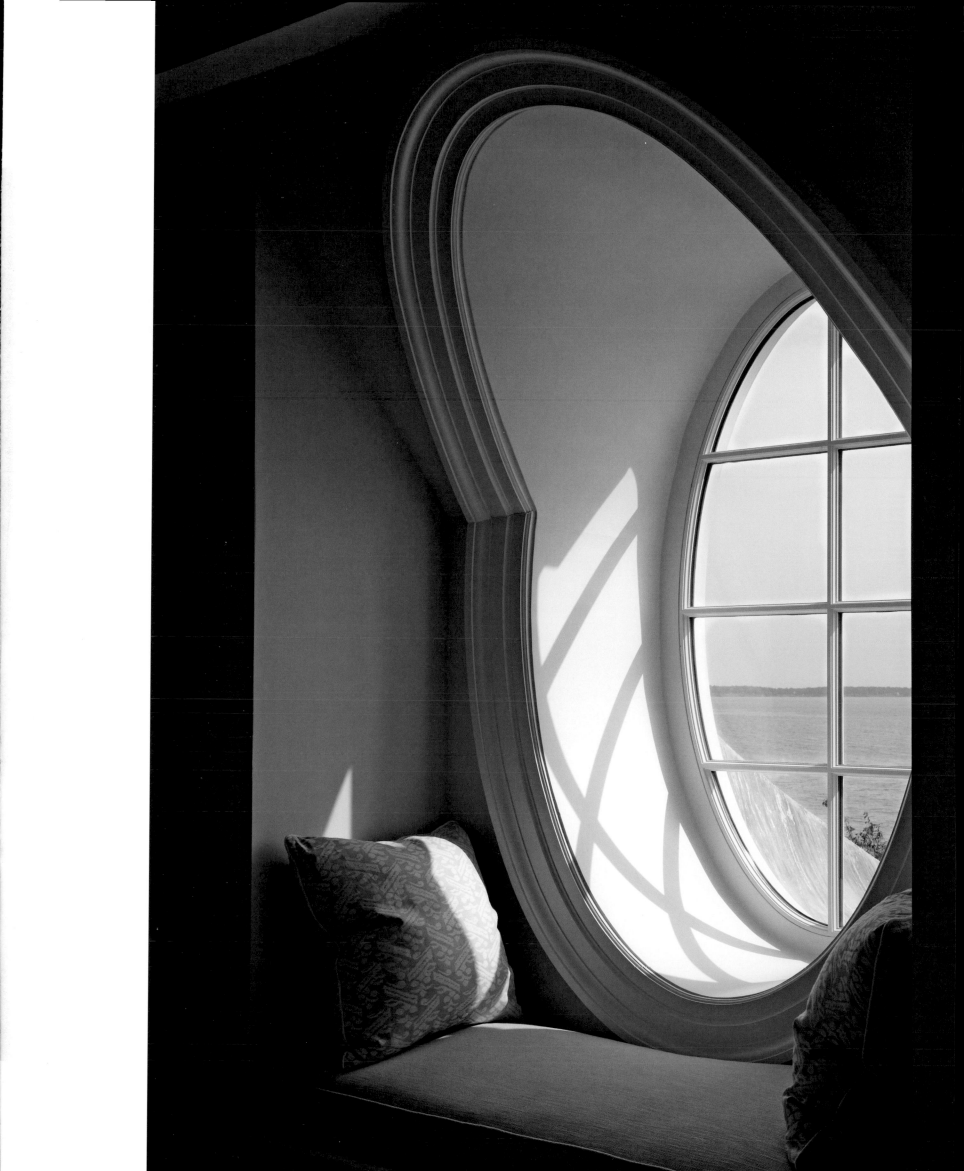

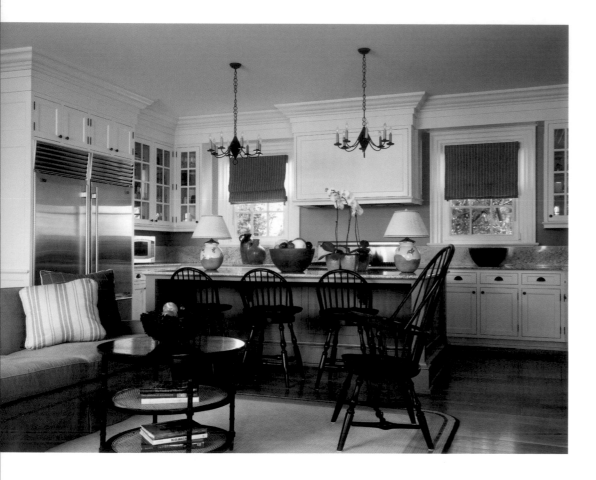

The barstools are an adaptation of the kitchen's original Windsor chair. Table lamps
on an island provide an intimate evening setting. Opposite: The round braided rug, table,
and iron chandelier enhance the circular composition of the rotunda.

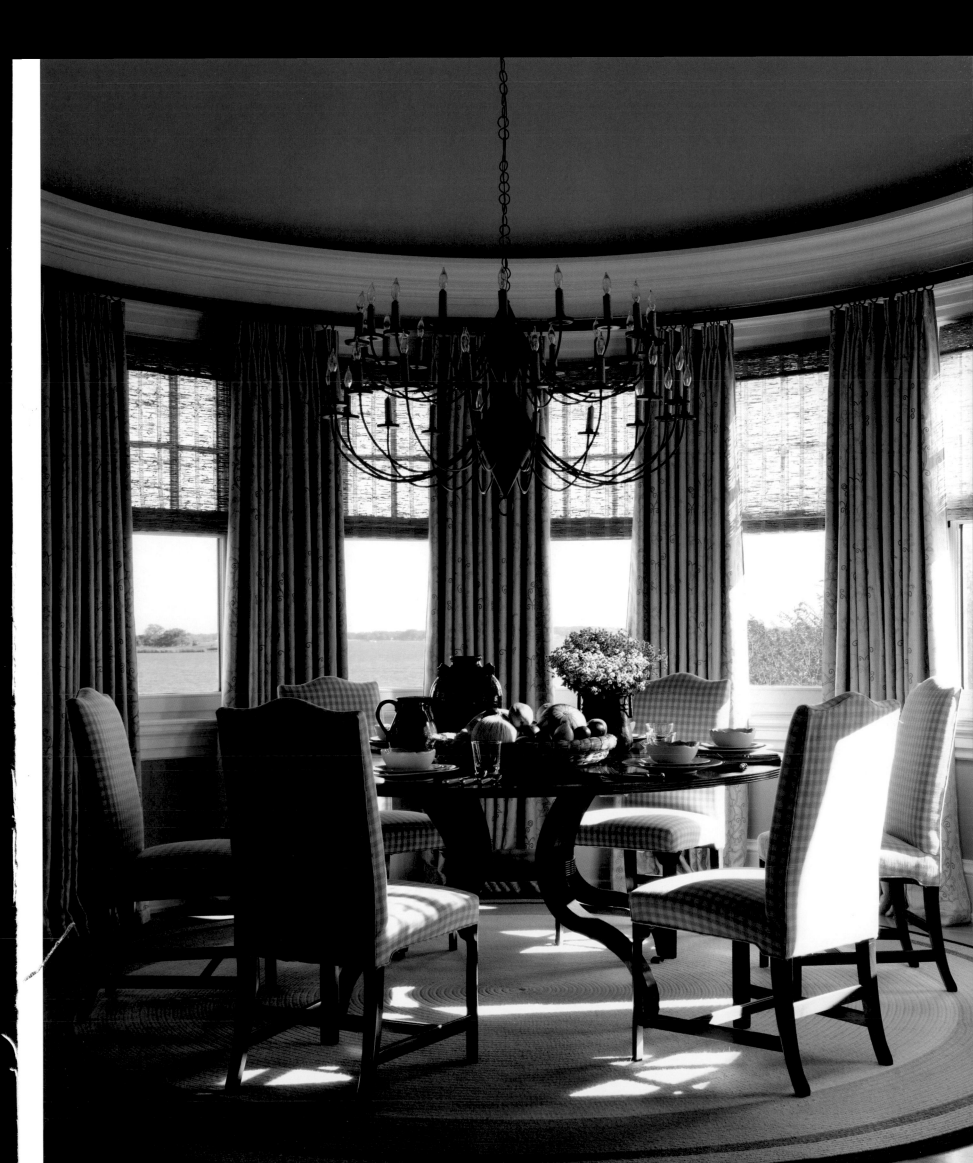

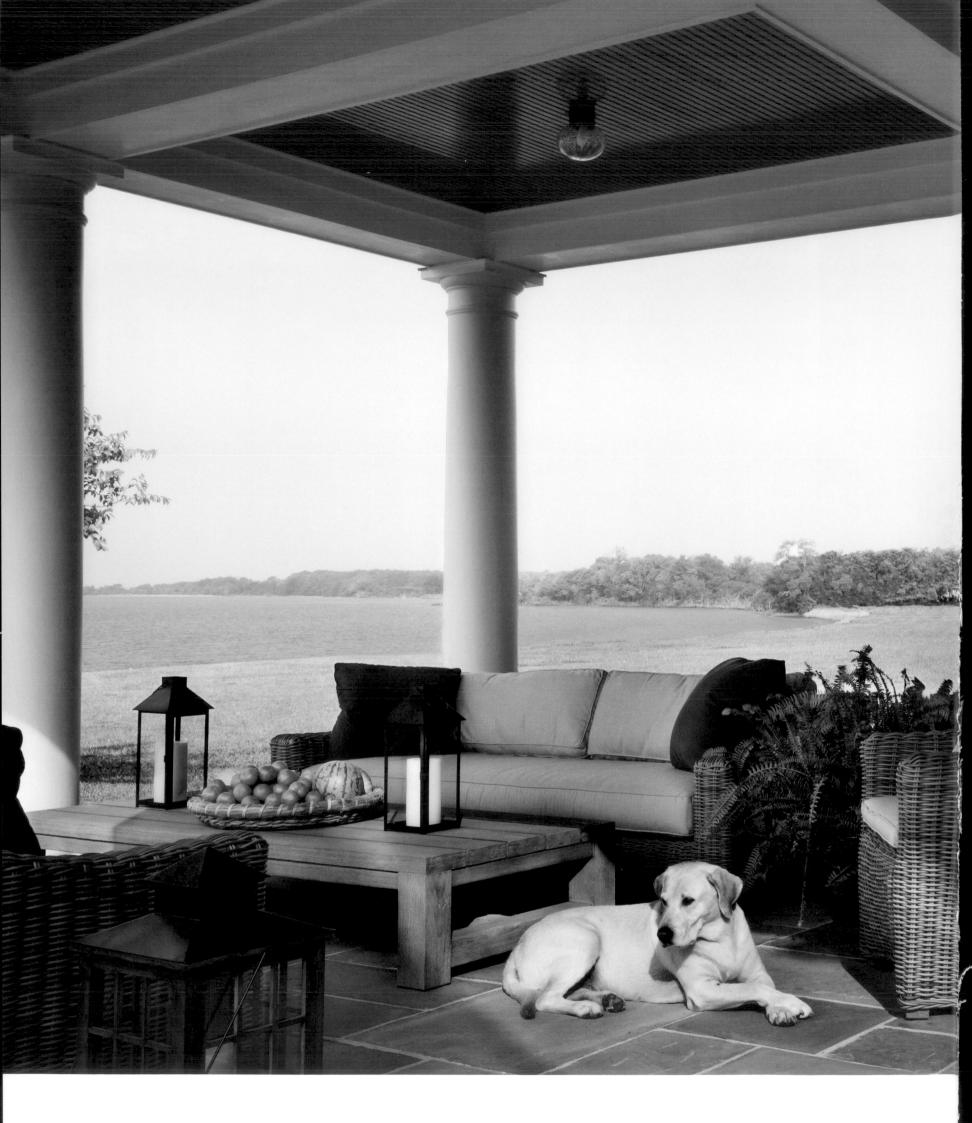

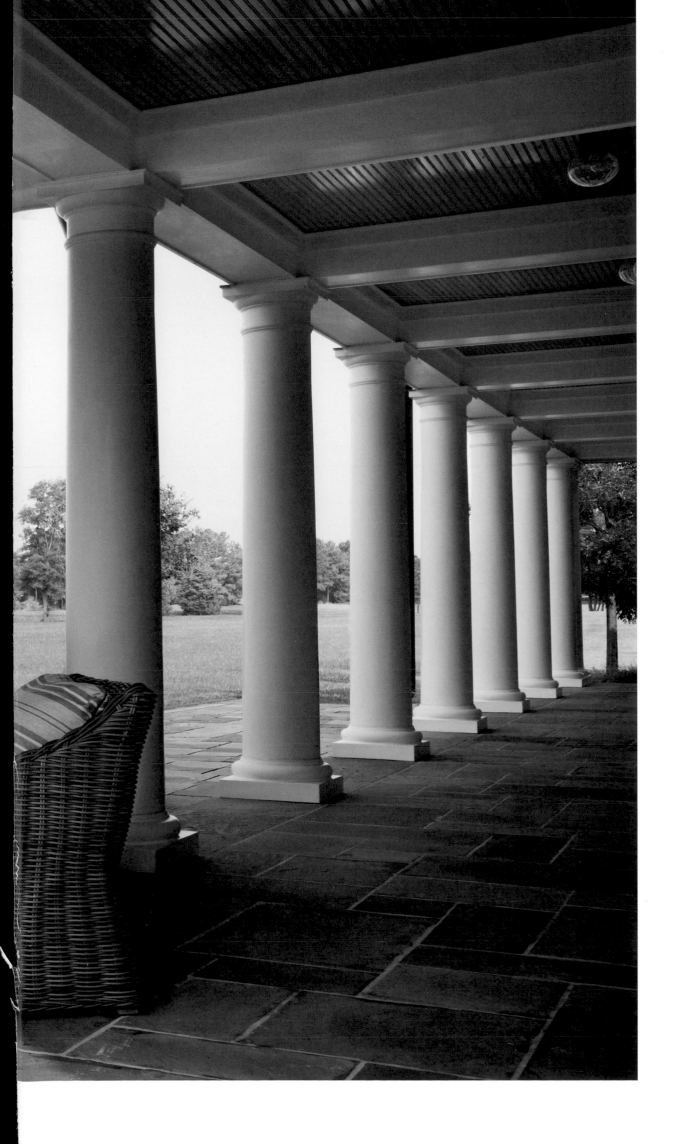

A wide porch runs along the back of
the house and overlooks the picturesque bay.

ACKNOWLEDGMENTS

I could not have created this book without the support of the following:

I am most grateful to my talented and hardworking team. Though the members at Sandra Nunnerley Interiors have changed throughout my firm's history, the atmosphere of creativity and strong work ethic remains the same.

Heartfelt appreciation and fondness to all of my clients, without whose willingness and trust none of this would have ever been possible.

SPECIAL THANKS TO

Creative Director Yolanda Cuomo for her exceptional creativity, energy, organization, and focus. The commitment and dedication to excellence by the entire studio team on this project are very much appreciated.

John Pelosi, for his tremendous professionalism and expertise. His steady guidance made this book a reality, it never would have happened without him.

Alexandra D'Arnoux for her confidence, friendship and treasured observations throughout the years.

Writer Christine Pittel, who brought her phenomenal eloquence to every sentence.

Publisher Daniel Power and his incomparable team at powerHouse, many thanks for their unwavering patience and skill.

Alejandra Cicognani and her team for their invaluable enthusiasm and creative placement on both sides of the Atlantic.

Nathan Lump for his keen eye and highly considered opinions.

Alan Yedin for his expertise, business acumen, and intelligence.

Finally, my sincerest gratitude to Pierre Durand. Thank you for your insight, support, and above all your friendship.

ARCHITECTS

Thank you to the following Architects who I was fortunate to collaborate with: Mark Ferguson, Damian Samora and Scott Sottile of Ferguson & Shamamian Architects; Bernard M. Wharton and Arthur Hanlon of Shope Reno Wharton Architects; Graham Wyatt at Robert A.M. Stern Architects; Mark Proicou and Sascha Reinking of Alexander Gorlin Architects; Woody Pier at Pier, Fine Associates; Fairfax & Sammons.

SOURCES

In the United States: The Chinese Porcelain Company, Robert McClain and Erin Sludzinski at McClain Gallery, Barry Friedman, Gagosian Gallery, Cristina Grajales Gallery, Jason McCoy Gallery, Loretta Howard Gallery, Pace Gallery, Paul Kasmin, HM Luther, 50/50 Gallery, Simon Capstick-Dale Fine Art Gallery, Christine Wächter of Winston Wächter Fine Art, Bernd Goeckler Antiques, Donzella, R 20th Century Gallery, The End of History, Gerald Bland Inc., Hartman Rare Art, Inc., Hyde Park Antiques, Ltd., Ingo Maurer, Kentshire, Kimcherova, DeLorenzo Gallery, Maison Gerard, R&Y Augousti, Sebastian & Barquet, Valerie Goodman Gallery, and V'soske.

In Europe: L'Arc en Seine, Alexandre Biaggi, Carpenters Workshop Gallery, Established & Sons, Christopher Farr, Galerie Chastel-Marechal, Galerie Dutko, Galerie Kreo, Galerie Lefebvre, Galerie Mougin, Galerie Vallois, Hemisphere Gallery, Hervé Van der Straeten, Themes & Variations, and Gordon Watson.

ARTISTS & ATELIERS

Barber Osgerby, Michele Oka Doner, Blue Meadow Flowers, Carlton House, Chapeau Antiques & Atelier, Doreen Interiors, J.C. Landa, Jean Carrau, Konrad Praczukowski of Nuance Studios, Carlos Queiroz at CQ Design Studio, Laszlo Sallay, Philippe Anthonioz, Hubert le Gall, Eric Vidal Atelier, and special thanks to Eamonn Ryan and the team at Nordic Custom Builders.

PHOTOCREDITS

SANDRA NUNNERLEY

INTERIORS

Published in the United States by powerHouse Books,
a division of powerHouse Cultural Entertainment, Inc.
37 Main Street, Brooklyn, NY 11201-1021
telephone 212.604.9074, fax 212.366.5247
e-mail: info@powerHouseBooks.com
website: www.powerHouseBooks.com

First edition, 2013

Library of Congress Control Number: 2013942849

ISBN 978-1-57687-669-5

BOOK DESIGN BY YOLANDA CUOMO DESIGN, NYC
Associate Designers: Kristi Norgaard and Bonnie Briant

Printed and bound in Italy by Graphicom Srl-Vicenza
Separations by Robert Hennessey

10 9 8 7 6 5 4 3 2 1